The Froehlich Foundation
German and American Art from Beuys and Warhol

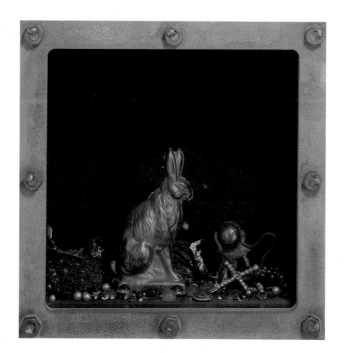

Joseph Beuys
'Friedenshase', 1982
Staatsgalerie Stuttgart

THE FROEHLICH FOUNDATION

German and American Art from Beuys and Warhol

Edited by Monique Beudert

GEORG BASELITZ

JOSEPH BEUYS

ANSELM KIEFER

IMI KNOEBEL

BLINKY PALERMO

A.R. PENCK

SIGMAR POLKE

CARL ANDRE GERHARD RICHTER

RICHARD ARTSCHWAGER ROSEMARIE TROCKEL

JOHN CHAMBERLAIN

DAN FLAVIN

DONALD JUDD

ON KAWARA

BRUCE NAUMAN

FRANK STELLA

CY TWOMBLY

ANDY WARHOL

TATE GALLERY PUBLISHING

Contents

Foreword 7

Stefan Germer
Intersecting Visions, Shifting Perspectives: 9
An Overview of German-American Artistic Relations

Thomas McEvilley
(Op)Posing Cultures: An Investigation of Beuys and Warhol 35

GEORG BASELITZ 46
JOSEPH BEUYS 56
ANSELM KIEFER 78
IMI KNOEBEL 84
BLINKY PALERMO 88
A.R. PENCK 94
SIGMAR POLKE 98
GERHARD RICHTER 118
ROSEMARIE TROCKEL 126

CARL ANDRE 134
RICHARD ARTSCHWAGER 138
JOHN CHAMBERLAIN 144
DAN FLAVIN 148
DONALD JUDD 152
ON KAWARA 158
BRUCE NAUMAN 162
FRANK STELLA 180
CY TWOMBLY 182
ANDY WARHOL 194

Nicholas Serota and Monique Beudert
The Making of a Collection: 221
An Interview with Josef and Anna Froehlich

Catalogue 235

The Froehlich Foundation collection, which this catalogue documents fully, was initiated in 1982 by Josef and Anna Froehlich. A visit to Documenta 7 in September of that year sparked their transition from informed onlookers to active participants in art. The Froehlichs' reaction to seeing 'Friedenshase', 1982 (p. 2) – a work by Josef Beuys in which a jewel-encrusted gold replica of Ivan the Terrible's crown was transformed into a golden hare – led to their close involvement with Beuys and eventually with a number of other German and American artists. Without being consciously aware of it, by inquiring about 'Friedenshase' the Froehlichs had taken the first step towards forming a collection which now numbers some 320 works. The collection includes the work of nine German and ten American artists, and is based on the principle of 'Sammlungsblöcke'. As a rule, each of these artists is represented by a group of works which has been rigorously selected to represent his or her individual achievement as well as their contribution to the art of our time. In the case of some artists, the collection includes a comprehensive survey of the artist's entire career. For example, Sigmar Polke is represented by paintings, photographs and works on paper made over a twenty-five year period. The full range of Bruce Nauman's work – drawings, photographs, sculpture, video, and neon pieces – is also included. Other artists have been treated in a more focused way, as can be seen in the marvellous group of works on paper by Cy Twombly, or the four magnificent large woodcuts by Anselm Kiefer.

As the Froehlichs' interest in art both expanded and became refined, the collection soon grew beyond the capacity of their house to contain it (or, even, in some cases, to exhibit it) and they began to consider the alternatives to keeping in storage works which could not be installed at home. The idea of a private museum was explored, but discarded because of the complexity of the undertaking and the realisation that building an institution around their collection might lead to its isolation from the world. Plans for a 'Collector's Museum' in Stuttgart began to be developed in 1988, but were abandoned in 1991, shortly after the reunification of Germany.

In 1993, in one of our occasional conversations which had taken place since our first meeting in 1986 at the time of the Nauman exhibition at the Whitechapel Art Gallery, I told Josef Froehlich of the decision made by the Trustees of the Tate Gallery to create a new museum in order to exhibit the national collection of modern art. At that point, the Bankside Power Station was just beginning to be considered as a possible site for the new museum. Characteristically, Josef immediately saw the potential for the building and the opportunity to create a museum of international significance. He enthusiastically endorsed the project by expressing the desire to see his collection become part of this new initiative. Over a period of eighteen months, discussions between us have led to the establishment of the Froehlich Foundation which has been formed to hold the collection. The chief aim of the Foundation is to make the collection available to a broad audience, both in Germany and internationally. In keeping with this objective, the Tate Gallery and the Froehlich Foundation have agreed to a series of annual installations of works from the collection to be integrated with the Tate Gallery's collection from now until 1999.

The first of these installations features the works of the German artists Blinky Palermo, Sigmar Polke and Gerhard Richter and the American sculptors Carl Andre, Richard Artschwager, and

Bruce Nauman. Over the next four years, the Tate Gallery's public will become acquainted with the extraordinary range of works which the Foundation holds. To a remarkable extent, the Foundation's collection complements the Tate Gallery's own collecting activity. Due to the policy of collecting each artist in often considerable depth, works from the Froehlich Foundation can be used to extend the account of contemporary art which the Tate already has begun to tell. The degree to which the two collections complement each other will be evident both over the next four years and at the time of the opening of the Tate Gallery of Modern Art in 2000, when the Foundation has agreed to make available for display a significant group of works as long-term loans.

This catalogue is another demonstration of the joint effort between the Froehlich Foundation and the Tate Gallery. Many of the works in the collection have been seen and catalogued in temporary exhibitions, but this is the first time that the collection will be fully documented and presented to the public. By producing the English language version of the catalogue, Tate Gallery Publishing has worked in conjunction with the Froehlich Foundation to make this volume available to readers in both English and German. We are most grateful to Stefan Germer and Thomas McEvilley for their response to our invitation to contribute essays touching on aspects of German and American art; to Sylvia Fröhlich for conceiving the handsome design of this publication and coordinating all aspects of it; and to Angelika Thill, Roland Nachtigäller and Nicola von Velsen for their work on the catalogue listing.

Following the first installation of works from the Froehlich Foundation at the Tate Gallery, the entire collection will be shown simultaneously in three institutions in Baden-Württemberg from September to November 1996: Staatsgalerie Stuttgart, Württembergischer Kunstverein, Stuttgart, and Kunsthalle, Tübingen. Subsequently, from February to April 1997, most of the collection will be exhibited in Hamburg at the Deichtorhallen, with the exception of a few works by Nauman and Polke which at the same time will be placed on loan to the Kunsthalle Hamburg in celebration of the opening of their new galleries. After the German showings of the collection, a selection of works from the Foundation will be on view at the Kunstforum Wien, in Austria, from May until August 1977.

We are pleased to be able to show the Froehlich Foundation collection at the Tate Gallery, Millbank, and look forward to working with the Foundation when the Tate Gallery of Modern Art opens at Bankside in 2000. We are grateful to Josef and Anna Froehlich for their co-operation and generosity in making possible the presentation of these important works to our public. I know they would wish to join me in thanking Monique Beudert, my colleague at the Tate Gallery, who has contributed so positively to our discussions about the collection and its exhibition. In the ten years since I first became acquainted with the Froehlichs and their collection, my admiration and respect have deepened for their dedication to the American and German art they collect. Our recent conversations about the collection have made it clear how strongly they are committed to, in their own words, living with art. That is, of course, the great benefit of having a private collection. For their determination to share their private enthusiasm with a larger, international, audience, we owe them a large debt of gratitude.

Nicholas Serota
Director

Stefan Germer **Intersecting Visions,
Shifting Perspectives:
An Overview of German-
American Artistic Relations**

I

With reunification an era has come to an end. The special relationship between Germany and the USA – of decisive importance both to the emergence of West German self-awareness and to the self-definition of the United States from the start of the Cold War onwards – has begun to disintegrate and lose its defining power. This is therefore a crucial moment to investigate one aspect of that relationship: the interaction between American and (largely West) German art. For, although artistic exchange between the two countries will undoubtedly continue in the future, the special relationship has become a historical phenomenon, demanding and permitting analysis.

*I like America, and
America likes me.*
Joseph Beuys

*I'm totally uninterested
in European art and I
think it's over with it.*
Donald Judd

To this end, we must free ourselves from the shorthand expressions and clichés that oversimplify and distort the complex and often contradictory processes involved. Notably, it is time to dispense with the idea that artistic creation can ever be understood in terms of national categories – that in the present case, for instance, it can be reduced to a 'specifically American' or 'specifically German' essence. As Benjamin Buchloh writes:

'To classify artistic production in terms of national allegiances is paradoxical, because it is done in pursuit of needs that are inimical to artistic production itself: the assertion of national prestige and state power; the conservation of culture in the abstract as inherited wealth; the expansion, consolidation and protection of markets. Sustained by national feeling, the (aesthetic) ego thus finds compensation for the inadequacies of real-life social communication and of political participation in the historical process.'[1]

To force artistic production into national pigeonholes is to falsify it twice over: first, by forcibly identifying it with entities with which it neither can nor wishes to be identical, since it finds its own identity (where it finds one at all) mostly in opposition to them; and, second, by foisting on it a prestige function that is all the more humiliating because it takes artistic production seriously not for its own sake but in reference to the national context. Even so, in any discussion of German-American relations in art after the Second World War, it would be naive to overlook the fact that those relations rested on something more than an aesthetic whim: namely a specific politico-historical situation that lastingly affected both their form and their further development.

In the immediate post-war period, the West German consciousness was dominated by three factors. The memory of past crimes was stubbornly blocked; all nationalism was discredited; and before long a united front was formed against the Socialist East. Taken together, these three factors explain why 'Americanisation' – motivated at first by military and later by economic considerations – affected West Germans more durably than other European peoples. In West Germany, Americanisation took on a psychological dimension that went far beyond the practical.

This psychological basis distinguishes the post-Second World War Americanisation from the fascination with America that prevailed under the Weimar Republic. In Weimar eyes, America was synonymous with modernity and technological progress, but also with mechanistic rationalisation: a vision of the future that struck many intellectuals as a welcome antidote to the smug traditionalism of the 'old' Europe that had been exploded by the catastrophe of the First World War. It was a vision that remained just foreign enough to become a real prototype for their own soci-

ety. This American enthusiasm had a practical economic basis. The eager fantasies of architects, artists and writers anticipated the reorganisation of industrial labour on the American-originated principles of F.W. Taylor and Henry Ford; they hailed the arrival of new (also American-devised) methods of mass distribution of goods; and they recorded the triumph, first and foremost in magazines and in the movies, of a form of mass culture that was also regarded as American. All the same, despite the pervasive presence of all things 'American', America was not a model for Weimar; there was no incentive to follow the precedent.

The situation after the Second World War was radically different. By looking to America, people hoped to escape from 'Germanness', and from all the terror that it had brought to Europe. Germans did not identify with America just because they had lost the war, or because it was necessary to bow to superior economic strength. The enthusiasm with which they accepted and imitated all things American derived from a deep psychological need: the wish to put their own past behind them, and to give themselves an *Ersatz* identity in the image of the victor.[2] This psychological motivation underlies the Americanisation of society and culture, as well as the artistic engagement with America.

This background makes it possible to understand why the relationship between the USA and West Germany cannot really be described in terms of 'cultural exchange'. For one thing, there was no exchange. On the German side, for a long time, a collective ego-ideal was patterned on the USA as a result of the specific exigencies of the post-war situation. But repressed guilt was only one aspect of this American-inspired self-image. At least as strong was the prospect that, by identifying themselves with America, Germans could distance themselves from the patterns of social discipline traditionally defined as 'German'. America opened up a whole fantasy spectrum of escape from the narrow confines of German experience and traditions. No such projections existed in the reverse direction, from the USA to Germany; and so, in many areas, this was an asymmetrical relationship. Germany has never fascinated America so exclusively or so intensely as America has fascinated Germany. Consequently, Germany has never occupied the position in the American psyche that it has assigned to America in its own.

The German-American artistic relationship is particularly marked by asymmetries of this kind. Its history is neither linear nor continuous, but is riddled with ruptures and fault lines. It starts with the destruction and expulsion of the avant-garde by the Nazis and continues intermittently in the American exile of those individual German artists who (like Josef Albers at Black Mountain College or Yale University) became the teachers of such American artists as Robert Rauschenberg and Eva Hesse (herself a childhood refugee from Nazi Germany). When Rauschenberg's work reached the Federal Republic, it led German viewers back to a forgotten and repressed figure: Kurt Schwitters. Only by responding to foreign art could they take possession of the remnants of a history that had never quite become their own. The politically enforced absence of the German avant-gardes preconditioned the response to American art in post-war Germany. It was via America that German artists absorbed avant-garde strategies and issues, albeit in fragmented and distorted forms.

Despite such asymmetries, the history of this relationship is not and never has been all one way. Over the last few decades it has undergone a step-by-step reversal, which is of course associated with extra-artistic factors – such as the growth of the Federal Republic's international role – but cannot be explained in such terms alone. The argument that follows presents a number of core episodes from a history that cannot yet be written as a whole. It will become clear that differing time frames and levels of interaction can yield considerably varying definitions of German-American artistic relations.

On the American side, it all began with the exportation of Abstract Expressionism, which was sustained by an imperial sense of mission and by the cultural demands of the Cold War. The Germans were never really successful in connecting with Abstract Expressionism, although – in relation to the artist's ambitions and role – it left lasting traces in their art production. This purely

receptive phase soon gave way to the beginnings of cooperation and genuine exchange. Artistic activity in West Germany became American-oriented, and in return American artists discovered West Germany as a locus for their work. Both these things marked a deliberate move away from national allegiances: freedom from the compulsion to assert hard-and-fast identities was a necessary precondition of international interchange. And yet, just as soon as the artistic product itself became marketable and saleable, the compulsion returned: identities had to be asserted, and frontiers hardened once more. Cooperation was now accompanied by national rivalry. Matters did not rest there, however: that artistic critique of ossified and reified notions of identity generated a renewed cooperation that continues to this day.

This reciprocal relationship will be described (at least in outline) in what follows. As our account proceeds, we deliberately shift its focus: the topic is not only the impact of American art in Germany, and the cooperation and rivalry between American and German artists, but finally the impact of German art on the USA.

II

The relationship began hesitantly. America constituted a political, military and economic presence in Germany, but it was the mid-1950s before it began to provide an artistic point of reference. The Marshall Plan and 'Re-education'; the formation of NATO, which tied the Federal Republic into the Western economic and social system; and a flow of imports and investments from America, made this part of Germany into a Western-oriented state. But in artistic matters the relationship did not keep pace either with political changes or with the 'Americanisation' of society, as reflected in an influx of products, films, and behaviour patterns. This was so even though the occupying power took an early interest in cultural issues via exhibitions and other initiatives. In Berlin, as early as 1951, the USA presented a survey of the evolution of American painting since the eighteenth century under the title *Amerikanische Malerei: Werden und Gegenwart* (American Painting: Evolution and Actuality). Selected by curators from leading US museums, the show included a selection from the early twentieth-century American avant-garde (including Arthur Dove, Charles Demuth and Marsden Hartley) and a survey of contemporary (post-1940) art, as represented by Hyman Bloom, Philip Evergood, Jackson Pollock, Robert Motherwell, William Baziotes, Mark Tobey and Mark Rothko.[3]

But as yet there was no public for American art. New York was a far-off place, not only from a German but from any post-war European perspective. In the 1950s, Paris was the place where the avant-garde existed, and this was the starting point for those Germans who sought to reconstruct, at least in part, the history of their own banned and crushed avant-garde movements.

'The lines of force,' as Benjamin Buchloh summarises the process, 'seem to have run from New York to Paris, and from there outward to the provincial centres of art. Even this took place with considerable time-lags, a characteristic feature of artistic life and thought in Europe at this period. And so, at the XXVth Venice Biennale in 1950, Pollock, de Kooning and Gorky represented American art alongside a French contribution made up of works by Bonnard, Matisse and Utrillo, and alongside German painters such as Klee, Macke, Kandinsky and Jawlensky (*sic*). In 1956, works by Franz Kline were to be found at the Biennale in juxtaposition with those of Bernard Buffet and Emil Nolde. This would suggest that, in Europe generally, the central artistic developments of the twentieth century had neither been absorbed nor worked through.'[4]

Even where efforts were made to piece together the shattered history of the avant-gardes, it was assumed that the

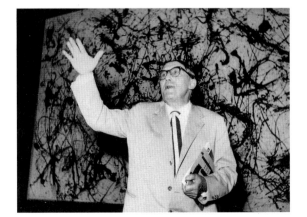

Arnold Bode in front of 'Number 32', 1950, by Jackson Pollock, Documenta 2, Kassel 1959

American contribution could safely be ignored.[5] In Kassel, the first Documenta exhibition (1955) presented the evolution of modern art as an exclusively European phenomenon; the USA was relegated to, at best, a marginal position, being represented only by Alexander Calder, Naum Gabo (who had become a US citizen in 1952), and the German émigré Kurt Roesch.[6]

Four years later, the situation had radically changed: the second Documenta gave a triumphal welcome to the Abstract Expressionists Jackson Pollock, Arshile Gorky, Willem de Kooning, Franz Kline, Robert Motherwell, Clyfford Still and Mark Rothko. The American contingent had grown considerably: with thirty-five out of the 219 artists in the show, it was hard to miss.

There were three reasons for this change, and for the sudden interest in American art. First, Documenta 2, unlike its predecessor, was not conceived as a historical survey but as a presentation of trends in art since 1945. Second, as a result of this the significance of abstract – and above all Abstract Expressionist – tendencies was more clearly evident than before. Third, the presence of a substantial selection of American artists was the result of a deliberate propaganda campaign waged by The Museum of Modern Art, New York (MoMA) with the support of the official United States Information Service (USIS). The Kassel exhibition culminated and terminated a series of touring exhibitions of current American art, organised from 1950 onwards, specifically for European audiences, by the International Program of MoMA. The director of the Program, Porter A. McCray, made his own selection of works for the 1959 Documenta, since the German organisers felt themselves incapable of performing the task.[7]

McCray was indeed well qualified for his job. He had studied architecture at Yale, and subsequently Wallace Harrison – architect to the Rockefellers, who set the tone at MoMA – had introduced him to Nelson A. Rockefeller. During the Second World War he had worked for Rockefeller's Office of Inter-American Affairs, and from 1946 to 1949 he had been a member of the Coordinating Committee of MoMA. After moving to Paris in 1951 to work in the exhibition section of the Marshall Plan office, he had returned in 1952 to take charge of the MoMA International Program, financed by the Rockefeller Brothers Fund.[8]

The International Program was part of the cultural Cold War. Having established military, political and economic supremacy, the USA intended to take the lead in cultural matters too, and Abstract Expressionism seemed tailor-made for this purpose.[9] It could readily be contrasted with the 'regimented, traditional and narrow-minded' Socialist Realism of the East; not only was it original and avant-garde, but it could be interpreted as the expression of 'Western Freedom' and a symbol of America.[10] The International Program, with its aggressive exhibition policy, ensured that this message was received in Europe.

In 1953–4 it sent its first exhibition, under the title *Twelve American Painters and Sculptors of the Present*, to Paris and then by way of Zurich, Düsseldorf, Stockholm and Helsinki to Oslo. In 1955–6 a second show, selected from the permanent collection of MoMA, was shown in Paris, Zurich, Barcelona, Frankfurt, London, The Hague, Vienna and Belgrade. This was the cue for a broad reassessment of recent American painting. Art magazines devoted articles and special issues to the phenomenon; the English critic Lawrence Alloway noted the appearance of a 'new aesthetic' with its roots in a culture that was alien, but nonetheless relevant, to the European observer.[11]

With the third exhibition, *New American Painting*, which was launched in 1958 and seen in Basel, Milan, Madrid, Berlin, Amsterdam, Brussels, Paris and London, 'the new art of the USA finally entered the international arena on a basis of full equality ... Most of the European art periodicals, insofar as they dealt with modern art at all, carried reports on the exhibition and used it as a starting point for wider reflections on US art and its new role in the world. Everyone began to talk about New York as the artistic centre that had finally pushed Paris into second place – not that Europe exactly welcomed this.'[12]

In Kassel there was no protest, only agreement and loud cheers. Not only did the American abstract artists fit into the conception of art history on which Werner Haftmann, the mastermind

of Documenta, had based the second Kassel exhibition: they seemed to confirm the project's validity on a worldwide level, as it were. Haftmann had interpreted the history of European Modernism as a journey into abstraction, away from reproductive and towards evocative imagery.[13] Once the Americans were included, his concept suddenly took on global dimensions: abstract painting could now be interpreted as the herald of a 'universal language' that would transcend 'regional cultures'.[14] And, although of course abstract painting had gained worldwide recognition under the aegis of the *pax americana* (with vigorous practical assistance from MoMA and USIS), Haftmann insisted in his opening speech on 11 July 1959 that these 'inner accords' had not arisen 'as a cultural after-effect of a political power complex' but were 'founded on nothing other than the sound of human voices calling, answered from a totally different part of the world'.[15]

Now of course this thesis of Haftmann's – enunciated just six months after an ultimatum from Khrushchev launched the second Berlin Crisis – was not a neutral statement of fact. It was a political provocation. Haftmann declared that abstraction, since it made interchange and communication possible between continents and provided a 'prototype of a world culture', was a practical manifestation of Western liberty and independence. He thus brought art, which was supposed to transcend history, right back into the arena of the Cold War and of those 'political power complexes' with which it was supposed to have nothing to do. In Kassel, thirty kilometres from the East German border, the identification of abstraction with Western freedom took on a special relevance, because it allowed Western exhibition organisers to distance themselves both from the figurative art of the Third Reich and from the Socialist Realism proclaimed at the *Dritte Deutsche Kunstausstellung* (Third German Art Exhibition) in Dresden, which announced itself as a counter to the 'formalistic art of American Imperialism'.[16]

But the presentation of American artists in Kassel was something more than a declaration of hostilities against the East. In the West, too, it marked the realisation that the time for a self-absorbed European Modernism (as promoted in the first Documenta) had passed. Hitherto in the lead, the French now had some formidable competition. Thenceforth the up-to-dateness of artistic practices would be assessed not by Parisian but by New York standards. This applied particularly to the nascent art production of West Germany. Arnold Bode, who devised and staged the 1959 Kassel exhibition, unmistakably reflected this paradigm shift in his hanging. He juxtaposed Ernst-Wilhelm Nay, the representative of a Federal Republic that craved recognition and inclusion in international artistic developments, not with pictures from the Ecole de Paris but with a big Jackson Pollock. The French might still just be in the lead, but from now on – or so Bode implied – German artists would not look to them but to the Americans who were poised to overtake them.

Bode's point was undoubtedly well taken, though not in the way he intended. What emerged from the Nay/Pollock confrontation was not the kinship but the fundamental difference between their respective artistic approaches; the effect was to relegate the notion of abstraction as a 'universal language' to the realm of pure fantasy. For the American painters' abstract work reflected a view of the act of painting, of artistic subjectivity and of paint considered in its materiality, which was poles apart from that of their European counterparts. As a result, of course, their painting – and above all Pollock's obsessive attachment to the visible and tangible materiality of his works – inevitably looked like a critique of the overblown lyricism and the fetishisation of the individual expressive gesture that were cultivated in the wake of the Ecole de Paris.

'The second Documenta, in 1959,' says Rudolf Zwirner, then a member of the exhibition secretariat and subsequently an art dealer, 'was intended as an apotheosis of international *Art Informel*; it ended up as its funeral. Unavoidable comparisons between paintings by Pierre Soulages and Franz Kline, or between the Tachistes and Pollock, revealed differences not only of principle but of quality. For the first time, the Americans' work was seen in close juxtaposition to that of the Europeans ... The confrontation was total, and so was the effect ... Ecole de Paris prices and paintings tumbled off their pedestals, and the pro-American euphoria mounted, slowly but surely, until the 1970s.'[17]

By desubjectivising the act of painting, concentrating on the materiality of paint, and treating the picture as an object, Abstract Expressionist painting afforded criteria by which to judge not only the authenticity of current European conceptions of abstraction but the validity of outworn definitions of painting in general. This message was not lost on the younger generation of painters. The 'sheer brazenness' that a youthful Gerhard Richter admired in Pollock's Documenta paintings gave him the strength to liberate himself from the compromises and false deference he had experienced in East Germany, where the canon was rigidly limited to Pablo Picasso, Renato Guttuso and Diego Rivera. Richter saw that a painting by Pollock was not a piece of formalistic trickery but possessed a necessity and truth of its own.[18]

Richter's revelatory experience marked the beginning of German artists' encounter with the art of the USA. Their astonishment reveals how incapable the Germans still were of any appropriate response to the American challenge. This they achieved only gradually: not by imitating and continuing practices learned from America, but by subjecting them to critical scrutiny.

III

Every artistic medium or practice has its own temporality. In any given location, different art forms are seldom at the same stage of development, and, at the end of the 1950s, the arts in the Federal Republic were conspicuously out of sync. Traditional media such as painting and sculpture looked retrograde, even provincial, by comparison with contemporary work from Paris and New York, as well as in relation to the history of the native avant-garde; they had difficulty in linking up with international developments or responding to them adequately. Painting in particular was a slow-moving medium: it lived by absorbing foreign prototypes, but any genuine interchange was thwarted by the absence of the artistic experiences driven out and suppressed by the Nazis.

Of course, avant-garde traditions had been torn apart just as brutally in music, dance, theatre and experimental literature, although there it proved easier to take up the threads. At the second Documenta in 1959, Tachism, *Art Informel* and Abstract Expressionism were still greeted with gasps – and Robert Rauschenberg's anti-Expressionist works, sent to Kassel at the same time, were either left in their crates ('Bed', 1955, The Museum of Modern Art, New York) or attacked by members of the public ('Kickback', 1959, Museum of Contemporary Art, Los Angeles). But from an early stage the other arts had not been far behind America in absorbing and productively developing the 'concrete' or 'concretistic' impulses that, in a range of different artistic fields, were soon to offer a basis for going beyond abstraction.[19]

For anyone who wanted to learn about the new techniques, Darmstadt, Cologne, Wuppertal, Düsseldorf and Wiesbaden were the places to go. The interaction took place a long way from the old centres, in small-scale impromptu contexts, and only occasionally with institutional support. The *Internationale Ferienkurse für Neue Musik* (International Vacation Courses for New Music), founded by the musical journalist Wolfgang Steinecke, were held in Darmstadt from 1946 onwards.[20] Expressly devised to counter German chauvinism, the courses brought together Luigi Nono, Pierre Boulez and Karlheinz Stockhausen; provided a forum for John Cage and La Monte Young; and supplied an initial orientation to young musicians like Nam June Paik.[21]

The electronic studio of West German Radio in Cologne attracted such composers as György Ligeti, Mauricio Kagel and Bengt Hambraeus, among many others, and prompted Paik to move to Cologne. Its director, Herbert Eimert, used the regular late-night slot of the *Musikalisches Nacht-programm* to broadcast electro-acoustic experiments as well as compositions by the Americans John Cage, Morton Feldman, Christian Wolff and Earle Brown.[22] The same musicians took part in the concerts that the Cologne artist Mary Bauermeister organised in her own studio. There, the pianist David Tudor – who saw himself as a 'messenger between Europe and the States' – played pieces by Cage, Wolff, Feldman, Brown, Toshi Ichiyanagi and Silvano Bussotti. In addition to

Cage (a frequent visitor to Cologne), Bauermeister's studio witnessed events by George Brecht (*Card Piece, Candle Piece*), 'short-form pieces' by La Monte Young[23] and action music by Nam June Paik (*Hommage à John Cage: Etude for pianoforte*) – pieces that owed their origins to Cage but pointed beyond his work. In October 1960 Bauermeister held a ballet evening in which Merce Cunningham and Carolyn Brown danced to music by Cage, Feldman, Brown, Wolff and others, in costumes by Robert Rauschenberg.[24]

In Cologne, the American musicians' work fell on receptive ears because it was perceived as a contribution to the solution of an artistic problem that was preoccupying minds in Europe as well as in America: how to develop a cross-boundary, 'intermedial' artistic practice opposed both to abstraction and to any confinement of the medium to the mere exploration of its own specificity. It made little difference that the participants arrived at this endeavour from a number of different directions – Bauermeister and her circle from Max Bill and the Hochschule für Gestaltung in Ulm, and also from the initial 'beyond painting' notions advocated by the artists who later formed Group Zero; the Americans inspired in part by the principles taught by Albers at Black Mountain College and in part by Zen Buddhism – or that in the course of time the movement absorbed 'concrete' poets, who set out to treat language as a material entity and involve their audience in the generation of meaning. What all these people shared was their abhorrence of a classic Modernism that had become set in its own conventions and had cut itself off from the everyday, the banal, and the fortuitous.[25]

Before long, specific art forms emerged and were practised on both sides of the Atlantic. Foremost among these were actions, performances and Happenings – not only because of the musical origins of many of the new practices but also because artists objected on principle to producing marketable objects. At his gallery in Cologne, from 1961 onwards, Haro Lauhus presented up-to-the-minute music and works by Mimmo Rotella, Wolf Vostell and Christo, showcased performances by the bassist Benjamin Patterson and had Daniel Spoerri unpack his trunk of works by the *Nouveaux Réalistes*.[26] In Wuppertal, Galerie Parnass, formerly devoted to Tachism, became the centre of action art;[27] and from 1958 onwards Paik and Cage performed at Jean-Pierre Wilhelm's Galerie 22 in Düsseldorf.[28]

George Maciunas moved to Germany in the autumn of 1961. Initially, the move had nothing to do with art. A resourceful organiser, Maciunas took refuge from the creditors of his AG Gallery in New York by taking a design job with the US Air Force in Wiesbaden. Of course, the move turned out to have everything to do with art: Maciunas had long been in contact with the experimental poet Hans G. Helms, who lived in Cologne; he had printed work by Diter Rot and Claus Bremer in the *Fluxus Anthology* edited by La Monte Young, and he was planning a new collective volume to include a text by Theodor W. Adorno.[29] Above all, he intended to continue in Europe the series of concerts that he had begun in New York under the title of *Musica Antiqua et Nova*.[30] 'Dear Mary Bauermeister,' he wrote to the artist, 'Could we hold festival in your studio June or July? It would be a good beginning for fluxus series ... We have enough performers now who will travel anywhere where audiences can be robbed or swindled.'[31]

Maciunas was drawn to Bauermeister not only by the musicians who had performed in her studio but above all by the idea that she was central to a circle which possessed a conception of art similar to his own Fluxus ideas. Thus, when Maciunas gave a lecture on 'Neo-Dada in den Vereinigten Staaten' (Neo-Dada in the United States) at Galerie Parnass in Wuppertal on 9 June 1962, he was pushing at an open door:

'Maciunas's theses precisely chimed with the principles of the European concrete artists. To summarise these once again: the use of image elements that connote nothing but themselves; renunciation of individual creative achievement, i.e. anti-individualism, the subjective gesture superseded; the viewer free to interpret ... Maciunas based himself firstly on the historical prototype that the Europeans had also espoused, that of Russian Constructivism – with its steadfastly experimental attitude to all materials, media and techniques, its anti-individualism and its aspira-

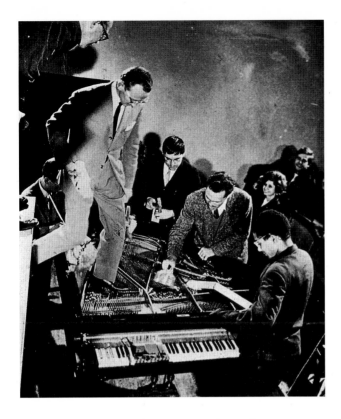

**Philip Corner
'Piano Activities',
Wiesbaden 1962**

tion to create a new form that would revolutionise life – and secondly on the principles of John Cage's musical practice: liberation of sound from individual intentions and predilections; compositional method based on random operations; acceptance of indeterminacy in performance practice; absence of distinction between composer, conductor, interpreter and audience.'[32]

What all this meant was brought home to a German audience during a festival organised by Maciunas at the Städtisches Museum in Wiesbaden in September 1962. In *Fluxus: Internationale Festspiele Neuester Musik*, Dick Higgins, Alison Knowles, Emmett Williams, Nam June Paik, George Maciunas and Wolf Vostell each provided a weekend of piano compositions, 'tape music and films', interspersed with Happenings and events.[33]

Was it by accident that the European history of Fluxus began in Germany? In a way, it was. The 'intermedial' and international practice of Fluxus was not, as such, tied to any specific place or situation. When artistic work was in progress, origins and nationalities were irrelevant; such categorisations always arise as a secondary consequence of commercial exploitation and marketing, and with Fluxus there was nothing to market. And yet it was not something that could have happened anywhere. The ideological narrowness of the Adenauer years had left German artists and intellectuals with a need for radical approaches to cut through the firmly re-established structures of the land of the Economic Miracle; their discomfort with their own nationality led to an appetite for exchange and internationalism that prepared the ground for the absorption of the new art.[34] Born of the specific past and the current political situation, patterns of understanding emerged that distinguished the West German response to Fluxus and kindred initiatives from that in other countries. Friedrich Heubach gives the following sketch of the circumstances in which this new art was received:

'These anti-art, anti-culture tendencies in art can be rightly understood, and their radicalism appreciated, only if they are seen within the cultural and political context of their day. The context, that is, of a fetid culture of psychological denial, barely conceivable today (though in places it is creeping back), with its remarkable ideological crop-rotation, its far from coincidental combination of historical amnesia and *Art Informel*, conflict taboo and abstract art, anti-intellectualism and *Ecole de Paris*. The context was the age of the Economic Miracle, which saw its panicky fear of giving offence attain the dignity of art through Tachism; which cultivated its thwarted sexuality through grubby, second-hand forms of Surrealism – and which finally found an object of revelation for its burning spirituality in the shape of monochrome painting ... Only by visualising how totally politics and culture were dominated by a half-baked, Christian-castrated Existentialism, by invocations of a nebulous Western heritage, by militant bigotry and by the all-distorting tyranny of the 'positive', the 'authentic', the 'profound' – in short, by a mentality that abhorred anything that was concrete or critical – only then can you assess just how radical Happening, Fluxus, Situationist, even early Pop artists were. At that time.'[35]

Although the Germans' reception of these new art forms was not defined in national terms, they did connect them with their native artistic and intellectual traditions. Cunningham's choreographies were viewed (and misinterpreted) in the context of *Ausdruckstanz*;[36] both Beat literature[37] and Fluxus production were related to the German tradition of *Kulturkritik* (specifically to the aesthetic theory of Adorno) and thereby interpreted as a social critique.[38] A number of the artists were well aware of this. And so, at Beuys's request, Maciunas supplied a manifesto for the Fluxus

performance organised at the Kunstakademie in Düsseldorf; while Paik appended this message to his *Hommage à John Cage*: 'Second movement is an admonition to the Economic Miracle of the Germans, where hard work and stupidity are combined in one.'[39] Hans G. Helms described the Korean's performance at Bauermeister's studio as an explicitly political action:

'When Nam June Paik ... posted himself behind the overturned piano, symbolically awakening his tight-packed audience with a burst from an imaginary machine gun, then darted forward to shampoo the head of Cage, who was in the seat next to mine, and snip off his tie, that emblem of bourgeois conformism – then, through the musical action, our ears were assailed by the sheer brutality of dominant imperialism, which either clammed them shut or opened them wide to the things that were being done all around us, in the Near East, in Africa, in Vietnam, in Central and South America, in the service of big capital.'[40]

The differences in approach that such interpretations reveal were matched by differences in artistic practice. In the collaborative activities of the multinational Fluxus group – though much was shared – clear differences soon emerged, eventually followed by open rivalries. This is illustrated by two episodes in which Vostell and Beuys, respectively, worked with American artists.

In New York in 1964, Vostell stood on a stage beside Allan Kaprow. In a joint action, both set out to explain to the audience what they meant by 'Happening'. This brought out their differences. Both agreed that art, in its outworn forms, had become ineffectual; it was too feeble to rival reality or even to represent it. Both therefore wanted to replace the passive contemplation of art with an experience of reality, as presented by the performance artist. But when it came to defining what they meant by reality, the German referred to the experience of the Second World War[41] and the brutality of post-war consumer society, while the American talked about the beauty as well as the destructiveness of Nature, speaking of technology and industry in a tone of almost naively optimistic enthusiasm.[42]

The two performances correspondingly differed. Kaprow worked anti-metaphorically; his works were intended to operate through collective action within the group, and thereby to convey an experience rather than a message. Vostell, in contrast, worked with metaphors, texts and symbols. His Happenings were more political than Kaprow's, in the sense that they referred to topical themes of the day; yet unlike Kaprow's, they set out to formulate a critique and thus embodied a didactic impulse. Vostell staged Happenings in order to teach his audience something. Unlike Kaprow, he thereby established a hierarchical distinction between the artist, who knew, and the public, who needed to know. He confused the desire to teach with the compulsive urge to impress. Where Kaprow made do with banal objects and minimal gestures, Vostell brought in jet fighters, locomotives and cars, dragging his participants through slaughterhouses, swimming pools and airports. But his materials, unlike Kaprow's, did not become objects of experience; they were more like gigantic educational toys.[43]

Echo, says Beuys, is a sculptural principle. But what if no answer comes? 'We intended to start at the same second and work for nine hours, I in Berlin, he in New York ... I made a sketch of the measurements and gave him full instructions concerning the space and the materials required.'[44] Wrapped in a roll of felt, Beuys lay with a dead hare at his head and another at his feet, in a room at Galerie René Block laid out with tufts of cut hair and fingernails,

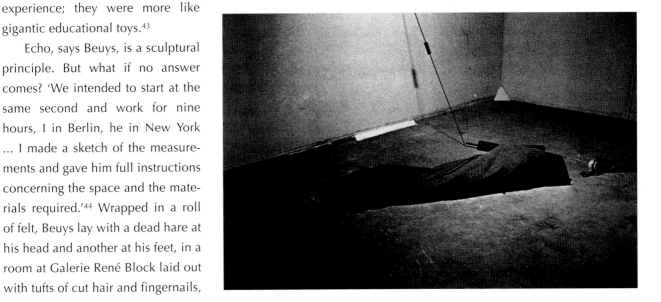

Joseph Beuys
'Der Chef The Chief',
1 December 1964,
Galerie René Block,
Berlin

a 'fat corner' and a 'fat cube', a felt roll and some copper rods; from time to time he made noises. But the transatlantic echo never came. For Robert Morris – who was supposed to supply the responses, 'synchronized to the second',[45] in this 1964 'Fluxus Song' (*Fluxus-Gesang Berlin-New York/New York-Berlin*) – did nothing, because he did not believe that Beuys would actually go through with such a lengthy performance.[46]

The misunderstanding is significant. It reveals profound differences between the two artists. Did Beuys ever really expect a response? After all, before suggesting the joint performance with Morris, he had gradually detached himself from the Fluxus community, articulated his differences and insisted on erecting boundaries. This he had done by establishing a personal vocabulary of symbols. The previous summer, in 1963, he had distanced himself from Kaprow's concept of the Happening by using fat in a performance for the first time, as if to give tangible expression to the aesthetic frontier between his framework and Kaprow's 'life-like art'.[47] Also in 1963, performing alongside the Fluxus people at the Düsseldorf Academy, he adopted their materials but endowed them with a mythic-religious significance as a means of distancing himself from his colleagues' 'pretentious Neo-Dada bourgeois-baiting'.[48]

It was 'Der Chef The Chief', 1964, the very same action in which he meant to involve Morris, that finally brought Beuys's differences with Fluxus to a head. Brief Happenings gave way to time-stretching performances; the preparation and demarcation of the action space and the creation of a personal, symbolic world increased the distance between artist and audience; fewer materials were used, but they were heavily charged with symbolic content.[49]

'With Fluxus,' writes Uwe M. Schneede, 'no experience of suffering or of happiness was to be had. But for Beuys the artist's work had always consisted in working through his own sufferings and his own history; transposed into an artistic event, these then became resistant to any instant, rational explanation. Fluxus actions were meant to be anonymous; Beuys actions were anything but ... They were inseparable from his personality, his powers of articulation, his history, his asceticism, his charisma, his body language and (not least) his sense of 'mission'. In the Beuysian action, the man and the work were causally linked.'[50]

Did all this leave any room for another artist? How did Beuys ever come to invite Morris in the first place? They had known each other for just two months: the American had come to Düsseldorf for his first European one-man show at Galerie Alfred Schmela, and had appeared alongside Yvonne Rainer in a *Sprech- und Tanzabend* (Evening of Speech and Dance) organised by Beuys at the Kunstakademie in October 1964.[51] Their encounter was too brief to explore the contradictions between their artistic attitudes, but it was long enough for Beuys to realise who was (or at least wanted to be) the 'Chief' in New York. For Beuys to have employed Morris as his American echo (or, more precisely, as a transatlantic amplifier) was as logical as it was for Morris to refuse to become a tool in someone else's project.

With Beuys's invitation (or should we say challenge?) to Morris, the interplay between German and American artists took on a quality markedly distinct from both the initial overawed enthusiasm for Abstract Expressionism and the subsequent equal partnership in concerts, dance and Fluxus activities. As soon as Beuys put himself forward as the 'Chief', Germany was again staking a claim to leadership, expressly in terms of a distinct national identity: 'Once Beuys was involved, the true Fluxus artists had to recognize and come to terms with the failure of their planned "International".'[52] The 'Chief' now laid down the meanings and expected others to empathise (or, like Morris, function as echoes). Hierarchy and authority replaced egalitarian anarchy: Beuys related to American artists not as a partner but as a rival. And ten years later, when he actually went to America, it was just the same.

IV

The attack took place in a vacant shop in a condemned building in Kaiserstrasse, Düsseldorf, in the spring of 1963. Self-promotion and self-praise were not in short supply: Manfred Kuttner, Konrad Lueg, Sigmar Polke and Gerhard Richter were showing their paintings. They announced:

'The major attraction of the exhibition is the subject matter of the works in it. For the first time in Germany, we are showing paintings for which such terms as Pop Art, Junk Culture, Imperialist or Capitalist Realism, New Objectivity, Naturalism, German Pop and the like are appropriate.'[53]

Of the labels proposed here, only one was to stick: Capitalist Realism. Rightly so. The name was a stroke of genius, because it suggested a programme. This was more than could have been achieved by any showing of the four protagonists' work in 1963. They had little in common beyond a shared rejection of outworn Modernist methods, combined with an interest in photographic and other prefabricated imagery derived from banal mass culture. But this was enough to enable them to anchor themselves, brashly and assertively, right inside the consumer culture of the West. The Capitalist Realists were able to position themselves in this way only because they had an existing prototype to refer to. The four of them defined their own art by reference to a foreign, and – hardly by accident – an American phenomenon: Pop art.

Their knowledge of Pop in 1963 did not come at first hand but through the media. Thumbing through *Art International*, Lueg, Polke and Richter had found articles that read like descriptions of their own work.[54] Or, at the very least, like signs that they were on the right track. The orientation of their source led them to assume that Pop was an American phenomenon: not a single British Pop artist rated a mention in *Art International*.[55] Ultimately, however, nationality was a minor issue. The work of the Capitalist Realists marked a new step in the artistic relationship with America because, instead of imitating an American prototype, it defined an existing body of work in terms of an analogy with American art. The Capitalist Realists accordingly declared:

'Pop art is not an American invention, and we do not regard it as an import – though the concepts and terms were mostly coined in America and caught on more rapidly there than here in Germany. This art is pursuing its own organic and autonomous growth in this country; the analogy with American Pop art stems from those well-defined psychological, cultural and economic factors that are the same here as they are in America.'[56]

For Richter, Lueg, Polke and Kuttner, their work was not so much a response to American art as a reaction to the mass-media saturation and redefinition of reality in the post-war Federal Republic – a process frequently described as Americanisation. Only because social conditions were comparable could an American definition be transferred to the practice of art in West Germany. More than differences in national origin, what counted was a shared point of departure, together with related ways of going about things:

'Pop art recognizes the modern mass media as genuine cultural phenomena and turns their attributes, formulations and content, through artifice, into art. It thus fundamentally changes the face of modern painting and inaugurates an aesthetic revolution. Pop art has rendered conventional painting – with all its sterility, its isolation, its artificiality, its taboos and its rules – entirely obsolete, and has rapidly achieved international currency and recognition by creating a new view of the world.'[57]

The example of America was relevant to the German artists for two reasons: it permitted them to react to a situation in which creativity had been expropriated by advertising and the mass media; and it put into their hands a 'brazen' artistic strategy that could be used to prise away the outworn conventions of traditional and Modernist art. What fascinated them about the Pop artists was above all their anti-painterly bent: the radical, downright 'inartistic' simplification of a Roy Lichtenstein, the banalisation of high art in Claes Oldenburg, the abolition of *peinture* and authorship in Andy Warhol.[58]

American art was thus not so much a prototype as a confirmation of the rightness of a path they had already found themselves on. The fact that such outside confirmation was needed

reflects the specific dilemma of post-war German art. Cut off from knowledge of its own avant-garde movements, which had developed strategies of their own for dealing with mass culture and advertising in the 1920s and 1930s, German art was able to reimport their insights only by way of 1960s America – so that, for instance, Richter learned about Schwitters's modes of operation by way of Rauschenberg.[59]

In this situation, Pop held out the promise of an international dimension – a prospect of breaking out of the fetid isolation of the West German art world. Accordingly, Richter and Lueg soon set off to see Ileana Sonnabend – who since her move to Paris in 1962 had become Europe's leading dealer in American Pop art – and presented themselves to her as the 'German Pop artists'.[60] They had been quick to grasp not only the way Pop worked but the distribution channels that accompanied it. Nevertheless, the differences between them and the American Pop artists were impossible to overlook: these resided, above all, in the Germans' mocking detachment from the world of consumers and commodities – as revealed for instance in the 'Demonstration for Capitalist Realism' that Lueg and Richter enacted at the Berges furniture store in Düsseldorf in October 1963, under the title *Life with Pop,* as well as in the pictorial strategies of Polke.

Lueg and Richter presented the entire contents of the store ('Extensive furniture exhibition of all current styles on 4 floors: 81 living rooms, 72 bedrooms, kitchens, individual pieces. Store rooms. Tightly packed alcoves, cubicles, rooms, stairs and passages filled with furniture, carpets, wall decorations, appliances, utensils'),[61] while slipping their own work unobtrusively in among the stock ('By K. Lueg: *Four Fingers; Praying Hands; Bockwursts on Paper Plate; Coathanger.* By G. Richter: *Mouth; Pope; Stag; Neuschwanstein Castle'*),[62] and displaying themselves to the public gaze in a living-room ensemble placed on white plinths, and strikingly without pictures. In so doing, they – unlike the American Pop artists – took as their theme not the appearances but rather the social uses of commodities.[63] This added dynamism to Duchamp's concept of the readymade (for this presentation turned artworks into furnishings and furnishings into art), while simultaneously shifting the perspective.

Where the Americans perceived objects only as signs, Richter, Lueg and Polke paid attention to the traces of use and wear. Their theme was not the commodity as a sleek, ahistorical fetish but the tactics by which, in a world of commodities, consumers assert themselves and construct a reality of their own. In the furniture store event, in Richter's photo paintings, and in Polke's conscious mistakes in reproducing his stereotypical source imagery, two elements surfaced that Pop art had omitted: the history of everyday life, and the anarchic impulse to assert oneself at the expense of the prefabricated object. The German artists' images seem to relate to their objects in a more detached and at the same time more reflected way than those of the Americans.

The grounds for this impression readily emerge from a comparison between Polke's methods and those of Lichtenstein. Where the latter fills his canvas by monumentalising banal motifs, Polke isolates his objects and uses blank areas to provoke reflection and distancing: 'Lichtenstein superimposes the techniques of rigorous pictorial organisation on the vocabulary of advertising. Polke disengages that vocabulary from pictorial organisation: he deconstructs, where Lichtenstein formalises; he seeks detachment, where Lichtenstein seeks effect.'[64]

Despite these differences in technique and impact, a measure of caution is in order when it comes to drawing distinctions. For one thing, anyone who regards ironic, critical detachment as the hallmark of Capitalist Realism needs to remember that in the 1960s German art critics were detecting those very qualities in the work of the American Pop artists. This can of course be dismissed as a misunderstanding based on cultural differences, or ascribed to the German inability to recognise that the unequivocal affirmation of what exists might be an aesthetic concept. But its most convincing explanation derives from the specific circumstances in which Pop art emerged in West Germany.[65] Although spoken of as a phenomenon since the mid-1960s, American Pop achieved public impact only towards the end of the decade, with the exhibition of the restorer Wolfgang Hahn's collection at the Wallraf-Richartz-Museum in Cologne, the press controversy

concerning major acquisitions by other collectors and the extensive exhibition of Pop at the fourth Documenta in 1968.

This sudden and massive American Pop presence coincided with the high point of the student movement in Germany, with the almost inevitable consequence that Pop was interpreted as a critique of capitalist society. This interpretation combined the older tradition of German art criticism, which legitimised art in terms of its critical detachment from the status quo, with more recent, Neo-Marxist axioms derived partly from Herbert Marcuse and partly from Walter Benjamin.[66] In the light of Marcuse's theories, Pop art could be interpreted as a move to make art more democratic by abolishing its elitist alienation from practical living; following Benjamin, Pop could be seen as the elimination of the artwork's fetish status and authorial sanction. However, not all Pop artists were hailed to an equal degree as critics of the status quo. Andreas Huyssen believed that the liberation of sensuality called for by Marcuse was present in Jasper Johns, Rauschenberg, Warhol, Lichtenstein, Tom Wesselman and Robert Indiana; but Rainer Crone considered that Warhol alone was a revolutionary artist and sought to set him firmly apart from Pop art.[67] Crone's hypothesis was highly original: by projecting onto Warhol Benjamin's and Bertolt Brecht's theories of authorship and reproducibility in art, he was able to claim this artist for the New Left – thereby remedying the most glaring deficiency of the New Left aesthetic: its lack of reference to the artistic production of its own time.[68] As we read in Crone's book:

Roy Lichtenstein, 'Big Modern Painting', 1967, Installation view, Documenta 4, Kassel 1968

'Art in Warhol does not serve the pursuit of individuality – or even of individualisation – but that of a revelatory structural analysis, of the conversion of art itself and its production apparatus to new functions, and of technical progress ... In Warhol, the aesthetic theory is defined by the conditions of production; traditional aesthetics are suspended – and not, as with Duchamp, negated – in favour of a content-defined analysis of existing society. As the material premise of his production of "art", Warhol takes a newspaper photograph accessible to all, an existing mass-produced image. For the transfer from photograph to easel picture, he uses contemporary technology in the shape of silkscreen – again, a process that all can use ... In itself, the potential reproducibility of an easel picture by Warhol, the doubt as to the individual producer's true authorship, deprives the latter of his centuries-old aura of autonomy, authenticity, self-determination.'[69]

Seen from posterity's omniscient perspective, Crone's expectations now seem illusory and overstated. We know that neither Pop art nor any of the artists involved ever had the revolutionary impact that was ascribed to them in 1968. Nonetheless, their emergence had its consequences. Pop turned contemporary art into a topic of public discussion; indeed, it shifted the whole relationship between art and public in West Germany. All at once, people were talking not only about American artists but about their German collectors; it became possible to discern the outlines of a network of independent dealers and intermediaries who were breaking free of dependence on their American colleagues and becoming a power in their own right within the international art world.

It was a start, albeit a modest one; and, in the cases of those who later became the leading art dealers – Rudolf Zwirner, Rolf Ricke, and Heiner Friedrich – it largely began with Pop. If one reads the protagonists' memoirs, the outlines of a collective biography become recognisable. These art dealers unanimously tell us that they were initially greeted with incomprehension and rejection, that they learned unaided to find their way around the New York artists and collectors (shaking off their dependence on art dealers like Ileana Sonnabend, who had hitherto dominated the European market), and that they made their final breakthrough with the support of a small group of high-powered collectors.[70]

In all this, they were taking advantage of the fact that Pop attracted – one might almost believe that it created – a new kind of art collector. First, such daring pioneers as Wolfgang Hahn blazed the trail;[71] then industrialists such as Karl Ströher and Peter Ludwig came on the scene, buying not individual works but whole ensembles, categories and collections. In this way they rapidly amassed major collections. In January 1968, with Heiner Friedrich as intermediary (and, it is said, at 'bargain prices'), Ströher bought the Pop art collection of the New York insurance broker Leon Kraushaar. Meanwhile, Ludwig assembled his basic Pop collection from the works shown at the fourth Documenta, supplemented this in 1973 with the central pieces from the Robert Scull collection and rounded it off soon afterwards by acquiring works by all the major Pop artists.[72]

These Pop buyers differed from traditional art collectors not only in the sheer extent of their purchases but above all in the social ends to which they employed them. Most of the work they bought was never meant for the walls of private houses, having been intended all along for the public. For Ströher and Ludwig had realised that what they possessed was best suited to be used as an art-political instrument. Of course, for this to happen the work had to enjoy a high public profile: both collectors therefore went all out for publicity. They sent their works on tour, lent them to museums, and from a very early stage – with a keen eye to the various target groups involved – demanded bilingual German-English catalogues. In 1968, the very year in which it was assembled, Ströher's Pop collection, together with his Beuys holdings and works by younger German artists, went on tour from Berlin by way of Düsseldorf and Bern to the Hessisches Landesmuseum in Darmstadt, where it was to remain on permanent loan under the title of *Bildnerische Ausdrucksformen 1969–70* (Forms of Pictorial Expression 1969–70). In the same year, Ludwig loaned 140 contemporary pieces from his collection to the Wallraf-Richartz-Museum in Cologne, thus positioning himself for a series of interventions in the city's museum politics that continues to this day.[73]

The emergence of the big collectors, and the appearance of German dealers on the international art market, turned German-American artistic relations into big news for the American press. It began with a number of spectacular deals in New York: 'American Pop Really Turns On German Art-Lovers', declared the *New York Times* on 27 November 1970, after Zwirner had paid $75,000 for one of Lichtenstein's big 'Brushstroke' paintings.[74] All of a sudden, West Germany was on the map as a serious art-collecting country, not to say a robust competitor. Rather in the style of a 'Wanted' poster, the November 1970 *Artforum* reproduced all those works, by Warhol, Lichtenstein, Oldenburg, George Segal and a string of other American artists, that were already in German collections.[75] In the accompanying article, Phyllis Tuchman exhorted her American readers to emulate the commitment shown by the German dealers, collectors and museum people who had shifted the centre of gravity of the international art market, with consequences that she described as follows:

'It is astonishing to see so much American art in Germany and it is unnerving to see New York art there before it is displayed in New York. Much of the art is so well chosen that the pleasure of experiencing art is even more rewarding than in New York ... American art – whether we recognize it or not – is now to be seen in museums in Germany.'[76]

Tuchman's article was not only a description but a first interpretation of this German enthusiasm for American art. Her starting point was her own observation that people in West Germany

were not simply collecting American work but had made a specific selection from what was available. It had struck her that the first generation of Abstract Expressionists, as well as certain exponents of Post-Painterly Abstraction such as Jules Olitski and Larry Poons, were poorly (if at all) represented in German collections. In the case of the Abstract Expressionists, the reason might have been economic – in that German collectors and institutions had been unable to afford the high prices that were already being demanded in the 1950s. But, said Tuchman, the reasons for the absence of Post-Painterly Abstraction were aesthetic ones. As collectors, she argued, the Germans were drawn to artistic tendencies to which they could relate on the basis of their own traditions – in particular, those of Expressionism and the Bauhaus. These favoured tendencies included Pop art, Color Field painting and Minimalism. Post-Painterly Abstraction held no appeal because the Germans lacked this kind of access to it. The art that was being imported into Germany was there to fill the gap left by the loss of the Germans' own avant-garde movements, thus serving as a surrogate starting-point and a link with the past for a new generation of German artists.[77]

Obviously, American art could not be treated as a function of, or surrogate for, German history without somewhat distorting its significance. German observers were informed by a highly selective view of the history of American art, which was determined on the one hand by needs stemming from perceived deficiencies at home and on the other by the arbitrary sample of work that was to be seen in German collections. And so, as seen from Germany, it was Rauschenberg and Johns – and not the Abstract Expressionists – who were the founding fathers of the new painting.[78] At the same time, through concentrating on artistic practices that were spectacular yet in a technical sense traditional, German collectors effectively narrowed their own field of vision, blocking out the anti-institutional and politically critical impulse in post-war American art:

'It is not without interest to observe that, at very the moment when Fluxus and Happening artists were turning into the painters of Pop art, and when the marketable object and the easel painting once more dominated the art scene ... a powerful new wave of response to specifically American art began. What became historically public and visible in the museums was the art that lent itself to a prestige showing: the ingratiating mediocrity of a Dine or Wesselmann, for instance, but not the central significance of a theorist such as Henry Flynt.'[79]

V

'It does not matter to me at all whether an artist lives in New York or in Düsseldorf. The New York label is no guarantee of quality – but many artists do live in New York, and some of them are outstanding. The term 'New York Art' may be appropriate for Pop or Color Field painters, but it certainly does not fit a lot of other artists who live there: in many of the American artists who interest me, I can locate nothing that is typically American. These artists, who produce a clear and simple art, exist in America as they do in Europe. They know each other well and almost form a unified group. This is a generation of artists without chauvinism, and they transcend national boundaries in their collective commitment to their art and ideas.'[80]

In these words, Konrad Fischer formulated the artistic creed of the late 1960s and early 1970s. It reflected the view of the art-producers, to whom national ascriptions were irrelevant, since they knew themselves to be in agreement with fellow artists abroad over methods. It comes as no surprise to find an art-dealer sharing this view. For by the late 1960s much had changed since the informal interchanges of the Fluxus period, and encounters between artists now received far more gallery support; indeed, they relied on the existence of a new and experimentally minded breed of gallery owners, who thought of themselves as producers rather than dealers.[81]

Fischer in Düsseldorf; Ricke, Zwirner and later Paul Maenz in Cologne; Friedrich and Franz Dahlem in Munich – all of these, by inviting American artists to come to them, ensured that West Germany made the transition from a place where American art was appreciated to a place where it was actually made.[82] This had been anticipated in the sporadic visits and work trips made by

**Blinky Palermo
'Flipper', 1970
Screenprint
see cat. 160**

American artists from the early 1960s onwards;[83] now these activities were expanded by dealer initiatives and regular exchange programmes (such as the grants made by DAAD in Berlin), supported by museum involvement and, last but not least, favoured by the general expansion of the art market. In 1967 the *Verein progressiver deutscher Kunsthändler* (Union of Progressive German Art Dealers) organised the first *Kunstmarkt* in Cologne;[84] and, one year later, Fischer and the critic Hans Strelow launched the *Prospect* exhibition series, a forum that enabled selected international galleries to present the current state of artistic production without having to concern themselves with sales.[85]

So international did the production and appreciation of art become, as a result of all these activities, that it would be inaccurate to describe it exclusively from the angle of the German-American relationship. However, even if we do limit ourselves to this restricted aspect of the subject, it is clear that the relationship underwent a qualitative change. In the 1950s, the West German art scene had responded to American impulses that it could not yet properly absorb; gradually, it had created structures to form a basis for acceptance and exchange. Then, in the early 1960s, it had developed strategies – as disparate and indeed contradictory as the actions of Beuys and the interventions of the Capitalist Realists – whereby it could respond to international artistic production, or absorb and process it for its own purposes. By the late 1960s, Germany had become a significant locus of international production in its own right. The response to Pop had been largely determined by American premises; but, with the passage of time, affinities of approach had come to obscure differences in origin.

This had three consequences for artistic production. Standards were internationalised; production was decentralised; and the chronological relation between Europe and the USA reversed itself. A succession of young American artists were seen first in Germany before they secured exhibitions in the United States.[87] In 1968, Fischer showed Robert Smithson's 'Nonsite' works for the first time anywhere, and gave Carl Andre, Sol LeWitt, Bruce Nauman, Lawrence Weiner, Robert Ryman and a whole series of conceptually oriented artists their first European individual exhibitions. Also in 1968, Richard Serra's 'Prop Pieces' and works by Keith Sonnier were seen at Ricke's gallery before they were shown in the USA. The following year, Ricke staged the first European concert by Philip Glass, together with a showing of films by Michael Snow.[88] In 1969, for his first individual exhibition at Galerie Heiner Friedrich, Michael Heizer made 'Munich Depression': a five-metre-deep, conical hollow with a diameter of three metres, in the satellite town of Neu-Perlach. In the same year he etched a stretch of pavement in Düsseldorf. Both these works had a low life-expectation, and so might equally well have borne the motto attached by Heizer to the one in Düsseldorf: 'As the physical deteriorates, the abstract proliferates, exchanging points of view.'[89]

Dematerialised and decommercialised, most of these projects tended, logically enough, to transcend nationality as well – not that this prevented artists from incorporating circumstances specific to the country where they worked, the Federal Republic. Far from it: in 1972, on the occasion of the Munich Olympic Games, Walter De Maria proposed sinking a borehole through a mound of Second World War bomb debris on the outskirts of the Olympic precinct, and on down into the earth to a depth equal to the height of the mound. His intention was to counter the ahistorical fiction of the 'joyous games', as promoted by the organisers, with a reminder of the detri-

tus of history, while simultaneously uniting that detritus with the earth in an act of reconciliation.[90] Richard Serra, in the film which he made jointly with Clara Weyergraf in 1979, *Steelmill/ Stahlwerk*, contrasted a documentary record of working conditions in a German steel mill with images of the making of his own 'Berlin Block for Charlie Chaplin', 1977 (National Staatliche Museum, Berlin) – thus placing that work, along with all the other works he had made in West Germany, within the context in which it was produced.[91]

What effect did the increase in the number of exhibitions, and the active presence of American artists, have on German art? It soon becomes apparent that this relationship cannot really be described straightforwardly in terms of influence or imitation. What took place in the work of such artists as Bernd and Hilla Becher, Hanne Darboven, Gerhard Richter and Blinky Palermo – all of whom were living in Düsseldorf and directly confronted with the new American work – can only be described as parallel evolution determined by analogous conditions. All these artists shared a point of departure – their opposition to an artistic practice that had become an empty sham – as well as the artistic strategies with which they responded: reducing authorial intervention by using serial or sequential forms, and/or adapting classic avant-garde devices such as the readymade and the grid pattern to new and changed conditions of production. These similarities of approach do not compel us to introduce the dubious notion of 'influence' in one direction or the other. It is enough to remember that Carl Andre wrote approvingly of the Bechers in *Artforum*; and that Richter, listing the artists from whom he had drawn most inspiration, named Andre, LeWitt, Ryman, Weiner, De Maria and Dan Flavin – precisely those whose work he had seen at Galerie Konrad Fischer in the late 1960s.[92] In his 'Colour Plates' and 'Grey Paintings', Richter found painterly equivalents for the American artists' conceptual and sculptural work. On both sides, artistic production came to be treated as a reflection of the conditions under which it was made and responded to.

That these relationships reflected shared approaches and attitudes rather than any ephemeral 'influence' is particularly worth remembering when the subject is Blinky Palermo. Frequently, Palermo is described as bearing an affinity to Barnett Newman or Ellsworth Kelly; or it is simply stated that his work 'Americanized itself even before he left for America'.[93] Such statements have a biographical foundation, for Palermo knew himself to be 'in' America long before he arrived there in 1970. For him, as for many of his generation, jazz and American underground literature had opened up a possibility of dissidence and a prospect of escape from the stifling confines of West German life.[94] The name Palermo, which was given to him in Beuys's class at the Düsseldorf Kunstakademie, has its origin in the world of American boxers and mobsters. Perhaps because the name Heisterkamp, with which he had signed his first pictures, was an adoptive one anyway, he instantly assumed the name and identity of Palermo, threw away his pipe and shaved his head.[95]

But all this is anecdote, not art. It would be wrong to reduce his artistic work to a mere reflection of American art, just because Palermo so deliberately opened himself up to certain aspects of American life. Of course, he profited artistically, as in other ways, from the intensified exchanges between Germany and the USA. In the galleries of his own Munich dealers, Heiner Friedrich and Walter Dahlem, he was able to see work by De Maria, Andre, LeWitt, Heizer, Flavin, John Chamberlain, Fred Sandback, Donald Judd and Richard Tuttle, and to meet some of the artists in person.[96] And, of course, the suppression of compositional elements in his canvases from 1964 onwards, and the object paintings he began that autumn, must be seen in the respective contexts of American 'nonrelational' painting and Rauschenberg's 'Combine Paintings'.[97]

All the same, the essence of Palermo's work does not lie in such periodic borrowings or correlations. The ties between his works and those of the artists with whom he is often associated – such as Kelly, Ryman and Tuttle – do not reside in formal correspondences or similarities so much as in the shared historical situation in which they were produced. That situation has been described as the 'international eclecticism that became both possible and necessary in the early 1960s',[98] or in other words the fragmentary and contradictory efforts of a post-war avant-garde to

connect with the state of artistic production historically attained by Piet Mondrian, Kazimir Malevich or Marcel Duchamp. In his wholesale suppression of authorial presence, in his synthesis of colour and line through the use of coloured insulating tape 'Object with Disc', 1966, in his conflation of figure and ground, and in his thematic use of the indexical 'Flipper', 1965 (Staatsgalerie moderner Kunst, Munich), Palermo took up genuine avant-garde issues of this kind and provided them – in parallel to the Americans – with resolutions that were all his own.[99] How remote these resolutions were from contemporaneous American was to become clear only after his death in 1977, when attempts were made in the USA to co-opt him as a Minimalist – thus entirely missing the disciplined lightness and musicality that make Palermo an exceptional figure among German and American artists alike.

VI

Had he not been long awaited? Ever since the late 1960s, his name had been a rumour on the American art scene. When Conceptual Art came to the fore, his star too began to rise. Not that he was a Conceptualist, of course. What was he? Revolutionary? Mystic? Charlatan? No one could say, because no one knew much about him. His image was better known than his art: the photographs and posters that preceded him; the head smeared with honey, explaining pictures to a dead hare; the kneeling figure, spreading his arms in a Jesus-like gesture and being baptised from a watering-can; the subversive who advances resolutely towards the viewer in hat, waistcoat, boots and jeans.[100]

Before he arrived in the States, Joseph Beuys was the great unknown of the American art world. Most people had no idea what his theories were. The photographs of his work that people had seen were described in terms of American art. He works with felt and fat? Sounds like Post-minimalist use of materials. He wears a felt suit and scribbles on blackboards? Looks like Oldenburg. He does actions and performances? Everyone does that.[101]

It took three attempts for Beuys to make his mark on America. From 'Der Chef The Chief' onwards, he kept his eye on New York, but it was another ten years before he set out in earnest to conquer the New World. Both the increased rigidity of the art market – which favoured object production rather than interaction, and marketable national trademarks rather than free international exchange – and the change in Beuys's own status meant that the visit was not, as it once might have been, a search for artistic collaboration, but a territorial expedition. By the early 1970s, Beuys was no longer an anonymous Fluxus activist but a star. He stage-managed his US debut accordingly as a tour, preceded by an advance guard of multiples, with personal appearances in New York, Chicago and Minneapolis. The tour had a missionary theme: *Energy Plan for the Western Man*. It was a flop.

'I was invited to dialogue, but you're sending us to sleep!' shouted his former Fluxus colleague Al Hansen, interrupting Beuys's long-winded disquisition on the universalisation and socialisation of creativity at the New York School of Social Research.[102] There was no dialogue. The hall was crowded, with more would-be auditors jostling for admission outside and raising an outcry when they were not admitted. Beuys

Joseph Beuys
'Dillinger-Aktion'
(Dillinger Action),
14 January 1974, in
front of the Biograph
Cinema, Chicago

held forth, drew diagrams on the blackboard – and lost his audience. When questions were taken, people just talked at each other. Soon losing interest in Beuys's political and cultural ideas, questioners started to make fun of the German professor and his copious explanations. Beuys replied in kind, and the occasion lost any last shred of credibility:

'This "dialogue" (it wasn't a dialogue but alternated between monologue and faintly brutal manipulation of successive "questioners") marked the first coming of the artist-as-social-worker ... His use of social dialogue may add another step to the evolution of creative means; but its failure to 'reach' real people cast a sour light on the isolation of art. And, unfortunately, such expansion of art into social activism reeks of intellectual slumming.'[103]

Both sides were disappointed. Expectations had run high – perhaps too high. Bored with its own artistic product, New York wanted an artistic sensation; Beuys wanted a transatlantic break-through. After the disastrous lecture date at the New School, it became clear that there was no chance of converting the USA to Beuys's convoluted doctrines of Art as Social Energy. In Chicago, the next stop on his tour, he changed tactics. Instead of mere words, he gave the public an image. He slipped into the role of the Chicago gangster John Dillinger, who in June 1934 was betrayed by his ex-mistress and shot dead by the police as he left the Biograph Theater:

'On January 14, 1974, he rode in a cab along Lincoln Avenue. He was wearing a felt hat and a long gray coat with a fur collar. He stopped the cab outside the Biograph Theater, jumped out, ran as if fleeing from a hail of bullets, slumped into a snowdrift ... and lay motionless.'[104]

'The negative energies in him could have led to a positive impulse. Instead they became sub-human. Our impulse of love for such people is superhuman,' said Beuys in the declaration that he appended to this action.[105] Not that the motifs were particularly important. What mattered was that in Dillinger Beuys had found a figure that would catch the public imagination: the artist as gangster, the outlaw as creator, the outcast who commits suicide by staging his own death at the hands of society. Because words had failed him, and his theory remained uncomprehended, Beuys resorted to the technique that had first made his reputation in America: he used imagery to design a spectacular identity for himself in the role of the outsider.[106]

On this first visit, he resorted to image-making as an improvised solution to an emergency situation; by the time of his second appearance in America, in May 1974, it had become the structuring principle of his entire trip. This time, right from the start, dialogue was out. 'I like America and America likes Me', declared the artist (with tongue somewhat in cheek, in view of the mixed reaction to his first visit). This time all contact was avoided. On arrival at the airport, Beuys was wrapped in felt, and an ambulance with blinds drawn rushed him to his gallery. There a coyote from Phifer's Animal Farm in Gillette, New Jersey, was his sole companion for three days.

And yet, although the artist now fenced himself off completely from his public (while still allowing viewing, filming and photography inside the gallery), this second action was intended to pick up the thread where it had been cut four months earlier. The means had changed, but the objective and the ambition had not. Beuys meant to break through to what he called the 'psychological trauma point of the United States' energy constellation': the dichotomy separating the intuitive thought processes of the Native Americans from the materialistic and mechan-

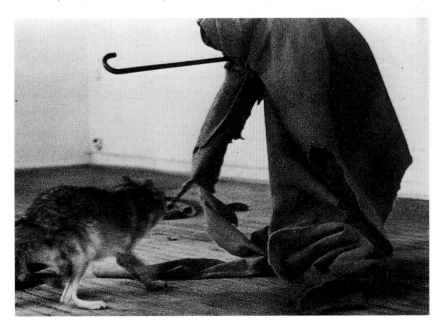

**Joseph Beuys
'I like America and America likes Me',
23 to 25 May 1974,
René Block Gallery,
New York**

istic values of the European settlers.[107] Through his dialogue with the coyote, which stood for Native America, the USA would become reconciled with itself and with its history, thus releasing creative energies that had long lain buried.[108]

A therapeutic and in a sense ethno-ecological project, its component steps remotely recalled the process of 'remembering – repeating – working through' in psychoanalysis, albeit with the difference that in place of 'working through' Beuys constructed a mythic-shamanistic fiction that substituted crude stereotypes for historical analysis.[109] Structurally, 'I like America and America likes Me' resembled other actions by Beuys, although by including the coyote he added a striking iconographic symbol with specifically American connotations. Was it possible, he was later asked, to deal with European and American culture in the same way? His reply was not that of the ahistorical shaman whose identity he had assumed during this performance, but that of a West German who had lived through the 'Americanisation' of the 1950s, and who knew that it was one of the preconditions for transferring his own working methods to the USA. Here, for an instant, a flash of historical awareness cuts through the mystical fog:

'Question: Is it possible for you to deal with European and American culture in the same way?

'Beuys: There is no difference. Yes sure, there is a difference, but from the political point of view there is not such a difference because both belong to the same system: the private capitalistic system. The model of what is taking place in West Germany is exactly the American understanding of money and economics. West Germany is exactly the mirror of the American culture.'[110]

And yet, the clearer it became that his message could not be transferred without comparable conditions of production, the more Beuys insisted on what separated him from the Americans. Judd, Andre, Morris: one after another, he accused his American colleagues of formalism.[111] For of course he knew full well that he could maintain his special status in the USA only so long as he kept up with the times in his choice of materials and techniques, and ahead of the times in his intentions and goals: 'My reality is another reality than the reality of American art', was his confident boast.[112] Here he zeroed in on the core of the problem. A public that had spent more than a decade learning to mistrust the metaphorical, and to treat materials strictly literally, seemed unlikely to understand his art, based as it was on allusions and rigid ascriptions of meaning.

However, from 'I like America and America likes Me' onwards, it became plain that such an understanding was not going to be necessary. Beuys had defined an image that was strong enough to take the place of a substantive discussion. With perfect logic, in its review of the coyote performance, *Art in America* contrived to draw a categorical distinction between the artist and his work, declaring that Beuys was a 'vital artist' even *without*, indeed *in spite of* his theories:

'Beuys is an artist who has publicized his theories so widely and has made his intentions so well known that they separate themselves from his art. His words, both the political and artistic ones, exist as a completely different oeuvre. This division is necessary. The question has never been whether or not he is a vital artist; it is obvious that he is. The question is how faith in him could survive after his pronouncements have been run through the shredder. If belief in any artist must be put in terms of faith, belief in Beuys must be. His art loses in his own analysis of it; it is centered in him, in his personality, in his intensity.'[113]

Faith was the response that the Guggenheim Museum in New York expected of visitors to its Beuys retrospective in 1979. The building was sunk in mystic gloom, and the artist's work was laid out in twenty-four 'Stations' – like the Stations of the Cross. It was the Guggenheim's first exhibition of a contemporary German artist. Beuys had finally arrived in America.[114]

For the critics, this retrospective marked the end of an epoch. With the entry of this German shaman, as they saw it, European art – so long dismissed by New York as a mere tributary province – had struck back powerfully at last. American hegemony in the art market, of which New York had been so sure ever since it 'stole the idea of modern art' from Paris in the 1940s, now seemed to be questioned, destabilised, threatened.[115]

Of course, a view that divides the world into spheres of influence and marks off conquests on

the map with little flags, as military men are wont to do (and as Leo Castelli actually did in an advertisement to launch his European campaign in 1964), signifies that artistic relationships have already ossified. To be precise, the prevalence of such a view reveals that market and institutional forces are taking precedence over productive exchanges among artists. In the world of middlemen, it is national categories, the terminology of influence and conquest, the desire to 'occupy' institutions, that come to the fore. To be a conqueror, you have to get things crystal clear. Before the Guggenheim presentation could take place, Beuys had to be reduced to his Teutonic, shamanistic side – or, to put it another way, his art had to be detached from other contemporary art. Only as an embodiment of the totally 'Other', incapable of being tied in with the American context, could Beuys make his entrance into the museum.[116]

His integration into the institutional context depended on neutralising his own artistic practice to fit within the clichés defined by that context. Not that this is likely to have bothered Beuys unduly. By his previous appearances in America, and by the way in which he had repeatedly emphasised the remoteness of his work from international practice, he had invited, even demanded such a response. And so, by the time he finally appeared in the flesh, at the heart of the American contemporary art world, there could no longer be any question of interchange, contact, or productive blurring of boundaries. He was invited as a monument, and he intended to be venerated as such.

One person perfectly summed up the process by which Beuys froze into an icon – or, even more precisely, the metamorphosis of the medium into a media product – and that was Andy Warhol.[117] That Beuys should have let himself be treated like Marilyn Monroe, reduced to the cliché of the gaunt man in the hat with the will-o'-the-wisp eyes, demonstrates just how far he had come since the actionist phase in which he had still been attempting transatlantic contact through 'Der Chef The Chief'. It shows the extent to which he had turned into the thing he had always offered to America: an image.

VII

It did not end with Beuys. Soon the advance scouts were raising the alarm. Excitedly, one of them noted:

'The art world is being subjected to a publicity and propaganda barrage about German art that has the look of a first step in a campaign of conquest. The German nation may not have been able to conquer the world, but German culture – today in the visual arts as once in music and philosophy – can do so, at least as its enthusiasts see it. And there is a sense of mission to the conquest, a sense that it must succeed – that it will prove something to the postwar Germans themselves, and to the world at large in this time of general insecurity, of cultural as well as socioeconomic uncertainty. Populist strategies have failed; a new sense of elitist originality seems called for everywhere. German originality in the visual arts will once and for all be demonstrated – an originality based on a revised elitist sense of the German spirit, the special German relationship to "Geist".'[118]

These words bespeak an enjoyable frisson of dread, a positively masochistic longing for subjugation: aggression is feared and yet desired. Twisted into psycho-military terms, this report summarises New York's reaction to the emergence of a string of highly disparate artists who were hastily lumped together under the label 'German Neo-Expressionists'.[119] Beuys had prepared the ground and mapped out for them the way to make a successful career in America. His Guggenheim appearance had demonstrated how launching a product encoded in nationalistic terms on the American market could pay off.

The 'Neo-Expressionists' followed in his footsteps, with the difference that they did not design their image themselves but fell back on the clichés about Germans that were already in circulation. One of these was that German art had an inbuilt tendency towards expressionism;

another was the stock figure of the 'evil German', distilled by Hollywood out of the history of Fascist Germany and popularised in countless war films. These two notions reinforced each other. The art-historical platitude gave respectability and artistic relevance to the mass-culture cliché – from which it derived in return an air of the daemonic, the forbidden and the vaguely political.

This mixture would never have worked without an art market hungry for new, rapidly consumable sensations.[120] Ever since the mid-1970s, New York critics had anxiously recorded a slackening, or geographical displacement, of artistic activity, and a growth in the importation of European ideas.[121] To turn this diffuse unease into a trend, these observations had to be bundled together under such code words as Postmodernism, Rediscovery of Painting and Return of Europe. It took some powerful marketing to give the German artists visibility: as recently as 1976, one artist now hailed as a 'Neo-Expressionist', K.H. Hödicke, had been regarded as a 'difficult' artist who could not be made palatable to the Americans.[122]

'Neo-Expressionism' was primarily a phenomenon created by its interpreters. Painters like Georg Baselitz, Markus Lüpertz or A.R. Penck, who had been ignored in the USA at the time of their first artistically significant appearances on the scene in the 1960s, attracted notice only in the early 1980s, when institutions and exhibitions fostered a new interest in the medium of painting, as a means to prepare the ground for new groups of figurative painters from Berlin, Hamburg and Cologne, as well as to suppress certain conceptual-contextualist practices. Only the combination of these disparate factors made the German artists' work interesting. Their so-called invasion was really a power game: what was at stake was not only the distribution of power on the international art market, but the imposition of a value-hierarchy on artistic practices within American art production.[123]

It was an exercise in reckoning, not in enlightenment. Stereotypes, not artistic concepts, dominated the debate. The introduction of the national element was entirely a displacement activity, one that served to block debate on the contemporary relevance of specific artistic modes such as figurative painting. The paintings were not scrutinised in terms of their artistic validity but primarily categorised as 'German' and arranged in order of their remoteness from the American artistic product. In the process it became clear that any artistic positions which could not be assimilated into American debates – though they might be unfamiliar enough to be interesting in the short term – were not going to have any long-term influence.

To succeed, art had to have an American connection – whether, like the work of most of the younger 'Neo-Expressionists', it was regarded as a reaction against the American-dominated artistic production of the early post-war years; or whether, as with Anselm Kiefer and as in part with Baselitz and Penck, it was interpreted as painting that differed in content from contemporary American work but remained interpretable in formal terms as a continuation of the great tradition of Abstract Expressionism.[124] Some went so far as to see this German painting as completing an impulse initiated by the Americans: 'These tensions', wrote the *Boston Globe* apropos of Anselm Kiefer, 'are representative of one of the largest issues in his art, the attempt to unite the scale and richness of Abstract Expressionism with meaningful subject matter: in other words, to unite the poles of form and content, the concrete and the ideal, and art and life.'[125]

Kiefer's path had the effect of a textbook example. It proved that being a successful cultural export is not a matter of affirming one's own identity but of fulfilling other people's expectations. This applies to form as much as to content. When Kiefer devised his Wagnerian-mythological-fascistoid image of Germanness, he was playing to the introjected gaze of his overseas public. He offered that public what it had always imagined 'Germanness' to be; and so, paradoxically enough, in assuming the pose of the 'German Artist' he was taking up a wholly foreign-defined position. Correspondingly, Kiefer's references to the Abstract Expressionist format and formal idiom must be explained in terms of deference to the public. He was attempting to reassure that public by enabling it to perceive that something ostensibly alien, something that had initially been described in terms of an 'attack' or 'invasion', was really a continuation of something

all-American. Far from dethroning the American masters, the young German artist enhanced their fame; in return, a little borrowed glory was reflected onto his own art.[126]

Kiefer was compensated for this twofold alienation by success in America. For a short while, he outdid even Beuys: he could take his pick of the museums for his US retrospective, his prices were in the millions, and he enjoyed a wave of press enthusiasm that was disconcerting in its unanimity.[127] This response was no accident. Kiefer was uniquely placed to give America's profoundly insecure conservatives what they expected from art.[128] At one stroke he gave them back what they thought they had lost in the ideological struggles of the 1970s. In place of a critique, Kiefer offered an affirmation; instead of abolishing the 'authorial' artist, he recast him as the painter-philosopher. Where painting itself had been called into question, he countered with a firm commitment to the traditional easel picture, tackling 'difficult and serious' subjects with a near-fetishistic display of meticulous craftsmanship.[129] And yet his transatlantic success was confined to critics and collectors: neither his revival of an obsolete role nor his consolidation of national myths into clichés afforded his fellow artists an opportunity for productive confrontation.

VIII

In many ways, the excitements and controversies of the 1980s mean nothing to the 1990s. The consolidation of art into national clichés seems infinitely remote in time. The difference between the decades has an economic explanation: what separates them is the crisis that overwhelmed the art market after its boom in the 1980s. With it vanished not only faith in art as an object of exchange and – at least for a time – the need to deck artistic output in national colours but, most importantly, the assumed existence and well-oiled routines of the 'art industry'. Suddenly it was necessary to justify what had previously been taken for granted. Since art could not constitute its own justification, people justified it firstly by regarding it as a critique of the systems, discourses and apparatuses within which it existed – the anti-institutional line – and secondly by referring the practice of art back to social and political issues: in other words, by contextualising it.

In both these ways, there was a return to definitions of art that had first been conceived during the 1970s and marginalised by the short-lived 1980s boom. With them, as in the 1970s, came a renewed form of international artistic cooperation, which has defined itself – as in the case of the New York/Cologne axis – not in terms of national differences but rather of common themes, starting-points and methods, addressed to similar publics through common journals as well as a network of personal and professional relationships.[130] These forms of artistic practice are based on the dissolution of firm identities and an involvement in each other's relationships. I therefore am not afraid for the future of artistic exchange ...

Translated from the German by David Britt

NOTES

1 Benjamin H.D. Buchloh, 'Einheimisch, Unheimlich, Fremd: wider das Deutsche in der Kunst?' in *von hier aus*, exh. cat., Messehallen Düsseldorf, Cologne 1984, p. 162.

2 Horst-Eberhard Richter, 'Amerikanismus, Anti-amerikanismus – oder was sonst?', *Psyche*, vol. 40, no. 7, 1986, pp. 583–99.

3 The exhibition was held as part of the Berlin Festival and shown at Schloss Charlottenburg and Rathaus Schöneberg (West Berlin's City Hall). See Yule F. Heibel, *Reconstructing the Subject: Modernist Painting in Western Germany, 1945–50*, Princeton 1995, p. 131.

4 Benjamin H.D. Buchloh, 'Avant-Propos zu Re(tro)spect', in Benjamin Buchloh, Rudi Fuchs, Konrad Fischer, John Matheson and Hans Strelow, eds., *ProspectRetrospect Europa 1946–1976*, exh. cat., Kunsthalle Düsseldorf 1976, p. 7.

5 On the conception of the first Documenta, see Walter Grasskamp, '"Entartete Kunst" und documenta I. Verfemung und Entschärfung der Moderne', in Grasskamp, *Die unbewältigte Moderne, Kunst und Öffentlichkeit*, Munich 1989, pp. 76 et seq.

6 Jean Leering, 'Die Kunst der USA auf der documenta in Kassel', in Dieter Honisch and Jens Christian Jensen, eds., *Amerikanische Kunst von 1945 bis heute: Kunst der USA in europäischen Sammlungen*, Cologne 1976, p. 68.

7 Rudolf Zwirner told an interviewer: 'Since Werner Haftmann, who put *documenta* together, knew nothing about contemporary American art, they asked The Museum of Modern Art in New York to make its own selection.' 'Wie die Pop-art nach Deutschland kam, Interview mit dem Galeristen Rudolf Zwirner', in Bernd Polster, ed., *Westwind: Die Amerikanisierung Europas*, Cologne 1995, p. 114.

8 Eva Cockcroft, 'Abstract Expressionism, Weapon of the Cold War', *Artforum*, vol.12, no. 10, June 1974, pp. 39–41. Quoted from Francis Frascina, ed., *Pollock and After: The Critical Debate*, New York 1985, p. 127.

9 On this see Max Kozloff, 'American Painting during the Cold War', in Frascina 1985, pp. 107 et seq.

10 Serge Guilbaut, *How New York Stole the Idea of Modern Art: Abstract Expressionism, Freedom, and the Cold War*, Chicago and London 1983.

11 Lucius Grisebach, 'Stationen amerikanischer Kunst in Europa nach 1945', in Honisch and Jensen 1976, pp. 9–23; see also the list of group exhibitions of American artists from 1945 onward, ibid., pp. 309 et seq.

12 Grisebach 1976, p. 13.

13 Werner Haftmann, 'Malerei nach 1945', in *documenta 2*, exh. cat., reprinted in Manfred Schneckenburger, ed., *documenta: Idee und Institution, Tendenzen, Konzepte, Materialien*, Munich 1983, p. 54.

14 Werner Haftmann, *Malerei im 20. Jahrhundert*, Munich 1954; trans. as *Painting in the Twentieth Century*, New York and London 1960.

15 Werner Haftmann, 'Vortrag anlässlich der Eröffnung der 2. documenta am 11. Juli 1959', in Schneckenburger 1983, p. 55.

16 On the relationship between the *Dritte deutsche Kunstausstellung* and *Documenta*, see Uwe M. Schneede, 'Autonomie und Eingriff: Ausstellungen als Politikum, Sieben Fälle', in *Stationen der Moderne: Die bedeutenden Kunstausstellungen des 20. Jahrhunderts*, exh. cat., Martin-Gropius-Bau, Berlin 1988–9, pp. 39–40.

17 Rudolf Zwirner, in Honisch and Jensen 1976, p. 142. See also Zwirner (n. 7 above), p. 114: 'When the crates arrived in Kassel, we were contractually obliged to hang the lot. Hence our consternation when, for example, one painting by Robert Rauschenberg came out of its crate. This painting was nothing but a quilt that he had nailed onto a board. The bedspread was caked solid with paint. This is now a famous object in The Museum of Modern Art; at that time we were too stunned to exhibit it at all. The paintings by Pollock, De Kooning and Kline were easier to get along with. And Pollock, who had just died, even got a com-memorative room to himself.'

18 Gerhard Richter, interview with Benjamin H.D. Buchloh, 1986:

Can you remember what particularly interested you about Pollock and Fontana?
The sheer brazenness of it! That really fascinated me and impressed me. I might almost say that those paintings were the real reason why I left the GDR. I realized that there was something wrong with my whole way of thinking.
Can you enlarge on the word 'brazenness'? It has connotations of morality; surely that's not what you mean.
But that is what I mean. I lived my life with a group of people who laid claim to a moral aspiration, who wanted to bridge a gap, who were looking for a middle way between capitalism and socialism, a so-called Third Path. And so the way we thought, and what we wanted for our own art, was all about compromise. In this there was nothing radical – to use a more appropriate synonym for 'brazen' – and it wasn't genuine, either, but full of false deference.
Deference to whom or to what?
To traditional artistic values, for instance. I real-ised, above all, that all those 'slashes' and 'blots' were not a formalistic gag but grim truth and liberation; that this was an expression of a totally different and entirely new content.
Gerhard Richter, 'Interview with Benjamin H. D. Buchloh, 1986', in Richter, '*The Daily Practice of Painting: Writings and Interviews 1962—1993*, ed. Hans-Ulrich Obrist, trans. David Britt, London and Cambridge, Mass., 1995, pp. 132–3.

19 Wilfried Dörstel, '"Knollengewächse" und "Rangierstelle": Europäische konkrete Kunst und amerikanischer Konkretismus im Atelier Mary Bauermeister', in *intermedial, kontrovers, exper-imentel: Das Atelier Mary Bauermeister in Köln 1960–62*, Historisches Archiv der Stadt Köln, Cologne 1993, pp. 136–49.

20 The stage productions of Gustav Rudolf Sellner at the Hessisches Landestheater were an added attraction. Under Sellner, Daniel Spoerri and the Concrete poet Claus Bremer worked on a theory and practice of a 'Dynamic Theatre' characterised by audience participation, actor-audience interac-tion, the use of chance, and the rejection of prede-fined event sequences. This work anticipated some features of the Happening, and was described as its precursor by Bremer on the occasion of Wolf Vostell's *In Ulm, um Ulm und um Ulm herum*. The poet and Fluxus activist Emmett Williams – who had lived in Germany since 1949, earning his liv-ing in Darmstadt as editor of the American Forces newspaper, *Stars and Stripes* – described the scene at Darmstadt's Keller-Klub an ideal setting for the Bohemian life: 'Sitting at the long wooden tables in the "catacombes" (it was more bohemian than the Parisian caves it sought to emulate) you might find Eugène Ionesco, Theodor Adorno, John Cage, Ernst Krenek, Karlheinz Stockhausen, Pierre Boulez, Jacques Audiberti, Kasimir Edschmid, Bruno Maderna, Luigi Nono, Earle Brown, and so many others, clinking glasses and exchanging words – and sometimes ideas – with the locals.' Emmett Williams, *My Life in Flux and Vice Versa*, Stuttgart and London 1991, p. 102.

21 See Ina Conzen, 'Vom Manager der Avant-garde zum Fluxusdirigenten. George Maciunas in Deutschland', in *Eine lange Geschichte mit vielen Knoten: Fluxus in Deutschland*, exh. cat., Institut für Auslandsbeziehungen, Stuttgart 1995, p. 18 et seq.

22 Hans G. Helms, 'Lauter "Originale": Köln zwischen 1955 und 1965 – zeitweilige Weltmetro-pole der neuen Musik', in Wulf Herzogenrath and Gabrielle Lueg, eds., *Die 60er Jahre, Kölnischer Weg zur Kunstmetropole: Vom Happening zum Kunstmarkt*, exh. cat., Kölnischer Kunstverein, Cologne 1986, pp. 130 et seq.

23 Including 'Poem for chairs, tables, benches etc (or the sound sources)'.

24 See *intermedial* (n.19, above), pp. 44 et seq., and Thomas Thorausch, 'Irritationen und Kritik: Reaktionen auf den Tanzabend von Merce Cunningham und Carolyn Brown in Berlin und Köln 1960', ibid., pp. 172–85.

25 What attracted the Americans to Cologne was summarised by the writer Hans G. Helms, who was an involved participant at the time, as follows: 'They made their way to Cologne in order to escape from the private capitalist conditions of production in their own country, and to take advantage of the special social treatment given to art in West Germany after 1945. The Americans' works were born of urgent social necessity; they bore the marks of material poverty as well as of McCarthy's witch-hunts; they mistrusted capitalism and industrial mass-production; they were anarchists who lusted after freedom for themselves and also for the interpreters and the public.' Helms 1986, p. 135.

26 See Herzogenrath and Lueg 1986, pp. 294 et seq.

27 See *Treffpunkt Parnass, Wuppertal 1949–65*, exh. cat., Von der Heydt-Museum, Wuppertal 1980.

28 Conzen 1995, p. 20.

29 Dörstel 1993, pp. 142 et seq.

30 One of the concerts was billed as 'Musica Antiqua et Nova Presents Festival of Electronic Music', the other as 'Musica Antiqua et Nova Presents Concert of New Sounds and Noises'. The programmes included pieces by Cage, Dick Hig-gins, Toshi Ichiyanagi, Jackson Mac Low, Joseph Byrd and La Monte Young.

31 Undated letter from George Maciunas to Mary Bauermeister, Historisches Archiv der Stadt Köln, Best. 1441, Nr. 25. Quoted from Dörstel 1993, pp. 142, 143.

32 Dörstel 1993, pp. 145–60.

33 See *WiesbadenFLUXUS 1962–82: Eine kleine Geschichte von Fluxus in drei Teilen*, exh. cat., Wiesbaden Städtisches Museum, 1992 and Berlin DAAD Galerie, 1983, and *Fluxus da capo, 1962 Wiesbaden 1992*, exh. cat., Städtisches Museum Wiesbaden 1992.

34 Johannes Cladders, 'jede kommunikation ist eine collage, Johannes Cladders erinnert sich an den frühen Fluxus im gespräch mit Gabriele Knapstein', in *Eine lange Geschichte* (n. 21, above), p. 15: 'It was partly because the Germans had these identity problems that such a strongly international atmosphere emerged here. What finished Paris was chauvinism; here in Germany that couldn't happen. Anyone could come and settle here, and, at least in the art scene, everyone was welcome. It was a wonderful situation, the best time of my life, this total freedom of identity.'

35 Friedrich Wilhelm Heubach, 'Die Kunst der 60er Jahre: Anmerkungen in enttäuschender Absicht', in Herzogenrath and Lueg 1986, pp. 113–14.

36 See Thorausch (n. 24, above), pp. 172 et seq.

37 Pyla Patterson, in *intermedial* (n. 19, above), p. 16: 'We felt exactly the same way about life [as the Beatniks or 'New Departures'], even though we looked neater or better groomed ... It may have been the spirit of Adorno rather than this Beatnik thing from the USA or England. The way we felt was more like Adorno, but it wasn't all that far from the Beat feeling. it was simply the postwar trauma: we were all traumatized. And everyone articulated it differently.'

38 Conzen 1995, p. 20.

39 Conzen 1995, p. 22.

40 Helms 1986, p. 136.

41 Wolf Vostell: 'My dominant image from my childhood [is] the dying person ... I lived through my first Happenings when I was eight or nine: dur-ing an air raid we all had to run a kilometre away from the school, and every child on his own had to find a different tree to shelter under ... and from there I saw aerial dogfights and bombs falling on the earth.' Vostell, in Jürgen Becker and Wolf Vos-tell, *Happenings, Fluxus, Pop-Art, Nouveau Réalisme: Eine Dokumentation*, Reinbek bei Ham-burg 1965, p. 403.

42 Allan Kaprow: 'In concrete terms, nature can make a sudden and highly poetic impression – as when, for instance, on an overcast winter day in the country, a bird suddenly flies over the leaden brown of a dying apple tree. As far as human constructions are concerned ... it is clear to me that at certain times the control panel of a big electronic computer in action, an aircraft factory ... a manned rocket lifting off, a jungle cleared for the building of the city of Brasilia, is considerably more effective than art.' In German in Becker and Vostell 1965, p. 404.

43 See Klaus Honnef, 'Le Montage comme principe esthétique: à propos du concept d'oeuvre chez Wolf Vostell', in *Murmures des rues: François Dufrêne, Raymond Hains, Mimmo Rotella, Jacques Villeglé, Wolf Vostell*, Rennes 1994, pp. 61 et seq.

44 Joseph Beuys, quoted from Uwe M. Schneede, *Joseph Beuys: Die Aktionen, Kommentiertes Werkverzeichnis mit photographischen Dokumentationen*, Ostfildern-Ruit bei Stuttgart 1994, p. 69.

45 The words of the gallery announcement.

46 Schneede 1994, p. 69.

47 Götz Adriani, Winfried Konnertz and Karin Thomas, *Joseph Beuys: Leben und Werk*, Cologne 1981, pp. 113 et seq. (1st ed., 1973).

48 Schneede 1994, p. 27. Beuys, in Adriani, Konnertz and Thomas 1981: 'That was the first public Fluxus action. My first ever. I can still remember the look of amazement on Dick Higgins's face: he had realized that this action had nothing whatever to do with a Dada concept. I think he guessed that this was something possessing an entirely different value. When I use the hare, which for the first time appears within this concept as a real presence, I mean to express a substantive relationship with birth and death, with metamorphosis in matter; and that has nothing to do with Neo-Dada bourgeois-baiting.'

49 Uwe M. Schneede, 'Die frühen Aktionen', in Volker Harlan, Dieter Koepplin and Rudolf Velhagen, eds., *Joseph Beuys Tagung*, Basel 1991, pp. 131 et seq.

50 Schneede 1994, p. 74.

51 Ibid.

52 Thomas Kellein, 'Zum Fluxus-Begriff von Joseph Beuys', in Harlan, Koepplin and Velhagen 1991, p. 137.

53 Gerd [Gerhard] Richter, Manfred Kuttner, Konrad Lueg, Sigmar Polke, 'Letter to a Newsreel Company', 29 April 1963, in Richter 1995, p. 15.

54 In particular, they read: Max Kozloff, '"Pop" Culture, Metaphysical Disgust and the New Vulgarians', *Art International*, vol. 6, no. 2, 1962, pp. 34–6; Barbara Rose, 'Dada Then and Now', *Art International*, vol. 7, no. 1, 1963, pp. 23–8.

55 Martin Hentschel, 'Die Ordnung des Heterogenen: Sigmar Polkes Werk bis 1986', unpublished diss., Bochum 1991, p. 58.

56 Gerd [Gerhard] Richter, Manfred Kuttner, Konrad Lueg, Sigmar Polke, 'Letter to a Newsreel Company', 29 April 1963, in Richter 1995, p. 16.

57 Ibid.

58 Richter, 'Interview mit Benjamin H. D. Buchloh, 1986' in Richter 1995, pp. 137–8.

59 Ibid., p. 136.

60 Ibid., p. 137.

61 'Programme and Report: The Exhibition *Leben mit Pop – Eine Demonstration für den Kapitalistischen Realismus*, Düsseldorf 11 October 1963', in Richter 1995, p. 20.

62 Ibid.

63 S. Küper, 'Konrad Lueg und Gerhard Richter: Leben mit Pop – Eine Demonstration für den kapitalistischen Realismus", *Wallraf-Richartz-Jahrbuch*, vol. 53, 1992, pp. 289–306.

64 Hentschel 1991, p. 97.

65 On this see Andreas Huyssen, 'The Cultural Politics of Pop', in Huyssen, *After the Great Divide: Modernism, Mass Culture, Postmodernism*, Bloomington and Indianapolis 1986, pp. 141–59.

66 See ibid., pp. 142 et seq.; Jost Herman, *Pop International: Eine kritische Analyse*, Frankfurt am Main 1971.

67 See Huyssen 1986, pp. 142 et seq.; Rainer Crone and Wilfried Wiegand, *Die revolutionäre Ästhetik Andy Warhols*, Darmstadt 1972.

68 In addition to the book he wrote with Wiegand in 1972 (n. 67 above), Crone also expounded his theories in *Andy Warhol*, Stuttgart 1976, and in *Das bildnerische Werk Andy Warhols*, Berlin 1976 (in which the political radicalism is somewhat toned down).

69 Crone and Wiegand 1972, pp. 28, 33, 34.

70 See Phyllis Tuchman, 'American Art in Germany, the History of a Phenomenon', *Artforum*, vol. 9, Nov. 1970, pp. 58–69. Also Zwirner (n. 7 above), pp. 114–115, and Rolf Ricke, in Honisch and Jensen 1976, pp. 143 et seq.

71 On Hahn, see 'Sammlung Wolfgang Hahn', in Herzogenrath and Lueg 1986, pp. 232 et seq.

72 Grisebach 1976, pp. 20-1. In 1970 an attempt had been made to buy up Scull's collection en bloc for the Staatsgalerie in Munich.

73 See Gert von der Osten, 'Der Sammler geht voran', in *Kunst der sechziger Jahre*, exh. cat., Wallraf-Richartz-Museum Cologne 1969, n.p.

74 Grisebach 1976, p. 21.

75 Tuchman 1970, pp. 58 et seq.

76 Ibid., p. 68.

77 Ibid., p. 69.

78 Ibid., p. 69.

79 Buchloh (n.4, above), p. 8.

80 Konrad Fischer in Honisch and Jensen 1976, pp. 147–8.

81 Rolf Ricke in Honisch and Jensen 1976, p.144: 'It was the beginning of a wholly new way of thinking within art, and of an entirely new relationship between the artist and the mediator, i.e., myself. The traditional path from studio to gallery was cut off and – at least in its traditional form – called in question: there began a new partnership between artist and gallery owner, whereby the latter was drawn into the genesis of art. The gallery … became what it has remained to this day, a studio; and the gallery owner became even more of a patron than before, by giving the artist the opportunity to realize his/her ideas for mostly unsaleable works, now based partly on the ground plan of the gallery itself. This also had the consequence that in essential ways the gallery became an agency. So first the artists had to make their pieces inside the gallery, and in the spring of 1967 I started sending plane tickets to those artists whom I wanted to show, inviting them to come and work there for several weeks.'

82 See *Ausstellungen bei Konrad Fischer Düsseldorf Oktober 1967 – Oktober 1992*, Bielefeld 1993; Gerd de Vries, ed., *Eine Avantgarde-Galerie und die Kunst unserer Zeit: Paul Maenz Köln 1970–1980–1990*, Cologne 1991; Paul Maenz, *Köln 1970–80: Der Blick zurück ist ein Blick auf die Gegenwart und/oder die Wahrheit hat viele Brüste*, Cologne 1991.

83 A special position among these early visitors is that of Eva Hesse, whose decidedly traumatic return to Germany, for fifteen months from June 1964, prompted her to shift from painting to sculpture. See Lucy L. Lippard, *Eva Hesse*, New York 1976, pp. 23 et seq.; Buchloh (n. 1, above), pp.164–8; Bill Barrette, *Eva Hesse Sculpture*, New York 1989, pp.9 et seq.; Jane Rankin-Reid, 'Eva Hesse: The 1965 Reliefs', *Artscribe International*, May 1989, pp.66–7; Maria Kreutzer, 'The Wound and the Self: Eva Hesse's Breakthrough in Germany', in *Eva Hesse*, exh. cat., Yale University Art Gallery, New Haven 1992, pp. 75 et seq. See also Carl Andre, 'Footnote to a 25 Year Old Gallery', in *Ausstellungen bei Konrad Fischer* (n. 82 above), p. 3.

84 Hein Stünke, 'Bemerkungen zur Vorgeschichte und Geschichte des Kölner Kunstmarktes', in Herzogenrath and Lueg 1986, pp. 342–6.

85 See Buchloh, Fuchs, Fischer et al. 1976, p.119; Tuchman 1970, p. 68.

86 Basic to the art of the period: Benjamin H.D. Buchloh, 'Formalism and Historicity: Changing Concepts in American and European Art Since 1945', in *Europe in the Seventies: Aspects of Recent Art*, exh. cat., Art Institute of Chicago 1977, pp. 82–111.

87 Tuchman 1970, p. 68.

88 For a list of events see Buchloh, Fuchs, Fisher et al. 1976.

89 Michael Heizer, in *Michael Heizer*, exh. cat., Museum Folkwang, Essen, and Rijksmuseum Kröller-Müller, Otterlo 1979, pp. 13–14.

90 Uwe M. Schneede: 'Un Américain en Allemagne: Walter De Maria', *Cahiers du Musée National d'Art Moderne*, vol. 32, 1990, pp. 53–63. The project was never realised.

91 Annette Michelson, Richard Serra and Clara Weyergraf, 'The Films of Richard Serra: An Interview', in *Richard Serra*, with Clara Weyergraf, *Interviews, etc., 1970–1980*, Yonkers, New York 1980, pp. 310 et seq.

92 Carl Andre, 'A Note on Bernhard and Hilla Becher', *Artforum*, vol. 11, no. 4, Dec. 1972, p. 59; Richter (n. 18 above), p. 142.

93 Bernhard Bürgi in conversation with Bice Curiger, *Parkett*, no. 3, 1984, p. 84.

94 Klaus Schrenk, 'Zum künstlerischen Werk von Palermo', in Thordis Müller, ed., *Palermo Bilder und Objekte, Werkverzeichnis*, vol. 1, Stuttgart 1994, p. 19.

95 On the dismantling of the 'Palermo myth', see Bernhard Schwenk, '"… who knows the beginning and who knows the end…": Studien zum Werk des Malers Blinky Palermo (Peter Heisterkamp 1943–77)', unpublished diss., Bonn 1991.

96 Ibid, p. 28.

97 Ibid, pp. 63 et seq.

98 Buchloh (n. 1, above), p. 170.

99 Ibid., pp. 170–1.

100 See Edit de Ak and Walter Robinson, 'Beuys; art encagé', *Art in America*, vol.62, no. 6, Nov.–Dec. 1974, pp. 76–9. The suspicion that some knew Beuys's images only by hearsay is reinforced by the following description of 'La Rivoluzione siamo noi', 1971: 'His highly charged persona became apotheosized in photographs and posters. One of the best was a huge full-figure poster drenched in charisma, pointedly subtitled by his marvellously handwritten "We are the Revolution" – in French.' (p. 76).

101 Kim Levin, 'Introduction', in Joseph Beuys, *Energy Plan for the Western Man: Joseph Beuys in America, Writings and Interviews*, ed. Carin Kuoni, New York 1990, p. 1.

102 Quoted from Caroline Tisdall, 'Beuys in America, or the Energy Plan for the Western Man', in Beuys 1990, p. 9.

103 De Ak and Robinson 1974, p. 77.

104 Heiner Stachelhaus, *Joseph Beuys*, trans. by David Britt, New York 1991, p. 173.

105 Joseph Beuys, quoted from Caroline Tisdall, 'Beuys in America, or the Energy Plan for the Western Man', in Beuys 1990, p. 12. The quotation stems from a lecture that Beuys gave at the School of the Art Institute in January 1974.

106 See Schneede 1994, p. 324.

107 David Levi Strauss, 'American Beuys: "I Like America & America Likes Me"', Komplizenhafter Widerstand gegen eine mögliche Wiedergutmachung – das ist die Geschichte Amerikas', *Parkett*, no. 26, 1990, pp. 130–6.

108 Beuys told Caroline Tisdall: 'I believe that I made contact with the psychological trauma point of the United States' energy constellation: the whole American trauma with the Indian, the Red Man. You could say that a reckoning has to be made with the coyote, and only then can the trauma be lifted. The manner of the meeting was important. I wanted to isolate myself, insulate myself, see nothing of America other than the coyote.' Beuys 1990, p. 141.

109 On Beuys's denial of psychoanalytical approaches, see Benjamin H. D. Buchloh, 'Joseph Beuys – Die Götzendämmerung', in *Brennpunkt Düsseldorf 1962–87: Joseph Beuys. Die Akademie. Der allgemeine Aufbruch*, exh. cat., Kunstmuseum Düsseldorf 1987, pp. 60–77.

110 Interview with Louwrien Wijers, 1979, reprinted in Beuys 1990, pp. 215 et seq. (quotation on p. 235).

111 Interview with Louwrien Wijers, 1979, reprinted in Beuys 1990, pp. 241–2: 'The people make a kind of equation between the European impulse in this moment in my work, and they feel a rather other intention to go on with art, an intention which is related to the problems of the world and related to the questions existing on ecology and on powers, you know. Whereas the American intentions go more – I must repeat – along the formalistic aspect of things.'

112 Interview with Louwrien Wijers, 1979, reprinted in Beuys 1990, p. 242.

113 De Ak and Robinson 1974, p. 78.

114 Caroline Tisdall, *Joseph Beuys*, exh. cat., Solomon R. Guggenheim Museum, New York 1979 (London 1979).

115 Robert Storr, 'Beuys' Boys', *Art in America*, vol. 76, no. 3, March 1988, p. 97.

116 On the Guggenheim retrospective, see Buchloh 1987, pp. 60 et seq.

117 Hans Belting, *Das Ende der Kunstgeschichte: Eine Revision nach zehn Jahren*, Munich 1995, pp.59–60.

118 Donald B. Kuspit, 'Acts of Aggression: German Painting Today', *Art in America*, Sept. 1982, p. 141.

119 In America, the label 'Neo-Expressionism' was used to cover not only two different generations but a whole, locally diverse artistic output. Georg Baselitz (b. 1938), K. H. Hödicke (b. 1938), Bernd Koberling (b. 1938), A.R. Penck (b. 1939) and Anselm Kiefer (b. 1945) were regarded as the elder group; the younger faction contained the Berliners, Helmut Middendorf (b. 1953), Salome (b.1954), Rainer Fetting (b. 1949), Bernd Zimmer (b.1948), Elvira Bach (b. 1951); the 'Mülheimer Freiheit' artists, Walter

Dahn (b. 1954), Jiri Dokoupil (b. 1954), Peter Bömmels (b. 1951), Hans Peter Adamski (b. 1947), Gerard Kever (b. 1956) and Gerhard Naschberger (b. 1955); and the Hamburg artists, Werner Büttner (b. 1954) and Albert Oehlen (b. 1954).

120 See Noemi Smolik, 'Das Ende der amerikanischen Ära oder wie lausig sind die Europäer?', *Kunstforum International,* no. 61, May 1983, pp.142–6.

121 Anon., 'Cultural Imperialism, Provincialism, and The New Internationalism', *Art-Rite,* vol. 8, 1975, pp. 4–6.

122 Irene von Zahn, 'Der europäische Koffer', *Magazin Kunst,* vol. 16, 1976, pp. 114–18.

123 Donald B. Kuspit, 'Flak from the "Radicals": The American Case against Current German Painting', in Jack Cowart, ed., *Expressions: New Art from Germany,* ex. cat., St. Louis and Munich 1983, pp. 43–55; quoted from Brian Wallis, ed., *Art After Modernism: Rethinking Representation,* New York and Boston 1984, pp. 137–51.

124 On the perception and ideological function of German painting in 1980s America, see Benjamin H. D. Buchloh, 'Figures of Authority, Ciphers of Repression', *October,* vol. 16, Spring 1981, pp. 39–68; reprinted in Wallis 1984, pp. 107–34.: 'What makes Kiefer, Penck, Baselitz so attractive to Americans (in particular) is that they teach a new art history lesson, one that begins with Picasso and Matisse, passes through German expressionists and the surrealists (especially Fautrier and the later postwar painting), and then decisively registers the extraordinary impact of Still, De Kooning, Kline, and Pollock. Who would not be seduced by the reflection of one's own national culture in the art of a succeeding generation, especially in a different geopolitical context?' (ibid., p. 33.)

125 *Boston Globe,* quoted from Gerald Schröder, 'Vom Satansbraten zum Götterboten. Rezeptionsgeschichte und Interpretationsansätze der Kunst Anselm Kiefers', unpublished seminar paper, Bonn University, 1989, p. 54.

126 'His reinvention of Pollock and the big School of New York canvas brings him close to us', crowed *Harper's Bazaar* in December 1987 (p. 191).

127 Schröder 1989, pp. 52 et seq.

128 The exception proves the rule; on occasion, even left-wingers have fallen for Kiefer. See Andreas Huyssen, 'Kiefer in Berlin', *October,* vol. 62, Autumn 1992, pp. 85–101.

129 Buchloh 1981, p. 133.

130 See Stefan Germer, 'Unter Geiern: Kontextkunst im Kontext', *Texte zur Kunst,* vol. 19, 1995, pp. 83–95.

Thomas McEvilley **(Op)Posing Cultures:**
An Investigation
of Beuys and Warhol

Joseph Beuys died in 1986 at the age of sixty-four, and Andrew Warhol in the following year at the age of fifty-eight. Within that strange, small enclave which chooses to call itself the 'art world', these events were regarded as having special portent.

Of course, any important artist's death is considered an event of consequence. There is not only a sense of loss attendant upon it, but in certain ways a sense of gain as well. Death becomes like the golden mask that covered Tutankhamen's face as he lay in the Valley of the Kings, across the muddy river from Karnak – it denies the deceased's mortality rather than confirming it: a new immortal has entered the pantheon! The market for the artist's works tends to go up. He is sanctified in art history to an extent that he was not when alive.

These two deaths, however, had an additional and special impact. There was a perception, on each side of the Atlantic, that something historic, even semi-mythic, had occurred. A period of several years ensued in which there was talk about who would inherit the mantle of one or the other. In Europe there were mentions of Jannis Kounellis, Sigmar Polke, and Anselm Kiefer as candidates for Beuys's mantle. In New York the discussion of who might be the 'new Warhol' centred (after Keith Haring's death) around Jeff Koons and Mark Kostabi.

The differences in these lists of contenders is revealing. The European artists involved were known for what Matthew Arnold called 'high seriousness'. The American artists involved were, on the contrary, known for what one might call 'high frivolousness'. In a simplistic sense, Beuys had been the king, Warhol the jester.

Beuys's work, and his legacy, had to do with nature and the flaws of so-called civilisation – indeed, a questioning of the premises of civilisation itself; Warhol's work had to do with the folly, yet reality, of civilisation, which the artist understood, in a raw down-to-earth way, as the market and capitalism and their puny cultural offshoots. Beuys appealed to nature for redemption or escape from culture. Warhol looked more pragmatically to culture, whatever its flaws, as the only available option. If there were a theological duel, Beuys would represent the soul, Warhol the anti-soul.

Yet various traits of these two figures on different sides of the Atlantic somehow brought them together in a linkage that has lasted now for about a decade: Beuys and Warhol, Warhol and Beuys. The two names seem to go easily together, despite the many problems or contradictions their synchronisity raises. This linkage is not merely a theory or proposal; it is simple fact. It has already been written into art history. In dealing with the cultural history of the pivotal generation between, say, 1965 and 1985 – at least in terms of the Western tradition – one inevitably confronts the opposed and equated figures of Warhol and Beuys. It is through these two personas, as through archetypes, that the tradition (including all of its specially Western nuances and oddities) has articulated its main directions.

The sense of a connection between these two artists already existed in their lifetimes. In 1980, as a part of his conflation of images of icons from pop and high culture, Warhol began a series of portraits of Beuys (cat. 302, cover). Beuys attended an exhibition of these works held at Lucio Amelio's gallery in Naples later that year. The two artists fraternised somewhat warily for the sake of a hungry press.

The reason that their meeting was such a media event was because both artists had always gone to great pains to attract attention to their personas, their public, media-situated images. The trajectory of Beuys's career describes a gradual shift from an early persona as self-appointed shaman healing the indelible wounds of post-war Germany, later inflated by ego to the persona of deity or king presiding over a court of acolytes. Warhol's portraits of him, beginning in 1980, more or less exploited this weakness. Warhol, on the other hand, went from an early role of shy provocateur, puncturing with his works of the early 1960s the bubble of metaphysical pretension with which Abstract Expressionism had surrounded itself, to a later, more ambitious role of mastermind of popular culture and of the conflation of high and low.

Both Warhol and Beuys acted out their often theatrical personas through the creation of trademarked looks that were easily recognised. In Beuys's case, in the early period, the costume involved the rumpled fedora which referred to gangsterism and the hunting vest which associated him with nature and the outdoors. Later in life a fur coat constituted an implicit claim to a kind of animal identity, while brass cymbals chimed a regal presence. For Warhol the principal piece of costuming was an outlandish fright wig of white hair, along with the wrinkled jeans that proclaimed 'America'. Both men also operated in more or less personal enclaves which attracted eccentrics. Beuys did so in the public domain, at the Düsseldorf Kunstakademie or the various shifting sites of the Free International University, venues in which his gestures were understood as relating to the concept of the state, or of the reform of the state. Warhol, on the other hand, pursued his often bizarre social aims in a privately controlled setting which did not relate to the idea of the state except through a desire to circumvent and subvert it. This was the Factory, where both famous and infamous deeds transpired in an atmosphere of charismatic secrecy.

Each of these artists made of his life a performance piece for the public eye. However, the ever-increasing grandiosity of Beuys's posing has sometimes been seen as his great flaw, diverting his work from the toughness of early works such as 'Fat Chair', 1964 (Ströher Collection, Hessisches Landesmuseum, Darmstadt), to the regal decorativeness of late works such as his exhibition in late 1985 about his own death (presented, appropriately, in the Palazzo Regale in Naples), in which the fur coat, laid out in a coffin-like vitrine, represented the artist's vacated, or transmogrified, selfhood (fig. p. 37). In Warhol's case, on the contrary, his success at aggrandising his persona is commonly seen as his great triumph.

The different evaluations of their roles as poseurs also reflects differences between the two cultures. In the realm of American glitz, Hollywood, and the land of market obsession, Warhol's achievement at manipulating the public through his persona was cynical but realistic. At the same time that he critiqued late capitalism, he also embodied it with a straight face. Beuys, on the other hand, formed by his association with the deep roots of Germanic mythos and classical German Romanticism, was neither cynical nor realistic, but somewhat overpowered by the sense of his own greatness.

It may be primarily because of the cultic attention to their personas that Beuys and Warhol have come to be linked. Nevertheless, there are other interesting, but often ambiguous, parallels and differences between them. A pattern of simultaneous sameness and difference extends throughout the comparison of their œuvres: a structural sameness tends to be balanced by deep differences of mood or spirituality.

The elements of similarity result in part from their occupying the same art-historical moment. The turning point on which both Beuys and Warhol focused involved a rejection of the traditional craft of easel painting, which seemed too polluted by its long association with Western hegemonic designs. Both were sceptical about Late Modernist modes of aestheticism, elitism, and the cult of the sublime. In Warhol's case this resulted in the photography-based silkscreen works, which denied the tradition of 'touch' through chemical and mechanical intervention. Beuys adopted a more varied means of avoidance, including performance art, sculpture, and concept.

In the years when their work began to attain maturity – the early 1960s – painting was

widely regarded as corrupted. This was for various reasons, one factor being its association with illusionism. The painting was regarded as a window on the wall – whether a window into the surrounding world, as in the Renaissance, or a window into the sublime, as in the last century or so of Modernism – yet it simultaneously represented the avoidance of the wall itself. It sacrificed the reality of the moment in favour of an imagined vision beyond. The nature of this vision was another problem. By presenting, or representing, the world as a finite terrain to be conquered and possessed, easel painting since the Renaissance had become associated with imperialism: the desire of the subject to control the object. Alternatively, by implying an escape into the sublime, as, say, the Abstract Expressionists did, painting cajoled the viewer into a neglect of social criticism and again affirmed the rightness of Western leadership by suggesting its apparent occupation of a metaphysical cutting edge which led toward the Hegelian idea of the End of History.

This was no longer the Modernist moment, but it was not yet the post-Modernist one, either. It was the moment in between, when artists still felt they might forge ahead into a future culmination, yet had lost the crypto-religious faith in the old order of aesthetic determination that was articulated in Kant's *Critique of Judgment* in 1796 and culminated in Clement Greenberg's boosting of the New York School in the 1950s and 1960s. In the decade from the early 1960s to the early 1970s a variety of strategies were developed to counteract the illusionism of traditional easel painting.

A prominent element, especially in American Pop art but also in various European contexts, was the appropriation of media images to collapse the traditional distinction between high and low culture. Both Beuys and Warhol incorporated into their work popular imagery that reflected the field of power relationships at a raw level – but they did it very differently. For Warhol the United States dollar, represented in 'Forty Two Dollar Bills', 1962 (cat. 274), or the Campbell's soup can, in 'Campbell's Soup Can (Vegetable)', also 1962 (cat. 275, p. 195), was simply an ultimate fact about the reality of the moment. That's all there is, his work proclaims: don't look any farther. For Beuys, on the contrary, 'Tafel III (Kapital = Kunst)', 1978 (cat. 92, p. 62), involved a protest against the misuse of art by capitalist society – with an implied plea for a return to a spiritual and nature-based relationship to culture.

A standard range of comparisons has developed which is intended to support the linkage of these two artists but which, upon closer analysis, may point more prominently to their differences. Beuys's use of media images of Greta Garbo, for example, has understandably been regarded as thematically linked with Warhol's use of images of Marilyn Monroe. There is a clear structural parallel in that both used found media images which were partly overpainted. But the underlying

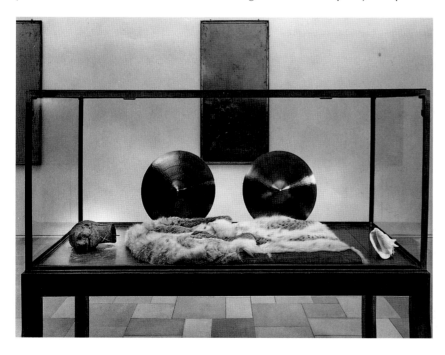

**Joseph Beuys
'Palazzo Regale',
(detail), 1985
Mixed media
Collection Kunst-
sammlung Nordrhein-
Westfalen, Düsseldorf**

themes or intentions behind these works may not have been so similar. Beuys fantasised Garbo as the lingering presence of a repressed goddess, who would be restored to power in a future age when the destructive aspect of the male personality was offset by a restoration of female spirituality. His Garbo was an optimistic, or at least hopeful glance toward the future, a fundamental principle that could not be brushed aside by changing circumstances. Her moment would swing round again.

Warhol's Marilyn Monroe comes to the viewer with a different aura. She seems to be presented as a victim, not a triumphant force. True, Warhol seems to have presented her as a kind of goddess, but a pathetic goddess, demeaned and destroyed by patriarchy. She will preside over no future age. She is a casualty on the side of the capitalist patriarchal road, like Warhol's disaster pictures of car wrecks.

Joseph Beuys
'Greta Garbo Cycle',
(Nos.1,12,13),
1964–9
Oil on paper
Private Collection

In the 'Greta Garbo Cycle', 1964–9, Beuys presented eleven overpainted newsprint photographs, photographs and photocopies of the actress, both in her phase as superstar and in her hermetic retirement. The eleven portraits are exhibited in a row, flanked by two similarly made images of male figures: Al Capone, and Ho Chi Minh. The implied meanings are ambiguous. It may seem that Capone and Ho represent the patriarchal establishment that confined the goddess within its stern parameters. Or it may imply that with her new ascendancy these media-heroic male figures may emerge as her attendants.

For Warhol the first and foremost popular image was neither the dollar nor the soup can but the face of Marilyn Monroe. Her almost white-blond look may indeed have been the source of elements of his own persona (fig. p. 42, 43). Some feel that he identified with her simultaneous celebrity and victimisation.

The next two faces on the coins of his imaginary realm, so to speak, were Elvis Presley and Elizabeth Taylor. Warhol was clearly disaffected with American society, yet these images affirmed it aggressively. In 'Double Elvis', 1964 (cat. 286, p. 202), the poor-white-trash American icon quick-draws, with his right hand, upon the world, like late capitalism saying, 'Look out, world; I'm comin' atcha'.

In his iconography of rootless, late-capitalist America, Warhol was not creating a new pantheon so much as pointing to one that already existed but had not been fully recognised. It was a pantheon underpinned by a theology of indifference. Relentlessly, as the decades passed, Warhol would reduce everything to lifeless substance through the silkscreen, all things treated alike; electric chairs, car wrecks, movie stars, flowers. As the years passed, his archetypal portraiture expanded to the Western tradition in general, incorporating images of Beethoven, Einstein,

Geronimo – and Beuys. He was picking out the elements for a new mythos, and this was a levelling gesture, subverting the European tradition of high culture in the name of American mass-marketing. Just as Marilyn Monroe was transported from the popular to the high culture, so Ludwig van Beethoven was translated from high culture to pop icon.

Garbo seems to have functioned for Beuys's persona somewhat as Monroe did for Warhol's. Beuys's gaunt, poetic, ravaged and melancholy look might have been to a degree based on the visual record of Garbo's personality. But he tended to feature male-heroic figures in a less ironic or distanced way than Warhol did. The gangster Al Capone, who held American governmental authority at bay with his ornery assertion of opposition and independence and Ho Chi Minh, who also held off the massive might of the superpower, represented for Beuys the power of opposition and single-minded determination. That both Capone and Ho Chi Minh attained heroic stature through opposing the American government demonstrates Beuys's recognition of the domination of American-style capitalism in the post-war world. Warhol's inclusion in his canon of a portrait of Geronimo, the renegade Apache chief who became an exhibit at the Columbian world exposition in Chicago in 1893, is not dissimilar to Beuys's cult of Capone. Both instances encapsulate a grudging acknowledgement of American post-war hegemony with an implicit critique of its legitimacy.

In acting out their public personas both artists worked on the social body more prominently than most artists have done, but seemingly in opposite directions. Warhol wanted to subvert it, Beuys to redeem it. There is no sense of redemption underlying Warhol's work, and no genuine sense of subversion underlying that of Beuys, who, though critical of his society, never seems to have lost hope for social rectitude. One can see this in works each artist exhibited in Germany in 1982, two years after their meeting in Naples. At the *Zeitgeist* exhibition in Berlin, Warhol showed paintings of Nazi architecture, while at Documenta 7 Beuys supervised the planting of 7,000 trees. Warhol, whose persona involved the idea that he was without a sense of social responsibility, was making a gesture of provocation toward the citizens of Berlin and at the same time creating pop icons from this forbidden imagery. Beuys, comparably double-edged, seems to have been referring to the project of tree-planting in the desert in Israel in the years following the war (the Gandhian idea of people acting on their own), while at the same time invoking nature as a palliative for the pangs of civilisation in general. Their tendencies toward double-meaning are structurally parallel, but Warhol's moves go bidirectionally toward provocation and subversion, Beuys's toward reconstruction and shamanic healing.

The linkage of these two artistic personas has led to a situation in which each of them represents his own culture in relation to the other: yet neither can be said to celebrate his cultural heritage in an unmediated way. Beuys was the first German artist to confront openly the recent historical problems of his culture, especially the Holocaust, which was a major theme of his work virtually from its beginning. In his early work, Warhol stressed the destructiveness of American civilisation, in the 'Disaster' pictures portraying car wrecks (such as 'Five Deaths (red)', 1962–3 (cat. 280, p. 197)) and electric chairs (such as 'Double Silver Disaster', 1963 (cat. 279, p. 198)). Though each pointed to problems in his culture, Beuys seems to have felt there was something to be done about them, while Warhol seems to have been unconcerned with this question.

The difference between the two artists can be measured by a comparison of the cultures from which they came. Warhol's work referred to a culture that was recent and rootless, while Beuys's was formed in part by the deep roots of Germanic tradition. In his performances Beuys sometimes feigned inarticulateness or the use of a language other than human. Examples include 'Der Chef The Chief', 1964, in which, rolled up in a sheath of felt fabric, Beuys uttered a sound which, as he described it, 'was deep in the throat and hoarse like the cry of the stag', and 'wie man dem Hasen die Bilder erklärt' (How to Explain Pictures to a Dead Hare), 1965, in which, immortalised by gold leaf, he spoke to his animal ally a language that transcended the distinction between nature and culture.

In terms of the Germanic tradition from which Beuys never escaped, these and other works related backward to the myth of Siegfried, who grew up in the forest. Siegfried knew the language of the birds and thus emerged from the forest singing beautifully, but knowing no human language. Similarly, Beuys's work stressed the idea of returning to nature and to a prelinguistic state. Warhol, on the contrary, represented capitalist market forces. He stressed language-like iconographic elements as commodities, without any belief in a higher truth value they might possess. He treated them as empty signifiers, mediated by continual irony. Unlike Siegfried, he knew human language, but knew it as a system of lies. Beuys self-consciously stood for the idea of truth, Warhol just as self-consciously for the idea of falsehood. Beuys came from a deep and ancient civilisation, Warhol from a more superficial, or at least more recent society without deep roots in tradition.

In their rejection of painterly passion these two artists represented the same moment, but their responses to that moment, characteristically, went in different directions. When Modernism lost credibility in the generation following the Second World War, two options offered themselves. One was an often sentimental desire to revive pre-Modern (and supposedly pre-patriarchal) forms and moods of culture. This was the tendency of the Flower Child movement, with which Beuys took pains to associate himself as a kind of elder statesman. The other was a colder-hearted rejection of Modernism for some unknown post-Modernist social form which could not really be predicted but did not seem to involve much sentimentality. Warhol can be seen as a seminal figure in this tendency, at least in the visual arts.

Their different responses to the moment of the end of Modernism were individual choices. But their responses can also be appreciated by regarding these two artists, for the moment, less as individual sensibilities than as representatives of different cultures. Beuys was from the more ancient culture, whose record goes back to Tacitus's *Germania*, a work of the second century AD. In that essay the Roman author criticises his own society in contrast to an idealised view of the Germanic tribal society of his period. The concept of the noble savage was articulated for the first time in this text, in reference to German culture. Beuys, falling in line with this ancient tradition which had been bolstered by the nineteenth-century preoccupation with Germanic folklore, chose, or at least made gestures toward, the pre-Modernist option. Many of his works, from the early beeswax sculptures of the late 1950s to later works such as 'Aktion im Moor' (Bog Action), 1971, 'The Pack', 1969 (Staatliche Museen, Kassel, Neue Galerie), and others, suggested that a retreat from civilisation was the only recourse. In 'Aktion im Moor' (Bog Action) Beuys ran into an Irish peat bog, sinking deeper and deeper into the swamp until he disappeared completely, leaving only his trademark fedora floating on the surface. The message is: Sink beneath civilisation; return into nature and the unconscious as into a cleaner and realer realm. In 'The Pack', one-person snow sleds, each equipped with a felt blanket, a lump of animal fat, and a flashlight, stream out of the rear hatch of a Volkswagen bus. The message, again, is: Get out of civilisation fast; head for the wilderness; sink yourself into its depths of unconsciousness and be redeemed by them. Many other works mime the shamanic ability to infiltrate nature and occupy it from within.

Warhol, on the other hand, embraced or at least acknowledged the decadence of civilisation as if without alternative. The dollar bill, the electric chair, the car wreck, and the Hollywood icon are simply what we have to work with. Beuys's desire to return to a natural state is countered by Warhol's famous response, in an interview, to the question, 'What do you want?': 'I want to be a machine.' Both of these approaches could be called post-Modernist in that they assumed a rejection of Modernism, but spiritually they went in opposite directions.

The relationship between art and spirituality has been a troubled topic for a generation or so. When, in the eighteenth century, secularism gained the upper hand in European high culture, the de-Christianisation of Europe was buffered, as Matthew Arnold remarked, by the creation of the cult of art and poetry. The Romantic era was underway. Art came to be associated with the idea

of the quest for the Grail. As the German Romantic poet Friedrich Schiller put it, the artist or poet was essentially a freed being; he already existed partly in the future and was engaged in dragging the present toward it. The artist's intuitions were not merely personal caprice, but communal involvements that would hasten history on its path toward its culmination. This gigantic role was the heavy burden that the Abstract Expressionists inherited. It seems to have been a devastating burden that few of them lived through safely.

In the generation after the Abstract Expressionists various revisions came into play. In the United States, the first exhibitions of Pop art, in 1962 and 1963, mocked the metaphysical pretension that had surrounded art for centuries. In Europe, similar iconoclastic events were happening, in France among the *Nouveaux Réalistes*, in Germany among the artists of the Zero Group and, subsequently, among the international Fluxus movement.

But there was a difference. The American practitioners of post-metaphysical art were solidly centred around the theme of degradation. Acknowledgement of the market, and of desire in itself as the fungible commodity, the blank cheque underlying all exchange value, led to a mixing of high and low, elite and popular, spiritual and material. In Europe it was less easy to let go of the spiritual heritage. A commitment to the Kantian-Hegelian type of meaning remains widely in place.

As the art-historiographic web has unwound itself in the last generation, Beuys (for Europe) and Warhol (for America) have become the principal symbols of differing approaches to the relationship between art and spirituality. Beuys remained committed to the idea of the spiritual in art, and Warhol was uncompromisingly against it from the beginning. Beuys has come to represent a celebration of a deep pre-Modernist tradition of Old European spirituality. Warhol seems to celebrate the shallower tradition of American capitalist commodification. Yet both were engaged, from different angles, in the project of dismantling the Kantian, formalist heritage.

For Beuys the way to regain spirituality was embodied in his gestures of regressing into pre-Modernist forms of life, thought, and action. He was moved by a feeling similar – whether or not there was actual influence – to Theodor Adorno's pronouncement that 'to write poetry after Auschwitz is obscene'. Extending this dictum to the visual arts meant that the making of pretty paintings was obscene. Beuys set out to find ways to make art after Auschwitz which acknowledged it honestly and thus were not obscene. Still, he was not naked and direct about it, but dealt in parables and suggestions.

For Warhol, however, the project of writing poetry – or making pretty pictures in the old sense – seemed obscene absolutely, at any time and in any place. Warhol characteristically accepted the war, the Holocaust, all the horrors of Late Modernism, with equanimity. The 'Double Silver Disaster', 1963 (cat. 279, p. 198), with the electric chair ironically elevated as the throne of heaven, is a sign of a deep cynicism which Beuys did not share. Beuys's answer to the 'Double Silver Disaster' was articulated repeatedly in his regression works. His empty felt suits ('Filzanzug', 1970 (cat. 82)) suggest that the problems of recent civilisation will require a reconceived humanity to resolve them.

Beuys and Warhol at dinner
Naples, April 9, 1980
Contact sheet
© Andy Warhol Foundation, Inc./DACS

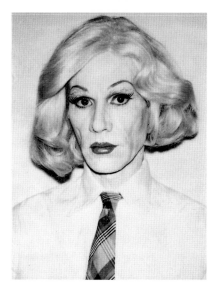

**Andy Warhol
'Self Portrait in Drag',
1981–2
Polaroid Polacolor
print**
© The Andy Warhol
Foundation, Inc/DACS

Beuys's blackboard works (such as '3 Tafeln', 1978 (cat. 90–2, p. 62)) point to the idea of the artist as a teacher who can suggest a direction toward this new humanity. They embody a desire to teach, which implies a hunch that salvation is somehow still obtainable. Even though they often appear to have been thrown about on the floor, as if the class had ended in failure – or perhaps had culminated in the dissolution of the old ways into a fruitful chaos – still the urge to correct and improve is there. Warhol had no such urge. In fact, he seemed to take a perverse glee in the acknowledgement of the horror of modern life. While Beuys devoutly desired some resolution to the horror, Warhol celebrated it coldly and casually, as if it were all, after all, that could have been expected of the human species. There is a reversed electrical charge in their relationships to the idea of spirituality. Beuys saw in it ennoblement, Warhol degradation.

A bottom line about an artist's intentionality is the list of materials he or she uses. Looking at the materials these two artists employed, the usual inverted inflections arise. Warhol showed no sentimental commitment to materials. His most characteristic mode, the silkscreen, was ideologically significant only through its introduction of photography into the painting process – its dilution of the cult of the touch. Beuys's materials, however, were ideologically saturated. Many of them were based on a sense of antiquity or prim-evalness. In one direction, this led into the theme of regression into nature – the use of natural substances such as beeswax and animal fat, or even of living animals, as in 'Titus/Iphigenie', 1969, in which Beuys performed on stage with a white horse, and 'Coyote: "I like America and America likes Me"', 1974, in which he lived in a gallery space with a coyote for several days. The choice of materials was an aspect of Beuys's orientation towards pre-Modernism and his sense that a close identification with nature might be redemptive in terms of the overwhelming problems of history and civilisation. It is in this respect that it has often been said that Beuys adopted the role of shaman in relation to his culture, attempting to heal it of its grievous ills through ritual and reidentification with the ground of being understood as natural force. The many fat, felt and battery works express this urge.

Beuys's apparent identification with the shamanic role extended beyond general themes to detailed articulations. From early on he adopted, or was directed toward, a particular shamanic ally – a non-human species with which he felt a bond through which natural power might flow. The first was the honey bee, adopted in 'Queen Bee', a series of sculptures begun in 1947, short-ly after his return from the Second World War. Subsequently, he extended and focused his sha-manic realm, emphasising over a long period the hare and the stag as his animal allies. In the famous performance, 'wie man dem Hasen die Bilder erklärt' (How to Explain Pictures to a Dead Hare), 1965, he presumed to speak the language of the animal ally – as Siegfried had known the language of birds, and as shamans the world over inaugurate their performances by summoning their bird or animal allies in the allies' own language. Beuys's performances with the white horse and the coyote were related incidents of shamanic communication with the non-human.

A famous biographical incident also contributed to Beuys's selection of motifs and materials. In 1943, while a pilot in the Luftwaffe, he was shot down over the Crimea in winter and, accord-ing to his account, almost froze to death. Again according to his account, he was taken in by a clan of semi-primitive Tartar tribespeople who restored him to health, at the same time showing him the way out of civilisation into nature. Stripping him, covering his body with animal fat, and wrapping him mummy-like in a felt material, they made of him a kind of human battery which could generate, contain, and reuse its own heat and energy. The truth about this episode and Beuys's account of it have been called into question but in any case this saga became a founda-tion of his work for decades, beginning in 1964 with 'Fat Chair', (Ströher Collection, Hessisches Landesmuseum, Darmstadt). Felt and fat became his signature materials, informing works such as

'The Pack', 1969 (sleds equipped with felt and fat), 'Der Chef The Chief' (in which he himself was rolled up in felt), and 'Iphigenie' (in which he chewed lumps of animal fat and spat them onto the stage). His corner-sited sculptures based on the process of filtration (which circumvented the problem of the ideological pollution of both the wall and the floor) featured fat and felt, as did numerous other works based on ideas of filtration and battery accumulation. Beuys's massive œuvre, too large to be described in detail in a single essay, was shot through with the conflated themes of the near-death experience, the salvation through tribal culture, and the shamanic identification with animal species and substances.

By contrast, Warhol conspicuously did not use natural substances as art materials. The principal exception – the 'Oxidation Paintings', 1978 onwards (cat. 300), made by urinating on canvases covered with metal paint which would then rust – was not so much an appeal to redemption through nature as a gesture of contempt for the tradition of Action Painting, in which Pollock and others spoke of the paint flung on the canvas as virtually a bodily fluid wrenched out of themselves in the creative process. Warhol's materials were mostly traditional art materials: photography, silkscreen, and overpainting. He usually avoided oil on canvas for much the same reasons as Beuys; but his silkscreen works are nevertheless rectangles of images hung on the wall, like easel paintings or advertisements. Rather than totally avoiding the association, as Beuys had tried to do through his practice of sculpture and performance, Warhol infiltrated it and attempted to rob it of legitimacy from within.

In Warhol's career there was also an iconic moment which directed his work for decades – which might be suggested as an analogue of Beuys's fat and felt salvation story. When Warhol was a window decorator at Bonwit Teller in New York City, employing silkscreen imagery among other tools of the trade, he expressed to a friend the desire to become a legitimate artist, but said he didn't know what to make. According to the legend, his friend replied, 'Paint something you like'. So he painted a United States dollar, or rather, silkscreened it. As usual, the gesture was doubly pregnant with meaning. On the one hand, it has come to be seen as an early critique of capitalist commodification of the artwork. On the other, it was a simple homage to money and the power it brings – an icon of unmediated desire. It shows Warhol's peculiar dedication to truth, and his matter-of-fact acknowledgement of it.

This primal Warholian work involved a disavowal of all spiritual claims about the nature of the art experience, both the Modern and the pre-Modern. It made no obeisance to either metaphysics or nature, but insisted on the sole reality of culture, no matter how corrupt and degenerate it might seem. In fact, it altogether disavowed ideas such as corruption and degeneracy in favour of a simple acceptance of what might be called the facts of life.

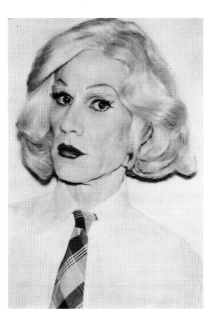

Andy Warhol
'Self Portrait in Drag',
1981–2
Unique Polaroid
photograph
Collection Anthony
d'Offay Gallery,
London
© The Andy Warhol
Foundation, Inc/DACS

Granting the differences between their cultures, Warhol, like Beuys, has come to be regarded as a shamanistic figure. But these cultural differences are very important. Warhol's shaman-like, or iconic, leadership conformed to an American (not Native American) pattern. His tribe was that of the United States, and he was sensing the future of his tribe under a new fetish. Both he and Beuys had somewhat outlandish faked appearances and personas which mimicked the outrageous behavior of shamans – the profession which the historian of religion Mircea Eliade has called an essentially psychotic role.

Indeed, much of Warhol's subsequent work can be seen as the presentation of new fetish objects to the other members of his tribe, from the Campbell's soup cans to the Brillo boxes to the silkscreened portraits of iconic figures. With his weird retinue of sexually ambiguous exhibitionists, Warhol travelled through the American art world like a stoned, spaced-out Dionysus. In *Bacchae*, the ancient Greek play by Euripides, when Dionysus walked by a jail the roof blew off and the walls fell out, releasing the prisoners. There could be no confinement of anyone within the field of his aura. In a limited

sense Warhol's was a parallel role. He freed American art from its bondage to the metaphysical imperatives of the Kantian tradition.

As always, the nature of the shamanic roles played by these two avatars was very different in intention. Beuys sought to lead a way out of civilisation and its discontents; by his unimpassioned acceptance Warhol stressed them as the only available options. Both artists acted out partially didactic roles – indicated in Beuys's case most obviously by the blackboard works, and in Warhol's by his leading of American culture through a review of everything that it already knew, as if to see it for the first time. But the lessons they were inculcating were very different.

Finally, in analysing this relationship, one has to acknowledge the fact that Germany and the United States have fought on opposing sides in two world wars during this century. In the massively influential œuvres of Beuys and Warhol one can glimpse the traces of the foundational causes of these conflicts. Beuys's œuvre, however enlightened its intentions, re-embodied the atavistic blood-and-soil tradition going back to Tacitus's *Germania*. Warhol's œuvre, however anti-enlightenment its intention, embodies the stark reality of the enlightenment's entanglement with capitalism and its system of alienation. While parallel figures – each semi-regal, really, in his own tradition – they approached reality from opposite directions, one pointing hopefully backward, the other pointing bleakly forward. At the intersection of their work a precise point might be found that would define their moment of the Western world.

GEORG BASELITZ

JOSEPH BEUYS

ANSELM KIEFER

IMI KNOEBEL

BLINKY PALERMO

A.R. PENCK

SIGMAR POLKE

GERHARD RICHTER

ROSEMARIE TROCKEL

GEORG BASELITZ

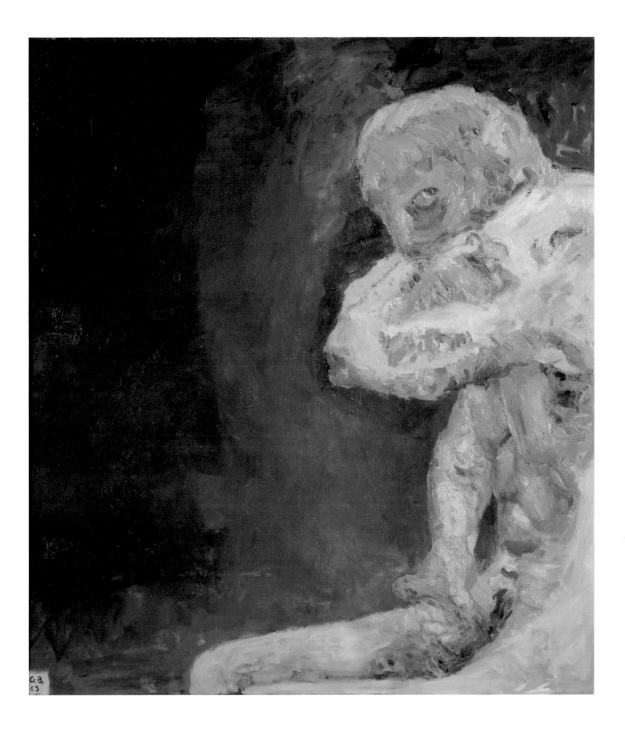

GEORG BASELITZ
Hommage à Wrubel –
Michail Wrubel – 1911
1963
cat. 15

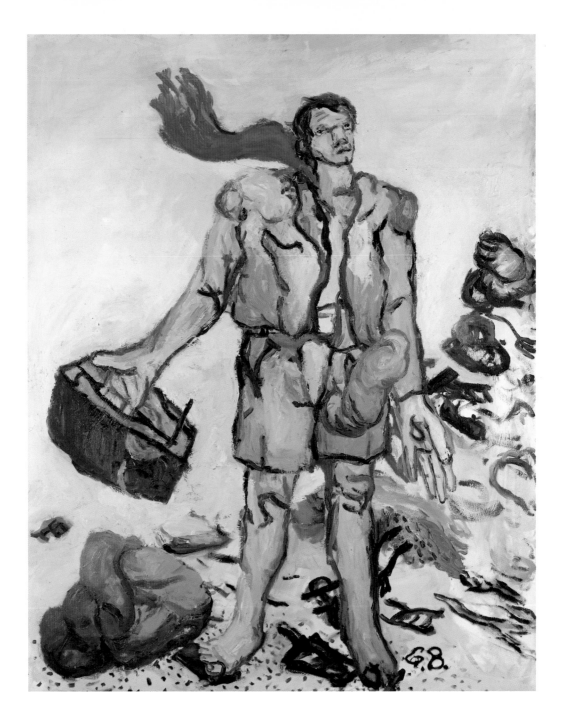

GEORG BASELITZ
Der Neue Typ
The New Type
1965
cat. 18

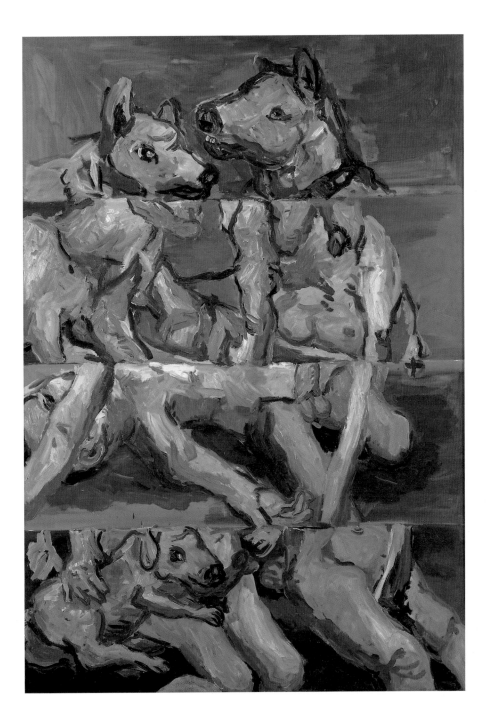

GEORG BASELITZ
Vier Streifen
(G. Antonin)
Four Stripes
(G. Antonin)
1966
cat. 22

GEORG BASELITZ
Orangenesser III
Orange Eater III
1981
cat. 24

GEORG BASELITZ
**Mann auf rotem
Kopfkissen**
Man on Red Pillow
1982
cat. 25

GEORG BASELITZ
Peitschenfrau
Whip Woman
1964
cat. 17

**Ohne Titel
(Ein neuer Typ)**
Untitled
(A New Type)
1965
cat. 19

GEORG BASELITZ
Große Nacht
Big Night
1962
cat. 13

Soldat
Soldier
1965
cat. 20

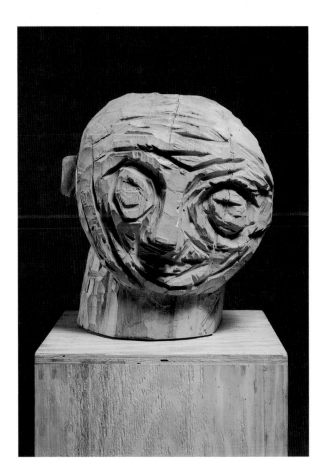

GEORG BASELITZ
Untitled
1982
cat. 26

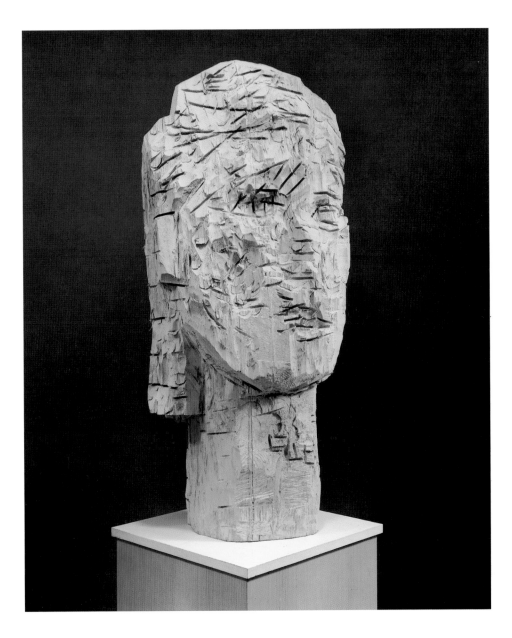

GEORG BASELITZ
**Dresdner Frauen –
Karla**
Women of Dresden –
Karla
1990
cat. 28

JOSEPH BEUYS

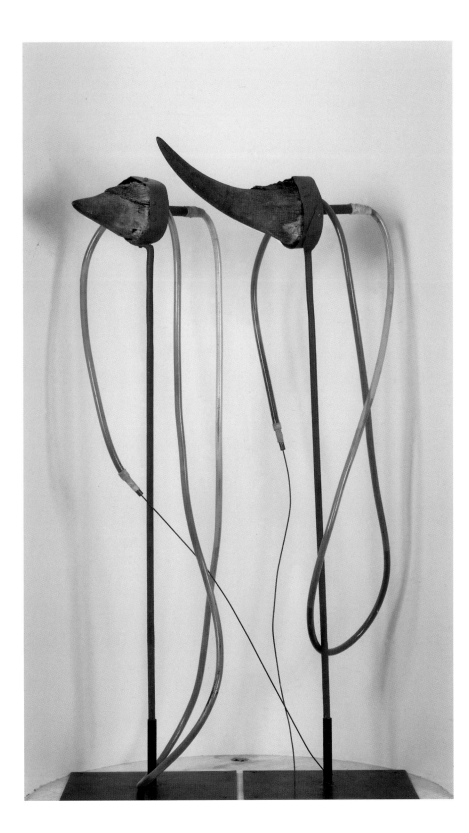

JOSEPH BEUYS
Plateau Central
1964
cat. 74

JOSEPH BEUYS
Sonde
Probe
1964
cat. 76

JOSEPH BEUYS
Erdtelephon
Earth Telephone
1968
cat. 80

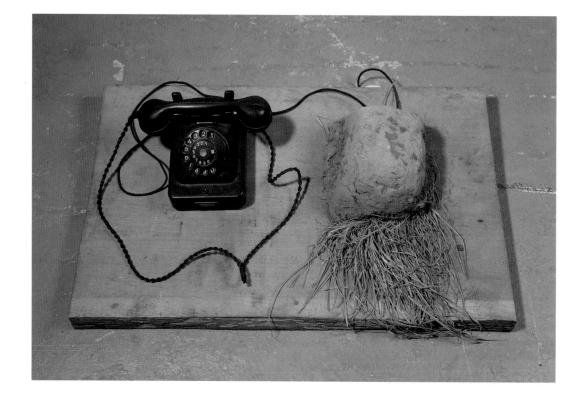

JOSEPH BEUYS
**Aus dem
Maschinenraum,
Anhänger**
From the
Machineroom, Trailer
1977
cat. 89

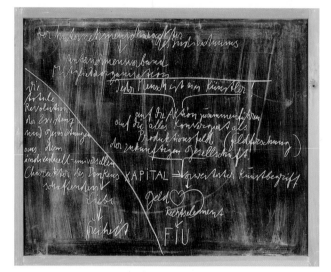

JOSEPH BEUYS
**Tafel I (Geist – Recht
– Wirtschaft)**
Board I (Spirit – Law
– Economics)
1978
cat. 90

**Tafel II
(Jeder Mensch
ist ein Künstler)**
Board II (Everyone
is an Artist)
1978
cat. 91

**Tafel III
(Kapital = Kunst)**
Board III
(Capital = Art)
1978
cat. 92

JOSEPH BEUYS
Schwan mit Ei
Swan with Egg
1983
cat. 96

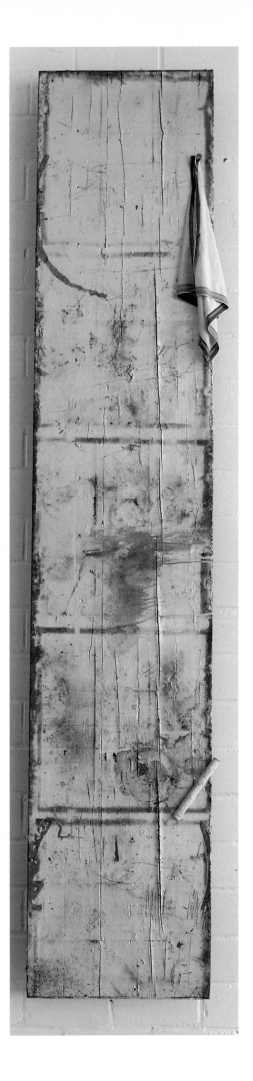

JOSEPH BEUYS
Eiszeit
Ice Age
1983
cat. 94

JOSEPH BEUYS
**Gefängnis
(Kabir + Daktyl)**
Prison
(Kabir + Daktyl)
1983
cat. 95

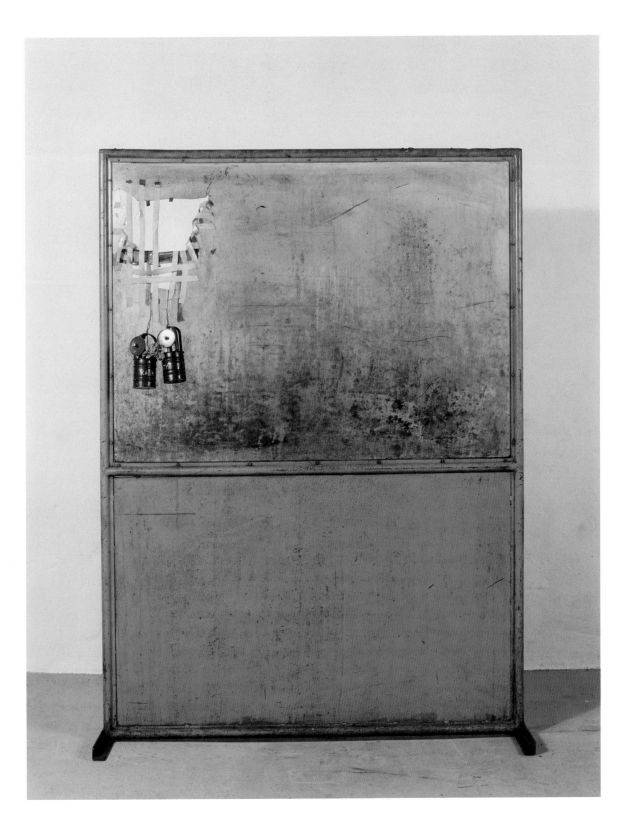

JOSEPH BEUYS
**Im Haus
des Schamanen**
In the House of the
Shaman
1954
cat. 36

JOSEPH BEUYS
Schlafender Kopf
über Induktor
Sleeping Head over
Inductor
1954
cat. 38

JOSEPH BEUYS
Toter Elch auf
Urschlitten
Dead Elk on Ur-Sled
1955
cat. 41

Elch mit Sonne
Elk with Sun
1957
cat. 48

JOSEPH BEUYS
**Aus dem Leben
der Bienen**
From the Life
of the Bees
1956
cat. 43

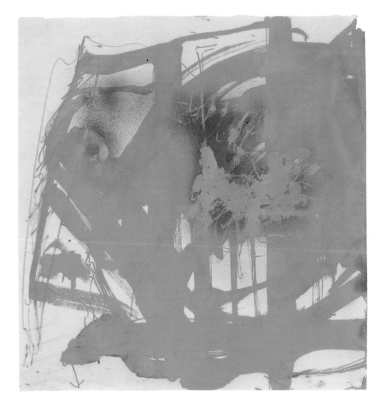

JOSEPH BEUYS
Brutkasten (solar)
Incubator (solar)
1957/58
cat. 51

Entladung
Unloading
1956
cat. 45

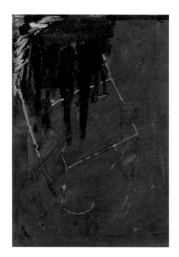

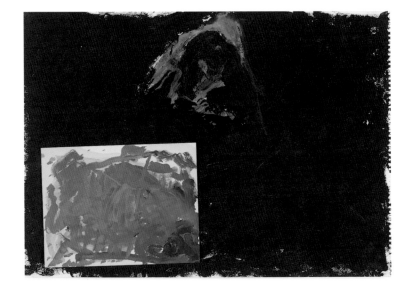

JOSEPH BEUYS
Urschlitten
Ur-Sled
1958
cat. 56

Gulo Borealis
1959/60
cat. 63

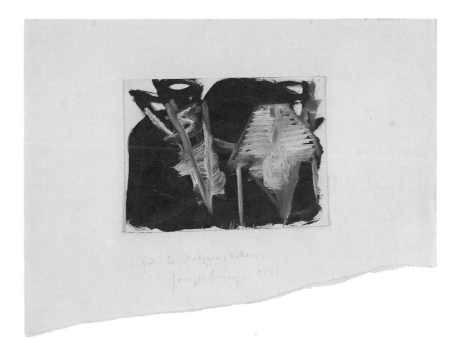

JOSEPH BEUYS
Für 2 Holzplastiken
For 2 Wooden
Sculptures
1958
cat. 53

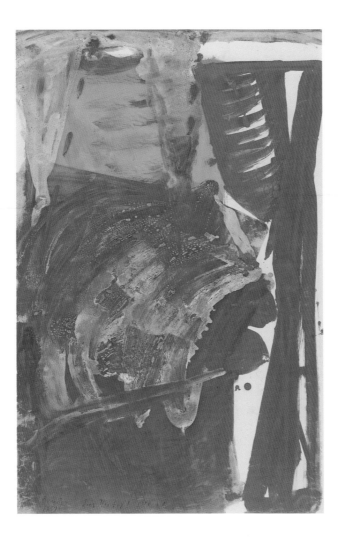

JOSEPH BEUYS
Ohne Titel
(für Hubert Troost)
Untitled
(for Hubert Troost)
1959
cat. 58

JOSEPH BEUYS
Steinbock
Capricorn
1959
cat. 61

JOSEPH BEUYS
**Strahlende Materie,
zwei aufgelegte
Polstäbe**
Radiating Matter,
Two Imposed Rods
1959
cat. 62

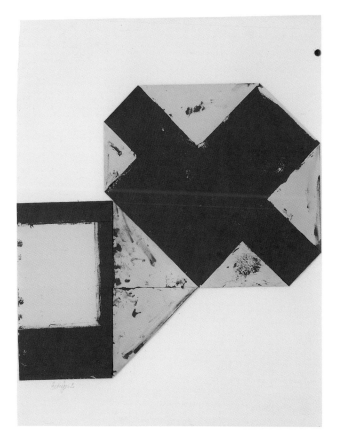

JOSEPH BEUYS
Ohne Titel
(Braunkreuz)
Untitled (Braunkreuz)
1961–2
cat. 71

JOSEPH BEUYS
Ohne Titel (Hörner)
Untitled (Horns)
1961
cat. 68

**Wassermann
im Gebirge**
Aquarius in the
Mountains
1961
cat. 70

**Ohne Titel (Schwan
und Körperteile)**
Untitled (Swan and
Body Parts)
1980–4
cat. 93

ANSELM KIEFER

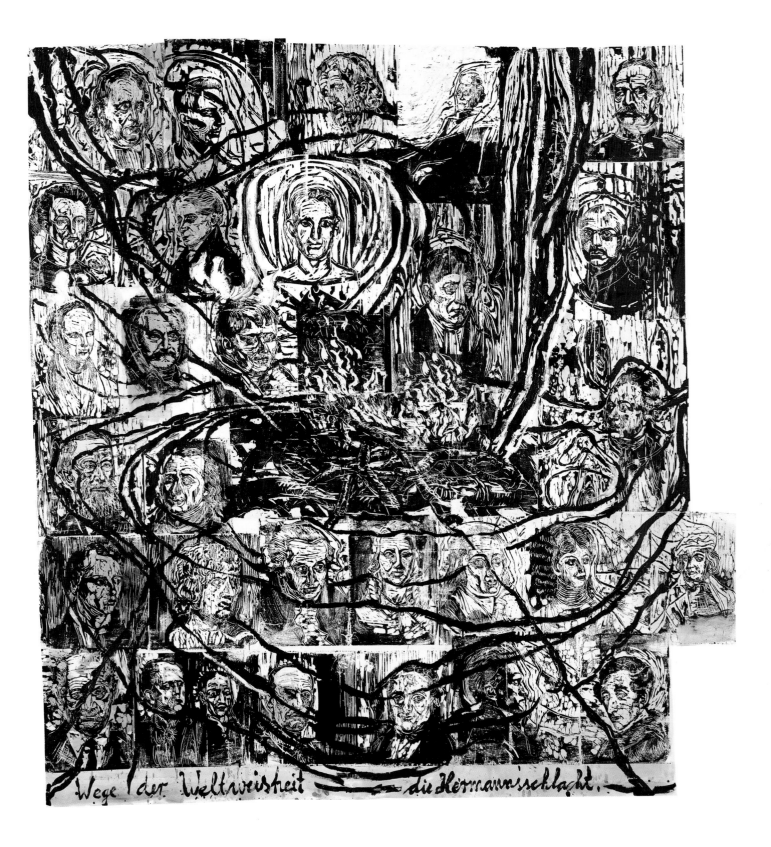

ANSELM KIEFER
**Wege der Weltweis-
heit – die Hermanns-
schlacht**
Ways of Worldly
Wisdom – Arminius'
Battle
1978
cat. 125

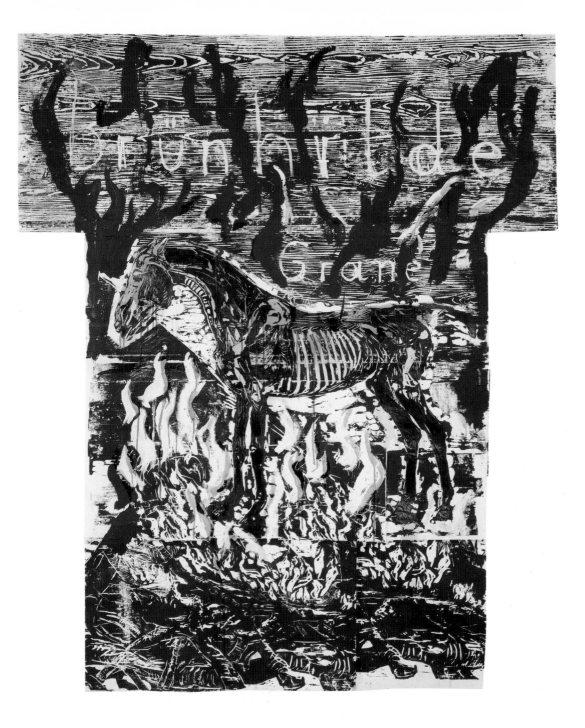

ANSELM KIEFER
Brünhilde – Grane
1978
cat. 124

ANSELM KIEFER
Der Rhein
The Rhine
1980–2
cat. 127

ANSELM KIEFER
**Dem unbekannten
Maler**
To the Unknown
Painter
1982
cat. 128

IMI KNOEBEL

IMI KNOEBEL
**Schwarzes Quadrat
auf Buffet**
Black Square on
Buffet
1984
cat.131

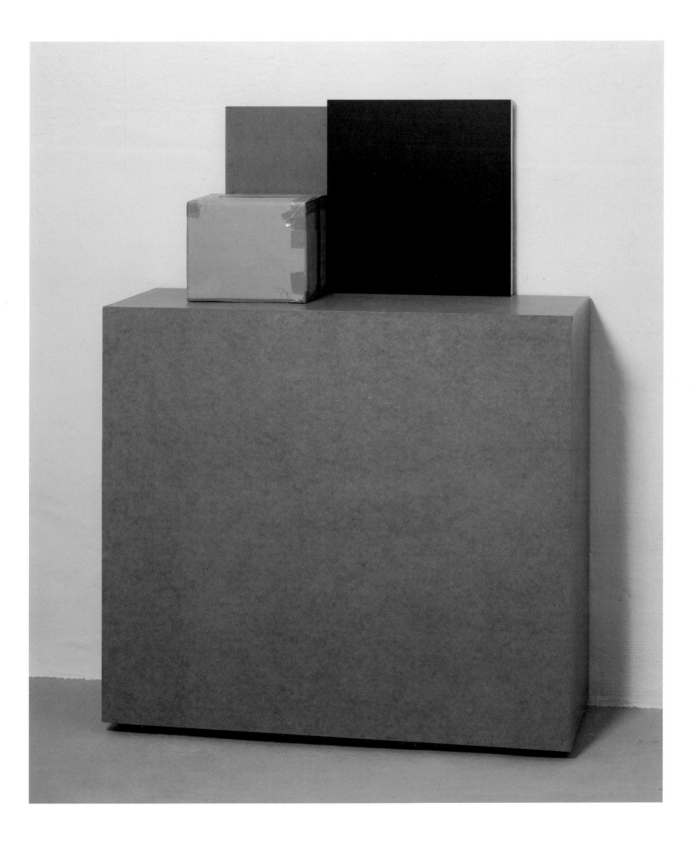

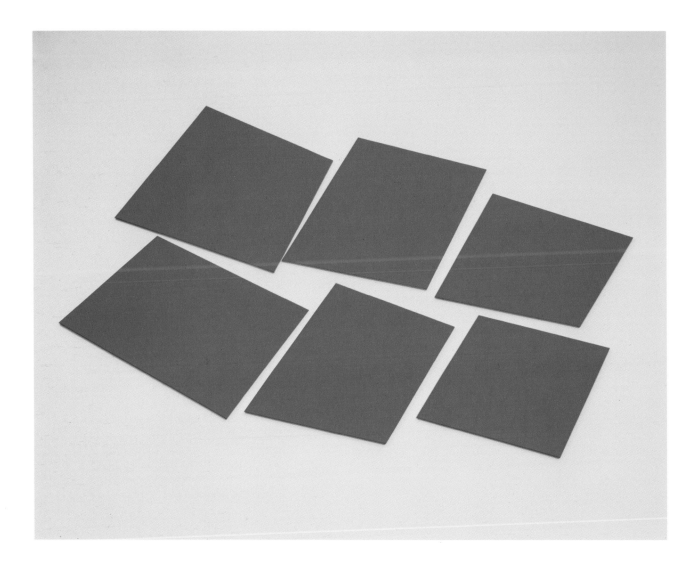

IMI KNOEBEL
Filipp
1975/84
cat. 129

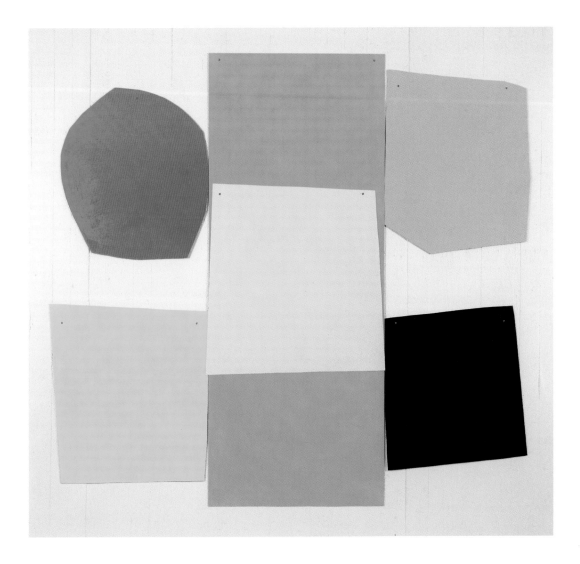

IMI KNOEBEL
**Fester Bester,
Bester Tester**
1980/91
cat. 130

BLINKY PALERMO

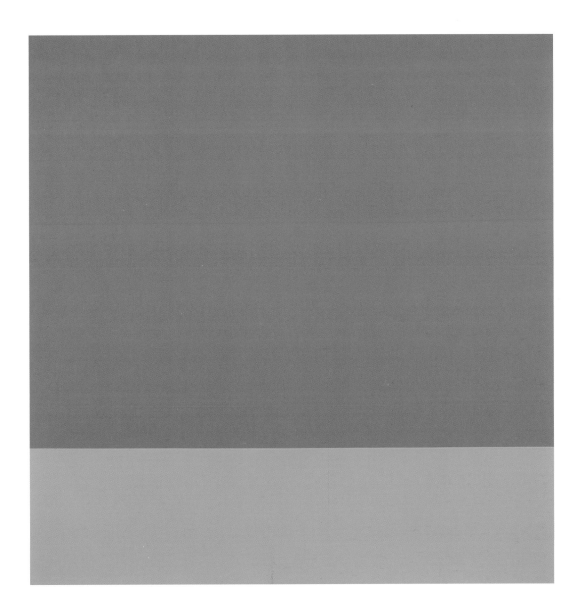

BLINKY PALERMO
Untitled
1967–9
cat.159

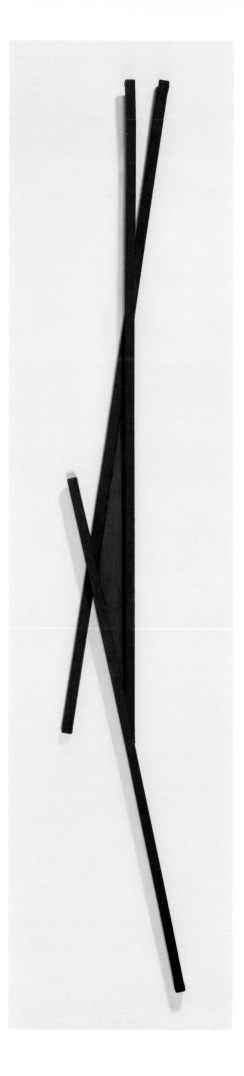

BLINKY PALERMO
Untitled
1967
cat. 158

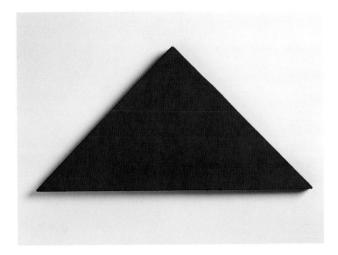

BLINKY PALERMO
Blaues Dreieck
Blue Triangle
1969
cat. 160-a

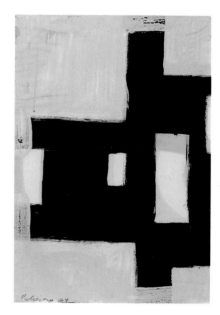

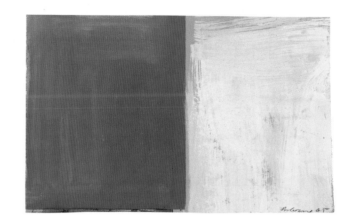

BLINKY PALERMO
Untitled
1964
cat. 155

Untitled
1965
cat. 157

BLINKY PALERMO
Untitled
1964
cat. 154

Untitled
1965
cat. 156

A.R. PENCK

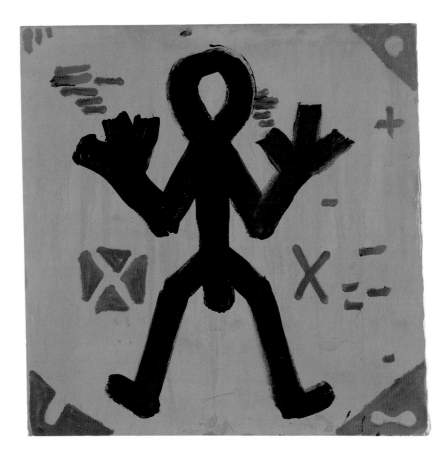

A.R. PENCK
Standard
1972
cat. 162

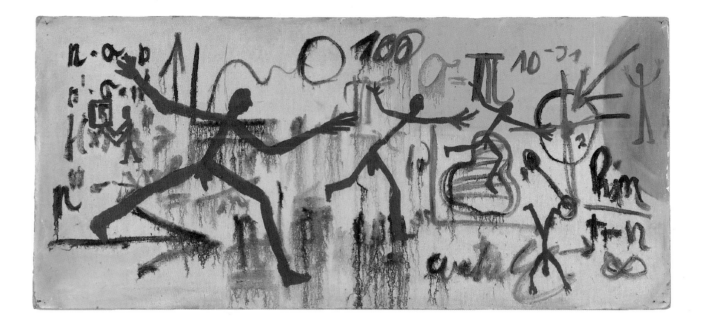

A.R. PENCK
**Komposition
(Übertritt: Ost/West)**
Composition
(Passage: East/West)
1968
cat. 161

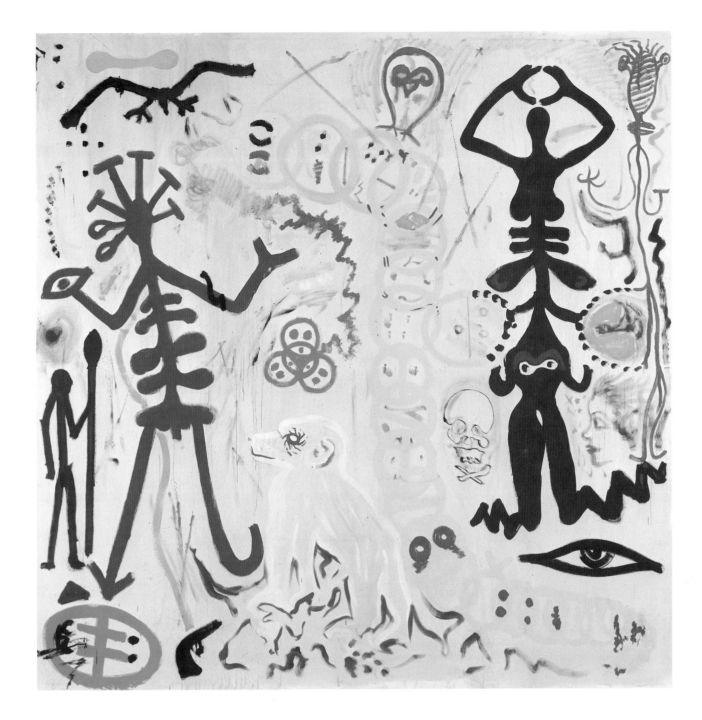

A.R. PENCK
N-Komplex
1976
cat. 163

SIGMAR POLKE

Höhere Wesen befahlen: rechte obere Ecke schwarz malen!

SIGMAR POLKE
Höhere Wesen befahlen: rechte obere Ecke schwarz malen!
Higher Powers Command: Paint the Right Hand Corner Black!
1969
cat. 217

SIGMAR POLKE
Würstchen
Sausages
1964
cat. 184

Moderne Kunst

SIGMAR POLKE
Moderne Kunst
Modern Art
1968
cat. 210

SIGMAR POLKE
5 Punkte
5 Dots
1964
cat. 174

SIGMAR POLKE
Freundinnen
Girlfriends
1965/66
cat. 191

SIGMAR POLKE
Profil
Profile
1968
cat. 214

SIGMAR POLKE
Sicherheitsverwahrung
Safekeeping
1978
cat. 223

SIGMAR POLKE
Hannibal mit seinen
Panzerelefanten
Hannibal with his
Armoured Elephants
1982
cat. 226

SIGMAR POLKE
Lingua Tertii Imperii
1983
cat. 227

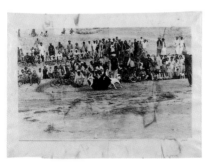

SIGMAR POLKE
Bärenkampf
Bear Fight
1974
cat. 221

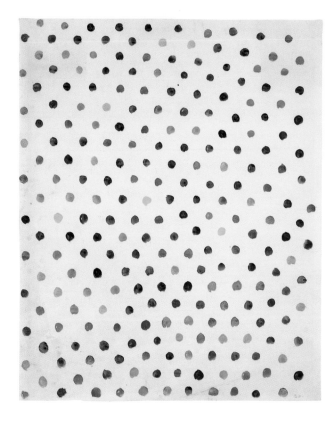

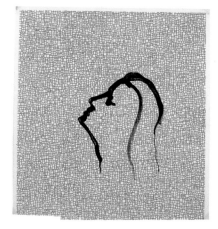

SIGMAR POLKE
Ohne Titel (Punkte)
Untitled (Dots)
1963
cat. 170

Gestricke Alpen
Knitted Alps
1963
cat. 166

Ohne Titel (Profil)
Untitled (Profile)
1965
cat. 190

SIGMAR POLKE
Für die Hausfrau
For the Housewife
1963
cat. 164

Warum nicht baden?
Why not bathe?
1964
cat. 182

Mehl in der Wurst
Flour in the Sausage
1965
cat. 187

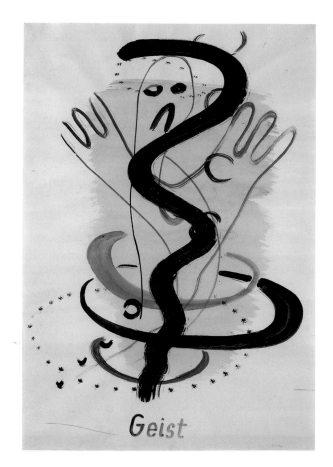

SIGMAR POLKE
Geist
Ghost
1966
cat. 193

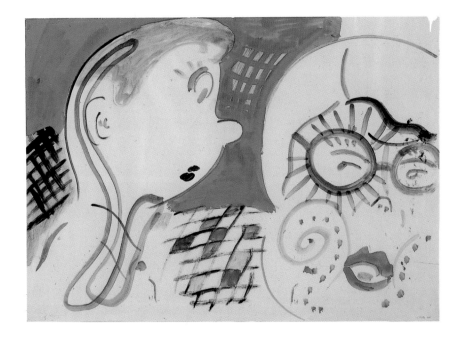

SIGMAR POLKE
**Ohne Titel (Kleiner
Kartoffelkopf)**
Untitled (Small
Potato Head)
1966
cat. 194

SIGMAR POLKE
Ohne Titel (Urlaub)
Untitled (Vacation)
1966
cat. 197

Ohne Titel (Libelle)
Untitled (Dragon-fly)
1966
cat. 198

**Ohne Titel
(Sternenhimmel)**
Untitled (Starry Sky)
1966
cat. 200

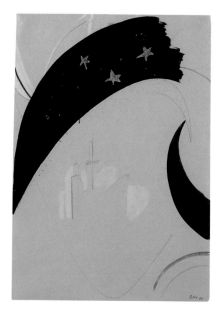

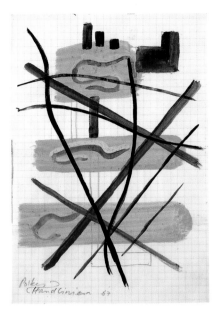

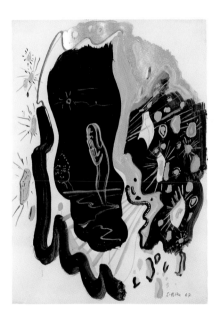

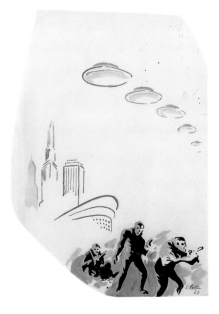

SIGMAR POLKE
Polkes Handlinien
Polke's Palm-lines
1967
cat. 207

**Ohne Titel
(Die Andacht)**
Untitled
(The Prayer)
1967
cat. 203

Ohne Titel (Ufos)
Untitled (UFOs)
1968
cat. 213

**Der Sternhimmel am
24.6. 24.00 Uhr zeigt
als Sternbild den
Namenszug
S. Polke**
The Starry Sky on
24 June 24.00 Hours
Shows a Constellation
in the Form of the
Name S. Polke
1969
cat. 216

SIGMAR POLKE
Untitled
1969
cat. 218

SIGMAR POLKE
Ohne Titel (Porträtist)
Untitled (Portraitist)
1979
cat. 225

GERHARD RICHTER

GERHARD RICHTER
Faltbarer Trockner
Folding Dryer
1962
cat. 229

GERHARD RICHTER
Phantom Abfangjäger
Phantom Interceptors
1964
cat. 230

GERHARD RICHTER
Schwimmerinnen
Swimmers
1965
cat. 231

GERHARD RICHTER
**Zwei Grau neben-
einander**
Two Greys Juxtaposed
1966
cat. 232

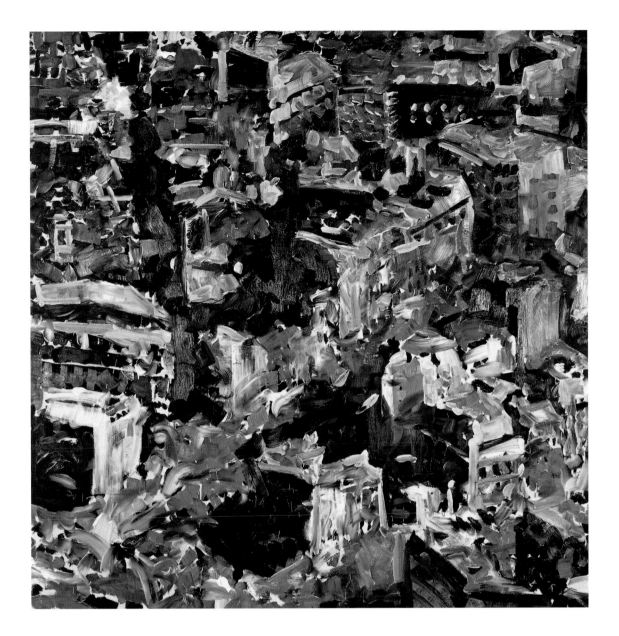

GERHARD RICHTER
Stadtbild Paris
Townscape Paris
1968
cat. 233

GERHARD RICHTER
Seestück
Sea Piece
1975
cat. 234

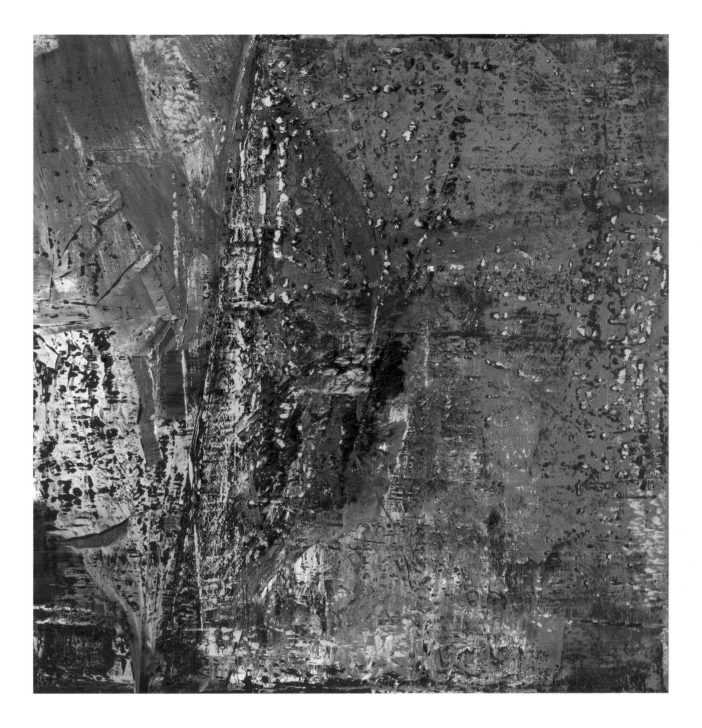

GERHARD RICHTER
Abstraktes Bild
Abstract Painting
1987
cat. 235

ROSEMARIE TROCKEL

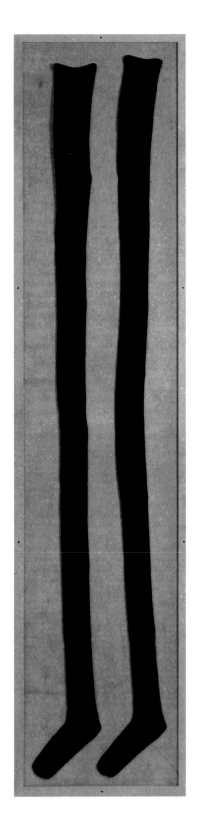

ROSEMARIE TROCKEL
Ohne Titel (Schwarze Endlosstrümpfe)
Untitled
(Black Endless Socks)
1987
cat. 241

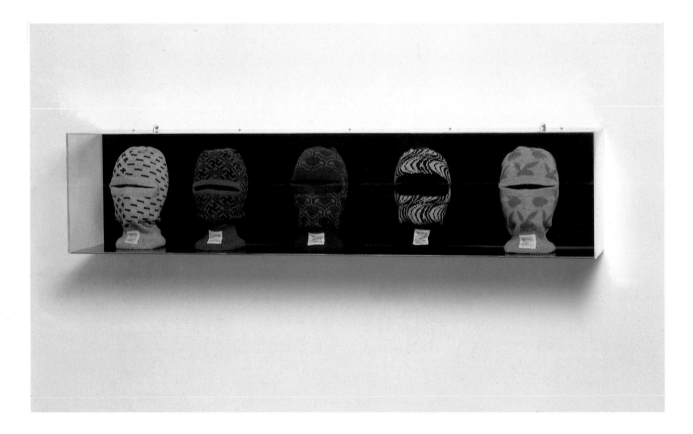

ROSEMARIE TROCKEL
Balaklava Box
1986–90
cat. 240

ROSEMARIE TROCKEL
Cogito, ergo sum
1988
cat. 242

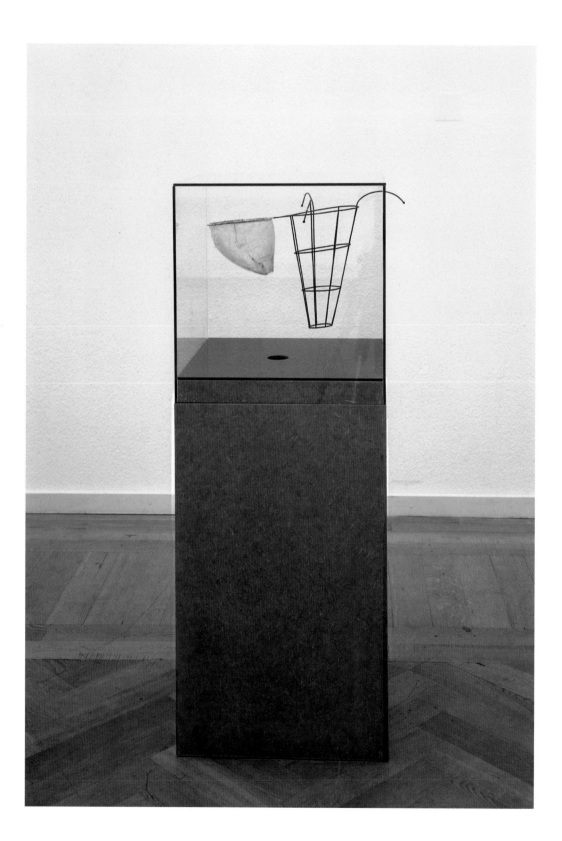

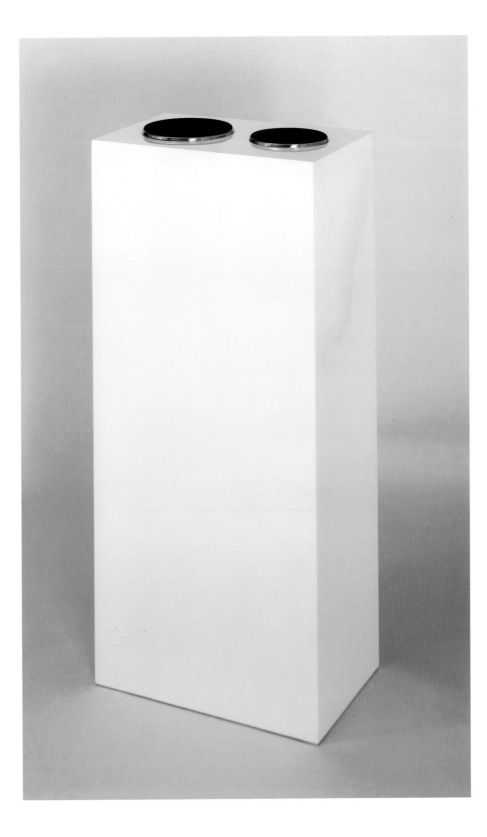

CARL ANDRE

RICHARD ARTSCHWAGER

JOHN CHAMBERLAIN

DAN FLAVIN

DONALD JUDD

ON KAWARA

BRUCE NAUMAN

FRANK STELLA

CY TWOMBLY

ANDY WARHOL

CARL ANDRE

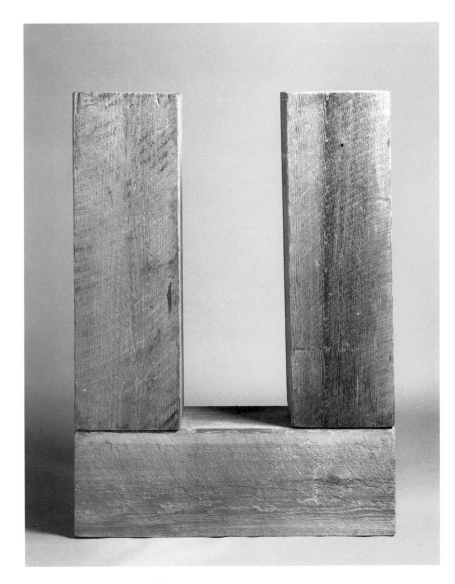

CARL ANDRE
Steel Row
1967
cat. 2

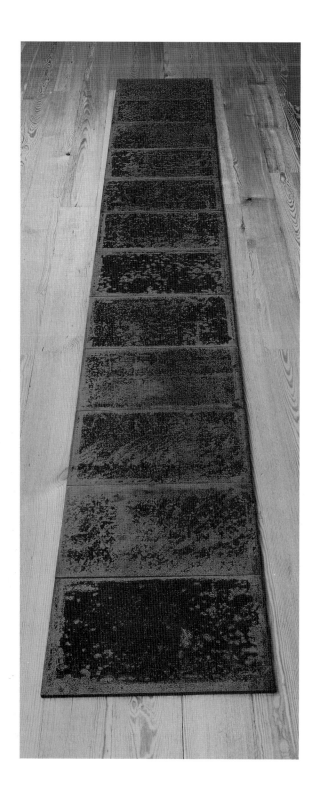

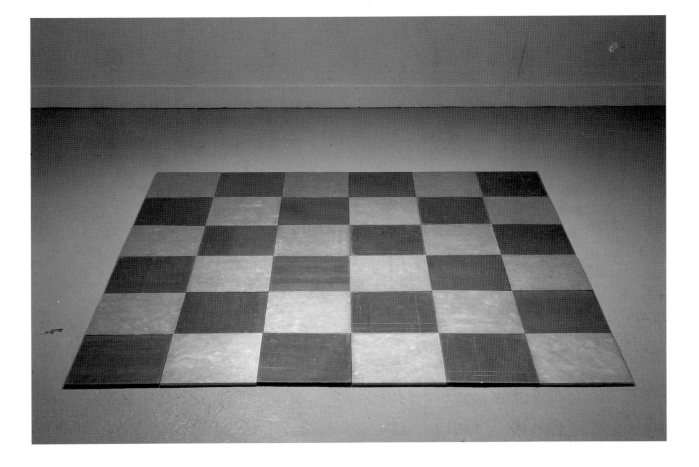

RICHARD ARTSCHWAGER

RICHARD
ARTSCHWAGER
**Tower III
(Confessional)**
1980
cat. 11

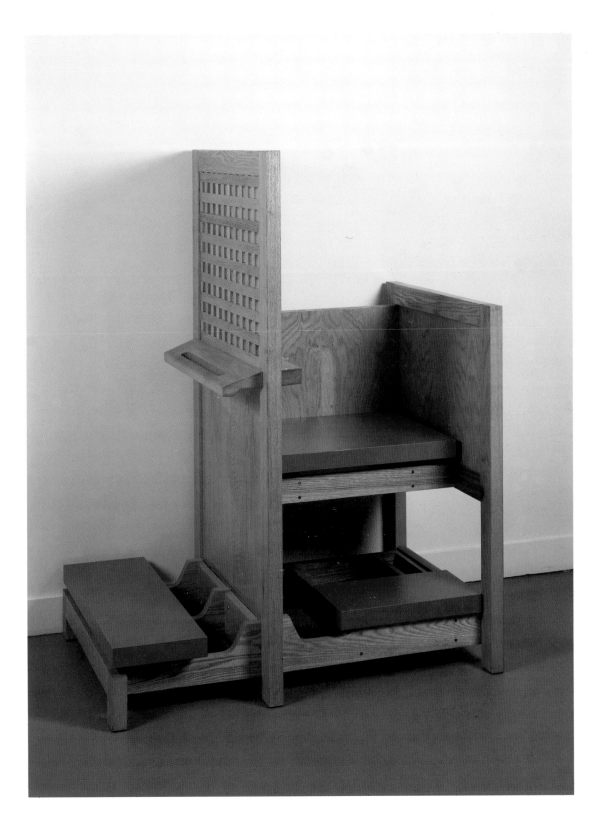

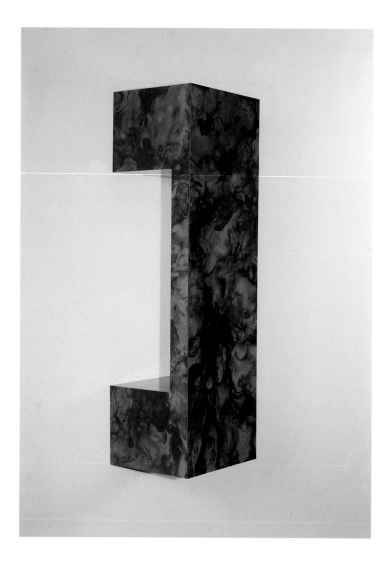

RICHARD
ARTSCHWAGER
Handle
1965
cat. 7

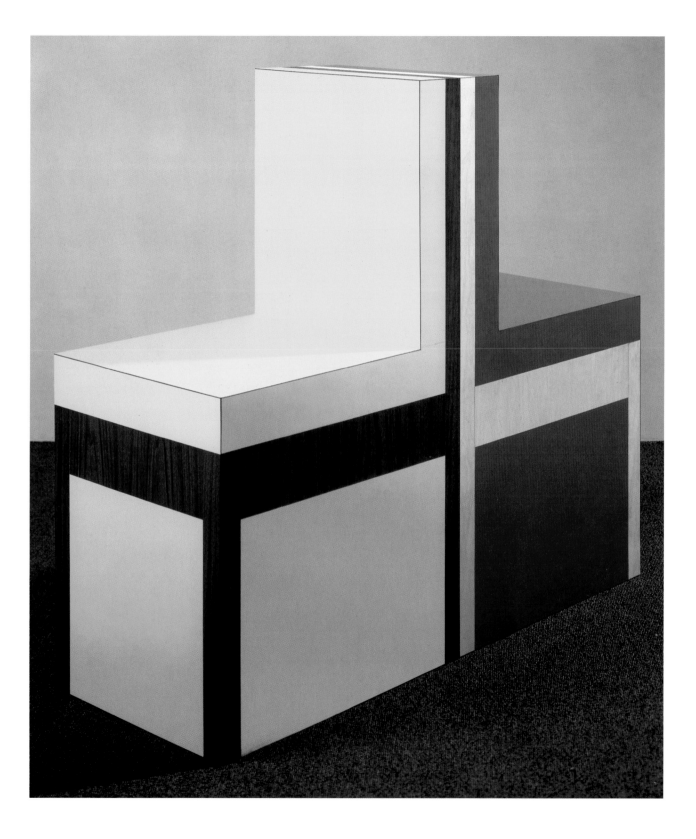

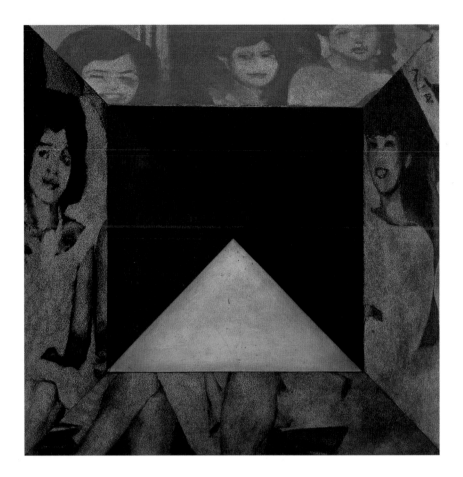

RICHARD
ARTSCHWAGER
Untitled (Girls)
1963–4
cat. 4

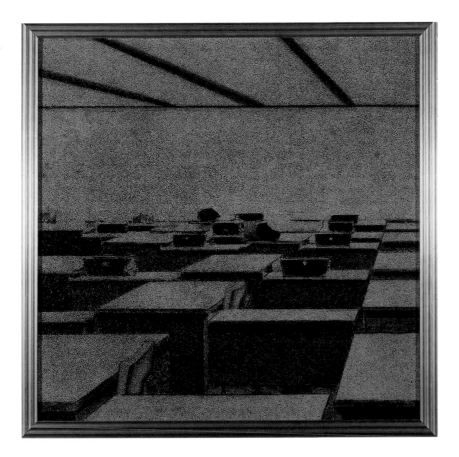

RICHARD
ARTSCHWAGER
Office Scene
1966
cat. 10

JOHN CHAMBERLAIN

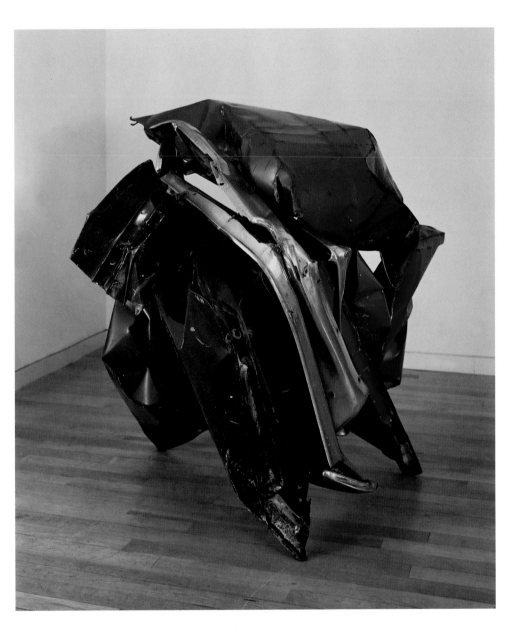

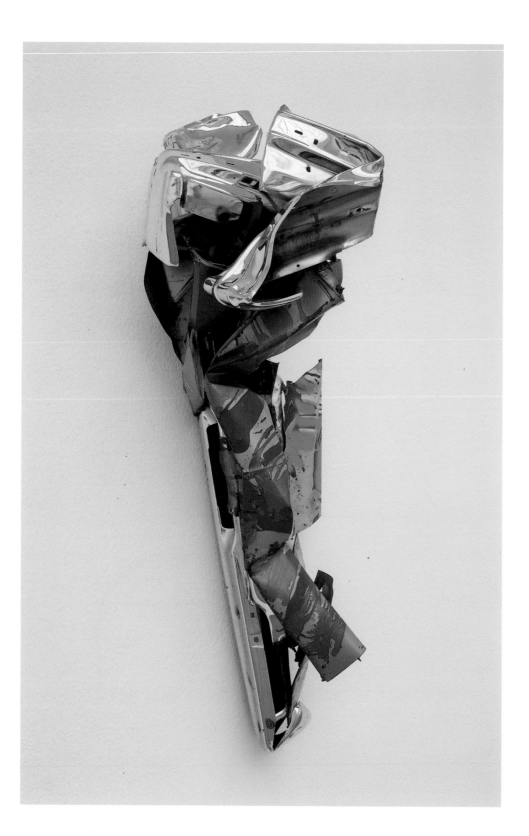

DAN FLAVIN

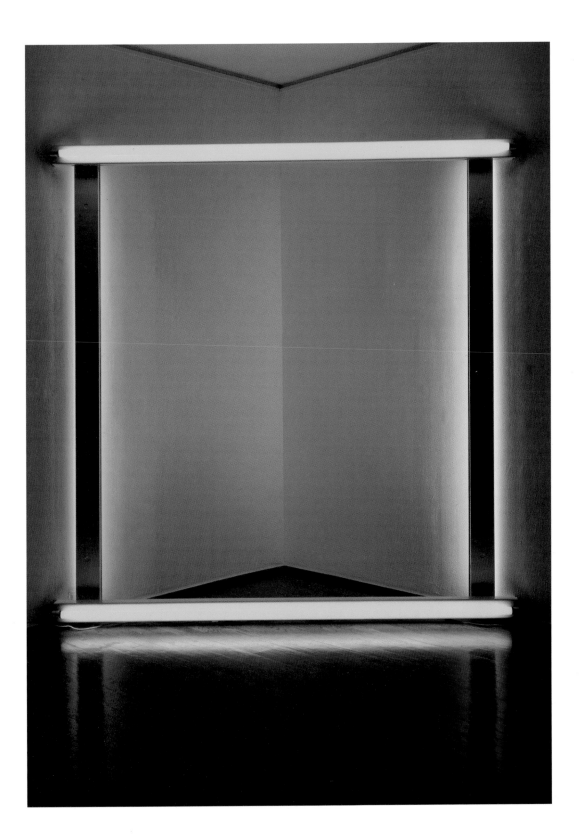

DONALD JUDD

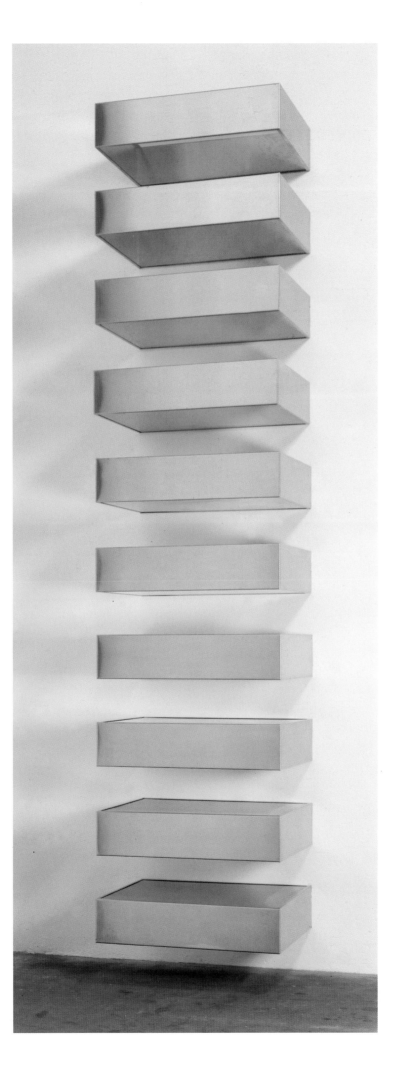

DONALD JUDD
Untitled
1968
cat. 114

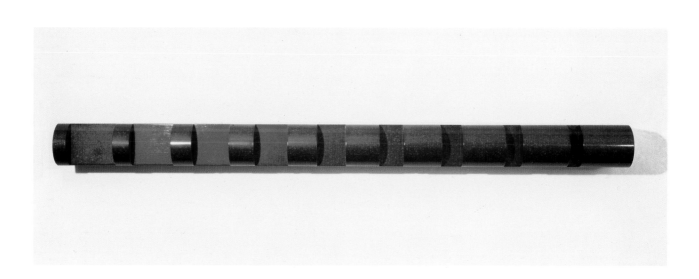

DONALD JUDD
Untitled
1965
cat. 112

154

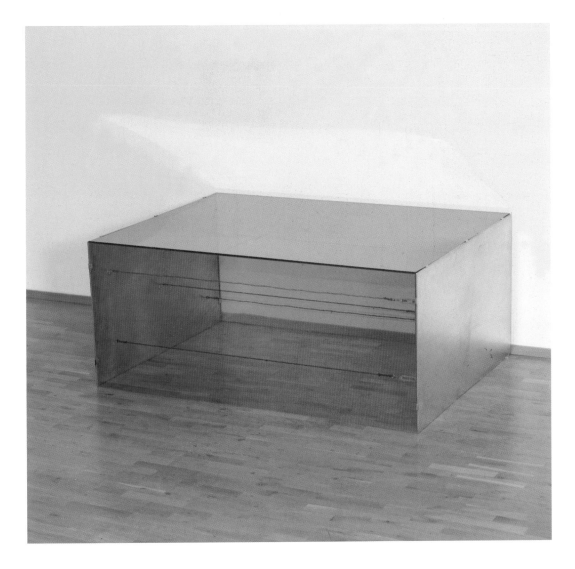

DONALD JUDD
Untitled
1989
cat. 116

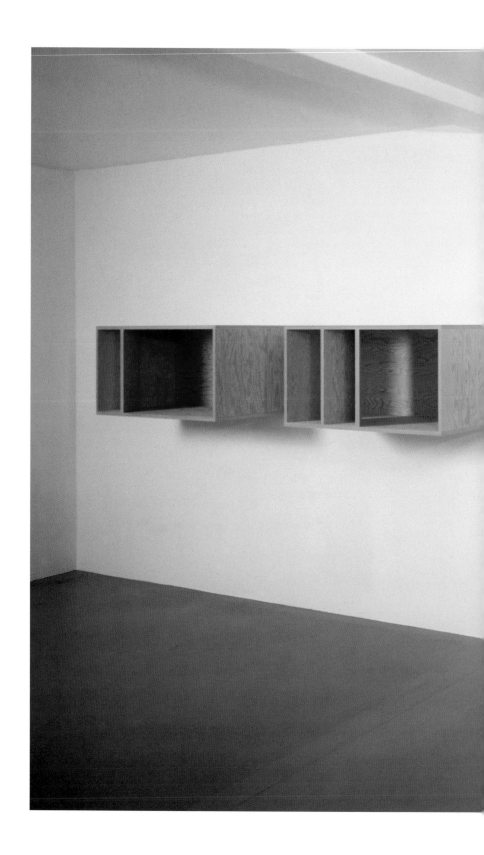

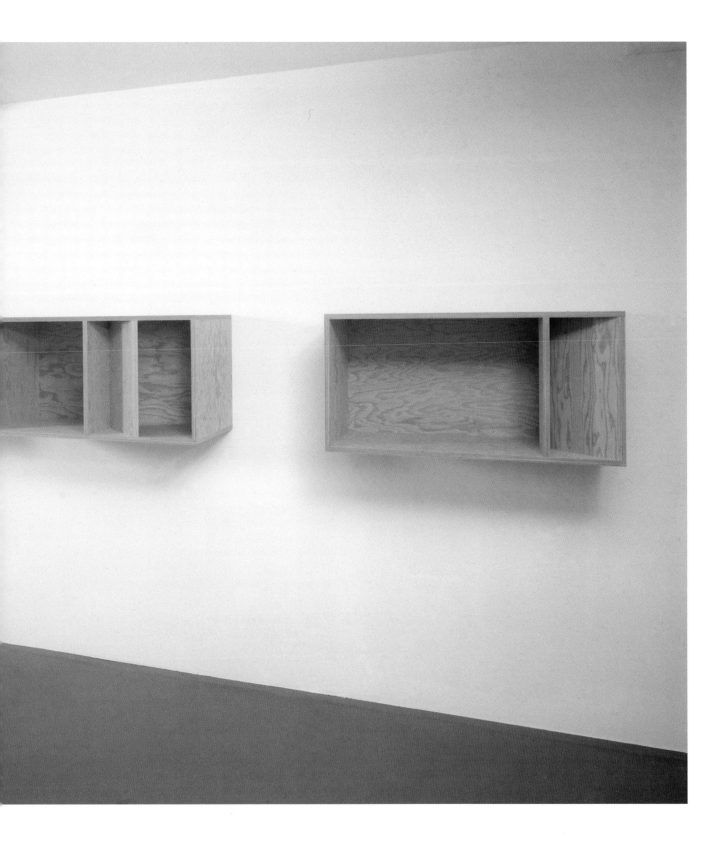

ON KAWARA

ON KAWARA
23. JAN. 1989
1989
cat. 119

ON KAWARA
24. JAN. 1989
1989
cat. 120

25. JAN. 1989
(Wednesday)
1989
cat. 121

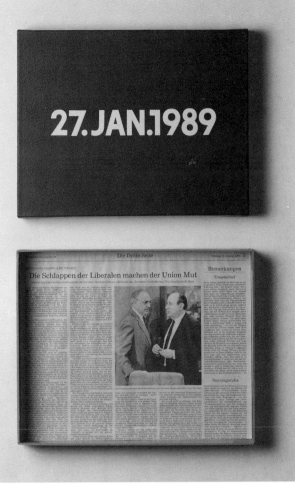

ON KAWARA
26. JAN. 1989
1989
cat. 122

27. JAN. 1989
1989
cat. 123

BRUCE NAUMAN

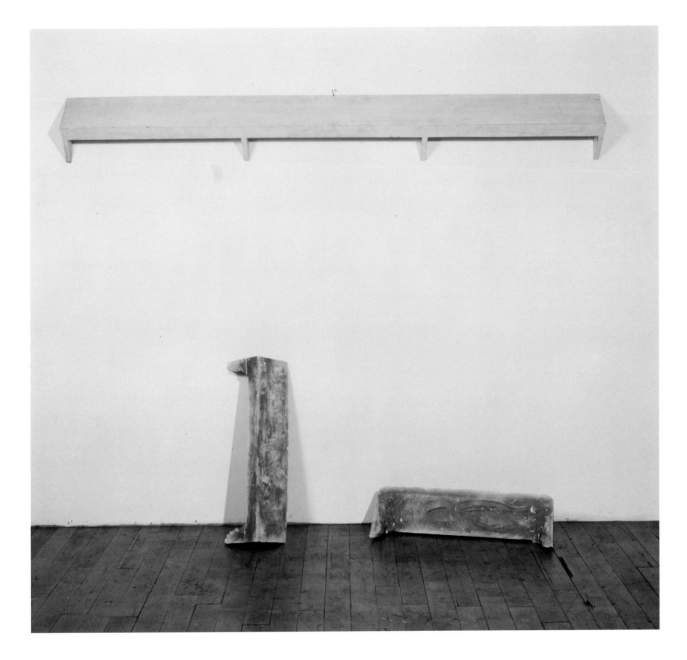

BRUCE NAUMAN
Untitled
1965
cat. 132

BRUCE NAUMAN
**Henry Moore,
Bound to Fail**
1967/70
cat. 136

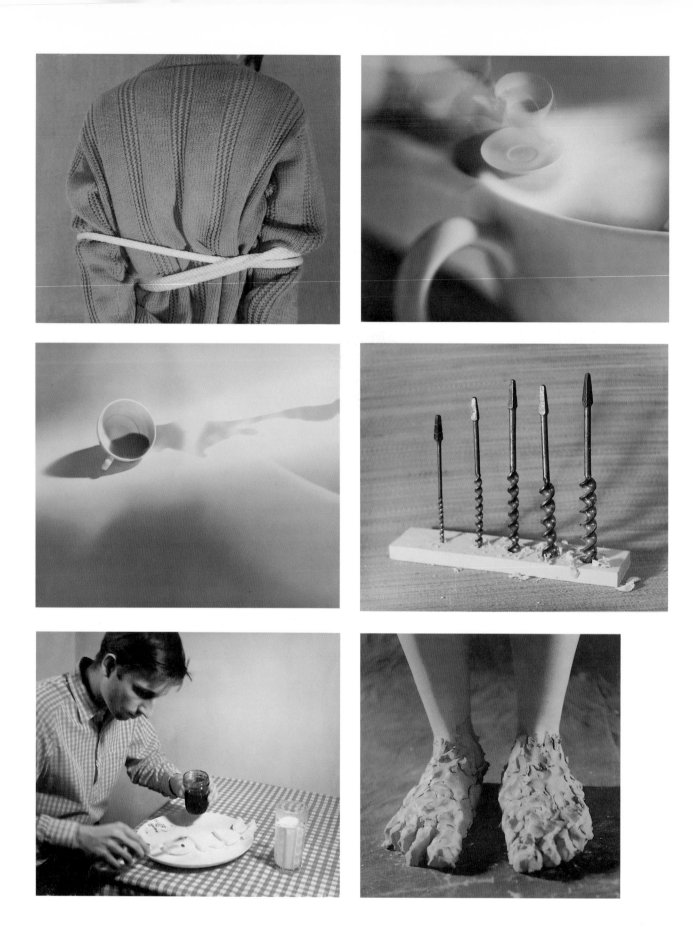

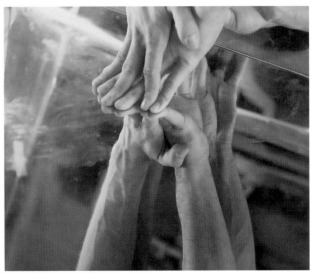

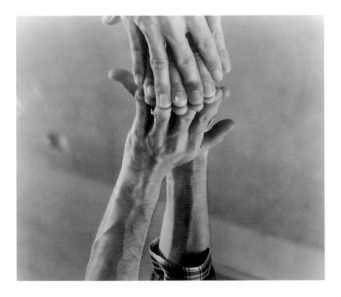

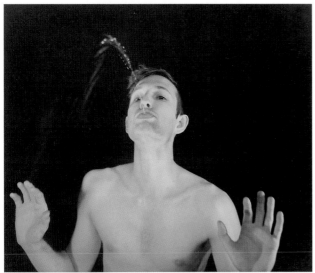

BRUCE NAUMAN
Eleven Color
Photographs
1966–7/70
cat. 134

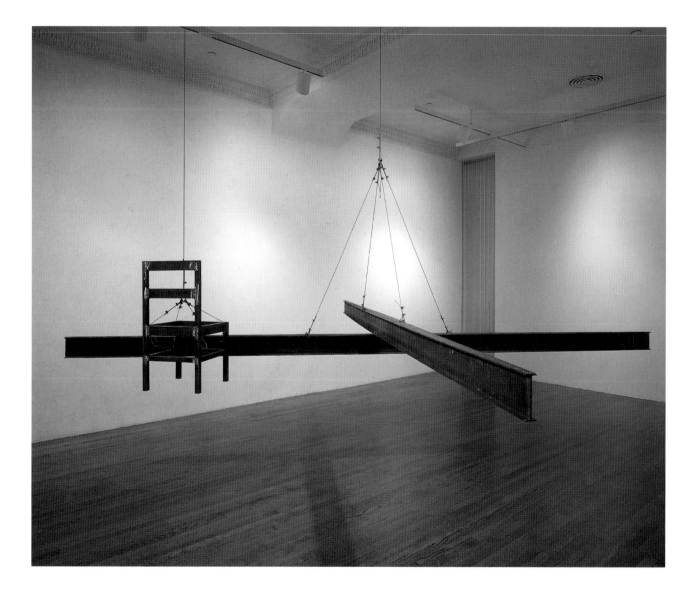

BRUCE NAUMAN
Musical Chair
1983
cat.142

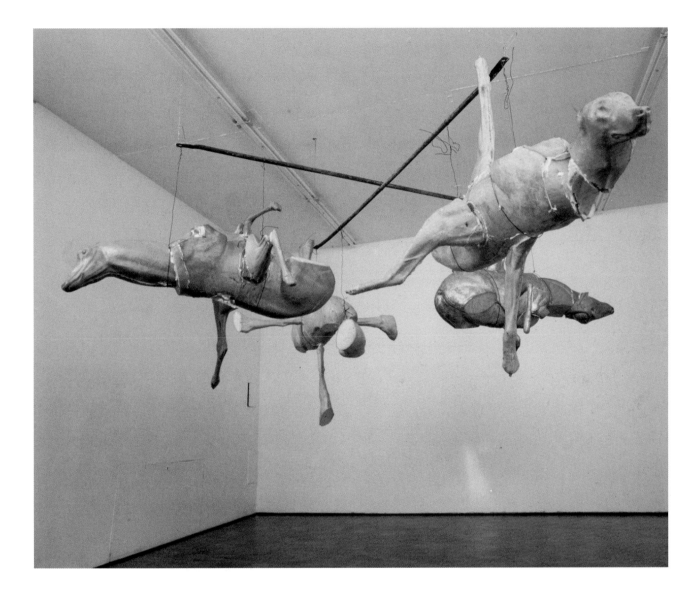

BRUCE NAUMAN
Untitled
(Two Wolves,
Two Deer)
1989
cat. 147

169

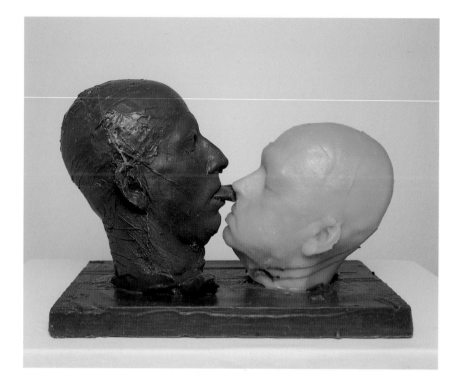

BRUCE NAUMAN
**Rinde Head/Andrew
Head (Plug to Nose)
on Wax Base**
1989
cat. 148

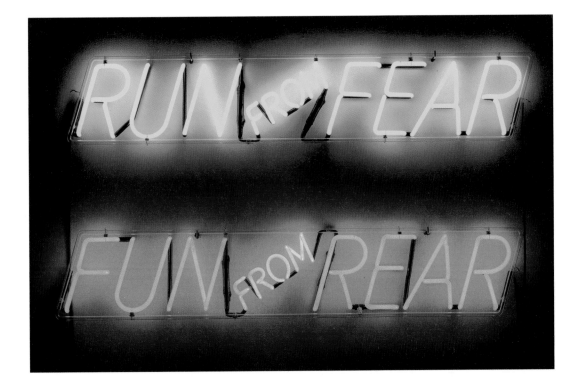

BRUCE NAUMAN
Run from Fear,
Fun from Rear
1972
cat. 140

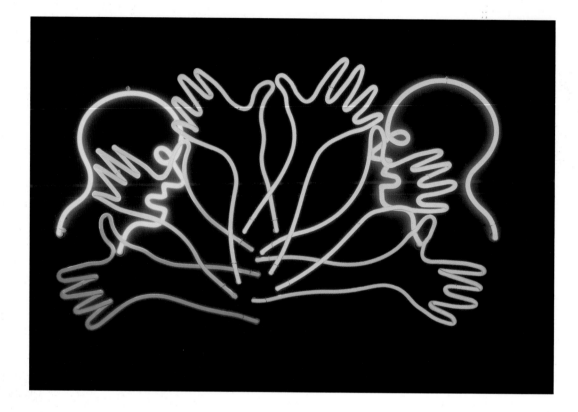

BRUCE NAUMAN
**Double Slap in
the Face**
1985
cat. 145

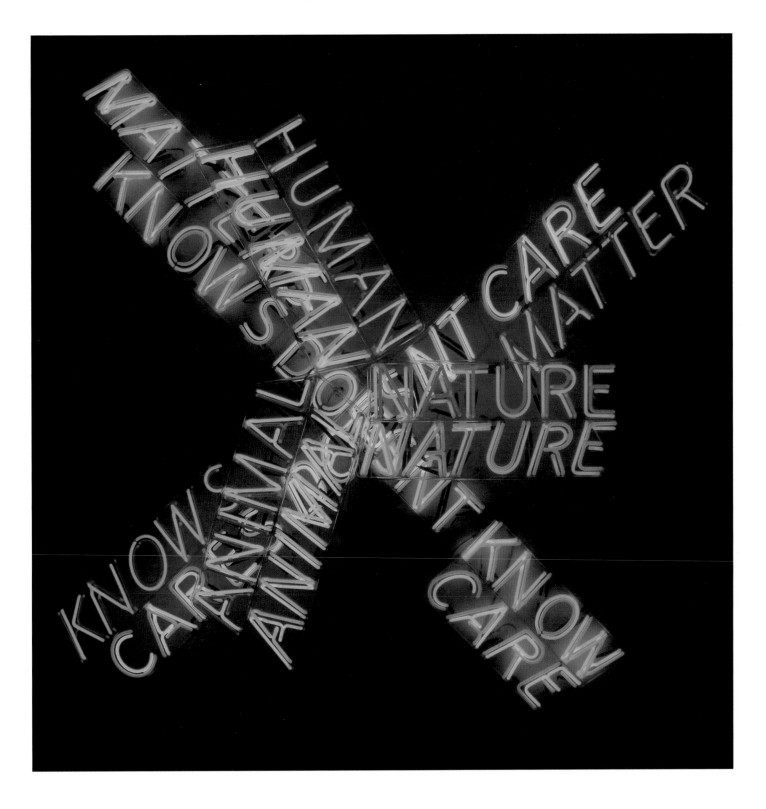

BRUCE NAUMAN
Human Nature/
Knows Doesn't Know
1983/86
cat. 143

BRUCE NAUMAN
Double No
1988
cat. 146

BRUCE NAUMAN
**Raw Material with
Continuous Shift –
MMMM**
1991
cat. 151

BRUCE NAUMAN
**Templates for Right
Half of My Body**
c. 1967
cat. 137

BRUCE NAUMAN
Raw War
1968
cat. 138

BRUCE NAUMAN
American Violence
1983
cat. 141

BRUCE NAUMAN
**Two Heads Double
Size**
1989
cat. 149

FRANK STELLA

CY TWOMBLY

CY TWOMBLY
Untitled
(Grottaferrata, Italy)
1957
cat. 249

CY TWOMBLY
Untitled (Augusta, Georgia)
1954
cat. 248

CY TWOMBLY
**See Naples and Die
(Dawn Series #7)**
1960
cat. 250

CY TWOMBLY
Untitled
1969
cat. 252

CY TWOMBLY
Untitled
1969
cat. 253

CY TWOMBLY
Virgil I
1973
cat. 254

Virgil II
1973
cat. 255

CY TWOMBLY
Virgil III
1973
cat. 256

Virgil IV
1973
cat. 257

I AM THYRSIS
of ETNA blessed with a
Tuneful Voice

CT, Aug 76

CY TWOMBLY
Idilli (I am Thyrsis
of Etna Blessed with
a Tuneful Voice)
1976
cat.260

CY TWOMBLY
Naxos
1982
cat. 263

17 nov 82

NAXOS

(Glooming)

ANDY WARHOL

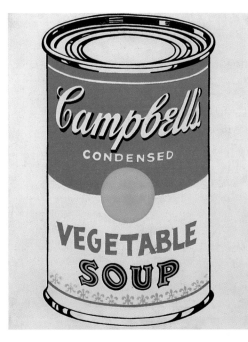

ANDY WARHOL
**Campbell's Soup Can
(Vegetable)**
1962
cat. 275

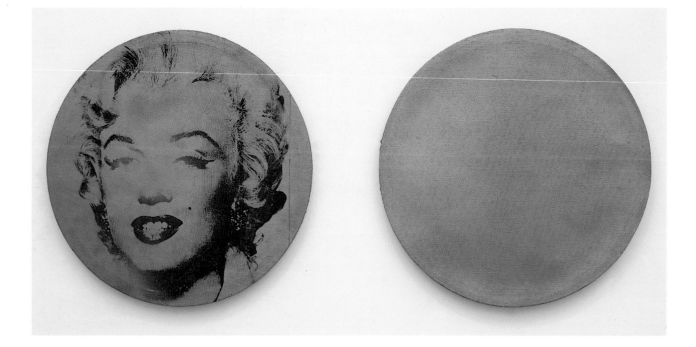

ANDY WARHOL
Gold Marilyn
1962
cat. 276

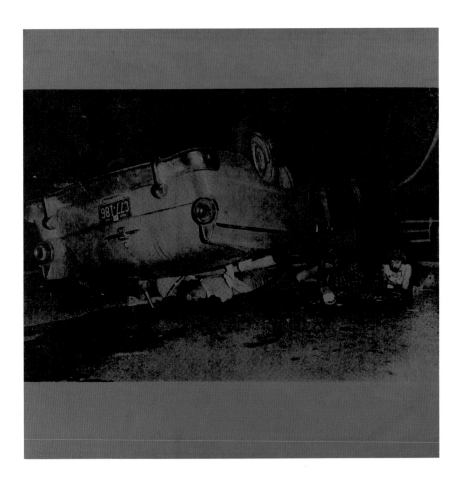

ANDY WARHOL
Five Deaths
1963
cat. 280

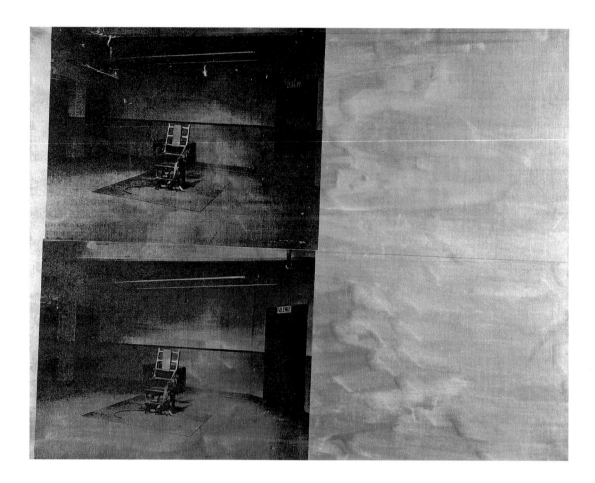

ANDY WARHOL
Double Silver
Disaster
1963
cat. 279

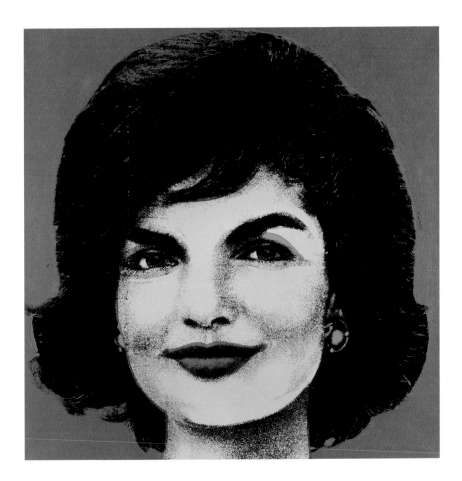

ANDY WARHOL
Red Jackie
1963
cat. 283

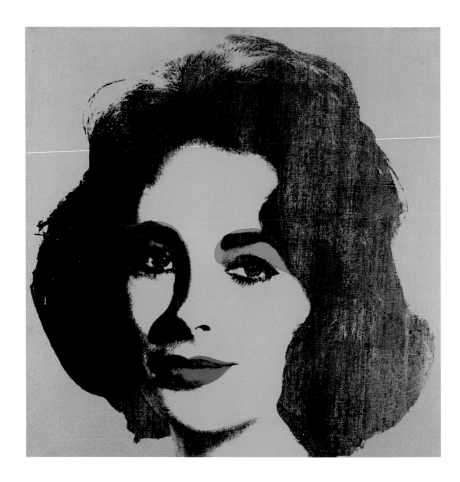

ANDY WARHOL
Liz
1963
cat. 281

Seized shipment: Did a leak kill . . .

. . . Mrs. McCarthy and Mrs. Brown?

ANDY WARHOL
Tunafish Disaster
1963
cat. 284

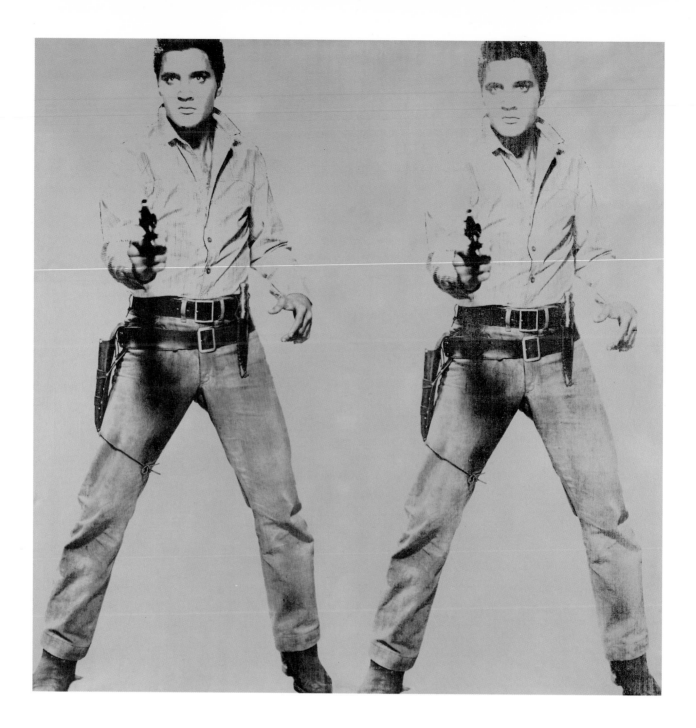

ANDY WARHOL
Double Elvis
1964
cat. 286

ANDY WARHOL
Early Self
1964
cat. 287

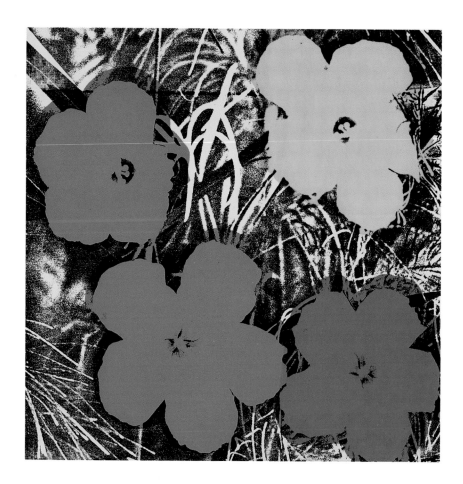

ANDY WARHOL
Flowers
1964
cat. 288

ANDY WARHOL
Little Race Riot
1964
cat. 292

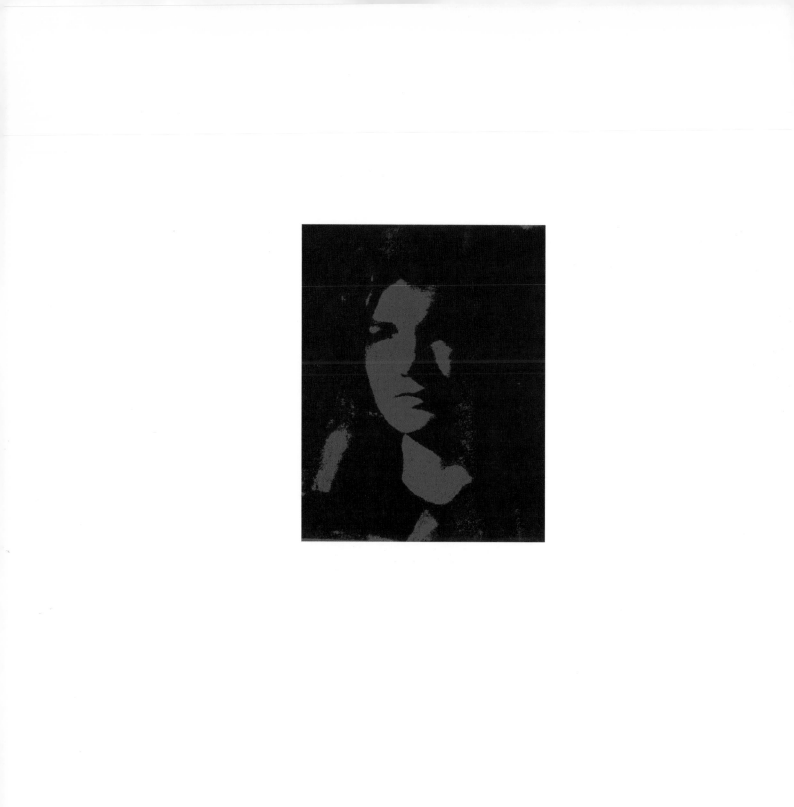

ANDY WARHOL
Jackie
1964
cat. 291

ANDY WARHOL
Marlon
1966
cat. 293

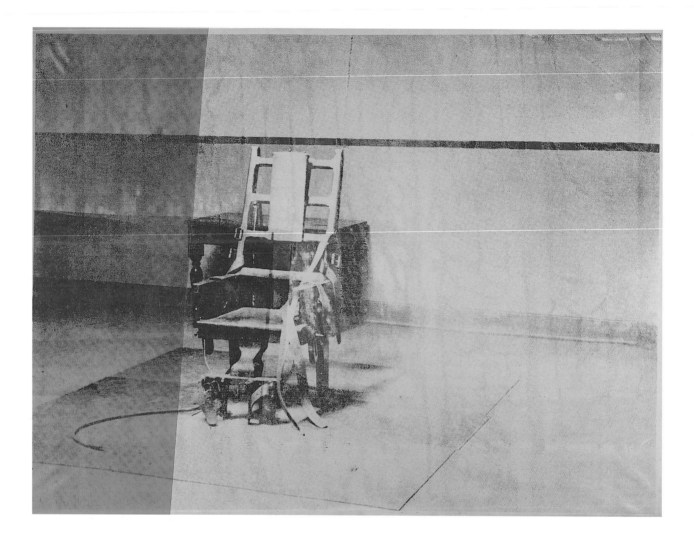

ANDY WARHOL
Big Electric Chair
1967
cat. 294

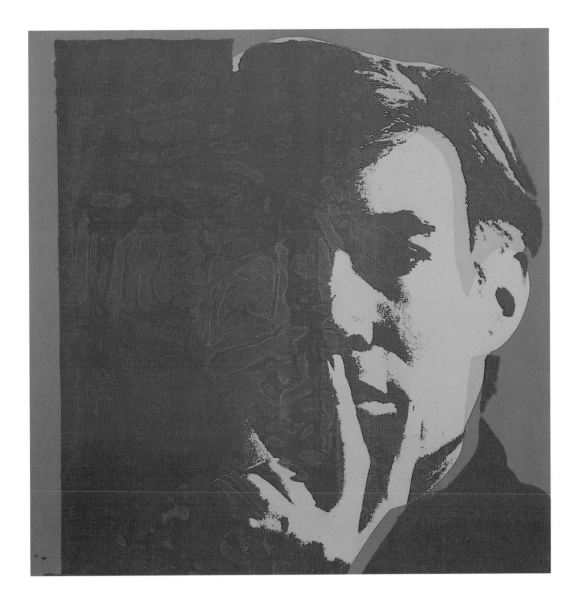

ANDY WARHOL
Self-Portrait
1967
cat. 295

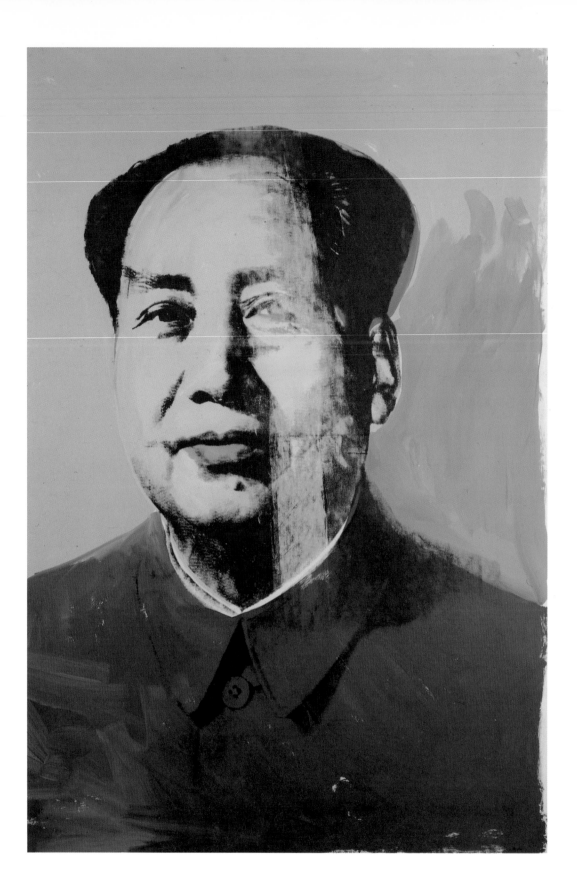

ANDY WARHOL
Mao
1972
cat. 297

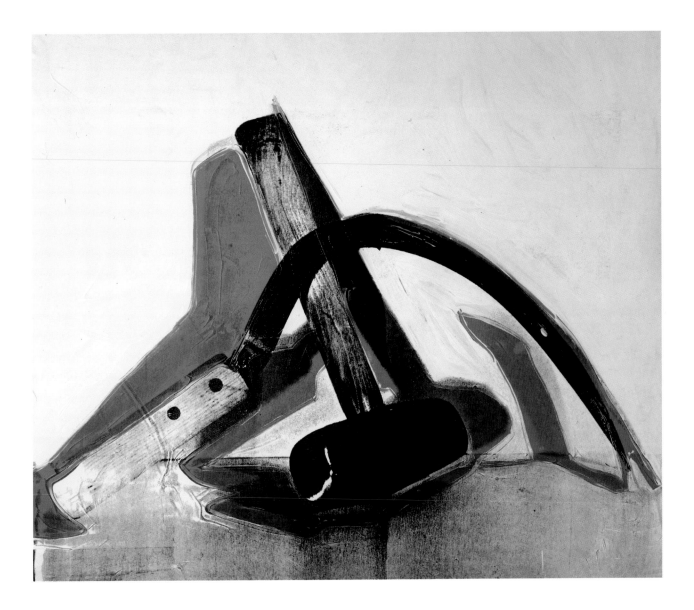

ANDY WARHOL
Hammer and Sickle
1976
cat. 298

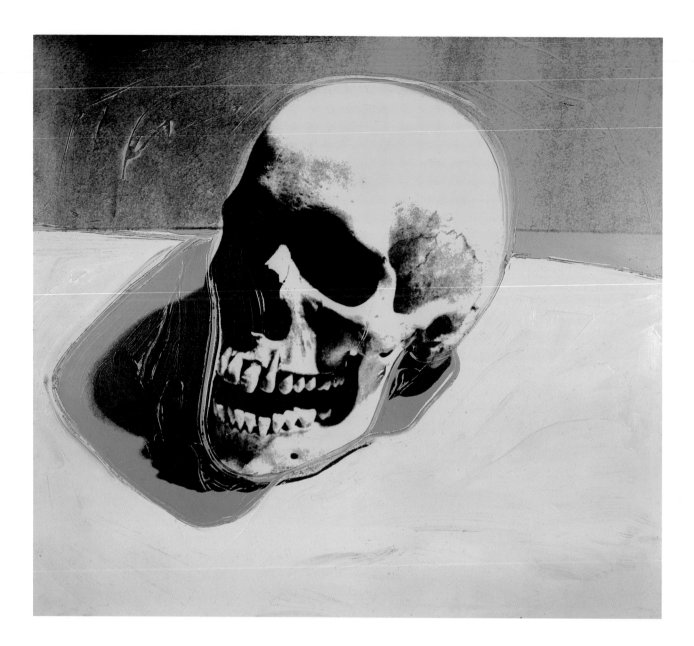

ANDY WARHOL
Skull
1976
cat. 299

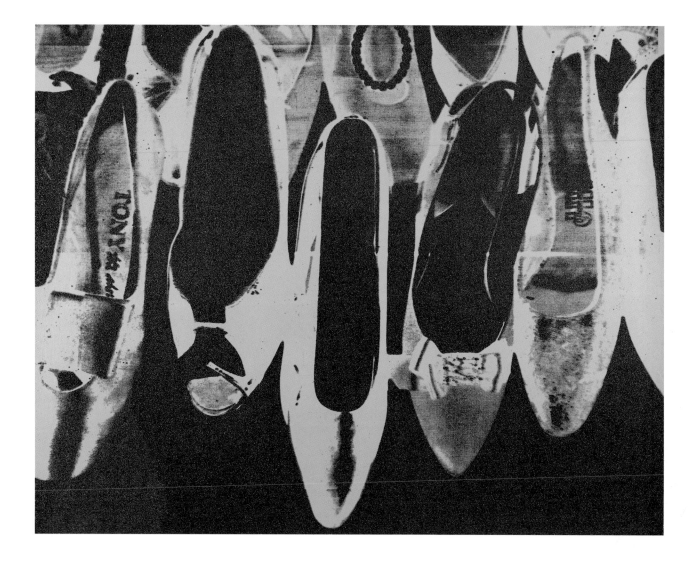

ANDY WARHOL
Diamond Dust Shoes
1980
cat. 301

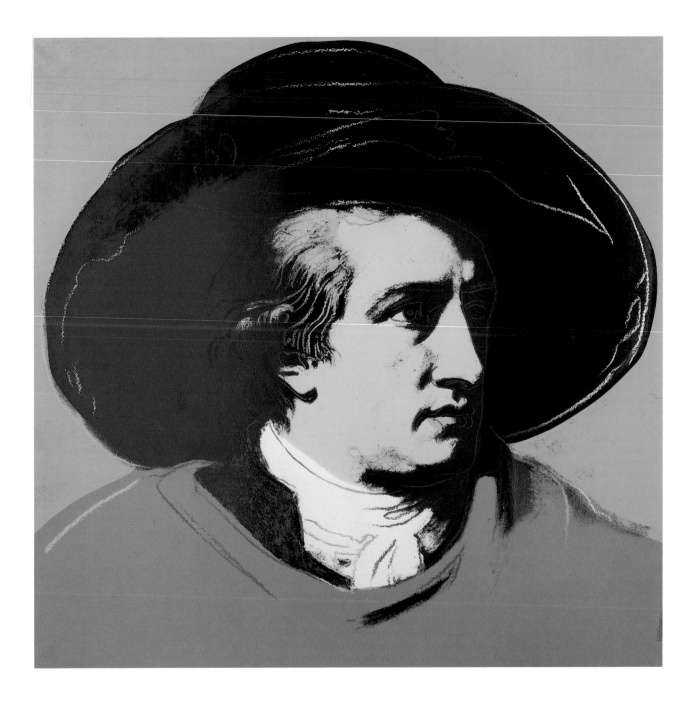

ANDY WARHOL
Goethe
1982
cat. 304

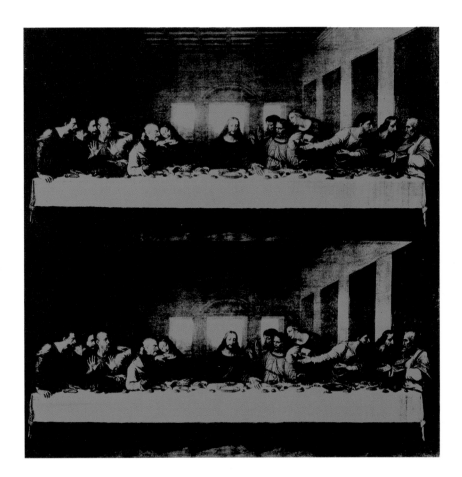

ANDY WARHOL
The Last Supper
1986
cat. 308

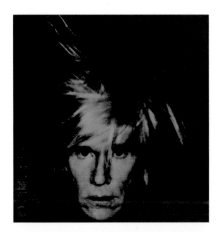
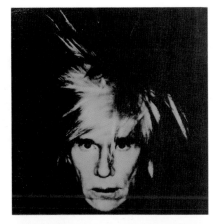
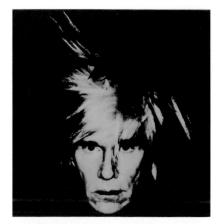
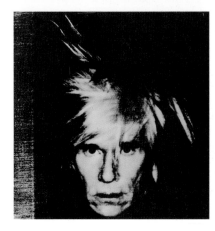
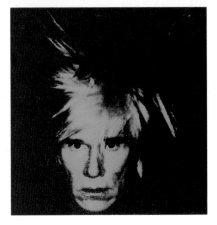
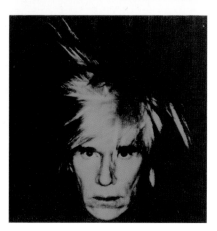

ANDY WARHOL
Six Self-Portraits
1986
cat. 306

ANDY WARHOL
Cagney
1964
cat. 285

ANDY WARHOL
Christine Jorgenson
1956
cat.264

Golden Nude
1957
cat. 268

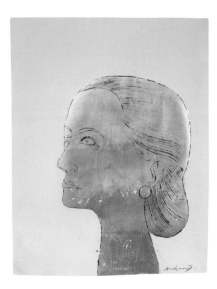

ANDY WARHOL
Young Boy Dreaming
1957
cat. 273

Helena Rubinstein
1957
cat. 269

Seated Male
1957
cat. 271

219

Clegg & Guttmann
'Matrimonial
Portrait'
(Josef and Anna
Froehlich), 1987
Cibachrome on
fibreboard
Collection Josef and
Anna Froehlich,
Stuttgart

Nicholas Serota and Monique Beudert **The Making of a Collection:
An Interview with
Josef and Anna Froehlich**

MB: Where were you brought up?

JF: I grew up in Bad Ischl, which is a small town, but a very famous spa in Austria, fifty kilometres east of Salzburg. It was the summer residence of the Kaiser Franz Joseph and it retained the atmosphere of his era. I went to school with grandsons of the Emperor and we played together in the Kaiser Villa. So, I think there was more liberalism in this town. At my parents' home there was no concern with art, either historical or contemporary, whatsoever.

NS: Were you introduced to art at school? What was your education?

JF: I studied automotive engineering in Steyr. There was a technical drawing class, but there were no art lectures and no fine art. I was strictly technically oriented. At the age of twenty or twenty-one, I went to Ann Arbor, Michigan, as a student through the Marshall Plan. At that time America was for me the big desire and I was very good at English because we had, in each city, an America House where you could read about America. We were living in the American occupied zone.

NS: Were you reading American technical journals?

JF: No, popular magazines. They had old *Life* magazines and of course we thought that America was the land of milk and honey. After I was a student, I had a job in Germany as an engineer and then I finally found a job with an American company, EX-CELL-O, who were looking for engineers for their new plant in London, Ontario. Later, I went to Detroit to work for the Cross company. I had a car, I was doing OK, I was making good money as a design engineer, working overtime. I bought an old Oldsmobile with a German friend and we drove all over America. We slept in the car, we went to places like Yellowstone Park, the Grand Canyon, Los Angeles, Disneyland and Las Vegas.

AF: No museums?

JF: We went to the museums like most people go to the museums, or people go to an opening because there is an opening. There was no intention of collecting art and no special interest in art. In the back of my mind I knew about some artists. This was not my prime interest, just a little, maybe, because I was also interested in what was going on in American culture.

MB: What did these American companies you worked for make?

JF: High-tech machines and systems for the automotive industry, which is really what I got into later, but in a different area. It was my entrée into the business I am in now. Early in 1960, Uncle Sam became interested in me and I decided studying would be better than going into the United States army. I had wanted to study business and administration, and I decided this was the moment to do it. I got an MBA from the Western University in London, Ontario, in 1962. Then I decided to go back to Europe.

NS: Why did you decide to come back?

JF: That's a good question. I was ready to go back. Both American companies had subsidiaries in the Stuttgart area and they offered me jobs. But of course the problem is that after you have been living for a while in America and you come back to Germany, everything is too small, everything is much more expensive, so I wanted to go back to America again. Then, after two years, I did go back to America for a visit.

This is an edited version of a conversation in English between Anna Froehlich (AF), Josef Froehlich (JF), Nicholas Serota (NS) and Monique Beudert (MB) which took place at the Froehlich residence in Stuttgart on 20 January 1996.

NS: When you came back to Germany did you go to museums or galleries?

JF: In the Fall of 1962, I settled in Stuttgart. We went to the museums casually ... just, what are we going to do tonight, there's an opening at the Kunstverein. There was no serious interest in art.

NS: Did you visit the Documenta exhibitions?

JF: I think the first Documenta I did was number six [in 1977]. I went to the first Biennale in 1976 where I saw the Beuys installation 'Strassenbahnhaltstelle', and the first Biennale Anna and I went to together was in 1980. I think it was Baselitz and Kiefer. I knew Baselitz and Kiefer and certain names, but there was no intention of collecting them.

MB: You were still a spectator.

JF: Yes, definitely a spectator like thousands of others who walked through and looked at things. We couldn't really differentiate between established art and young art; we just looked at it with very great interest. It was an interest which quickly grew, and it was part of a change in my life. My first marriage had ended in 1979–80, and I think this plays a key role when we met Beuys. Anna and I had a new liaison. She fled Hungary in 1967 and was living outside Stuttgart, married to someone else ... and her marriage broke up and my marriage broke up and in 1980–1 ... it was a new beginning. As Beuys says, there is a stone on your road, one stumbles over it and another one picks it up and makes something out of it. Also, I was interested in vintage sport cars, I had been collecting scientific instruments, and I realised very soon that this was not enough. I saw a challenge in art, and I saw that I was looking at art but I didn't know much about it. It was not that Beuys came and we said, all of a sudden, we're interested in art.

NS: Anna, did you have any early interest in art?

AF: When I was in Hungary I had an interest in art, but not a lot. But I bought a painting with my first month's salary. The whole salary, one painting; it is here.

JF: Well, you were braver than I was.

NS: And you still have it. Josef, what would you say has been Anna's contribution to the collection?

JF: I think it is her contemplative part. She doesn't talk much, she observes very well and whenever we were discussing a painting, I found out that she has in many ways a much better eye than I have. She plays a very important role; Beuys liked her much and Andy Warhol said she looks much better than I do. She was always, or practically always, there at the visits to artists. I think that she is the *Ruhende Pol* the quiet pole, the central pole, when we go to see things. What did I learn from Anna? Well, ... to sit back and think about it. She always says *brauchst du nicht*, you don't need it. Beuys always said to me, when I said what do you think about this?: *brauchst du nicht*. Then I start thinking, why don't I need this? ... Or think of the conversations I have had with you and Monique. It's a point that should be raised. You were extremely helpful in discussing the collection. Remember the Twombly discussions – whether to have only works on paper or whether to add some paintings? Finally, Twombly confirmed it to me personally: 'I am primarily a draughtsman.' Many people have had input into the collection knowingly or unknowingly. For example, Kynaston McShine at The Museum of Modern Art once said to me that a private collection can and should show the passion of the collector, and he is right. I think there must be discussions going on, pros and cons and contributions coming, even if the other party isn't aware of it or doesn't know. This is the beauty of art: that you cannot just press a computer and ask what about this work of art, is it good or bad?

MB: What would you say was your first acquisition?

JF: In 1982 we visited Frau Dr Krohn at her gallery in Badenweiler and bought some paintings by Geiger, Ackermann and Fleischmann. But the first *real* acquisition? I think it must have been around 1982 and it was before I met Beuys. I was in London because of my business; I have a plant in Basildon, Essex. I went to Anthony d'Offay's gallery. I bought two little Sandro Chias which I quickly traded back for a Baselitz, a fracture painting.

Also interesting is that in 1982 I went to Documenta twice. The second time, in September, we had decided to take a tour. We walked into the Fridericianum and on the left, in the entrance

there was the big Hare by Flanagan. Also on the left, but further down, there was a wall protruding and the [Beuys] 'Friedenshase' (p. 2) was set into the wall, behind armoured glass. I asked who was the artist or whose hare was this and the guide said Flanagan. I said, 'I mean this little one.' She said, 'This is Beuys.' And Anna, you probably remember, I said, 'This is what I want.'

AF: Yes, that is what he said.

NS: Why were you interested in the Hare? You didn't notice the Hare the first time.

JF: Maybe because it was so small and enclosed in a sort of cave in the wall. I was not looking for the Hare, it was a coincidence, but as I said, luck is if you see it. What is important is that I called Frau Moj, who was working in the Documenta office, and she connected me with the FIU [Free International University] bureau where I left the message that I was interested in the Hare. Then Franz Dahlem, who was the head of the Dia Foundation in Europe and was working with Beuys, called my secretary and said, 'Who is Herr Froehlich? What does he do? What does he collect? Who is his gallerist?' Dahlem said he wanted to visit me to set up a meeting between Beuys and me. And when he was here he just stayed and stayed. We were interested in Beuys, but I played it a little bit cool and Beuys wanted to know more about me. 'Who is this Herr Froehlich who is interested in my Hare?' So we decided that Anna should go to the *Zeitgeist* exhibition in Berlin with Franz Dahlem to meet Beuys and to present him with information about my company.

NS: So Beuys sent you an emissary and you sent Beuys an emissary.

JF: Exactly. Franz Dahlem was the emissary and he of course was responsible for getting the 7,000 Oaks project started at the Documenta. So Anna went to *Zeitgeist*, and she met Beuys and gave him literature about my company. The next thing was that Dahlem was here again and I had several phone discussions with Beuys and I was very intrigued because he immediately said '*du, Josef*', as if I had known him for ages.

NS: Why did you get involved with the 7000 Oaks?

JF: I was fascinated by what was going on. Dahlem asked me for 35,000 marks for the project and I was prepared to give it to them. I think this is why Beuys was intrigued. He had found someone who didn't say 'I give you 35,000 marks, what are you going to give me?' I had the feeling that this was a chance to get involved with the inner circle of art and learn about art, not just by going to galleries, but by knowing the creators.

MB: Was it the difference between being passive and active?

JF: You can be active by going to exhibitions and galleries and reading, but I think you need what we call in German *einen Stein des Anstosses*, a key experience, which always gets things going. And the key experience was that I said I was interested in the Hare. All of a sudden I had to deal with people who were like nothing I had ever met before. When I met Franz Dahlem and the way he went about it, this was completely new. Dahlem said, the way you live, this has to change. He looked at the art we had in our house and told us to get rid of it and use the money to buy some good art. So he made a selection and arranged for those works to be sold at auction at Ketterer in May 1983. What we sold had cost around 500,000 DM, and we realised 150,000 DM from the sale. Dahlem said: 'Forget it, this is *Lehrgeld* [learning money].' I was very upset because we realised so little and we had been planning to use the money to buy Baselitz and Beuys. On the other hand, I said, 'Fine, you have to free yourself.' Beuys always spoke of the *Geistige Reinigung*, the mental clearing, or purification. Therefore, with hindsight, Dahlem was perfectly right – get rid of it, don't just put it in storage.

MB: Did you know about the 7,000 Oaks project when you visited Documenta?

JF: Yes, of course, on the first visit we were all wondering about the pile of stones. Beuys created this project and I think it is still very questionable whether it was the right project in Kassel. Beuys called it '*Stadtverwaldung anstatt Stadtverwaltung*': Let a city be covered with trees instead of covered with bureaucracy. It doesn't sound good in English but it sounds good in German. Beuys was, of course, *ein Grüner*, he was a work horse for the Green Party, but later they dropped him. Certainly Kassel was not a place which needed 7,000 trees and the city didn't want to pay

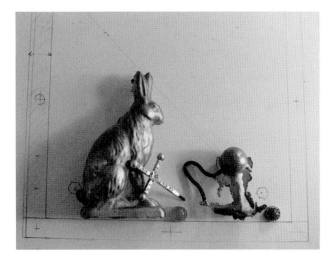

Design for the safe to contain 'Friedenshase' in the Staatsgalerie Stuttgart, March 1984

for the 7,000 trees. But it was a pilot project as far as ecology is concerned. I think that Beuys was ahead of his time when it came to environmental protection. I still say that the 7,000 trees would have been better planted in another place, but it was the Documenta.

MB: It was at a point when Beuys was moving his art more towards direct social action and he was operating on a larger scale.

JF: Dahlem said recently that Beuys had already lost a certain sense of reality with this big project. Beuys had a very intriguing plan, to put the 7,000 steles directly in front of the Fridericianum and the steles would disappear, one by one, until the 7,000 trees were planted, and the last stele was gone. I think it was very ingenious. So Heiner and Philippa Friedrich agreed to finance the 7,000 steles and Beuys thought at that time there would be sufficient citizens who would give 500 DM for a tree and a stele. This is the first work of art where he stuck out his neck and said he would finance it. Then they realised they were sitting with the 7,000 steles and hardly any trees planted. Here comes Froehlich and he is interested in the Hare. Later on I realised that this 35,000 marks was extremely crucial for them – Franz Dahlem said, 'You were *der Goldene Rettungsanker* [the Golden Lifesaver] – because then they could go back to Kassel and say we have money, we can plant more trees. I realised this after I received the letter from Beuys. I said 'Why does he send me a love letter like this because I gave him 35,000 marks?'

MB: The project wasn't moving.

JF: The project was just about to die; it would have been a catastrophe for him. He found in me someone who said I'll support your 7000 Oaks project, and we had an understanding. Whenever he needed money for the project, he and I would discuss it. In 1983 I gave him the money for 700 trees, and for 600 trees in 1984. Beuys flew to Japan for an exhibition of his work at the Seibu Museum in 1984, and while he was there he did television advertising for Sapporo Beer. In 1985 Götz Adriani held an exhibition for the 7,000 Oaks in Tubingen where artists donated works to help finance the project. Then one day Beuys said, 'Josef, it's enough, I don't need any money from you anymore.'

MB: This is the letter here, dated 28 January 1983.

JF: Yes, he said it took him a long time before he decided to send this letter. 'Thank you ... *durch mein Leben und meine Arbeit* ... through my life and my work I can thank you and the 7,000 Oak project in Kassel is already being discussed all over the world.' He was with Bruno Kreisky; he writes, 'Your Austrian chancellor has invited me to an official meeting ... with the Austrians I have chances, they will make the hare run ... what I am very pleased about is that you are clever ... that you are enlightened ... that you understand that I cannot thank you ... just like a businessman ... because something hare-like is important ... maybe I must come to you soon and I must make you a few nice big paintings ... I heard from Franz you are bringing your house in the direction of art ... I thank you in any case, not only in words ... also in deed: *Blutsbrüderschaft* (blood brotherhood).' This was a very overwhelming letter.

NS: He wrote to you in January; when did you meet him?

JF: On 9 March in Düsseldorf. For my birthday he gave me the 'Steinhase', a colour photograph of a stele with a hare on it, which he inscribed '*Für Josef zum Geburtstag von Joseph – 09.03.1983.*' The next day Beuys, Dahlem, Anna and I drove to Cologne, and at the Dia space on Bismarckstrasse we drank *Blutsbrüderschaft*. Franz had a bottle of champagne and Beuys pulled a little bottle of hare's blood out of his vest and put some into the champagne and we drank *Blutsbrüderschaft* ... And then Beuys asked whether I was going to keep the Hare in my house or would I consider lending it to the Staatsgalerie, which was under construction. I said, yes, I would

be pleased. So he phoned Beye right there. '*Guten Tag,* Herr Beye ... Josef Froehlich is here ... we are just speaking about the Hare and we were discussing if you would be interested in having the Hare as a *Leihgabe* [loan] from Herr Froehlich.' Beye said, 'Yes, of course, fantastic!' and Beuys said, 'OK, we're coming to see you.'

NS: Tell us about Beuys's installation at the Staatsgalerie.

JF: So we walk in and we saw just raw construction and Beye said, 'Herr Beuys, here is the room I had in mind for you.' Beuys looked at it and said, 'My "Dernier Espace" is longer than this room, should I cut it off?' and looked longingly at the central gallery, which was much larger. Beye said, 'I don't have enough Beuys works, I cannot give you this space.' Beuys walked around and around and said, 'I'll make you a proposal.' On the way out he picked up a small scrap of aluminium and going home in the car he drew on it a swan with an egg ('Schwan mit Ei', cat. 96, p. 63) and he gave it to me when we got to the house. I said, 'Thank you, what are we going to do with it?' and he said I should make a zinc case for it. Then he went to the phone and called the collector Herbig and asked whether he could use the 'Plastisch-Elastischer Fuß' [which Herbig owned] for the installation at the Staatsgalerie. Herbig agreed. I was making a drawing for the zinc case, and Beuys also sat down and made sketches. He put the 'Dernier Espace' here, the two vitrines here and the crucifixion here and the 'Plastisch-Elastischer Fuß' here, and he said 'Your little Hare is in the corner.' I said, 'Why in the corner, why not in the middle?' He said, 'That's why.' He made this sketch and the next day we went to the Staatsgalerie with his proposal. I could see that Beye was astonished, but anyway he said, 'Yes, fantastic,' and Beuys had the main gallery. This was my first experience of Beuys's power of persuasion.

In April 1983 Beuys came with Dahlem to visit my plants in Leinfelden and Plochingen. In Plochingen he found the materials for 'Eiszeit' (cat. 94, p. 64) and 'Gefängnis' (cat. 95, p. 65). He saw the board for 'Eiszeit', and we put it into the boot of the car, and put the handkerchief on it. Then we lost it at an intersection, but finally it ended up here. I am sure when he saw the board he immediately knew what was going to happen with it. At home, he started drawing on it immediately. And every time he came to our house, the first thing he did was go to the board and draw another *Zotteltier* [shaggy animal] on it. Also, he had picked up a piece of an old steel pipe from a scrap heap at the factory, and he told me to cut off a straight section ten centimetres long which he later signed and attached to the board.

MB: What was the original function of the board?

JF: The board was in the spray booth. It was on two trestles and it was a flat surface where people painted metal boxes. It was used over and over and this is how it got the texture. The 'Gefängnis (Kabir and Daktyl)' (cat. 95, p. 65) was called *Gefängnis* in my factory and it was just standing as a protection shield between two machines. It was made out of steel tubing with sheet metal on the bottom and Plexiglas on top.

MB: The top had become opaque and it had a hole in it. Why *Gefängnis*?

JF: Because an employee mended the hole with masking tape and wrote on the tape the word *Gefängnis* [prison]. At first Beuys wanted to cut the legs off. Then he called later and changed his mind. On 17 January 1984, eight months later, he came with the two little old carbide lamps, one inscribed Kabir, the other Daktyl, and a stone. And he said, 'Now I have the work finished,' and hung them on.

MB: Beuys also arranged some of his multiples in a vitrine in your house, didn't he?

JF: Yes, I had this vitrine made to hold my collection of scientific instruments. When Beuys saw my collection, he was fascinated by the instruments, and he thought I should add some of his multiples, like the 'Intuition'

Installation of 'Friedenshase' in the Staatsgalerie Stuttgart, March 1984

Joseph Beuys
drawing on 'Eiszeit',
1983

box, which he gave me, and 'Telephon S – – – Ǝ' (cat. 88) and others. I keep adding to the display, and at the moment there are about fifteen multiples in it (fig. p. 227).

Another way we became involved with Beuys was through his design of the logo for my company, for which I paid him. Actually, I did all the work. I made about ten different versions and he came and looked at them. The one he liked the best was also my favourite. The type came from a poster I had found on the street in Edinburgh; it is Renner Futura, 1929. Beuys improved the layout and refined the design of the logo and he recommended we replace the greenish blue we had used previously with the blue from the air-mail sticker. He said the *Luftpostaufkleber blau* [airmail sticker blue] is the genuine blue.

MB: Do you think one half of collecting is pursuing the objects, and the other half is appreciating the objects?

JF: No, it's not just the pursuit. I think if you really concern yourself with art it cannot be just about trophies. In German, '*die Prinzipen der Kunst sind die Prinzipen des Geistes*' [the principles of art are the principles of the spirit]. We both have experienced *die Auseinandersetzung*, the confrontation with art, that art gives something back. As Picasso said, 'Art is not there to decorate your home, it is a weapon to be used against your enemies.' It sharpens your mind. Beuys made me aware of this through his famous poster CREATIV-ITY=CAPITAL. I immediately put one in each of my plants to make people aware that creativity *is* capital, not only moneywise.

MB: Did you ever hear Beuys speak in public?

JF: Several times. I heard Beuys for the first time in English, in front of a large audience, in July 1983 in London. I remember it was to students, in the V&A lecture room, and how uninhibited he was. His English was not perfect and I realised that there were things he could not get across to an English-speaking public. He was almost like a tiger when he was in front of the public, but he also liked to withdraw ... it was very interesting. Another time was at the Staatsgalerie, Stuttgart, in April 1984 at a public debate between him and the Austrian sculptor Alfred Hrdlicka on the topic of '*Endzeit der Kunst – wie geht es weiter*'? [The End of Art – Where do we go from here?]. Beuys was not as serious as Hrdlicka, he made people laugh, but he also was very eloquent. At the end of the discussion, Beuys was surrounded by a big crowd. He was signing everything, even a cast on a broken leg. Beuys was always present at his installations in exhibitions. He was always ready to discuss, to meet people, to stir things up.

NS: When did you get your first Beuys drawing?

JF: The first one was 'Elch mit Sonne' (cat. 48, p. 68) which I bought from Dietmar Werle in late 1982. Dahlem told him to offer it to me. In 1983 Werle offered me a group of early Beuys draw-ings. I couldn't judge them of course, so I made photographs and when we were in London for the Beuys opening at d'Offay's, I went to where Beuys was staying at the Ritz and said to him, 'What do you think?' He said 'Fantastic, where did you get them?' I said 'I just want to know from you if you approve or not,' and he said, 'Of course.' They are still the backbone of this collection (for example, 'Aus dem Leben der Bienen' (cat. 43, p. 69), 'Entladung' (cat. 45, p. 70) and 'Zwei Figuren' (cat. 57)). I paid what was for me an enormous sum at that time for about a dozen works; later on I found out that they had been handed around the museums, no one wanted to buy them. I was the last one in the chain.

NS: At this time were you beginning to think about making a collection rather than decoration for your home?

JF: I did not think of collection or decoration, I knew now that I was on the way of buying good

art, getting serious about it. I was discussing with Beuys what I should collect from Beuys. He said, 'Well, you don't have big sculptures. Why don't we make a nest of drawings? In Stuttgart there will be a nest of Beuys drawings.' So I have quite a few drawings which I bought directly from him. It was clear I would become a Beuys collector with the works he made for me. I also realised that Beuys is a fantastic draughtsman. He always said that when he drew he was putting his thoughts to paper. It was not just a drawing like many other artists. You see those drawings over there ... pencil, ink, with acid, collages ... I don't know any draughtsman who could be compared with Beuys, draughtsman is not really the right word. We have to talk about works on paper, collages. To say that Beuys is a good draughtsman is far too limited. So we made a mutual decision that I should concentrate on drawings because at that time we were still thinking of in here [at home]. We didn't call it decoration ... *living* with art was the idea. When you see the way we live now, it has changed us. At that time I was not thinking about building a collection which is Germans and Americans, there were no calculations, it emerged gradually.

MB: How did Beuys influence your living?

JF: Through many conversations. Gradually I realised that Beuys was essentially a minimalist. I think that this was also a reason I got interested in Minimal art, like Andre, Judd and Flavin. I was reading *Specific Objects* by Judd, and his complete writings. I was very interested in Judd's art criticism and his opinions about other artists, for example, John Chamberlain. There was a definite drive for reduction and minimalism in our lives.

NS: In his list of favourites Beuys mentions his three 'giants' – Malevich, Mondrian and Newman – and he describes Newman as the father of Minimal art.

JF: Obviously Newman was one of the artists he appreciated very much and he said Palermo would never have been possible without Newman, which is a very interesting statement. So there must have been a connection Newman – Beuys, Beuys – Palermo. We didn't discuss Newman in any detail. He also described Brancusi as the father of Art Deco.

MB: When was the Hare installed at the Staatsgalerie?

JF: In February 1984 I went to Beuys's house to take possession of the Hare and we discussed my design of the safe to contain the Hare (fig. p. 224). The safe was made in my factory. We were planning to install the 'Friedenshase' (p. 2) at the Staatsgalerie for the opening on 9 March. Heiner Bastian phoned me and said Beuys was sick, he could not come. I said, 'Then I will put the Hare into the safe. The Staatsgalerie can't open with the safe empty.' He said, 'You can't do that.' I said, 'Yes, I can.' Then Beuys phoned up and said he was coming, so I picked him up at the airport, and we went to the Staatsgalerie (fig. p. 225). It was a lot of fun, putting the Hare in the safe ... the pearls ... the sun ... the cross ... Everything was – we call it in German *locker* – easygoing. He didn't say, 'It must be exactly here.' He said, 'As long as it looks good. Just make it look natural, easy, flowing.' That's what I learned from him. Another term I learned from him is *eine ehrliche Arbeit* – is this an honest work from an artist or is it not? I asked how he could judge by looking what is not honest in a work? He defined honesty in terms of being true to what the artist was trying to do in his art.

MB: How did you become aware of Polke's work?

JF: When all these discussions took place with Dahlem and with Beuys, naturally we also discussed other artists. Who they considered were good artists, those who were part of their circle, and certainly Polke and Baselitz. Beuys was not such a great friend of Baselitz but Dahlem did a lot for Baselitz in the 1960s. Dietmar Werle also brought Polke to my attention. So we were influenced by what they considered good artists. For me Beuys was the institution. If he said, 'This is OK,' I tried to understand it by questioning it.

Vitrine containing
multiples by Joseph
Beuys and scientific
instruments

NS: But in the summer of 1984 you went to the Venice Biennale and as you say you discovered your passion for Nauman.

JF: Yes, it was by accident. I didn't ask Beuys about this, but Nauman was shown with Beuys at an exhibition in Venice during the 1984 Biennale, called *Quartetto*. We saw works which we had never seen before. We saw this narrow corridor which we squeezed through, we saw the floating room. These things were new and unlike what we knew. When I got interested in Warhol it was very easy: consumerism, soup can, Marilyn, disasters. But I think if we had not met Beuys, his work would never have been understandable for me. It was very difficult but then I finally realised that you cannot see a Beuys sculpture like any other sculpture, you must see the life in front of you, its intuition, its feeling.

MB: And Warhol was different because it was an image that you could read.

JF: To discover Warhol ... I think my fascination for him perhaps was because of America. I am sure if I had not been in America I would not have had such an appreciation for Warhol. I was young, I found this new Pop art interesting. But again why Warhol? Why not Lichtenstein? Or why not Rosenquist, Oldenburg, or any of the others? There was something about Warhol, his radical choice and presentation of images, which we understand better today than we did thirty years ago.

NS: Did you act on this passion for Nauman?

JF: Of course. I immediately bought 'Run From Fear' (cat. 140, p. 171) and 'Musical Chair' (cat. 142, p. 168) from Angela Westwater and I bought the drawing 'American Violence' (cat. 141, p. 178) from Donald Young. He also had this huge neon called 'Knows Doesn't Know' (cat. 143, p. 173), but it was reserved for another collector. Then he called me at Christmas and said the collector had decided it was too big for his house, and I was able to buy it. I wasn't surprised, because it is a huge, complicated work. So by 1987 I had Beuys drawings, Polke, Baselitz, Palermo, Nauman, Warhol, Judd ... I got friendly with Leo Castelli and Susan Brundage, the director of Leo's gallery, and bought works by Judd, Artschwager and Serra. I knew I was on the right way. I got myself known.

NS: Which were the works that Beuys made in collaboration with you, the 'works in progress', as you referred to them?

JF: There were three works. The 'Schwan mit Ei' (cat. 96, p. 63), for which I made the zinc case, he later finished by adding a piece of slate incised with the image of a large egg. The sculpture with the lightning conductor was not finished. The one with the working title of 'Beginning of the Colonisation of North America' was almost finished. I had these pitch pine beams brought over from the United States for the floor of our house at Beuys's suggestion. Beuys looked at them and was fascinated by their age and by their structure. He started counting the rings (fig. p. 229) – it was clear that he had some idea in his mind – and I told him that if he wanted to know their age he had to know when they were cut. So I found out where they were from and how old they were. They were salvaged from docks in Baltimore built in 1889–90. The salvage company, Mountain Lumber, told us that they calculated the trees had started growing in Mississippi in 1624. My research said that the first white man in this particular area of America was a Jesuit priest, Jacques Marquette, who arrived at the Mississippi in 1673. Based on this information, we arrived at the conclusion that the tree out of which this beam was cut had about a diameter of two inches at the time when the first white man came to America. Beuys first thought of inserting into the beam a two-inch gold or platinum ring as the instrument of *Verletzung*, of hurting, where the continent was hurt by the white man. Later we decided that steel was the proper material because it rusts. After his death I put the steel ring into the centre of the growth rings in the beam ... that's why I consider it unfinished.

MB: How well did you know Andy Warhol?

JF: Warhol is short ... I was aware of Warhol when I was in America in the early 1960s, and I recall going to an exhibition of his work, probably at the Stable Gallery, when I was in New York for a weekend before I came back to Europe. I returned to America for a visit at the time of the

1964 World's Fair, and while driving into New York from the airport I saw the pavilion with the 'Most Wanted Men' on it. It made a very strong impression on me. Twenty-five years later, in 1989, I loaned three Warhols to The Museum of Modern Art retrospective, and I remember feeling very pleased that they had wanted to borrow my works.

MB: Which work by Warhol did you acquire first?

JF: The first ones were the 'Double Silver Disaster' (cat. 279, p. 198) and the four foot 'Flowers' (cat. 289). Then I bought the signed Brillo box from Marian Goodman, and she made my first contact with Vincent Fremont, who worked for Andy. Anna and I went to the Green Door on 33rd Street and they took us through the studio. Warhol was not there. There was this seven foot flower painting hanging in Vincent's office. I asked how much it was. $350,000! Too expensive! Then, of course, in the meantime I became a Warhol collector.

In July 1986 there was the *Self-Portraits* exhibition at Anthony d'Offay. I bought a series of six 'Self-Portraits' (cat. 306, p. 216). Then later there was a party at the Café Royal. Anthony introduced me. I think this was the first time I had a dialogue with Warhol.

MB: But by then you already had a few of his pieces.

JF: Yes, I had the 'Soup Can' (cat. 275, p. 195) and nine or ten other pieces. I was well on my way as a Warhol collector.

NS: Have your ideas about what is important in Warhol changed in the last ten years?

JF: No, I think I realised very early, and it is not very difficult with Warhol, that the 1960s are the most important phase. What he did with consumerism in America which was just emerging in the 1960s, and his disaster paintings. I don't think I had great difficulty in becoming a mature Warhol connoisseur. I was chasing certain paintings for years, like the 'Double Elvis' (cat. 286, p. 202). I think it took me three or four years. Finally Andrew Fabricant at Gagosian came up with the vintage double Elvis I wanted. There were certain works that I just had to have, like the Marilyn and Marlon, and Elvis.

Joseph Beuys counting the growth rings on pitch pine beams, Summer 1983

MB: So you decided that there were certain Warhol icons that you wanted to have?

JF: I wanted certain Warhols that were from my time in America. Elvis Presley, I was dancing to ... and Marlon Brando was in the movies ... these were my idols. Marilyn, Liz and Jackie, these were my icons. The 'Little Race Riot' (cat. 292, p. 205), for instance, which I got rather late. These riots happened in Birmingham, Alabama, in May 1963, just after I left America. This was all very present for me. I think, definitely, or most likely, I would never have concerned myself with Warhol as I did if I had never been in America as a young man during those crucial years.

MB: Which, coincidentally, were crucial years for Warhol.

JF: Right. I was never interested in pre-Pop paintings from Warhol. For me, it started with the soup can, when he made the soup can into a piece of art and Duchamp remarked, 'If you take a Campbell's soup can and repeat it fifty times, you are not interested in the retinal image. What interests you is the concept that wants to put fifty Campbell soup cans on the wall.' Also there is a famous statement by Warhol which I discovered. He said: 'The Americans are much better at consuming than thinking, and I am as American as they come.'

And then there was the portrait session in London in 1986 (fig. p.230). Andy, Anthony d'Offay, Fred Hughes, Anna and I had lunch. And Fred said 'OK, now let's go to work', so we went in a Rolls Royce to the Ritz. I didn't have a tie so Fred gave me his tie and then Andy got out this big Polaroid camera, and I was sitting there. We tried different poses: smoking, not smoking, smiling, not smiling. And the interesting thing is that Warhol, at lunch, sitting around, was very bored, was not interested in the conversation but as soon as he took this camera in his hand he was a com-

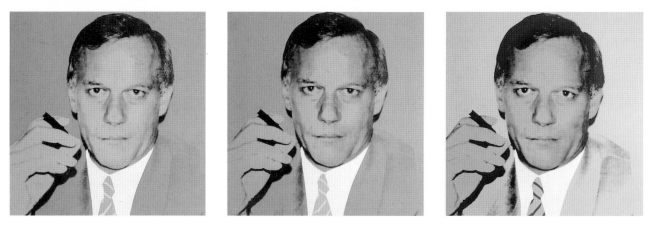

pletely different person. It was so exciting to sit there. He made about twenty-five or thirty shots and then we put them on a table, and very quickly there were only five left. He said, 'Out of these we'll make something. How would you like them?' I said, 'What do you mean?' He said, 'Well, minimalist or expressionist?' I said, 'No, no, I'm a minimalist.' So these were the shots, and then in November Anna and I went to the studio in New York. There were three finished paintings: one dark grey, one light grey and a blue one. I decided then on the dark grey one, and the blue one, but not the third. Then we had lunch together in the studio and Andy said, 'Your wife, what about her? She looks nice,' and it was decided that we would make Anna's portrait. But Warhol died a few months later, in February 1987. The strange thing is that about two weeks before he died, I don't know why, I phoned Fred Hughes and asked about my third painting. I said, 'Make me a good price,' and he did, but said, 'Don't tell anyone; this is because you are a Warhol collector.' So I bought the painting, which arrived after Warhol was dead and so is not signed. It's only authenticated. Don't ask me why I just phoned up, you can call it intuition, which I don't believe in, or a very strange coincidence.

NS: You don't believe in intuition?

JF: My education as an engineer doesn't really let me believe in it, but sometimes I wonder. My *Weltbild* [view of life] does not allow me to, really. You know Einstein once said he didn't believe in God but there was too much order in the universe not to believe in any higher being.

MB: In the same way, are there too many times where intuition has worked for you not to believe in it?

JF: I don't know, do you consider this is intuition? This incident with Warhol or with Beuys, is it intuition or is it just a coincidence? But it is just too much of a coincidence, isn't it? I think you run into these opportunities all the time but the question is, are you ready to do something with it? How do you respond ?

MB: When did you start to think of yourself as a collector? By the time you were having your photograph taken by Warhol you were a Warhol collector.

JF: There were certain times when we were still thinking, how does it fit in our house? Possibly this is one reason why we started out buying smaller works.

NS: But when you bought 'Knows Doesn't Know' (cat. 143, p. 173), you knew you would never be able to show it in your house.

JF: Right, and also the 'Musical Chair' (cat. 142, p. 168). At that time I was not concerned any more about whether it did or did not fit in our house. In 1985 I bought the ten foot 'Flowers' which would never fit in our house, and which I had in my factory. I had a mini-Kunsthalle in my factory on the top floor, 250 square metres where I installed 'Know Doesn't Know', the 'Musical Chair', the 'Flowers' (cat. 289), and a Judd stack. This was a nice little Kunsthalle and after it was finished I realised it was just a little *Spielwiese* [playground], and it didn't make sense in the long run. So I think it was about that time, 1985–6, where we started gradually buying major works where the fascination of the artist counted and size was no longer a concern. The largest work we ever bought is the Frank Stella 'Lo Sciocco Senza Paura' (cat. 236, p. 181). This was a slow pro-

cess you get into when you start buying art and you realise that you can't hang it on your wall. What you see here [at home] is best suited for drawings and smaller formats, there's no question about it. So it was a gradual process, and at this time also the interest in Americans and Germans was intuitive. Later on we made a virtue out of it and decided, only Americans and Germans. The reasons are simple: I lived in both America and Germany, and of course, it was important that we could communicate with the artists.

NS: Why is that important? It's not important for every collector.

JF: I want to know the artist because I want to know the person. What is the person like who creates this work of art? When I see a Nauman and I know Nauman well then I know that it is only possible for Bruce Nauman to come out of America, in particular from the area he is from. Just like a Warhol is only possible as an American and Beuys as a northern European. I am convinced that an artist and his product are one unity. So when I know the work I also want to know the artist.

MB: Is it the personality, or the intelligence or the character?

JF: Everything. Character, personality, intelligence. On second thought I don't think it is their intelligence. It is a way a person behaves, the way he talks, what he does ... it's an attitude and his work is a product of that attitude. Also, the country he is from, the culture. Just like a Beuys could only have happened where he happened, not from the Black Forest. Can you see Andy Warhol coming from Europe? Impossible. Andy is a product of New York. I think it is also important at what time. Beuys was the right man at the right time. If Beuys would come today it wouldn't work, we are in a different culture. Beuys was after the war, today's Beuys would have to be quite different and today's Warhol would be quite different too.

NS: Where did this idea of *Sammlungsblöcke* come from, the concept of collecting each artist in depth?

JF: The first instance was the complete Palermo graphics and multiples in 1982. I purchased them from Fred Jahn and financed the catalogue documenting them. This was at Dahlem's suggestion. Very early, everyone I talked to – whether it was Beuys, or for instance, Adriani – told me not to start accumulating. In German, you won't have a *Sammlung* you will have an *Ansammlung*; that means you won't have a collection, you'll have an accumulation. Very early it made sense to me that if you have one Baselitz, if you have only one whoever it is, you just cannot represent an artist. You are much better off if you try to represent an artist over a certain period of time. Or as with Baselitz and Richter where I only covered certain years but these are for me the most fascinating years. The most recent Baselitz I have is a sculpture from 1990. I have visited Baselitz in his studio several times. Once when I stopped by to see him, he had ten yellow painted wooden sculptures placed in a line. I saw the one I liked best, which Baselitz called 'Jacqueline'. A few months later, Pace Gallery made an exhibition of these sculptures and titled them the 'Women of Dresden.' By this time, Jacqueline's name had been changed to 'Karla' but I bought her anyway (cat. 28, p. 55).

NS: Do you focus on a particular period or type of work?

JF: Not necessarily. A period I like best, this is very simple. When you look at my Polkes this is the period of Polke as I like him best: cynical, reflecting on German culture at that time; and when the 'Higher Beings' commanded him.

MB: What do you admire about artists' drawings?

JF: For me the idea exists that a good artist also must be a good draughtsman. I think here again I am traditional and I think Beuys had an influence on me. Take Nauman, he is a good draughtsman. So is Beuys, beyond any question. Baselitz is probably as good a graphic artist as he is a painter.

MB: And being a good draughtsman is being able to express yourself on paper? Is Polke a good draughtsman?

JF: He is a good draughtsman. In the early works I have, he used paper to develop his own par-

ticular style, which is a bit like cartoons. When you look at my Beuys stacks over there, Beuys had many ways of expressing himself on paper. Baselitz has a certain way which has been changing over the years. With Nauman they are all related to his work, but there is something in it which makes the drawing not just a sketch for a neon.

NS: Who are the artists not of our time who are important to you? You collect some Dürer prints.

JF: Yes, but only by image. I finally have 'Adam and Eve' to complete the images I wanted. Dürer was another fantastic draughtsman. As Vasari said, 'The entire world was astonished by his mastery'. I think also because at that time, Dürer's time, drawing was making a replica of nature, like his animals and plants. This has completely changed, due to photography and computers and everything. But I find it very fascinating to collect these Dürer prints. This is a completely new experience and a learning curve. At the same time I would not want to be just an old master print collector. I think it would be too boring because you are dealing too much with the past. It is much more exciting to deal with the artists of your time. Some people always said to me you are too conservative, you are not collecting forward. I said I can only collect forward if there is interest. I'm doing some forward collecting.

MB: How did you decide to collect Kiefer woodcuts? This is a very specific focus.

JF: I knew Kiefer, there was an exhibition here in the Kunstverein. I don't really know why I did this, but I bought a Rhein very early on, a woodcut. We had this hanging here for a long time and Beuys preferred it to the painting I had at the time, 'Donauquelle'. I started getting interested in Kiefer in discussions with Beuys because Kiefer also was a Beuys student. I came to the conclusion that one of Kiefer's inventions, where he expanded art, was in his woodcuts, by the fact that he composed his woodcuts together.

MB: So he was really reusing an older art form. We saw the large Dürer print, 'The Triumphal Arch', 1515, at the British Museum, remember? It was made out of 192 woodblocks.

JF: Yes, but that was *one* image. Kiefer made a collage out of *many* images. The images like the 'Rhein' (cat. 127, p. 81) and the 'Wege der Weltweisheit' (cat. 125, p. 79) are for me the most fascinating works. I cannot really tell you exactly when I said I want all the major woodcuts. After I had the Rhein I bought 'Grane' (cat. 124, p. 80) and 'Dem unbekannten Maler' (cat. 128, pp. 82–3) and all of a sudden I said, 'What do I need now?' I needed 'Wege der Weltweisheit'. I looked at several and I finally found the one I wanted from Heiner Bastian. It was not a matter of getting all four woodcuts, but once you have two or three you say, 'Well, what else is there?'

MB: So the collection grows by looking at the collection.

JF: Exactly. As Heidegger says, *Besinnung* makes a collection – this point was made in an article written by Günther Gercken.[1] I made my mistakes in collecting. We didn't go about it in a very strategic way but the closer we came to the target I think the easier we found what we should and shouldn't do. We didn't sit down and decide to start with Beuys, or with Warhol. We didn't sit down and say let's collect and how do we collect and what do we collect. Also our interests have changed, some artists are no longer in the collection and some came into the collection later. Now there's more focus.

NS: Most of the artists in the foundation are from two generations. There is only one artist who comes from the next generation, so why Trockel?

JF: The main reason for Trockel is because I see in her work a continuation with Beuys. I don't think she ever studied with Beuys but when you see her early work, I think we can agree that this is very Beuys. Also I think she left him behind when she produced the stockings and the knittings. I think she was probably one of the most interesting artists of the 1980s in Germany and she's a good draughtsman. I became very interested in her sculptures.

NS: What was this quote of Heidegger that you said before: 'Thinking is ... thought makes a collection'?

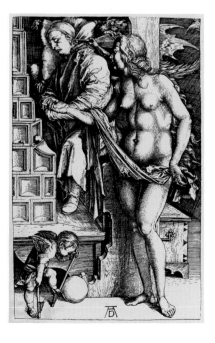

Albrecht Dürer
'The Temptation of the Idler'; or, 'The Dream of the Doctor', 1498
Copper engraving
Collection Josef and Anna Froehlich, Stuttgart

232

JF: *Nein.* In German Heidegger said '*die Besinnung erbringt eine Sammlung*'. Of course, Heidegger was not writing about a collection of objects, he used *Sammlung* to refer to a state of concentration or composure, but I think the statement can have a broader meaning. In English, I looked it up, *Besinnung* in this case is 'thinking of'. Contemplating is not quite the right word. To 'make thought of', or 'reflection'? I have decided that the proper word for *besinnung* in this context is 'thinking about', by using a combination of analysis, intuition and discipline. That's what leads to forming a collection. The word 'collection' is also not quite right because collection always has a connotation of quantity rather than quality. But we don't have any better word. In German we have the word *Sammlung* and in English you have the word collection. When you say collection it is just like a jewellery or a stamp collection. There is always the suggestion of quantity and not quality. You cannot really collect quality can you?

MB: Of course you can.

JF: You can collect quality when it comes to art but you cannot have a collection of quality.

MB: No, quality is not a commodity.

JF: No ... what does it really mean to be a collector?

MB: It's the collection that defines the collector.

JF: That's exactly it.

1 Günther Gercken, 'Privates und öffentliches Sammeln zeitgenössischer Kunst', *Kunst-Bulletin* no. 5, 1984, p. 8–15.

Anna and Josef
Froehlich
1994
Galerie der Stadt
Esslingen

Catalogue of the Froehlich Foundation and Collection

Angelika Thill
in co-operation with Brigitte Kölle

This catalogue of the works of the Froehlich Foundation and Collection is arranged alphabetically by artist and chronologically for the works of each artist according ot the year of completion.

A selected bibliography is given for every artist which lists in chronological order publications which have been cited in the 'Exhibitions and Literature' section of the entries. The abbreviations for each title in the bibliography are used in this section.

Each entry consists of catalogue number and illustration page reference, title, date, medium, dimensions and inscriptions. Dimensions are given in centimetres followed by inches, height preceding width and followed by depth in the case of sculptures and constructions. For cast sculpture, the cast number and size of the edition are indicated. Publishers for prints and multiples are given, with edition number followed by size of edition.

Provenance, exhibition history (with and without catalogues) and additional literature on the work (e.g. monographs, auction or collection catalogues, articles, etc.) are also given for each work.

Where possible, all data have been checked against the original works of art and therefore may differ from previously published data.

The Froehlich Collection includes the complete graphic work and multiples made by Blinky Palermo. They are not listed indivually in this catalogue, but are represented by one example, 'Blaues Dreieck' (cat. 160-a). A complete listing of these graphics and multiples is published in 'Mönchengladbach 1983' cited in the Palermo bibliography.

Index of abbreviations

auct. cat.	auction catalogue
b.	bottom
cat. no.	catalogue number
coll. cat.	collection catalogue
diss.	dissertation
ed.	editor
eds.	editors
et. al.	and others
exh. cat.	exhibition catalogue
l.	left
m.	middle
no cat.	no catalogue
not exh.	not exhibited
not in cat.	not in catalogue
p.	page
pp.	pages
r.	right
repr.	reproduction
t.	top
unpag.	unpaginated
vol.	Volume

CARL ANDRE
born 1935 in Quincy, Massachusetts
lives in New York

Bibliography
The Hague 1969
Carl Andre, exh. cat. Haags Gemeentemuseum, The Hague, Aug. – Oct. 1969
New York 1970
Carl Andre, exh. cat. Solomon R. Guggenheim Museum, New York, Sept. – Nov. 1970
Berne 1975
Carl Andre: Sculpture 1958 – 1974, exh. cat. Kunsthalle Bern, April – June 1975
Andre, Le Va, Long, Washington 1976
Andre, Le Va, Long, exh. cat. Corcoran Gallery of Art, Washington 1976–7
Eindhoven 1978
Carl Andre. Wood, exh. cat. Stedelijk van Abbemuseum, Eindhoven, Nov. – Dec. 1978
Andre, Flavin, Judd ..., Greenwich 1978
Carl Andre, Dan Flavin, Donald Judd, Richard Long, Brenda Miller, Michael Singer, exh. cat. Hurlbutt Gallery, Greenwich Library, Greenwich, Conn., 1978
Grids, New York 1978
Grids. Format and Image in 20th Century Art, exh. cat. Pace Gallery, New York 1978–9; Akron Art Institute, Ohio, 1979
Minimalism, New York 1982
Diane Waldman (ed.), *Minimalism x 4. An exhibition of sculpture from the 1960s. Robert Morris, Carl Andre, Sol Lewitt, Donald Judd*, exh. cat. Whitney Museum of American Art, New York 1982
The Hague 1987
Carl Andre, exh. cat. Haags Gemeentemuseum, The Hague, and Stedelijk van Abbemuseum, Eindhoven, Jan. – March 1987
Polke, Andre, Munich 1989
Polke, Andre. Eine Gegenüberstellung, exh. cat. Kunstforum München, 1989
Krefeld 1996
Carl Andre Sculptor 1996, exh. cat. Kaiser-Wilhelm-Museum, Krefeld, and Kunstmuseum Wolfsburg, Feb. – April 1996

cat. 1, ill. p. 135
Posts on Threshold (Element Series)
1960 [designed], 1971 [executed]
Western red cedar
three parts, each 30.4 x 30.4 x 91.4;
overall 121.9 x 91.4 x 30.4 (each 12 x 12 x 36; overall 48 x 36 x 12)

Provenance
Russell Cowles, Minneapolis
Private collection, Cannes
Elisabeth and Gerhard Sohst, Hamburg
acquired 1992

Exhibitions and Literature
Locksley – Shea Gallery, Minneapolis 1971 [no cat.]
Berne 1975, cat. no. 1960-7, p. 15 [under the title 'Post and Threshold (Element Series)']

Eindhoven 1978, cat. no. 48, repr. unpag.
Sperone Westwater Fischer, New York 1978 [no cat.]
The Hague 1987, cat. no. 1960-7, repr. p. 13
Krefeld 1996, cat. no.8 p., repr. 81

Extended loan to Kunsthalle Hamburg since 1994

cat. 2, ill. p. 136
Steel Row
1967
Hot rolled steel
twelve parts, each 38.1 x 53.2 x 1;
overall 50.8 x 457.2 x 1 (each 15 x 21 x 3/8; overall 20 x 180 x 3/8)

Provenance
Dwan Gallery, New York
Annina Nosei Weber, Ronald Feldman, Los Angeles
Francesco Pellizzi, New York
Gagosian Gallery, New York
acquired 1987

Exhibitions and Literature
Dwan Gallery, New York 1967 [no cat.]
The Hague 1969, repr. p. 53 [under the title '12 Pieces of Steel']
New York 1970 [under the title '12 Pieces of Steel'], cat. no. 19, repr. p. 44
Berne 1975, cat. no. 1967–1, p. 25
Minimalism, New York 1982, repr. unpag.
The Hague 1987, cat. no. 1967–1
Ein Blick auf die Kunst der 70er Jahre aus einer Stuttgarter Privatsammlung: Andre, Chamberlain, Flavin, Judd, Nauman, Künstlerhaus Stuttgart, 1989 [no cat.]
Krefeld 1996, cat. no. 29, repr. p. 133

cat. 3, ill. p. 137
Aluminum-Steel Plain
1969
Aluminum and steel
thirty-six parts, each 0.8 x 30.5 x 30.5;
overall 0.8 x 182.8 x 182.8 (each 3/8 x 12 x 12; overall 3/8 x 72 x 72)

Provenance
Paula Cooper Gallery, New York
Mr. and Mrs. Paul Anka, Los Angeles
Gagosian Gallery, New York
Sotheby's New York, 25.2.1993, Sale 6397, Lot 325
acquired 1993

Exhibitions and Literature
New York 1970 [not in cat.]
Berne 1975, cat. no. 1969-49, p. 47
Andre, Le Va, Long, Washington 1976 [not in cat.]
Andre, Flavin, Judd ..., Greenwich 1978 [not in cat.]
Grids, New York 1978, repr. unpag.
Summer Show, Sperone Westwater Fischer, New York 1979 [no cat.]
Invitational, Brown University, Providence, Rhode Island, 1980 [no cat.]

5

Art Into Landscape, Harold Reed Gallery,
New York 1980 [no cat.]
The Hague 1987, cat. no. 1969-52, repr. p. 43
Andre, Polke, Munich 1989, repr. 4
Krefeld 1996, cat. no. 47, repr. p. 175

Sotheby's New York, auct. cat. Sale 6397, 1993,
Lot 325, repr.

RICHARD ARTSCHWAGER
born 1924 in Washington, D. C.
lives in New York

Bibliography

Castelli, New York 1967
 Leo Castelli: Ten Years, exh. cat. Leo Castelli
 Gallery, New York 1967
American Art, St. Louis 1969
 *American Art in St. Louis. Paintings,
 Watercolors and Drawings Privately Owned,*
 exh. cat. Art Museum of St. Louis 1969
Chicago 1973
 Richard Artschwager, exh. cat. Museum of
 Contemporary Art, Chicago, Feb. – March
 1973
Hamburg 1978
 *Richard Artschwager. Beschreibungen,
 Definitionen, Auslassungen,* exh. cat.
 Kunstverein in Hamburg, Sept. – Oct. 1978
Buffalo 1979
 Richard Artschwager's Theme(s), exh. cat.
 Albright-Knox Art Gallery, Buffalo, July – Aug.
 1979; Institute of Contemporary Art,
 University of Pennsylvania, Oct. – Nov. 1979;
 et al.
Biennale, Venice 1980
 La Biennale di Venezia. General Catalogue,
 exh. cat. Venice 1980
Duisburg 1982
 Richard Artschwager, exh. cat. Wilhelm
 Lehmbruck Museum, Duisburg 1982
documenta 7, Kassel 1982
 documenta 7, exh. cat., vols. 1 and 2, Kassel
 1982
Alibis, Paris 1984
 Alibis, exh. cat. Musée national d'art moder-
 ne, Centre Georges Pompidou, Paris 1984
Content, Washington 1984
 Content. A Contemporary Focus 1974 – 1984,
 exh. cat. Hirshhorn Museum and Sculpture
 Garden, Washington 1984
The Tremaine Collection, Hartford 1984
 *The Tremaine Collection: 20th Century
 Masters – The Spirit of Modernism,* exh. cat.
 Wadsworth Atheneum, Hartford, Conn., 1984
Saatchi Collection, London 1984
 Art of Our Time – The Saatchi Collection,
 coll. cat., vol. 2, London 1984
Basle 1985
 Richard Artschwager, exh. cat. Kunsthalle
 Basel, Oct. – Nov. 1985; Stedelijk Van
 Abbemuseum, Eindhoven, Nov. 1985 – Jan.
 1986; et al.
New York 1986
 Richard Artschwager, exh. cat. Mary Boone
 and Michael Werner Gallery, New York, Oct.
 1986
L'Epoque, Paris 1987
 L'Epoque, la Mode, la Morale, la Passion,
 exh. cat. Musée national d'art moderne,
 Centre Georges Pompidou, Paris 1987
New York 1988
 Richard Armstrong (ed.), *Richard
 Artschwager,* exh. cat. Whitney Museum of
 American Art, New York, Jan. – April 1988;
 San Francisco Museum of Modern Art, June –
 Aug. 1988; et al.
Paris 1989
 Artschwager, Richard, exh. cat. Musée natio-
 nal d'art moderne, Centre Georges Pompidou,
 Paris, July – Sept. 1989
The Times, New York 1990
 Douglas Blau (ed.), *The Times, The Chronicle
 & The Observer,* exh. cat. Kent Fine Art, New
 York 1990
Devil on Stairs, Philadelphia 1991
 *Devil on the Stairs. Looking Back on the
 Eighties,* exh. cat. Institute of Contemporary
 Art, Philadelphia; Newport Harbor Art
 Museum, Newport Beach 1991–2
Neue Möbel, Esslingen 1994
 *Neue Möbel für die Villa. New Furniture for
 the Villa,* exh. cat. Villa Merkel, Galerie der
 Stadt Esslingen, Stuttgart 1994

cat. 4, ill. p. 142
Untitled (Girls)
1963 – 4
Acrylic on Celotex
74.9 x 74.9 (29 1/2 x 29 1/2)
recto signed and dated '1964'

Provenance
Leo Castelli Gallery, New York
Private collection
Sotheby's New York, Sale 6694, Jan. 1995,
Lot 25
acquired 1995

Exhibitions and Literature
Sotheby's New York, auct. cat. Sale 6694, 1995,
Lot 25, repr.

cat. 5
Mirror
1964
Formica
154.9 x 109.2 x 10.2 (61 x 43 x 4)

Provenance
Leo Castelli Gallery, New York
Galerie Neuendorf, Hamburg
Saatchi Collection, London
Sotheby's New York, 3.10.1991, Sale 6213,
Lot 95
acquired 1991

Exhibitions and Literature
Chicago 1973, repr. unpag.
Duisburg 1982, repr. p. 118
Basle 1985, cat. no. 5, repr. unpag.

Hamburg 1978, cat. no. 4, [repr. p. 30, drawing
under the title 'Formica-Mirror']
The Saatchi Collection, London 1984, cat. no. 4,
repr. unpag.
Sotheby's New York, auct. cat. Sale 6213, 1991,
Lot 95, repr.

cat. 6
Chest of Drawers
1964 [remade 1979]
Formica on wood
91.4 x 106.7 x 35.5 (36 x 42 x 14)

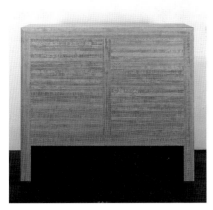

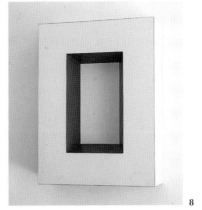

8

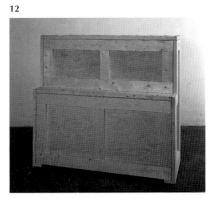

Provenance
Texas Gallery, Houston
Mary Boone Gallery, New York
Thomas Segal Gallery, Los Angeles
Margo Leavin Gallery, Los Angeles
Leo Castelli Gallery, New York
acquired 1987

Exhibitions and Literature
Buffalo 1979 [not in cat.]
New York 1986 [not in cat.]
Thomas Segal Gallery, Los Angeles, Nov. 1986 –
Jan. 1987 [no cat.]
Margo Leavin Gallery, Los Angeles, March –
Dec. 1987 [no cat.]
New York 1988, cat. no. 26, repr. p. 70
Neue Möbel, Esslingen 1994 [not in cat.]

Paris 1989, repr. p.48 [not exh.]

cat. 7, ill. p. 140
Handle
1965
Formica on wood
108.3 x 33.3 x 30.8 (42 5/8 x 13 1/8 x 12 1/8)

Provenance
Leo Castelli Gallery, New York
Galerie Neuendorf, Hamburg
Saatchi Collection, London
Sotheby's New York, 13.11.1991, Sale 6237, Lot
142
acquired 1991

Exhibitions and Literature
Richard Artschwager, Leo Castelli Gallery,
New York 1967–8 [no cat.]
Biennale, Venice 1980, p. 51
Basle 1985, cat. no. 9, p. 8, repr. unpag.

Kunstforum International, vol. 38, April 1980,
repr. p. 59
The Saatchi Collection, London 1984, cat. no. 6,
repr. unpag.
Sotheby's New York, auct. cat. Sale 6237, 1991,
Lot 142, repr.

cat. 8
Relief I
1965
Formica on wood
72.8 x 55 x 18.8 (28 5/8 x 21 5/8 x 7 3/8)

Provenance
Leo Castelli Gallery, New York
Mr. and Mrs. Burton Tremaine, Meriden, Conn.
Christie's New York, 9.11.1988, Sale 6722,
Lot 19

Exhibitions and Literature
Richard Artschwager, Leo Castelli Gallery,
New York, Jan. – Feb. 1965 [no cat.]
Castelli, New York 1967, repr. unpag.
Buffalo 1979, repr. p. 40
The Tremaine Collection, Hartford 1984,
repr. p. 126

Christie's New York, auct. cat. Sale 6722, 1988,
Lot 19, repr.

cat. 9, ill. p. 141
Chair/Chair
1965 [remade 1977]
Formica on wood
91.4 x 91.4 x 50.8 (36 x 36 x 20)

Provenance
Daniel Weinberg, Los Angeles
Mr. and Mrs. Harry Macklowe, New York
Gagosian Gallery, New York
acquired 1994

Exhibitions and Literature
Buffalo 1979, repr. p. 37
New York 1986, repr. unpag.
New York 1988, cat. no. 31, repr. p. 75

cat. 10, ill. p. 143
Office Scene
1966
Acrylic on Celotex with metal frame
106.5 x 109 (42 x 43)

Provenance
Leo Castelli Gallery, New York
Mr. and Mrs. Sidney S. Cohen, St. Louis
Greenberg Gallery, St. Louis
Fay Gold Gallery, Atlanta
Saatchi Collection, London
Mr. and Mrs. Brooks Barron, Detroit
Sotheby's New York, 7.5.1992, Sale 6290,
Lot 151
acquired 1992

Exhibitions and Literature
American Art, St. Louis 1969
Chicago 1973, repr. unpag. [under the title
'Office']
Buffalo 1979, repr. p. 49
New York 1988, cat. no. 39, repr. p. 82
Paris 1989, repr. p. 60

John Russell, 'Artschwager's Climate of
Ambiguity', in: *New York Times,* 22. 7. 1979,
repr. unpag.
The Saatchi Collection, London 1984, cat. no. 9,
repr. unpag.
The Times, New York 1990, cat. no. 2, unpag.
[not exh.]
Sotheby's New York, auct. cat. Sale 6290, 1992
Lot 151, repr.

cat. 11, ill. p. 139
Tower III (Confessional)
1980
Formica and oak
152.4 x 119.4 x 81.3 (60 x 47 x 32)

Provenance
Leo Castelli Gallery, New York
Saatchi Collection, London
Sotheby's New York, 1.11.1994, Sale 6616,
Lot 58
acquired 1994

Exhibitions and Literature
Richard Artschwager, Lawrence/New York, 1980
[no cat.]
Richard Artschwager, Leo Castelli Gallery,
New York 1981 [no cat.]
documenta 7, Kassel 1982, vol. 2, repr. p. 20
Group Show, Ronald Feldman Gallery, New
York 1983 [no cat.]
Alibis, Paris 1984, repr. p. 48
Content, Washington 1984, cat. no. 14,
repr. p. 48
Basle 1985, p. 10, cat. no. 29, repr. unpag.
L'Epoque, Paris 1987, repr. p. 96
New York 1988, cat. no. 81, repr. 88, p. 131
Paris 1989, repr. p. 86
Devil on the Stairs, Philadelphia 1991,
cat. no. 64, repr. p. 53

William Zimmer, 'Furniture Outlets (or Formica
follows functions)', in: *The Soho News,*
1.12.1981, repr. p. 48
Coosje van Bruggen, 'Richard Artschwager', in:
Artforum, Sept. 1983, no. 22, repr. p. 49
The Saatchi Collection, London 1984,
cat. no. 17, repr. unpag.
S. H. Madoff, 'Richard Artschwager's Sleight of
Mind', in: *ARTNews,* no. 87, Jan. 1988, p. 121
Sotheby's New York, auct. cat. Sale 6616, 1994,
Lot 58, repr.

cat. 12
Untitled (Piano)
1994
Wood
147.3 x 160 x 50.8 (58 x 63 x 20)

Provenance
Mary Boone Gallery, New York
acquired 1995

Exhibitions and Literature
Richard Artschwager, Mary Boone Gallery, New
York, Nov. 1994 [no cat.]

GEORG BASELITZ
born 1938 in Deutschbaselitz, Saxony
lives in Derneburg

Bibliography
Berlin 1963
 Georg Baselitz, exh. cat. Galerie Werner und
 Katz, Berlin 1963
Munich 1966
 Baselitz. Ölbilder und Zeichnungen, exh. cat.
 Galerie Friedrich & Dahlem, Munich, June –
 Aug. 1966
Basle 1970
 Georg Baselitz. Zeichnungen, exh. cat.
 Kunstmuseum Basel, April – May 1970
Berne 1976
 *Baselitz. Malerei, Handzeichnungen,
 Druckgraphik,* exh. cat. Kunsthalle Bern, Jan.
 – March 1976
Villa Romana, Baden-Baden 1977
 *Zum Beispiel Villa Romana, Florenz – Zur
 Kunstförderung in Deutschland,* exh. cat.
 Staatliche Kunsthalle Baden-Baden, 1977;
 Palazzo Strozzi, Florence 1977
Braunschweig 1981
 Georg Baselitz, exh. cat. Kunstverein
 Braunschweig, Oct. – Nov. 1981
Düsseldorf 1981
 Georg Baselitz – Gerhard Richter, exh. cat.
 Städtische Kunsthalle Düsseldorf, May – July
 1981
London 1982
 Georg Baselitz. Paintings 1966 – 69, exh. cat.
 Anthony d'Offay Gallery, London, Nov. –
 Dec. 1982
Mythe, Drame, Tragédie, Saint Étienne 1982
 Mythe, Drame, Tragédie, exh. cat. Musée
 d'art et d'industrie, Saint Étienne 1982
Zeitgeist, Berlin 1982
 Christos M. Joachinides and Norman Rosen-
 thal (eds.), *Zeitgeist. Internationale Kunst-
 ausstellung Berlin 1982,* exh. cat. Martin-
 Gropius-Bau, Berlin 1982; Berlin 1982
 [English edition: *Zeitgeist,* Royal Academy,
 London 1982]
Cologne 1983
 Georg Baselitz. Holzplastiken, exh. cat.
 Galerie Michael Werner, Cologne, Jan. 1983
London 1983
 Baselitz. Paintings 1960 – 83, exh. cat. The
 Whitechapel Art Gallery, London, Sept. –
 Oct. 1983; Stedelijk Museum, Amsterdam,
 Jan. – March 1984; et al.
Bordeaux 1983
 Baselitz. Sculptures, exh. cat. Musée d'art
 contemporain de Bordeaux, March – April
 1983
Expressions, St. Louis 1983
 Expressions: New Art from Germany, exh. cat.
 St. Louis Art Museum, 1983; The Institute for
 Art and Urban Resources (P. S. 1), Long Island
 City 1983; et al.; Munich 1983
Vancouver 1984
 Georg Baselitz, exh. cat. Vancouver Art
 Gallery, Nov. 1984 – Jan. 1985
Légendes, Bordeaux 1984
 Légendes, exh. cat. Musée d'art
 contemporain, Bordeaux 1984
London 1985
 Georg Baselitz. Paintings 1964 – 67, exh.cat.
 Anthony d'Offay Gallery, London, May 1985

Bielefeld 1985
 Georg Baselitz. Vier Wände, exh. cat.
 Kunsthalle Bielefeld 1985
Paris 1985
 *Georg Baselitz. Sculptures et Gravures
 Monumentale,* exh. cat. Bibliothèque
 Nationale, Paris 1985
European Iceberg, Toronto 1985
 Germano Celant (ed.), *The European Iceberg.
 Creativity in Germany and Italy Today,*
 exh. cat. Art Gallery of Ontario, Toronto;
 Milan 1985
Basle 1986
 Georg Baselitz, exh. cat. Galerie Beyeler,
 Basle, April – June 1986
New German Art, Adelaide 1986
 Wild Visionary Spectral: New German Art,
 exh. cat. Art Gallery of South Australia,
 Adelaide 1986; Art Gallery of Western
 Australia, Perth 1986; et al.
Hanover 1987
 Carl Haenlein (ed.), *Georg Baselitz.
 Skulpturen und Zeichnungen, 1979 – 1987,*
 exh. cat. Kestner-Gesellschaft, Hanover,
 May – July 1987
London 1987
 Georg Baselitz. Sculpture & Early Woodcuts,
 exh. cat. Anthony d'Offay Gallery, London,
 Dec. 1987 – Jan. 1988
Frankfurt 1988
 *Georg Baselitz. Der Weg der Erfindung.
 Zeichnungen, Bilder, Skulpturen,* exh. cat.
 Städtische Galerie im Städelschen
 Kunstinstitut, Frankfurt a. M., May – Aug.
 1988
Franzke, *Baselitz,* 1988
 Andreas Franzke, *Georg Baselitz,* Munich
 1988
Florence 1988
 Georg Baselitz. Dipinti 1965 – 1987, exh. cat.
 Centro Mostre di Firenze, Sala d'Arme di
 Palazzo Vecchio, Florence, April – June 1988;
 Hamburger Kunsthalle, July – Sept. 1988,
 Milan 1988
Tokyo 1988
 Georg Baselitz. Paintings, exh. cat. Akira Ikeda
 Gallery, Tokyo, Feb. 1988
Zurück zur Natur, Karlsruhe 1988
 *Zurück zur Natur, aber wie? Kunst der letzten
 20 Jahre,* exh. cat. Städtische Galerie im Prinz
 Max Palais, Karlsruhe 1988
Skulptur, Darnétal 1989
 Skulptur, exh. cat. Darnétal, Éditions de la dif-
 ference, Paris 1989
New York 1990
 Georg Baselitz. The Women of Dresden, exh.
 cat. The Pace Gallery, New York, Oct. – Dec.
 1990
Zurich 1990
 Georg Baselitz, exh. cat. Kunsthaus Zürich,
 May – July 1990; Städtische Kunsthalle
 Düsseldorf, July – Sept. 1990
Barcelona 1990
 Georg Baselitz, exh. cat. Centre Cultural de la
 Fundació Caixa de Pensions, Barcelona, Feb.
 – April 1990; Sala de Exposiciones de la
 Fundación Caja de Pensiones, Madrid, May –
 July 1990
La Sculpture Contemporaine, Paris 1991
 La Sculpture Contemporaine après 1970, exh.
 cat. Fondation Daniel Templon Musée
 Temporaire, Paris 1991

Autorittrato, Lucerne 1991
 Autorittrato del Blu in Prussia, exh. cat.
 Kunsthalle Lucerne 1991
Munich 1992
 Georg Baselitz. Retrospektive 1964 – 1991,
 exh. cat. Kunsthalle der Hypo-Kulturstiftung,
 Munich, March – May 1992; Scottish
 National Gallery of Modern Art, Edinburgh,
 May – July 1992; et al.
Transform, Basle 1992
 *Transform: Bild Objekt Skulptur im 20. Jahr-
 hundert,* exh. cat. Kunstmuseum und
 Kunsthalle Basel, 1992
de Méredieu, *Artaud,* 1992
 Florence de Méredieu, *Antonin Artaud – les
 covilles de l'Ange,* Paris 1992
Karlsruhe 1993
 *Georg Baselitz. Gemälde: Schöne und
 häßliche Porträts,* exh. cat. Städtische Galerie
 im Prinz Max Palais, Karlsruhe, June – Sept.
 1993; Neue Galerie der Stadt Linz, Oct. –
 Dec. 1993
Humlebaek 1993
 Baselitz. Vaerker fra 1990 – 93, exh. cat.
 Louisiana Museum of Modern Art,
 Humlebaek, May 1993
Peinture, Bordeaux 1993
 Peinture: Emblèmes et Références, exh. cat.
 Musée d'art contemporain, Bordeaux 1993 – 4
Stuttgart 1994
 Georg Baselitz. Druckgrafik 1965 – 1992,
 exh. cat. Sara bilden Art Museum, Tampere,
 Sept. – Oct. 1994; Kunstakademie Riga, Nov.
 – Dec. 1994; et al., Stuttgart 1994
Saarbrücken 1994
 Georg Baselitz. Werke 1981 – 1993, exh. cat.
 Saarland Museum, Saarbrücken, Feb. – April
 1994, Stuttgart 1994
Hamburg 1994
 Georg Baselitz. Skulpturen, exh. cat.
 Kunsthalle, Hamburg, Feb. – April 1994,
 Stuttgart 1994
Painting, Drawing & Sculpture, London 1994
 Painting, Drawing & Sculpture, exh. cat.
 Anthony d'Offay Gallery, London 1994
The Romantic Spirit, Edinburgh 1994
 *The Romantic Spirit in German Art 1790 –
 1990,* Royal Scottish Academy and The
 Fruitmarket Gallery, Edinburgh 1994;
 Hayward Gallery, South Bank Centre, London
 1994 – 5; Stuttgart 1994 [German edition see:
 Der Geist der Romantik, Munich 1995]
Der Geist der Romantik, Munich 1995
 *Ernste Spiele. Der Geist der Romantik in der
 deutschen Kunst 1790 – 1990,* exh. cat. Haus
 der Kunst, Munich 1995, Stuttgart 1995 [origi-
 nal edition see: *The Romantic Spirit,*
 Edinburgh 1994]
New York 1995
 Diane Waldman (ed.), *Georg Baselitz,* exh.
 cat. The Solomon R. Guggenheim Museum,
 New York, May – Sept. 1995; Los Angeles
 County Museum of Art, Los Angeles, Oct.
 1995 – Jan. 1996; et al.
Berlin 1996
 Georg Baselitz, Ausst.-Kat. Nationalgalerie
 Berlin, Mai – Sept. 1996

14

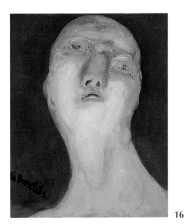

16

21

cat. 13, ill. p. 53
Große Nacht
Big Night
1962
Watercolour and pencil on paper
63 x 48 (24 7/8 x 18 15/16)
recto b. r. 'G. Baselitz 62' and verso b. m.
'"Große Nacht" G. Baselitz 1962'

Provenance
Hahn Collection, Cologne
Rudolf Zwirner, Cologne
David Zwirner, New York
acquired 1995

Exhibitions and Literature
Berlin 1963 [not in cat.]
Frankfurt 1988, cat. no. 125, repr. p. 102

cat. 14
Kopf Antonin Artaud
Head of Antonin Artaud
1962
Ball-point pen on paper
29.7 x 21.1 (11 5/8 x 8 3/8)
recto b. m. 'A. A.' and b. r. 'A. Artaud
G. Baselitz'

Provenance
Franz Dahlem, Darmstadt
Ludwig Rinn, Munich
Hahn Collection, Cologne
David Zwirner, New York
acquired 1994

Exhibitions and Literature
Basle 1970, cat. no. 26
Frankfurt 1988, cat. no. 114, repr. p. 90
New York 1995, cat. no. 22, repr. p. 21

de Méredieu, *Artaud,* 1992, repr. title page

cat. 15, ill. p. 47
Hommage à Wrubel – Michail Wrubel – 1911
1963
Oil on canvas
162 x 146 (63 3/4 x 57 1/2)
recto b. l. 'G. B. 63' and verso t. l. 'G Baselitz
1963 Hommage à Wrubel "Michael Wrubel"
[in Cyrillic] – 1911' and on the stretcher
'Baselitz 1963 "alte Heimat – Scheide der
Existenz"' [title of the overpainted painting]

Provenance
...
Krätz Collection, Buchschlag
Sotheby's New York, 14.11.1991, Sale 6263,
Lot 3
acquired 1991

Exhibitions and Literature
Galerie Werner & Katz, Berlin 1963
Frankfurt 1988, cat. no. 39, repr. p. 117
Stuttgart 1994, repr. 4, p. 17
New York 1995, cat. no. 26, repr. p. 23

Franzke, *Baselitz,* 1988, cat. no. 26, repr. p. 40
Sotheby's New York, auct. cat. Sale 6263, 1991,
Lot 3, repr.
Karlsruhe 1993, repr. p. 79 [not exh.]

cat. 16
P. D. Idol
1964
Oil on canvas
101 x 81.5 (39 3/4 x 32 1/8)
recto b. l. 'G Baselitz' and verso t. on the stret-
cher 'G. Baselitz P.D. Idol'

Provenance
Helmut Klinker, Bochum
...
Thomas Borgmann, Cologne
acquired 1983–4

Exhibitions and Literature
Munich 1966, repr. 1, upag.
Frankfurt 1988, cat. no. 45, repr. p. 139

Franzke, *Baselitz,* 1988, cat. no. 41, repr. p. 48

cat. 17, ill. p. 52
Peitschenfrau
Whip Woman
1964
Pencil on paper
62.5 x 48.5 (24 5/8 x 19 1/8)
recto b. m. 'Baselitz' and verso b. r. 'G. Baselitz
64 Peitschenfrau'

Provenance
Johannes Gachnang, Berne
acquired 1995

Exhibitions and Literature
Basle 1970, cat. no. 61

cat. 18, ill. p. 48
Der neue Typ
The New Type
1965
Oil on canvas
162 x 130 (63 3/4 x 51 1/8)
recto b. r. 'G. B.' and verso t. l. 'G. Baselitz 65
Der neue Typ'

Provenance
Verlag Gachnang & Springer, Berne – Berlin
acquired 1993

Exhibitions and Literature
Berne 1976, cat. no. 4, repr. 4, unpag.
Stuttgart 1994, repr. 5, p. 18
The Romantic Spirit, Edinburgh 1994, cat. no.
262, repr. p. 442; *Der Geist der Romantik,*
Munich 1995, cat. no. 6, repr. 25, p. 104
New York 1995, cat. no. 44, repr. unpag.
Berlin 1996, Kat. 45

Villa Romana, Baden-Baden 1977, repr. p. 91
[not exh.]

cat. 19, ill. p. 52
Ohne Titel (Ein neuer Typ)
Untitled (A New Type)
1965
Pencil and charcoal on packing paper
61.5 x 50 (24 1/4 x 19 3/4)
signed recto b. l. 'Baselitz 67' and b. r. 'G B'

Provenance
Johannes Gachnang, Berne
acquired 1996

Exhibitions and Literature
Autorittrato, Lucerne 1991 [not in cat.]

cat. 20, ill. p. 53
Soldat
Soldier
1965
Gouache and chalk on paper
66 x 48.3 (26 x 19)
signed recto b. 'G. B.' and signed verso

Provenance
Heiner Friedrich Galerie, Cologne
Galerie Michael Werner, Cologne
Hahn Collection, Cologne
David Zwirner, New York
acquired 1994

Exhibitions and Literature
Expressions, St. Louis 1983 [not in cat.]

cat. 21
Der Baum
The Tree
1966
Oil on canvas
162 x 130 (64 x 51)
recto b. r. 'Baselitz' and verso t. m. on the
stretcher 'G. Baselitz, Der Baum 66'

Provenance
Franz Dahlem, Darmstadt
...
Galerie Neuendorf, Hamburg
Anthony d'Offay Gallery, London
acquired 1986

Exhibitions and Literature
London 1983, repr. p. 74
London 1985, cat. no. 9, repr. unpag.
Bielefeld 1985, cat. no. 4, repr. p. 121
Florence 1988, cat. no. 10, repr. p. 41

cat. 22, ill. p. 49
Vier Streifen (G. Antonin)
Four Stripes (G. Antonin)
1966
Oil on canvas
200 x 140 (78 3/4 x 55)
verso t. l. 'Baselitz 1966 vier Streifen G. Antonin'

Provenance
Galerie Neuendorf, Hamburg
Galerie Gillespie-Laage-Solomon, Paris
Private collection, Germany
Anthony d'Offay Gallery, London
Astrup Collection, Oslo
Anthony d'Offay Gallery, London
acquired 1995

Exhibitions and Literature
London 1982, cat. no. 4, repr. unpag.
Mythe, Drame, Tragédie, Saint Étienne 1982,
cat. no. 10, repr. p. 34 [under the title 'Vier
Streifen, Mann in dreigeteilt']

23

27

London 1985, cat. no. 15, repr. unpag.
New German Art, Adelaide 1986, cat. no. 1,
repr. p. 29
Painting, Drawing & Sculpture, London 1994,
cat. no. 5

Peinture, Bordeaux 1993, repr. p. 49 [not exh.]

cat. 23
Ohne Titel (Mann am Baum)
Untitled (Man by the Tree)
1967
Pencil on paper
72.5 x 52.5 (28 1/2 x 20 5/8)
recto b. l. 'G. B.'

Provenance
Johannes Gachnang, Berne
acquired 1995

cat. 24, ill. p. 50
Orangenesser III
Orange Eater III
1981
Oil on canvas
146 x 114 (57 1/2 x 44 7/8)
recto b. l. 'G. B.' and verso t. r. '"Orangen-
esser" III, April 1981'

Provenance
Gelco Collection, Eden Prairie, Minneapolis
Rhona Hoffman Gallery, Chicago
Galerie Neuendorf, Hamburg
Galerie Zwirner, Cologne
acquired 1988

Exhibitions and Literature
Braunschweig 1981 [not in cat.]
Düsseldorf 1981, repr. unpag.
Barcelona 1990, repr. 2, p. 75
Saarbrücken 1994, cat. no. 1, repr. unpag.

Jürgen Hohmeyer, 'Düsternisse im Rittersaal',
in: *Der Spiegel,* no. 6, 7. 2. 1994, repr. p. 165

cat. 25, ill. p. 51
Mann auf rotem Kopfkissen
Man on Red Pillow
1982
Oil on canvas
250 x 250 (98 3/8 x 98 3/8)
recto b. m. 'G B 17. VIII. 82' and verso t. l.
'Mann auf rotem Kopfkissen' "Mann im Bett"
[crossed out] 17. VIII. 82' and t. m. 'G. Baselitz'

Provenance
Galerie Neuendorf, Hamburg
Galerie Michael Werner, Cologne
Mary Boone/Michael Werner Gallery,
New York
Galerie Michael Werner, Cologne
Elisabeth Kübler Fine Art, Zurich
acquired 1995

Exhibitions and Literature
Zeitgeist, Berlin 1982, cat. no. 11, repr. p. 77
Vancouver 1984, repr. p. 38
Tokyo 1988, repr. unpag.

Barcelona 1990, repr. 9, p. 89
Georg Baselitz. The Zeitgeist Paintings, Mary
Boone Gallery, New York 1991 [no cat.]
Saarbrücken 1994, cat. no. 26, repr. unpag.
New York 1995, cat. no. 133, repr. unpag.
Berlin 1996, cat, no. 119

Franzke, *Baselitz,* 1988, cat. no. 150,
repr. p. 176

cat. 26, ill. p. 54
Untitled
1982
Beech
50 x 45 x 45 (19 1/2 x 17 1/2 x 17 1/2)

Provenance
Private collection
Mary Boone/Michael Werner Gallery,
New York
Galerie Michael Werner, Cologne
Elisabeth Kübler Fine Art, Zurich
acquired 1995

Exhibitions and Literature
London 1983, repr. p. 20
Cologne 1983, repr. p. 20–21
Bordeaux 1983, repr. pp. 31, 33
Légendes, Bordeaux 1984, repr. p. 44
Bielefeld 1985, cat. no. 23, repr. p. 85
Paris 1985, repr. p. 19
European Iceberg, Toronto 1985, repr. p. 74
Basle 1986 [not in cat.]
Hanover 1987, cat. no. 5, repr. unpag.
London 1987, repr. unpag.
Frankfurt 1988, cat. no. 5, pp. 162, 168
Barcelona 1990, repr. 3, p. 142, pp. 34, 52
Munich 1992, repr. 42, repr. unpag.
Stuttgart 1994, repr. 19, p. 37

'N. N.' in: *Lo Spazio Umano,* no. 2, 1985,
repr. p. 39
Parkett, Nr. 11, 1986, repr. on cover page
Franzke, *Baselitz,* 1988, cat. no. 164, repr.
p. 191
Skulptur, Darnétal 1989, repr. 8, 12 [not exh.]

cat. 27
Die Kirche
The Church
1986
Oil on canvas
253 x 209 (99 5/8 x 2 1/4)
recto b. m. 'G B 1. X. 86' and verso t. m.
'G. Baselitz' and on the stretcher l.
m. '3. VI. 86' and on the stretcher m. '3. VI. 86
+ 1. X. 86 "die Kirche"'

Provenance
Galerie Michael Werner, Cologne
acquired 1989

Exhibitions and Literature
Zurück zur Natur, Karlsruhe 1988 [not in cat.]
Zurich 1990, Kat. 63, repr. p. 147

cat. 28, ill. p. 55
Dresdner Frauen – Karla
Women of Dresden – Karla
1990
Tempera on ash
157 x 67.5 x 57 (62 1/4 x 26 5/8 x 22 1/2)
on rear of sculpture '5.III.90' and '5.III.90 G.B.'

Provenance
Pace Gallery, New York
acquired 1991

Exhibitions and Literature
New York 1990, repr. p. 31
La Sculpture Contemporaine, Paris 1991,
repr. p. 59
Transform, Basle 1992, cat. no. 147
Humlebaek 1993, cat. no. 38, repr. p. 53
Hamburg 1994, repr. p. 59
New York 1995, cat. no. 103, repr. unpag.
Berlin 1996, cat. no. 93

Extended loan to Staatsgalerie Stuttgart since
April 1992

JOSEPH BEUYS
born 1921 in Kleve
died 1986 in Düsseldorf

Bibliography
Fünf Sammler, Wuppertal 1971
 Fünf Sammler. Kunst unserer Zeit, exh. cat.
 Von der Heydt-Museum, Wuppertal 1971
Darmstadt 1972
 *Joseph Beuys. Zeichnungen und andere
 Blätter aus der Sammlung Karl Ströher,* exh.
 cat. Hessisches Landesmuseum, Darmstadt,
 June – Aug. 1972
Adriani et al., *Beuys,* 1973
 Götz Adriani, Winfried Konnertz, Karin
 Thomas, *Joseph Beuys,* Cologne 1973
Hanover 1975
 Joseph Beuys, exh. cat. Kestner-Gesellschaft,
 Hanover, Dec. 1975 – Feb. 1976
Ghent 1977
 Joseph Beuys, exh. cat. Museum van
 Hedendaagse Kunst, Ghent, Oct. – Dec. 1977
New York 1979
 Caroline Tisdall (ed.), *Joseph Beuys,* exh. cat.
 Solomon R. Guggenheim Museum, New
 York, Nov. 1979 – Jan. 1980
Murken, *Beuys und die Medizin,* 1979
 Axel Hinrich Murken, *Joseph Beuys und die
 Medizin,* Münster 1979
Parnass, Wuppertal 1980
 Treffpunkt Parnass. Wuppertal 1949 – 1965,
 exh. cat. Von der Heydt-Museum, Wuppertal
 1980
Wendepunkt, Krefeld 1980
 Wendepunkt: Kunst in Europa um 1960, exh.
 cat. Museum Haus Lange, Krefeld 1980
Munich 1981
 *Joseph Beuys. Arbeiten aus Münchener
 Sammlungen,* exh. cat. Städtische Galerie im
 Lenbachhaus, Munich, Sept. – Oct. 1981
Adriani et al., *Beuys,* Cologne 1981
 Götz Adriani, Winfried Konnertz, Karin
 Thomas, *Joseph Beuys. Leben und Werk,*
 Cologne 1981
Aquarelle, Kassel 1984
 Aquarelle, exh. cat. Kasseler Kunstverein,
 Kassel, 1984–5
Pittura tedesca contemporanea, Venice 1984
 Pittura tedesca contemporanea, exh. cat.
 Chiesa San Samuel, Venice 1984
Vom Zeichnen, Frankfurt 1985
 *Vom Zeichnen. Aspekte der Zeichnung 1960
 – 1985,* exh. cat. Frankfurter Kunstverein,
 Frankfurt 1985; Kasseler Kunstverein, Kassel
 1986; et al.
Wasserfarbenblätter, Münster 1985
 *Wasserfarbenblätter von Joseph Beuys, Nicola
 De Maria, Gerhard Richter, Richard Tuttle,*
 exh. cat. Westfälischer Kunstverein, Münster
 1985
Munich 1986
 Beuys zu Ehren, exh. cat. Städtische Galerie
 im Lenbachhaus, Munich, July – Nov. 1986
Berlin 1987
 *Joseph Beuys. Frühe Arbeiten aus der
 Sammlung van der Grinten,* exh. cat.
 Ministerium für Bundesangelegenheiten des
 Landes NRW, Bonn, Nov. – Dec. 1987;
 Akademie – Galerie im Marstall, Berlin
 (GDR), Jan. – March 1988, et al. Cologne
 1987

Watercolours, London 1987
 *Watercolours by Joseph Beuys, Blinky
 Palermo, Sigmar Polke, Gerhard Richter,*
 exh. cat. Goethe-Institut, London 1987
Waldungen, Berlin 1987
 Waldungen: Die Deutschen und ihr Wald,
 exh. cat. Akademie der Künste, Berlin 1987
Berlin 1988
 Heiner Bastian (ed.), *Joseph Beuys –
 Skulpturen und Objekte,* exh. cat. Martin
 Gropius-Bau, Berlin, Feb. – May 1988;
 Munich 1988
Signaturen, Ghent 1988
 Signaturen. Beuys – Wols, exh. cat. Museum
 van Hedendaagse Kunst, Ghent 1988
Kleve 1991
 *Joseph Beuys, Städtisches Museum Haus
 Koekkoek,* Kleve, April – June 1991
Düsseldorf 1991
 Joseph Beuys – Natur Materie Form, exh. cat.
 Kunstsammlung Nordrhein-Westfalen,
 Düsseldorf, Nov. 1991 – Feb. 1992, Munich
 1991
New Displays, London 1992
 New Displays, exh. cat. Tate Gallery, London
 1992 [leaflet]
Terra de nadie, Granada 1992
 Terra de nadie, exh. cat. Hospital Real,
 Cuesta del Hospicio, Granada 1992
Schellmann, *Beuys,* 1992
 Jörg Schellmann (ed.), *Joseph Beuys. Die
 Multiples. Werkverzeichnis der
 Auflagenobjekte und Druckgraphik 1965 –
 1986,* Munich 1992
Theewen, *Vitrinen,* 1993
 Gerhard Theween, *Joseph Beuys. Die
 Vitrinen,* Cologne 1993
New York 1993
 *Thinking is Form. The Drawings of Joseph
 Beuys,* exh. cat. Museum of Modern Art, New
 York, Feb. – May 1993; Museum of
 Contemporary Art, Los Angeles, June – Aug.
 1993; et al.
Kassel 1993
 Veit Loers and Pia Witzmann (eds.), *Joseph
 Beuys: documenta-Arbeit,* exh. cat. Museum
 Fridericianum, Kassel, Sept. – Nov. 1993;
 Stuttgart 1993
Zurich 1993
 Joseph Beuys, exh. cat. Kunsthaus Zürich,
 Nov. 1993 – Feb. 1994
Madrid 1994
 Joseph Beuys, exh. cat. Museo Nacional
 Centro de Arte Reina Sofía, Madrid, March –
 June 1994
Paris 1994
 Joseph Beuys, exh. cat. Musée national d'art
 moderne, Centre Georges Pompidou, Paris,
 June – Sept. 1994
Aspekte deutscher Kunst, Salzburg 1994
 Thaddaeus Ropac (ed.), *German Art. Aspekte
 deutscher Kunst 1964 – 1994,* exh. cat.
 Salzburger Festspiele, Salzburg 1994;
 Heidelberg 1994
Wide White Space, Brussels 1994
 Wide White Space 1966 – 1976, exh. cat.
 Palais des Beaux-Arts, Brussels 1994;
 Kunstmuseum Bonn, 1995; Düsseldorf 1994

The Romantic Spirit, Edinburgh 1994
 *The Romantic Spirit in German Art 1790 –
 1990,* Royal Scottish Academy and The
 Fruitmarket Gallery, Edinburgh 1994;
 Hayward Gallery, South Bank Centre, London
 1994–5, Stuttgart 1994 (German edition see:
 Der Geist der Romantik, Munich 1995)
Der Geist der Romantik, Munich 1995
 *Ernste Spiele. Der Geist der Romantik in der
 deutschen Kunst 1790 – 1990,* exh. cat. Haus
 der Kunst, Munich 1995; Stuttgart 1995
 [original edition see: *The Romantic Spirit,*
 Edinburgh 1994]
Rites of Passage, London 1995
 *Rites of Passage. Art for the End of the
 Century,* exh. cat. Tate Gallery, London 1995
Schirmer, *Beuys,* 1996
 Lothar Schirmer (ed.), *Joseph Beuys. Eine
 Werkübersicht,* Munich 1996

cat. 29
Ohne Titel (Zwei junge Tiere)
Untitled (Two Young Animals)
1949
Pencil and tracing paper pasted on paper
21 x 30 on 33 x 34.5 (8 1/4 x 11 3/4 on
13 x 13 5/8)
recto m. r. 'Beuys 1949'

Provenance
Galerie Schmela, Düsseldorf
...
Dietmar Werle, Cologne
acquired 1984

Exhibitions and Literature
Munich 1986, repr. p. 144
Düsseldorf 1991, cat. no. 29, repr. 16

cat. 30
Untitled
1952
Gouache, watercolour and pencil on paper
25 x 32.5 (9 7/8 x 12 3/4)
recto b. r. 'Beuys 1952'

Provenance
...
Christie's London, 29.6.1989, Sale Beuys-4087,
Lot 760
acquired 1989

Exhibitions and Literature
Düsseldorf 1991, cat. no. 71, repr. p. 315
New York 1993, cat. no. 19, repr. 23, p. 138
Aspekte deutscher Kunst, Salzburg 1994
[not in cat.]

Christie's London, auct. cat. *Joseph Beuys,
Sculpture, Drawing, Multiple and Prints,* 1989,
repr. p. 117

35

32

34

cat. 31, ill. p. 241
Zwei Plastiken
Two Sculptures
1952
Ferrous hydroxide and pencil on lined paper
pasted on cardboard
two parts, each 14.8 x 10.5 on 32.8 x 45.7
(each 5 7/8 x 4 1/8 on 12 7/8 x 18)
verso on right and left double sheet 'Beuys 52'

Provenance
Galerie Schmela, Düsseldorf
...
Galerie Möllenhoff, Cologne
Konrad Mönter, Meerbusch
Dietmar Werle, Cologne
acquired 1983

Exhibitions and Literature
Munich 1986, repr. p. 156 [dated 1954]
Düsseldorf 1991, cat. no. 88, repr. p. 316

cat. 32
Amazone
Amazon
1953
Watercolour and pencil on paper pasted on
paper
15.8 x 13 on 29.7 x 21.5 (6 1/4 x 5 1/8 on
11 3/4 x 8 1/2)
recto b. l. 'Beuys ~ 1953 Amazone' and verso
m. 'Beuys Amazone 1953'

Provenance
...
Kunsthaus Lempertz, Sale A 656, Cologne, Nov.
1990, Lot 39
acquired 1990

Exhibitions and Literature
Düsseldorf 1991, cat. no. 78, repr. p. 315
New Displays, Tate Gallery, London 1992
[not in cat.]
New York 1993, cat. no. 24, repr. 24, p. 138
Aspekte deutscher Kunst, Salzburg 1994,
cat. no. 27, repr. p. 153

Kunsthaus Lempertz, Cologne, auct. cat. Sale A
656, 1990, Los 39, repr.

cat. 33
Blume Geysir Jungfrau
Flower Geyser Virgin
1954
Pencil on paper pasted on paper
30.9 x 50.1 on 75.3 x 49.8
(12 1/8 x 19 3/4 on 29 5/8 x 19 5/8)
recto on drawing 'Blume Geysir Jungfrau' and
recto b. m. on bottom paper 'Beuys 1954' and
verso b. m. on drawing 'Beuys 1954'

Provenance
...
Konrad Mönter, Meerbusch
acquired 1995

Exhibitions and Literature
Kleve 1991, cat. no. 27, repr. p. 30
[under the title 'Ohne Titel (Geysir etc.)']

cat. 34
Braun-Kreuz
Brown-Cross
1954
Oil on paper
20.8 x 14.8 (8 1/4 x 5 7/8)

Provenance
Galerie Möllenhoff, Cologne
Konrad Mönter, Meerbusch
Dietmar Werle, Cologne
acquired 1987

Exhibitions and Literature
Düsseldorf 1991, cat. no. 89, repr. p. 316
New Displays, Tate Gallery, London 1992
[not in cat.]

cat. 35
Hase und verschiedene Skizzen
Hare and Different Sketches
1954
Pencil and ferrous hydroxide on paper
29.7 x 41.5 (11 3/4 x 16 3/8)
verso m. l. 'Joseph Beuys 1954'

Provenance
acquired 1983

Exhibitions and Literature
Munich 1986, repr. p. 150 [dated 1953]
Signaturen, Gent 1988, repr. p. 92
Düsseldorf 1991, cat. no. 80, repr. p. 315
Joseph Beuys, Thomas Ammann Fine Art,
Zurich, Nov. 1993 – Feb. 1994 [no cat.]
Aspekte deutscher Kunst, Salzburg 1994
[not in cat.]

cat. 36, ill. p. 66
Im Haus des Schamanen
In the House of the Shaman
1954
Gouache, watercolour and pencil on paper
21.9 x 26.4 (8 5/8 x 10 3/8)
verso b. m. 'Im Haus des Schamanen Joseph
Beuys 1954 für Block'

Provenance
Galerie Schmela, Düsseldorf
Ströher Collection, Darmstadt
Galerie Schmela, Düsseldorf
acquired 1984–5

Exhibitions and Literature
Darmstadt 1972, cat. no. 35, p. 12, repr. p. 7
Hanover 1975, cat. no. 63, repr. p. 47
Wasserfarbenblätter, Münster 1985, repr. unpag.
Munich 1986, repr. p. 155
Watercolours, London 1987, cat. no. 3,
repr. p. 4
Düsseldorf 1991, cat. no. 91, repr. p. 316
New Displays, Tate Gallery, London 1992
[not in cat.]
Joseph Beuys, Thomas Ammann Fine Art, Zurich,
Nov. 1993 – Feb. 1994 [no cat.]

Adriani et al., *Beuys,* 1973, repr. 39, p. 32
New York 1979, repr. 32, p. 23 [not exh.]
Murken, *Beuys und die Medizin,* 1979, repr. 6,
p. 62
Adriani et al., *Beuys,* 1981, repr. 31, p. 64
Berlin 1987, repr. p. 225 [not exh.]

cat. 37
Untitled
1954
Pencil and watercolour on paper pasted on paper
two pages, each 14 x 21 on 50 x 33
(each 5 1/2 x 8 1/4 on 19 5/8 x 13)
recto b. l. 'Beuys 1954'

Provenance
Galerie Schmela, Düsseldorf
Galerie Möllenhoff, Cologne
Konrad Mönter, Meerbusch
Dietmar Werle, Cologne
acquired 1983

Exhibitions and Literature
Aquarelle, Kassel 1984, unpag. [index of exhibited works]
Munich 1986, repr. p. 151
Düsseldorf 1991, cat. no. 164, repr. p. 320

33

37

39

44

40

cat. 38, ill. p. 67
Schlafender Kopf über Induktor
Sleeping Head over Inductor
1954
Ferrous hydroxide, watercolour, oil and pencil
on paper pasted on cardboard; frame and glass
painted with varnish
14.7 x 22.2 on 34.3 x 25 on 37.6 x 28,
with frame 67 x 51.7, in frame 67 x 51.7
(5 3/4 x 8 3/4 on 13 1/2 x 9 7/8, with frame
26 3/8 x 20 3/8, in frame 26 3/8 x 20 3/8)
recto t. l. carved in painted glass 'Joseph Beuys
Schlafender Kopf über Induktor 1954' and recto
b. r. on brown cardboard 'Beuys 1954' and
verso t. l. on backing board 'Joseph Beuys 1954
Schlafender Kopf über Induktor "La Muse
endormi"'

Provenance
Konrad Mönter, Meerbusch
acquired 1995

Exhibitions and Literature
Kleve 1991, cat. no. 23, repr. p. 28

cat. 39
Tierfrau
Animal Woman
1954
Pencil on envelope and paper, pasted on paper
16 x 13 [torn irregularly] on 29.5 x 21
(6 1/4 x 5 1/8 on 11 5/8 x 8 1/4)
verso on drawing 'Tierfrau Joseph Beuys 1954'
and verso with typewriter 'em Gruß' and by
hand with blue ball-point pen 'serfürth'

Provenance
Erhard Klein, Bonn
acquired 1985

cat. 40
Untitled
c. 1955
Pencil on paper
48.2 x 64.5 [right side torn irregularly]
(19 x 25 3/8)

Provenance
Galerie Möllenhoff, Cologne
Konrad Mönter, Meerbusch
Galerie Karsten Greve, Cologne
Heiner Bastian, Berlin
Anthony d'Offay Gallery, London
acquired 1994

Exhibitions and Literature
Düsseldorf 1991, cat. no. 99, repr. 38

cat. 41, ill. p. 68
Toter Elch auf Urschlitten
Dead Elk on Ur-Sled
1955
Pencil with traces of ferrous hydroxide on paper
pasted on paper
44.3 x 50 on 49.5 x 65 (17 1/2 x 19 3/4 on
19 1/2 x 25 5/8)
recto b. m. on bottom paper 'Beuys 55 Toter
Elch auf Urschlitten' and
verso b. m. on drawing 'Joseph Beuys 1955
Toter Elch auf Urschlitten'

Provenance
Christie's London, 29. 6. 1989, Sale Beuys –
4087, Lot 755
acquired 1989

Exhibitions and Literature
Düsseldorf 1991, cat. no. 97, repr. 97
New York 1993, cat. no. 31, repr. 28, p. 142
Aspekte deutscher Kunst, Salzburg 1994
[not in cat.]

Christie's London, auct. cat. *Joseph Beuys.
Sculpture, Drawings, Multiples and Prints,* 1989,
repr. p. 109

cat. 42
Das große Zahnbluten
The Big Toothbleed
1955/56 [previously: 1966]
Watercolour on paper pasted on paper
11.4 x 16.2 on 19.2 x 27.4 (4 1/2 x 6 3/8
on 7 1/2 x 10 3/4)
verso on drawing 'Das grosse Zahnbluten Beuys
1955' and verso on backing board m. 'Beuys
1956 Das große Zahnbluten' and verso on bot-
tom paper m. 'Nr. Beuys 1955 Das grosse
Zahnbluten'

Provenance
...
Galerie Karsten Greve, Cologne
Dr. Heinz Kroppen, Düsseldorf
Galerie Karsten Greve, Cologne
acquired 1985

Exhibitions and Literature
Ghent 1977, cat. no. 140, repr. p. 227
Wendepunkt, Krefeld 1980, cat. no. 3
Wasserfarbenblätter, Münster 1985, repr. unpag.

42

Joseph Beuys. Aquarelle, Galerie Karsten Greve,
Cologne 1985 [no cat.]
Munich 1986, repr. p. 221
Watercolours, London 1987, cat. no. 6,
repr. p. 6
Signaturen, Ghent 1988, repr. p. 86–7
Düsseldorf 1991, cat. no. 354, repr. p. 330
New Displays, Tate Gallery, London 1992
[not in cat.]
Joseph Beuys, Thomas Ammann Fine Art,
Zurich, Nov. 1993 – Feb. 1994 [no cat.]

cat. 43, ill. p. 69
Aus dem Leben der Bienen
From the Life of the Bees
1956
Ferrous hydroxide on paper
48 x 64.5 [left side torn irregularly]
(18 7/8 x 25 3/8)
recto b. l. 'Joseph Beuys 1956' and verso b. l.
'1956 Aus d. Leben der Bienen'

Provenance
...
Galerie Möllenhoff, Cologne
Konrad Mönter, Meerbusch
Dietmar Werle, Cologne
acquired 1983

Exhibitions and Literature
Aquarelle, Kassel 1984, repr. unpag.
Wasserfarbenblätter, Münster 1985, p. 27
(index of exhibited works)
Munich 1986, repr. p. 166
Watercolours, London 1987, cat. no. 4
Düsseldorf 1991, cat. no. 128, repr. p. 318
New Displays, Tate Gallery, London 1992
[not in cat.]
New York 1993, cat. no. 38, repr. 33, p. 145

cat. 44
Die Keltin
The Celt
1956
Pencil on paper pasted on cardboard
29.5 x 11 on 69 x 55
(11 5/8 x 4 3/8 on 27 1/6 x 21 5/8)
recto b. l. on cardboard 'Beuys 1956 Keltin' and
verso b. on drawing 'Joseph Beuys 1956 Keltin'

Provenance
Dr. Heinz Kroppen, Düsseldorf
Galerie Karsten Greve, Cologne
acquired 1985

Exhibitions and Literature
Ghent 1977, cat. no. 83, repr. p. 173
Joseph Beuys. Aquarelle, Galerie Karsten Greve,
Cologne 1985 [no cat.]
Munich 1986, repr. p. 163
Signaturen, Ghent 1988 [not in cat.]
Düsseldorf 1991, cat. no. 117, repr. p. 317
Joseph Beuys, Thomas Ammann Fine Art,
Zurich, Nov. 1993 – Feb. 1994 [no cat.]

E. N., 'Angstsprung. Beuys-Papierarbeiten bei
Ammann', in: *Frankfurter Allgemeine Zeitung,*
12.2.1994

46

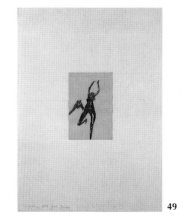

49

50

cat. 45, ill. p. 70
Entladung
Unloading
1956
Ferrous hydroxide, silver chloride, Cuprum
Metallicum and crayon on paper
43.3 x 42 (17 x 16 1/2)
verso b. r. 'Joseph Beuys 1956'

Provenance
Galerie Schmela, Düsseldorf
Galerie Möllenhoff, Cologne
Konrad Mönter, Meerbusch
Dietmar Werle, Cologne
acquired 1983

Exhibitions and Literature
Wasserfarbenblätter, Münster 1985, repr. unpag.
Munich 1986, repr. p. 167
Watercolours, London 1987, cat. no. 5, repr. p. 7
Düsseldorf 1991, cat. no. 129, repr. 160
New York 1993, cat. no. 39, repr. 87, p. 188

cat. 46
Vier Frauen
Four Women
1956
Pencil on paper pasted on paper
46 x 32 on 62.5 x 48 (18 1/8 x 12 5/8 on
24 5/8 x 18 7/8)
recto b. m. on bottom paper 'Beuys 1956
4 Frauen' and verso b. l. 'Beuys 55/56'

Provenance
...
Galerie Möllenhoff, Cologne
Konrad Mönter, Meerbusch
Diemar Werle, Cologne
acquired 1984

Exhibitions and Literature
Munich 1986, repr. p. 165
Düsseldorf 1991, cat. no. 119, repr. p. 317
New Displays, Tate Gallery, London 1992
[not in cat.]
Joseph Beuys, Thomas Ammann Fine Art,
Zurich, Nov. 1993 – Feb. 1994 [no cat.]
Aspekte deutscher Kunst, Salzburg 1994
[not in cat.]

cat. 47
Akt in Gold
Nude in Gold
1957
Gold paint on paper
40.5 x 13.5 (16 x 5 3/8)
verso m. 'Joseph Beuys 1957'

Provenance
...
Dietmar Werle, Cologne
acquired 1983

Exhibitions and Literature
Munich 1986, repr. p. 177
Signaturen, Ghent 1988, repr. p. 96
Düsseldorf 1991, cat. no. 156, repr. p. 319
Joseph Beuys, Thomas Ammann Fine Art,
Zurich, Nov. 1993 – Feb. 1994 [no cat.]

cat. 48, ill. p. 68
Elch mit Sonne
Elk with Sun
1957
Pencil on paper
34 x 65.8 (13 3/8 x 25 7/8)
verso b. m. 'Beuys Beuys 1957 Elch mit Sonne
1957'

Provenance
...
Galerie Möllenhoff, Cologne
Konrad Mönter, Meerbusch
Dietmar Werle, Cologne
acquired 1982

Exhibitions and Literature
Munich 1986, repr. p. 174
Signaturen, Ghent 1988 [not in cat.]
Düsseldorf 1991, cat. no. 137, repr. 98
New Displays, Tate Gallery, London 1992
[not in cat.]
New York 1993, cat. no. 54, repr. 47, p. 155
Aspekte deutscher Kunst, Salzburg 1994,
cat. no. 28, repr. p. 154
The Romantic Spirit, Edinburgh 1994, repr. p. 77
Der Geist der Romantik, Munich 1995, repr. 20,
p. 62

cat. 49
Zwei Frauen
Two Women
1957
Ferrous hydroxide and pencil on paper mounted
on paper
22.2 x 15 on 68.5 x 50 (8 3/4 x 5 /8 on
27 x 19 5/8)
recto b. l. on paper 'Joseph Beuys 1957 zwei
Frauen' and verso m. on drawing 'Beuys 1957
2 Frauen'

Provenance
Dr. Heinz Kroppen, Düsseldorf
Galerie Karsten Greve, Cologne
acquired 1985

Exhibitions and Literature
Ghent 1977, cat. no. 106, repr. p. 191
[under the title 'Zonder Titel/Naaktfiguren']
Aquarelle, Galerie Karsten Greve, Cologne 1985
[no cat.]
Düsseldorf 1991, cat. no. 157, repr. 65
[under the title 'Ohne Titel (Aktfiguren)']
New Displays, Tate Gallery, London 1992
[not in cat.]
Aspekte deutscher Kunst, Salzburg 1994
[not in cat.]

cat. 50
Am kristallklaren Bergbach
By the Crystal-Clear Mountain Stream
1957/58
Pencil on paper pasted on paper
three parts, overall 29.5 x 29.5
(overall 11 5/8 x 11 5/8)
verso b. 'Joseph Beuys 1957/58 am kristallklaren
Bergbach' and on the largest drawing t. l. 'B'
Beuys collaged together an early drawing and
two smaller sheets, and titled the new work
'Am kristallklaren Bergbach'.

Provenance
Hannes Jähn, Cologne [largest drawing]
Dietmar Werle, Cologne [largest drawing]
acquired 1984

Exhibitions and Literature
Munich 1986, repr. p. 169
Düsseldorf 1991, cat. no. 127, repr. p. 318
New Displays, Tate Gallery, London 1992
[not in cat.]
Der Geist der Romantik, Munich 1995,
cat. no. 24, repr. 92, p. 167

cat. 51, ill. p. 70
Brutkasten (solar)
Incubator (solar)
1957/58
Watercolour and pencil on cardboard
22.8 x 31.1 (9 x 12 1/4)
recto b. r. 'Beuys 1957/58' and recto t. r. 'Beuys'
and verso b. 'Joseph Beuys 1957/58 Brutkasten
(solar)'

47

52

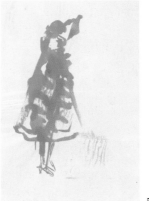

54

55

57

Provenance
Galerie Schmela, Düsseldorf
Ströher Collection, Darmstadt
Galerie Karsten Greve, Cologne
Dr. Heinz Kroppen, Düsseldorf
Galerie Karsten Greve, Cologne
acquired 1985

Exhibitions and Literature
Wendepunkt, Krefeld 1980, cat. no. 10,
repr. p. 19
Wasserfarbenblätter, Münster 1985, p. 27
[index of exhibited works]
Aquarelle, Galerie Karsten Greve, Cologne 1985
[not in cat.]
Munich 1986, repr. p. 179
Watercolours, London 1987, cat. no. 7,
repr. p. 11
Düsseldorf 1991, cat. no. 169, p. 320
New Displays, Tate Gallery, London 1992
[no cat.]
New York 1993, cat. no. 58, repr. 50, p. 158

cat. 52
Cirkus
Circus
1958
Pencil and coloured pencil on paper and carbon
paper pasted on cardboard
overall 18 x 21 (7 1/8 x 8 1/4)
verso on bottom cardboard 'Joseph Beuys
Zirkus [crossed out] Cirkus 1958'

Provenance
Galerie Bernd Klüser, Munich
acquired 1984

Exhibitions and Literature
Munich 1981, cat. no. 117, repr. 196
Düsseldorf 1991, cat. no. 191, repr. 238
New Displays, Tate Gallery, London 1992
[not in cat.]

cat. 53, ill. p. 72
Für 2 Holzplastiken
For 2 Wooden Sculptures
1958
Oils, *(including Braunkreuz)* on paper mounted
on paper
23.3 x 31.5 on 48.5 x 65 [bottom edge torn irre-
gularly] (9 1/8 x 12 3/8 on 19 1/8 x 25 5/8)
recto b. m. on bottom paper 'für 2 Holzplastiken
Joseph Beuys 1958' and verso on drawing
'Joseph Beuys für 2 Holzplastiken'

Provenance
Galerie Möllenhoff, Cologne
Konrad Mönter, Meerbusch
Dietmar Werle, Cologne
acquired 1983

Exhibitions and Literature
Munich 1986, repr. p. 186
Düsseldorf 1991, cat. no. 183, repr. p. 321
Joseph Beuys, Thomas Ammann Fine Art,
Zurich, Nov. 1993 – Feb. 1994 [no cat.]

cat. 54
Mädchen winkend
Waving Girl
1958
Ferrous hydroxide on paper
29.8 x 21 (11 3/4 x 8 1/4)
verso b. m. 'Beuys 1958 Mädchen'

Provenance
...
Galerie Möllenhoff, Cologne
Konrad Mönter, Meerbusch
Dietmar Werle, Cologne
acquired 1983

Exhibitions and Literature
Aquarelle, Kassel 1984, unpag. [index of exhibi-
ted works]
Munich 1986, repr. p. 176 [dated 1957]
Signaturen, Ghent 1988, repr. p. 97
Düsseldorf 1991, cat. no. 158, repr. 203

cat. 55
Sender und Empfänger im Gebirge
Transmitter and Receiver in the Mountains
1958
Pencil on paper pasted on paper
15 x 21.3 on 50.3 x 35 (5 7/8 x 8 3/8 on
19 3/4 x 13 3/4)
recto b. m. on bottom paper 'Beuys 1958 Sender
und Empfänger im Gebirge'

Provenance
acquired 1984

Exhibitions and Literature
Munich 1986, repr. p. 182
Düsseldorf 1991, cat. no. 180, repr. p. 321
New Displays, Tate Gallery, London 1992
[not in cat.]
Der Geist der Romantik, Munich 1995,
cat. no. 36, repr. 90, p. 166

cat. 56, ill. p. 71
Urschlitten
Ur-Sled
1958
Oil *(Braunkreuz)* and gold paint on paper pasted
on paper
21 x 15 on 69.5 x 48 (8 1/4 x 5 7/8 on
27 3/8 x 18 7/8)
recto b. m. on bottom paper 'Beuys 1958
Urschlitten' and verso b. m. on drawing
'Beuys 1958 Urschlitten'

Provenance
Bernd Klüser, Munich
acquired 1984

Exhibitions and Literature
Munich 1986, repr. p. 185
Düsseldorf 1991, cat. no. 192, repr. 188
New Displays, Tate Gallery, London 1992
[not in cat.]
Joseph Beuys, Thomas Ammann Fine Art,
Zurich, Nov. 1993 – Feb. 1994 [no cat.]

Aspekte deutscher Kunst, Salzburg 1994,
cat. no. 29, p. 155

E. N., 'Angstsprung. Beuys-Papierarbeiten bei
Ammann', in: *Frankfurter Allgemeine Zeitung,*
12.2.1994

cat. 57
Zwei Figuren
Two Figures
1958
Ferrous hydroxide and pencil on paper
50 x 23.7 (19 5/8 x 9 3/8)
signed verso m. 'Joseph Beuys 1958'

Provenance
Galerie Schmela, Düsseldorf
Konrad Mönter, Meerbusch
Dietmar Werle, Cologne
acquired 1983

Exhibitions and Literature
Aquarelle, Kassel 1984, unpag. [index of exhib-
ted works]
Munich 1986, repr. p. 164 [dated 1956]
Düsseldorf 1991, cat. no. 116, repr. 64

cat. 58, ill. p. 73
Ohne Titel (für Hubert Troost)
Untitled (for Hubert Troost)
1959
Oil *(Braunkreuz)* and gouache on paper
77.5 x 51 (30 1/2 x 20 1/8)
recto b. l. 'Joseph Beuys 1959 für Hubert Troost'
and verso b. l. 'Joseph Beuys 1959'

Provenance
Hubert Troost
Galerie Schmela, Düsseldorf
acquired 1991

Exhibitions and Literature
Düsseldorf 1991, cat. no. 216, repr. 140
New Displays, Tate Gallery, London 1992
[not in cat.]
Joseph Beuys, Thomas Ammann Fine Art,
Zurich, Nov. 1993 – Feb. 1994 [no cat.]

E. N., 'Angstsprung. Beuys-Papierarbeiten bei
Ammann', in: *Frankfurter Allgemeine Zeitung,*
12.2.1994

cat. 59, ill. p. 246
Sonnenzeichen
Sun-Sign
1959
Lead foil and oil *(Braunkreuz)* on photo-
envelope mounted on paper
30.7 x 19.2 on 68.5 x 50 (12 1/8 x 7 1/2 on
27 x 19 5/8)
recto b. m. on paper 'Joseph Beuys 1959
Sonnenzeichen'

Provenance
...
Galerie Bernd Klüser, Munich
acquired 1984

60

59

64

Exhibitions and Literature
Düsseldorf 1991, cat. no. 221, repr. p. 323

cat. 60
Staubbild
Dust Picture
1959
Pencil and dust on parchment pasted on paper
28.5 x 61 [torn irregularly] on 50 x 65
(11 1/4 x 24 on 19 5/8 x 25 5/8)
recto b. r. on paper 'Joseph Beuys Staubbild
1959'

Provenance
...
Galerie Möllenhoff, Cologne
Konrad Mönter, Meerbusch
acquired 1995

Exhibitions and Literature
Kleve 1991, cat. no. 40, repr. p. 41

cat. 61, ill. p. 74
Steinbock
Capricorn
1959
Oil on canvas pasted on perforated paper
15.5 x 14 [cut irregularly] on 28.3 x 20.6
(6 1/8 x 5 1/2 on 11 1/8 x 8 1/8)
recto t. on paper 'Joseph Beuys 1959 Steinbock'

Provenance
Konrad Mönter, Meerbusch
Galerie Karsten Greve, Cologne
Dr. Heinz Kroppen, Düsseldorf
Galerie Karsten Greve, Cologne
acquired 1985

Exhibitions and Literature
Joseph Beuys. Aquarelle, Galerie Karsten Greve,
Cologne 1985 [no cat.]
Munich 1986, repr. p. 188
Düsseldorf 1991, cat. no. 222, repr. p. 323
Joseph Beuys, Thomas Ammann Fine Art,
Zurich, Nov. 1993 – Feb. 1994 [no cat.]
Aspekte deutscher Kunst, Salzburg 1994
[not in cat.]

cat. 62, ill. p. 75
Strahlende Materie, zwei aufgelegte Polstäbe
Radiating Matter, Two Imposed Rods
1959
Oil *(Braunkreuz),* strips of paper, tape and paper
pasted on paper
88 x 63 (34 5/8 x 24 3/4)
verso m. 'Beuys 1959 Strahlende Materie, zwei
aufgelegte Polstäbe'

Provenance
Galerie Schmela, Düsseldorf
acquired 1984

Exhibitions and Literature
Munich 1986, repr. p. 197
Düsseldorf 1991, cat. no. 231, repr. 164

cat. 63, ill. p. 71
Gulo Borealis
1959/60
Oil and gouache on paper pasted on sketchpad
paper
33.5 x 47.5 (13 1/4 x 18 3/4)
verso b. m. 'Beuys Joseph Beuys Gulo Borealis
u. brennende Jurte 1959 + 1960'

Provenance
acquired 1984 – 5

Exhibitions and Literature
Munich 1986, repr. p. 195
Watercolours, London 1987, cat. no. 8,
repr. p. 10
Düsseldorf 1991, cat. no. 224, repr. p. 323
New Displays, Tate Gallery, London 1992
[not in cat.]

cat. 64
Braunkreuz, Wohnplatz
Braunkreuz, Residential Estate
1960
Oil on envelope mounted on paper
32.5 x 23 on 66.7 x 49.8 (12 3/4 x 9 on
26 1/4 x 19 5/8)
recto b. m. on paper 'Joseph Beuys k 1960 +
Braunkreuz + (Wohnplatz)' and verso 'Joseph
Beuys 1960 Braunkreuz + (Wohnplatz)'

Provenance
Galerie Tanit, Munich
Dietmar Werle, Cologne
acquired 1986

Exhibitions and Literature
Düsseldorf 1991, cat. no. 225, repr. p. 323
New Displays, Tate Gallery, London 1992
[not in cat.]

cat. 65, ill. p. 57
Hörner
Horns
1961
Two horns from African rhinoceroses, metal bars
and settings of the horns, plastic hoses wrapped
in adhesive gauze bandage, bronze pedestal
height: 145; large horn 60, small horn
40 long; pedestal each 30 x 30 (height: 57 1/8;
large horn 23 5/8, small horn 15 3/4 long;
pedestal each 11 3/4 x 11 3/4)

Provenance
Willy and Fänn Schniewind, Neviges
A. and C. Ribbentrop, A. C. R. Galerie, Eltville
acquired 1995

Exhibitions and Literature
Fünf Sammler, Wuppertal 1971, repr. 115
[under the title 'Ohne Titel']
New York 1979, repr. 94, p. 59
Parnass, Wuppertal 1980, repr. 21
Munich 1986, repr. p. 101
Düsseldorf 1991, cat. no. 250, repr. 103
Kassel 1993, repr. 93, p. 159

Zurich 1993, cat. no. 9, repr. p. 44 – 5
Paris 1994, repr. p. 140, 141

Adriani et al., *Beuys,* 1973, repr. 56, p. 42
Adriani et al., *Beuys,* 1981, repr. 42, p. 81

cat. 66
Fee und Hase
Fairy and Hare
1961
Oil on paper
21.3 x 30.2 (8 3/8 x 11 7/8)
verso b. m. 'Fee und Hase Joseph Beuys 1961'

Provenance
acquired 1984 – 5

Exhibitions and Literature
Düsseldorf 1991, cat. no. 258, repr. p. 325
Aspekte deutscher Kunst, Salzburg 1994
[not in cat.]

cat. 67
Hasengeist sieht Falle wieder
Hare-ghost Sees Trap Again
1961
Oil and pencil on paper
29.7 x 20.8 (11 3/4 x 8 1/4)
verso m. 'Hasengeist sieht Falle wieder Joseph
Beuys 1961'

Provenance
acquired 1984 – 5

Exhibitions and Literature
Munich 1986, repr. p. 206 [under the title
'Hasengeist vor Hasenfalle']
Waldungen, Berlin 1987, repr. p. 295
[under the title 'Hasengeist vor Hasenfalle']
Düsseldorf 1991, cat. no. 259, repr. p. 325
Aspekte deutscher Kunst, Salzburg 1994
[not in cat.]

cat. 68, ill. p. 77
Ohne Titel (Hörner)
Untitled (Horns)
1961
Watercolour and pencil on parchment pasted
paper
two sheets, each 20.8 x 29.8 on 46.5 x 32.7
(8 1/4 x 11 3/4 on 18 1/4 x 12 7/8)

66

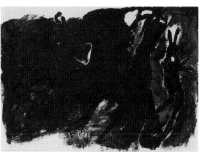

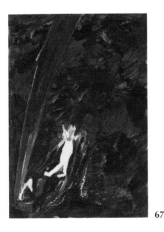

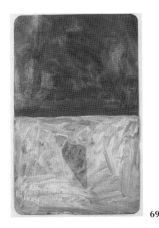
67

73

top sheet recto b. l. 'Beuys 61' and bottom sheet recto b. m. 'Beuys 61' and on paper recto b. r. 'Beuys 1961'

Provenance
A. and C. von Ribbentrop, A. C. R. Galerie, Eltville
acquired 1995

Exhibitions and Literature
Munich 1986, repr. pp. 204, 205
Düsseldorf 1991, cat. nos. 251, 252, repr. 102, 104
New York 1993, cat. no. 86, repr. 85, p. 186

Schirmer, *Beuys,* 1996, cat. no. 63

cat. 69
Vogelschädel
Bird Skull
1961
Oil *(Braunkreuz)* and synthetic polymer on cardboard
45.9 x 29.8 (18 1/8 x 11 3/4)
verso b. m. 'Joseph Beuys 1961 Vogelschädel'

Provenance
acquired 1984–5

Exhibitions and Literature
Munich 1986, repr. p. 199
Düsseldorf 1991, cat. no. 260, repr. p. 325
Aspekte deutscher Kunst, Salzburg 1994
[not in cat.]

cat. 70, ill. p. 77
Wassermann im Gebirge
Aquarius in the Mountains
1961
Ink and pencil on paper mounted on cardboard
21 x 27.8 on 44.5 x 34.5 (8 1/4 x 11 on 17 1/2 x 13 5/8)
verso b. r. 'Joseph Beuys 1961 Wassermann im Gebirge' and verso b. r. on cardboard '1961 Joseph Beuys Wassermann im Gebirge'

Provenance
acquired 1984–5

Exhibitions and Literature
Munich 1986, repr. p. 207 [dated 1961]
Düsseldorf 1991, cat. no. 296, repr. p. 326
Der Geist der Romantik, Munich 1995, cat. no. 44, repr. 91, p. 167

cat. 71, ill. p. 76
Ohne Titel (Braunkreuz)
Untitled (Braunkreuz)
1961–2
Oil *(Braunkreuz)* on cut, folded, and pasted paper mounted on paper
65 x 49.5 (25 5/8 x 19 1/2)
recto b. l. on paper 'Beuys 1962' and verso b. l. 'Beuys 1961'

Provenance
Galerie Schmela, Düsseldorf
acquired 1991

Exhibitions and Literature
... irgendein Strang ..., Galerie Schmela, Düsseldorf, 1965 [no cat.]
New York 1979, repr. 114, p. 77
Düsseldorf 1991, cat. no. 304, repr. 181
Zurich 1993, repr. 20, p. 61
New York 1993, cat. no. 99, repr. 95, p. 194
Madrid 1994, repr. 20, p. 63
Paris 1994, repr. p. 159
Aspekte deutscher Kunst, Salzburg 1994, cat. no. 31, repr. p. 157

Adriani et al., *Beuys,* 1973, repr. 106, p. 79
Berlin 1988, repr. 46, p. 97 [not exhibited]

cat. 72
Drei Wimpel
Three Pennants
1962
Oil and pencil on cardboard
61.1 x 80.3 (24 x 31 5/8)
verso b. l. 'Beuys 1962'

Provenance
acquired 1984–5

Exhibitions and Literature
Düsseldorf 1991, cat. no. 303, repr. p. 327
Joseph Beuys, Thomas Ammann Fine Art, Zurich, Nov. 1993 – Feb. 1994 [no cat.]

cat. 73
Filzplastiken an Körperwinkeln
Felt Sculptures in Body Crevices
1964
Pencil, watercolour and oil on lined paper pasted on paper
20.7 x 14.5 on 31 x 23 (8 1/8 x 5 3/4 on 12 1/4 x 9)
verso on drawing b. m. 'Filzplastiken an Körperwinkeln Beuys 1964' and verso on bottom paper m. 'Beuys 1964 Filzplastiken an Körperwinkeln'

Provenance
Dietmar Werle, Cologne
acquired 1984

Exhibitions and Literature
Munich 1986, repr. p. 215
Watercolours, London 1987, cat. no. 9
Düsseldorf 1991, cat. no. 328, repr. 90
New Displays, Tate Gallery, London 1992
[not in cat.]

cat. 74, ill. p. 58
Plateau Central
1964
Pencil on marble in zinc box
30 x 30.5 x 2.2 (11 3/4 x 12 x 7/8)
verso on box "1964" [with stencil] 'Joseph Beuys' and recto on marble m. 'Plateau Central'

Provenance
Konrad and Dorothee Fischer, Düsseldorf
acquired 1995

Exhibitions and Literature
Pittura tedesca contemporanea, Venice 1984, repr. p. 35
Berlin 1988, cat. no. 42, repr. p. 167
Düsseldorf 1991, cat. no. 335, repr. 133

Adriani et al., *Beuys,* 1973, repr. 69, p. 52
New York 1979, repr. 340, p. 206
[not exhibited]
Adriani et al., *Beuys,* 1981, repr. 53, p. 97

cat. 75
Schamane
Shaman
1964
Ink and pencil on paper
double page, each 29.5 x 23 (each 11 5/8 x 9)
verso on left page b. r. 'Schamane Joseph Beuys 1964 Doppelblatt links' and verso on right page b. m. 'Schamane Joseph Beuys 1964 Doppelblatt rechts'

Provenance
acquired 1984–5

Exhibitions and Literature
Munich 1986, repr. p. 214
Düsseldorf 1991, cat. no. 325, repr. p. 328
Joseph Beuys, Thomas Ammann Fine Art, Zurich, Nov. 1993 – Feb. 1994 [no cat.]

E. N., 'Angstsprung. Beuys-Papierarbeiten bei Ammann', in: *Frankfurter Allgemeine Zeitung,* 12.2.1994

72

75

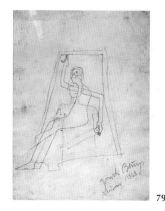

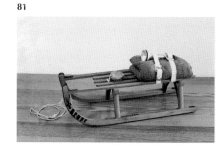

cat. 76, ill. p. 59
Sonde
Probe
1964
Galvanised copper and zinc in zinc box
26 x 29 x 15 (10 1/4 x 11 3/8 x 5 7/8)
verso t. m. on box 'Sonde 1964' and [stamped in oil (*Braunkreuz*)] 'Beuys +'

Provenance
Galerie Schmela, Düsseldorf
Galerie Möllenhoff, Cologne
Konrad Mönter, Meerbusch
Dietmar Werle, Cologne
acquired 1983

Exhibitions and Literature
Berlin 1988, cat. no. 41, repr. p. 166
Düsseldorf 1991, cat. no. 334, repr. 132
Zurich 1993, cat. no. 18, repr. p. 56
Madrid 1994, cat. no. 18, repr. p. 58
Paris 1994, cat. no. 20, repr. p. 148

cat. 77
Fossiler Phoenix
Fossilised Phoenix
1966
Felt-tip pen and watercolour on paper mounted on cardboard
21 x 15 on 34.5 x 36.5 (8 1/4 x 5 7/8 on 13 5/8 x 14 /8)
verso on drawing b. '1966 J. Beuys Fossiler Phoenix' and verso on cardboard b. m. 'Fossiler Phoenix'

Provenance
acquired 1984 – 5

Exhibitions and Literature
Munich 1986, repr. p. 217
Watercolours, London 1987, cat. no. 10
Düsseldorf 1991, cat. no. 355, repr. p. 330
Joseph Beuys, Thomas Ammann Fine Art, Zurich, Nov. 1993 – Feb. 1994 [no cat.]

cat. 78
Zwei Fräulein mit leuchtendem Brot
Two Young Ladies with Shining Bread
1966
Oil-painted chocolate on paper mounted on cardboard
72 x 20 x 1.5 (28 3/8 x 7 7/8 x 1/2)
recto t. m. 'Joseph Beuys 1966'
unnumbered/500, Typos Verlag, Frankfurt a. M.

Provenance
Galerie Erhard Klein, Bonn
acquired 1985

Exhibitions and Literature
Schellmann, *Beuys,* 1992, cat. no. 2, p. 38, repr. p. 39

cat. 79
Akademie
Academy
1968
Pencil on paper
40 x 29.5 (15 3/4 x 11 5/8)
recto b. r. 'Joseph Beuys Akademie 1968'

Provenance
Dietmar Werle, Köln erworben 1983

Exhibitions and Literature
Munich 1986, cat. repr. p. 223
Düsseldorf 1991, cat. 375

cat. 80, ill. p. 60
Erdtelephon
Earth Telephone
1968
Telephone, clumps of earth with grass and cable on wooden board
20 x 76 x 49 (7 7/8 x 29 7/8 x 19 1/4)
verso on the wooden board b. l. in pencil 'Joseph Beuys 68'

Provenance
Private collection, Netherlands
Sotheby's Amsterdam, April 1987, auction no. 453, Lot 187
Schlegel Collection, Berlin
Heiner Bastian, Berlin
acquired 1994

Exhibitions and Literature
Métamorphose de l'objet. Art et anti-art 1910 – 1970, Musée des Arts décoratifs, Paris 1972 [no cat.]
Berlin 1988, cat. no. 55, repr. p. 197
Düsseldorf 1991, cat. no. 371, repr. 189
Zurich 1993, cat. no. 25, repr. p. 77
Madrid 1994, cat. no. 25, repr. p. 79
Paris 1994, cat. no. 28, repr. p. 169

Sotheby's Amsterdam, auct. cat. no. 453, 1987, Lot 187, repr. p. 61
Theween, *Vitrinen,* 1993, footnote 1, p. 25f.

cat. 81
Schlitten
Sled
1969
Wooden sled, felt, belts, flashlight and fat
35 x 90 x 35 (13 3/4 x 35 3/8 x 13 3/4)
numbered
18/50, Galerie René Block, Berlin

Provenance
Galerie René Block, Berlin
acquired 1987

Exhibitions and Literature
Zurich 1993, cat. no. 27, repr. p. 75 (Madrid 1994, cat. no. 27, repr. p. 77; Paris 1994, cat. no. 27, repr. p. 168)
Wide White Space, Brussels 1994, p. 269

Schellmann, *Beuys,* 1992, cat. no. 12, p. 52, repr. p. 53

cat. 82
Filzanzug
Felt Suit
1970
Sewn and stamped felt
overall 170 x 60 (66 7/8 x 23 5/8)
numbered
27/100, Galerie René Block, Berlin

Provenance
René Block, Berlin
acquired 1987

Exhibitions and Literature
Berlin 1988, cat. no. 61, repr. p. 201
Düsseldorf 1991, cat. no. 389
Terra de nadie, Granada 1992, p. 102
Rites of Passage, London 1995, cat. no. 31 [Exhibited as part of 'Absorption. Work in Progress,' 1995, an installation by Jana Sterbak, repr. unpag.]

Schellmann, *Beuys,* 1992, cat. no. 26, p. 64, repr. p. 65

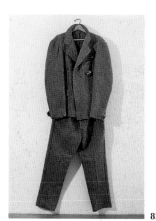

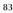

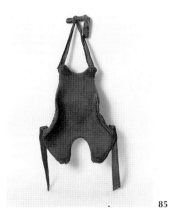

85

cat. 83
Steintorso am Einweihungsgrab
Stone Torso by Initiation Grave
1971
Pencil and watercolour on paper pasted
on paper
21.5 x 27.5 (8 1/2 x 10 7/8)
verso b. 'Joseph Beuys 1971 Steintorso am
Einweihungsgrab'

Provenance
acquired 1984–5

Exhibitions and Literature
Düsseldorf 1991, cat. no. 407, repr. p. 333

cat. 84
Im Gebirge (Wärmeplastik mit Fettwinkel)
In the Mountains (Warmth Sculpture with Fat
Angle)
1972
Oil on paper with two pins, felt and fat
35.5 x 47 x 1 (14 x 18 1/2 x 3/8)
verso 'Im Gebirge (Wärmeplastik mit Fettwinkel)
Joseph Beuys 1972'

Provenance
...
Phillips, London, 27.6.1988, Sale 27224, Lot 234
acquired 1988

Exhibitions and Literature
Düsseldorf 1991, cat. no. 227, repr. 176
New Displays, Tate Gallery, London 1992
[not in cat.]

Phillips, London, auct. cat. Sale 27224, 1988,
repr. p. 35

cat. 85
**Rückenstütze eines feingliederigen Menschen
(Hasentypus) aus dem 20. Jahrhundert p. Chr.**
Backrest for a Fine-limbed Person (Hare-type) of
the 20th Century
1972
Cast iron
96 x 45 x 15 (37 3/4 x 17 3/4 5 7/8)
1/2 (trial casting, Edition Seriaal, Amsterdam)

Provenance
Klaus Kinkel, Baden-Baden
acquired 1988

Exhibitions and Literature
Berlin 1988, cat. no. 65, repr. p. 204
Düsseldorf 1991, cat. no. 411, repr. no. 85

Schellmann, *Beuys,* 1992, cat. no. 65, p. 98,
repr. p. 99

cat. 86
Silberbesen und Besen ohne Haare
Silver Broom and Broom without Bristles
1972
Silver-plated wooden broom and copper broom
with felt underlay
139 x 51; copper broom: 130 x 51
(54 3/4 x 20 1/8; 5 1/8 x 20 1/8)
'Joseph Beuys' and '18/20' embossed on silver-
plated broom
18/20, Edition René Block, Berlin

Provenance
René Block, Berlin
acquired 1987

Exhibitions and Literature
Schellmann, *Beuys,* 1992, cat. no. 62, p. 94,
repr. p. 95

cat. 87
Das Schweigen
The Silence
1973
Five reels of Ingmar Bergman's film *The Silence*
(1962), galvanised
each 38 diameter and 4 high; in carton 25 x 38
(each 15 and 1 5/8; 9 7/8 x 15)
'Beuys', numbering and titles impressed on
metal plaques
42/50, Edition René Block, Berlin and Multiples,
New York
titles (given by Beuys) of the reels:
1 Coughing Fit – Glacier +
2 Dwarves – animalisation
3 Past – vegetabilisation
4 Tank – mechanisation
5 We are free Geyser +

Provenance
René Block, Berlin
acquired 1987

Exhibitions and Literature
Berlin 1988, cat. no. 66, repr. p. 210

Schellmann, *Beuys,* 1992, cat. no. 80, p. 116,
repr. p. 117

cat. 88
Telephon S – – – Ǝ
1974
Two tin cans, each 24 h x 10 diameter (one with
oil *(Braunkreuz)),* label, and string 4/24
Arranged in a crate as 'Zwei Fluxus-Objekte',
together with a green painted violin by Henning
Christiansen (Objects from a Fluxus-concert
'…oder sollen wir es verändern' by Beuys/
Christiansen, Städtisches Museum
Mönchengladbach, 27. 3. 1969) numbered 4/24;
this version arranged in an edition of app. 12;
Schellmann & Klüser, Munich

Provenance
Hauswedell & Nolte, Hamburg
acquired 1987

Exhibitions and Literature
Berlin 1988, cat. no. 67, repr. p. 211

Schellmann, *Beuys,* Munich 1992, cat. no. 135,
136, repr. pp. 152, 153
Der Geist der Romantik, Munich 1995, cat. no.
38, repr. 41, p. 119 [not exh.]

cat. 89, ill. p. 61
Aus dem Maschinenraum, Anhänger
From the Machineroom, Trailer
1977
'Romi' margarine and felt in boxes
two parts, overall 23 x 110 x 7
(overall 9 x 43 1/4 x 2 3/4)
outside on the box 'Aus dem Maschinenraum
Joseph Beuys Anhänger' and 'Joseph Beuys
1977'
The vitrine containing the work was fabricated
by J. W. Froehlich.

84

86

88

97

98

99

Provenance
René Block, Berlin
acquired 1987

Exhibitions and Literature
Düsseldorf 1991, cat. no. 441, repr. 213
Kassel 1993, cat. no. 97, repr. p. 151
Zurich 1993, cat. no. 41, repr. p. 103
Madrid 1994, cat. no. 41, repr. p. 105
Paris 1994, cat. no. 45, repr. p. 151

cat. 90, ill. p. 62
Tafel I (Geist – Recht – Wirtschaft)
Board I (Spirit – Law – Economics)
1978
Chalk on blackboard
90 x 110 (35 3/8 x 43 1/4)

Provenance
Galerie Politart, Nijmegen
Dr. van Lieshout, Lent
Galerie Rudolf Zwirner, Cologne
acquired 1989

Exhibitions and Literature
Düsseldorf 1991, cat. no. 450, repr. p. 336
Zurich 1993, cat. no. 42, repr. p. 94
Madrid 1994, cat. no. 44, repr. p. 96
Paris 1994, cat. no. 46, repr. p. 199

cat. 91, ill. p. 62
Tafel II (Jeder Mensch ist ein Künstler)
Board II (Everyone is an Artist)
1978
Chalk on blackboard
90 x 110 (35 3/8 x 43 1/4)

Provenance
Galerie Politart, Nijmegen
Dr. van Lieshout, Lent
acquired 1989

Exhibitions and Literature
Düsseldorf 1991, cat. no. 451, repr. p. 336
Zurich 1993, cat. no. 43, repr. p. 93
Madrid 1994, cat. no. 43, repr. p. 95
Paris 1994, cat. no. 47, repr. p. 198

cat. 92, ill. p. 62
Tafel III (Kapital = Kunst)
Board III (Capital = Art)
1978
Chalk on blackboard
90 x 110 (35 3/8 x 43 1/4)

Provenance
Galerie Politart, Nijmegen
Dr. van Lieshout, Lent
acquired 1989

Exhibitions and Literature
Düsseldorf 1991, cat. no. 449, repr. p. 336
Zurich 1993, cat. no. 44, repr. p. 95
Madrid 1994, cat. no. 42, repr. p. 97
Paris 1994, cat. no. 48, repr. p. 199

cat. 93, ill. p. 77
Ohne Titel (Schwan und Körperteile)
Untitled (Swan and Body Parts)
1980–4
Pencil on paper
30 x 30 (11 3/4 x 11 3/4)

Provenance
acquired 1984–5

Exhibitions and Literature
Vom Zeichnen, Frankfurt 1985, repr. p. 45
[under the title 'ohne Titel']
Munich 1986, repr. p. 242
Düsseldorf 1991, cat. no. 492, repr. p. 338
New Displays, Tate Gallery, London 1992
[not in cat.]

cat. 94, ill. p. 64
Eiszeit
Ice Age
1983
Wooden board with synthetic polymer, iron
pipe, pencil and handkerchief
250 x 50 x 2.5 (98 3/8 x 19 5/8 x 1)
on iron pipe 'EISZEIT, Joseph Beuys,
17.04.1983'
The wooden board is a found object from a
spray booth in the JW Froehlich factory at
Plochingen.

Provenance
acquired 1983

Exhibitions and Literature
Düsseldorf 1991, cat. no. 485, repr. 236
Zurich 1993, cat. no. 46, repr. supplement p. 7
Madrid 1994, cat. no. 46, repr. supplement p. 7
Paris 1994, cat. no. 56, repr. pp. 212, 213
Der Geist der Romantik, Munich 1995,
cat. no. 16, repr. 127, p. 196

cat. 95, ill. p. 65
Gefängnis (Kabir + Daktyl)
Prison (Kabir + Daktyl)
1983
Steel tubing, sheet metal, plexiglas, two carbide
lamps, lacquer, stone and tape
195 x 145 x 40 (76 3/4 x 57 1/8 x 15 3/4)
'Kabir' and 'Daktyl' respectively on each carbide
lamp and recto t. r. on the iron rack 'Joseph
Beuys 17.4.1983'
The steel frame with Plexiglas was originally
used as a protective shield in the JW Froehlich
factory at Plochingen.

Provenance
acquired 1983

Exhibitions and Literature
Berlin 1988, cat. no. 81, repr. p. 227
Düsseldorf 1991, cat. no. 484, repr. p. 338
Zurich 1993, cat. no. 47, repr. p. 107
Madrid 1994, cat. no. 47, repr. p. 109
Paris 1994, cat. no. 57, repr. p. 217

cat. 96, ill. p. 63
Schwan mit Ei
Swan with Egg
1983
Pencil on aluminum with plaster primer, incised
slate and zinc box
40 x 50 x 3 (15 3/4 x 19 5/8 x 1 1/8)
verso on the aluminum found object with pencil
'für Josef Joseph Beuys Schwan mit Ei'
The aluminium element is a found object from
the construction of the Staatsgalerie Stuttgart.
The zinc box was made by J. W. Froehlich
according to Beuys's specifications. The slate
element was added by Beuys a few months after
the box was made.

Provenance
acquired 1983

Exhibitions and Literature
Berlin 1988, cat. no. 80, repr. p. 225
[dated 1982]
Düsseldorf 1991, cat. no. 468, repr. 42

cat. 97
Entwurf für Tiberiusbrücke Rimini
Design for Tiber Bridge Rimini
1984
Pencil on paper pasted on paper
three parts; 10.5 x 14.7 on 21 x 29.4 on
40.5 x 30 (4 1/8 x 5 3/4 on 8 1/4 x 11 5/8 on
16 x 11 3/4)
verso on drawing b. m. 'Entwurf für
Tiberiusbrücke Rimini Joseph Beuys 1984'

Provenance
acquired 1984–5

Exhibitions and Literature
Munich 1986, repr. p. 246
Düsseldorf 1991, cat. no. 490, repr. p. 338

cat. 98
Norwegen
Norway
1984
Pencil on coloured cardboard mounted on paper
three parts; each 21 x 13 on 47.7 x 31.4
(each 8 1/4 x 5 1/8 on 18 3/4 x 12 3/8)
verso on left page 'Doppelblatt links Joseph
Beuys 1984 Norwegen 1984' and verso on right
page 'Doppelblatt rechts Joseph Beuys 1984
Norwegen'

Provenance
acquired 1984–5

Exhibitions and Literature
Vom Zeichnen, Frankfurt 1985, repr. p. 46
Munich 1986, repr. p. 247
Düsseldorf 1991, cat. no. 491, repr. p. 338

101

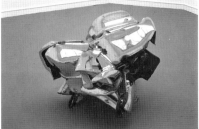

104

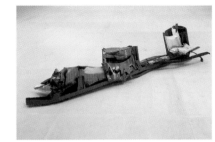

cat. 99
Zählebig zielen willst Du?
1984
Pencil on paper
29.5 x 21 (11 5/8 x 8 1/4)
recto m. 'Zählebig zielen willst Du? daß das der Hase dir sagt wirst du vermissen' and 'vermissen du wirst sagt dir der Hase das daß du willst zielen zählebig' and verso m. 'zählebig zielen willst du? daß das der Hase dir sagt wirst du vermissen Beuys 1984'
The title of this drawing is the first line of the above poetic inscription in German by Beuys which is untranslatable.

Provenance
gift from the artist 1984

JOHN CHAMBERLAIN
born 1927 in Rochester, Indiana
lives in Sarasota, Florida

Bibliography
Three Young Americans, Oberlin 1961
 Three Young Americans, exh. cat. Allen Memorial Art Museum, Oberlin College, Oberlin, Ohio, 1961
New York 1971
 John Chamberlain. A Retrospective Exhibition, exh. cat. Solomon R. Guggenheim Museum, New York, Dec. 1971 – Feb. 1972
New York 1984
 John Chamberlain. New Sculpture, exh. cat. Xavier Fourcade Inc., New York, Feb. – March 1984
Los Angeles 1986
 Julie Sylvester (ed.), *John Chamberlain. A Catalogue Raisonné of the Sculpture 1954 – 1985,* exh. cat. Museum of Contemporary Art, Los Angeles 1986; New York 1986
Baden-Baden 1991
 John Chamberlain, exh. cat. Staatliche Kunsthalle Baden-Baden, May – July 1991; Staatliche Kunstsammlungen Dresden, Albertinum, Aug. – Nov. 1991; et al.
Gondola, New York 1991
 Gondola and Dooms Day Flotilla, exh. cat. Dia Center for the Arts, New York 1991
Amerikanische Kunst, Berlin 1993
 Amerikanische Kunst im 20. Jahrhundert. Malerei und Plastik 1913 – 1993, exh. cat. Martin-Gropius-Bau, Berlin 1993; Royal Academy of Arts and the Saatchi Gallery, London; et al. Munich 1993 (English edition: *American Art in the 20th Century. Painting and Sculpture 1913 – 1993,* London 1993)
New York 1994
 John Chamberlain. Recent Sculpture, exh. cat. Pace Gallery, New York, Sept. – Oct. 1994
Amsterdam 1996
 John Chamberlain. Present work and fond memories, exh. cat. Stedelijk Museum Amsterdam, May- June 1996

cat. 100, ill. p.145
Hillbilly Galoot
1960
Painted and chromium-plated steel
152.4 x 152.4 (60 x 60)

Provenance
Allan Stone Gallery, New York
Beth Urdang, New York
Sotheby's New York, 6.10.1992, Sale 6342, Lot 77
acquired 1992

Exhibitions and Literature
Three Young Americans, Oberlin 1961
Los Angeles 1986, cat. no. 65, p. 60 [under the title 'ohne Titel']
Amerikanische Kunst, Berlin 1993, cat. no. 161, repr. unpag.

Forbes Whiteside, 'Three Young Americans', in: *Allen Memorial Art Museum Bulletin,* vol. 19, Autumn 1961, p. 52–57 [under the title 'Untitled']
Sotheby's New York, auct. cat. Sale 6342, 1992, Lot 77, repr. [under the title 'Untitled']

cat. 101
Iron Stone
1969
Painted and chromium-plated steel
101.5 x 123 x 111.5 (40 x 48 1/2 x 44)

Provenance
Lo Giudice Gallery, Chicago
Walter Kelly Gallery, Chicago
Mr. and Mrs. Abe Adler, Los Angeles
Gagosian Gallery, Los Angeles
Annina Nosei, New York
Francesco Pellizzi, New York
Gagosian Gallery, New York
acquired 1987

Exhibitions and Literature
Hard and Soft. Recent Sculpture, Lo Guidice Gallery, Chicago, Illinois, 1970 [no cat.]
New York 1971, cat. no. 90, repr. p. 86
John Chamberlain, Walter Kelly Gallery, Chicago, Illinois, Dec. – Jan. 1975 [no cat.]
Los Angeles 1986, cat. no. 344, repr. p. 109
Kunst der 70er Jahre, Künstlerhaus Stuttgart, 1989 [no cat.]
Baden-Baden 1991, cat. no. 22, repr. p. 62 – 63
Amerikanische Kunst, Berlin 1993, cat. no. 160, repr. unpag.

Heiner Protzmann, 'Iron Stone. John Chamberlain im Albertinum', in: *Dresdner Kunstblätter,* no. 4, Dresden 1991

cat. 102, ill. p. 146
Coke Ennyday
1977
Painted and chromium-plated steel
200.5 x 75 x 84 (79 x 29 1/2 x 33)

Provenance
Heiner Friedrich, New York
acquired 1996

Exhibitions and Literature
John Chamberlain Sculpture. An Extended Exhibition, Dia Art Foundation, New York, Sept. 1983 – Feb. 1985 [no cat.]
Los Angeles 1986, cat. no. 557, repr. p. 153
Baden-Baden 1991, cat. no. 28, repr. p. 77
Amsterdam 1996 [cat. not yet published]

cat. 103, ill. p. 147
Flavin Flats
1977
Painted and chromium-plated steel
195.5 x 95.5 x 94 (77 x 37 1/2 x 37)

Provenance
Heiner Friedrich, New York
acquired 1996

Exhibitions and Literature
ohn Chamberlain Sculpture. An Extended Exhibition, Dia Art Foundation, New York, Sept. 1983 – Feb. 1985 [no cat.]
New York 1983, cat. no. 29, repr. p. 74
Los Angeles 1986, cat. no. 559, repr. p. 153
Baden-Baden 1991, cat. no. 29, repr. p. 74
Amsterdam 1996 [cat. not yet published]

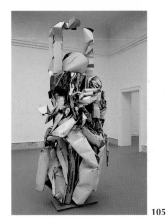

105

109

cat. 104, ill. p. 251
Gondola Jack Kerouac
1982
Painted and chromium-plated steel
86.5 x 383.5 x 76 (34 x 151 x 30)

Provenance
Xavier Fourcade Inc., New York
Pace Gallery, New York
acquired 1992

Exhibitions and Literature
New York 1984, repr. unpag.
*John Chamberlain / Alan Saret – Contemporary
Sculpture,* The Art Galleries, University of
California, Santa Barbara, March – April 1984
[no cat.]
John Chamberlain, Margo Leavin Gallery, Los
Angeles, March 1985 [no cat.]
Los Angeles 1986, cat. no. 674, repr. p. 184
Gondola, New York 1991, repr. unpag.
Amsterdam 1996 [cat. not yet published]

Suzanne Muchnic, 'Two Sculptors show their
creative metal', in: *Los Angeles Times,*
16.4.1984
Roberta Smith, 'Sculpture in the City From
Blankets to Bronze', in: *New York Times,*
weekend supplement, 20.4.1990, repr.

cat. 105
Endzoneboogie
1988
Painted and chromium-plated steel
295 x 124 x 124 (116 x 48 1/4 x 48 1/2)

Provenance
Pace Gallery, New York
acquired 1989

Exhibitions and Literature
New York 1989, cat. no. 12, repr. unpag.
Baden Baden 1991, cat. no. 41, repr. p. 86
Amsterdam 1996 [cat. not yet published]

Extended loan to Staatsgalerie Stuttgart since
1992

cat. 106
Urban Garlic
1994
Painted and chromium-plated steel
187.3 x 227.3 x 198.8 (73 3/4 x 89 1/2 x 78 1/4)

Provenance
Pace Gallery, New York
acquired 1994

Exhibitions and Literature
New York 1994, repr. p. 17
Amsterdam 1996 [cat. not yet published]

DAN FLAVIN
born 1933 in New York
lives in Wainscott, Long Island

Bibliography
Los Angeles 1984
"monuments" for V. Tatlin, exh. cat. Museum
of Contemporary Art, Los Angeles, April –
June 1984; Corcoran Gallery of Art,
Washington, Sept. – Nov. 1984; et al.

cat. 107, ill. p. 149
The diagonal of May 25, 1963
1963
Fluorescent light [green]
243.8 (96)
1/3

Provenance
Bernard Venet, Paris
Marc Landeau, Paris
Sotheby's New York, 31.10.1984, Sale 5243,
Lot 54
Margo Leavin Gallery, Los Angeles
Sotheby's New York, 10.11.1993, Sale 6494,
Lot 23
acquired 1993

Exhibitions and Literature
Sotheby's New York, auct. cat. Sale 5243, 1984,
Lot 54, repr.
Sotheby's New York, auct. cat. Sale 6494, 1993,
Lot 23, repr.

cat. 108, ill. p. 150
Untitled (monument for V. Tatlin)
1967–70 [designed], 1990 [produced]
Eight fluorescent lights [cool white]
in four sizes: 243.8, 182.9, 122, 61; overall
height: 243.8, overall width 81.3 (each: 96, 72,
48, 24; overall height: 96, overall width: 32)
1/5

Provenance
Leo Castelli Gallery, New York
Fundació Juan March, Madrid
Morgan Spangle Inc., New York
acquired 1993

Exhibitions and Literature
Dan Flavin. Tatlin Monuments, Mary Boone
Gallery, New York, March 1991 [no cat.]

Los Angeles 1984, repr. 74 [drawing]

cat. 109
Untitled
1969
Two fluorescent lights [pink and red]
243.8 [pink], 61 [red] (96, 24)
1/3

Provenance
Heiner Friedrich, Cologne/New York
Galerie Schmela, Düsseldorf
acquired 1984

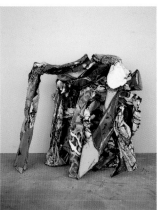

106

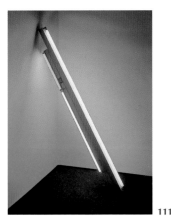

111

115

cat. 110, ill. p. 151
Untitled (for Donna) 5a
1971
Six fluorescent lights [yellow, blue, pink]
each 243.8, overall 243.8 x 243.8 (each 96,
overall 96 x 96)
3/5

Provenance
Leo Castelli Gallery, New York
acquired 1994

Exhibitions and Literature
Summer Group Exhibition, Leo Castelli Gallery,
New York 1994 [no. cat.]

cat. 111
Untitled (fondly to Helen)
1976
Three fluorescent lights [blue, green and yellow]
243.8 [blue], 122 [green], 61 [yellow]
(96, 48, 24)
4/5

Provenance
Margo Leavin Gallery, Los Angeles
Christie's London, 27.10.1994, Sale 5273,
Lot 120

Exhibitions and Literature
Christie's London, auct. cat. Sale 5273, 1994,
Lot 120, repr. p. 86

DONALD JUDD
born 1928 in Excelsior Springs, Missouri
died 1994 in New York

Bibliography
Art of the Sixties, Ridgefield 1968
 *Art of the Sixties: 60's: Selections from the
 Collection of Hanford Yang*, exh. cat. Aldrich
 Museum of Contemporary Art, Ridgefield
 1968
Made of Plastic, Flint 1968
 Made of Plastic, exh. cat. Flint Institute of
 Arts, The Waters Arts Centre, Flint 1968
Pasadena 1971
 John Coplans (ed.), *Don Judd*, exh. cat.
 Pasadena Art Museum, May – July 1971
Ottawa 1975
 Brydon Smith (ed.), *Donald Judd. Catalogue
 Raisonné of Paintings, Objects and Wood
 Blocks 1960–1974*, exh. cat. National Gallery
 of Canada, Ottawa, May – July 1975
Affiliations, New York 1985
 *Affiliations. Recent Sculpture and its
 Antecedents*, exh. cat. Whitney Museum of
 American Art, New York, June – Aug. 1985
List Family Collection, Cambridge 1985
 *Giacometti to Johns. The Albert and Vera List
 Family Collection*, exh. cat. Hayden Gallery,
 Albert and Vera List Visual Arts Center,
 Massachusetts Institute of Technology,
 Cambridge, Mass., March – April 1985
New York 1988
 Donald Judd, exh. cat. Whitney Museum of
 American Art, New York, Oct. – Dec. 1988
Bilderstreit, Cologne 1989
 Johannes Gachnang / Siegfried Gohr (eds.),
 *Bilderstreit. Widerspruch, Einheit und
 Fragment in der Kunst seit 1960*, exh. cat.
 Museum Ludwig in den Rheinhallen der
 Kölner Messe, Cologne 1989
Amerikanische Kunst, Berlin 1993
 *Amerikanische Kunst im 20. Jahrhundert.
 Malerei und Plastik 1913 – 1993*, exh. cat.
 Martin-Gropius-Bau, Berlin 1993; Royal
 Academy of Arts and The Saatchi Gallery,
 London 1993; et al.; Munich 1993 [English
 edition: *American Art in the 20th Century.
 Painting and Sculpture 1913 – 1993*, London
 1993]
Wiesbaden 1993
 Kunst + Design. Donald Judd. Art + Design.
 exh. cat. Museum Wiesbaden, Dec. 1993 –
 March 1994; Städtische Kunstsammlungen,
 Chemnitz; et al.; Stuttgart 1993
Art of the Sixties, Tokyo 1995
 Revolution: Art of the Sixties. From Warhol to
 Beuys, exh. cat. Museum of Contemporary
 Art, Tokyo 1995

cat. 112, ill. p. 154
Untitled
1965
Lacquer on galvanised iron
12.7 x 175.3 x 21.6 (5 x 69 x 8 1/2)
5/7

Provenance
Leo Castelli Gallery, New York
Hanford Yang, New York
Mr. and Mrs. Russell Cowles, Wayzata,
Minnesota
Maria Garbona, France
Galerie Daniel Templon, Paris
Gagosian Gallery, New York
acquired 1987

Exhibitions and Literature
Art of the Sixties, Ridgefield 1968, cat. no. 35
Ottawa 1975, cat. no. 70, repr. p. 131
Amerikanische Kunst, Berlin 1993, cat. no. 201,
repr. unpag.
Art of the Sixties, Tokyo 1995, cat. no. 71, repr.
p. 165

Pasadena 1971, cat. no. 26, repr. 32, p. 54
[repr. of different example: Collection City Art
Museum of St. Louis]

cat. 113, ill. p. 155
Untitled
1966
Plexiglas and stainless steel
50.8 x 122 x 86.4 (20 x 48 x 34)

Provenance
Leo Castelli Gallery, New York
Gagosian Gallery, New York
Leo Castelli Gallery, New York
acquired 1987

Exhibitions and Literature
Made of Plastic, Flint 1968
New Media: New Methods, Robertson Centre,
Binghamton, N.Y.; Montclair Art Museum, 1969
et al. [no cat.]
Ottawa 1975, cat. no. 82, repr. p. 138
New York 1988, cat. no. 31, repr. p. 54
Andre, Chamberlain, Flavin, Judd, Nauman,
Künstlerhaus Stuttgart, 1989 [no cat.]
Bilderstreit, Cologne 1989, cat. no. 295,
repr. p. 310
Amerikanische Kunst, Berlin 1993, cat. no. 201,
repr. unpag.
Art of the Sixties, Tokyo 1995, cat. no. 72,
repr. p. 166

Lars Morell, 'Talraekker hos Donald Judd', in:
Billedkunsten, Oct. 1995, p. 10 ff., repr. p. 12

cat. 114, ill. p. 153
Untitled
1968
Plexiglas and stainless steel
ten parts, each 23 x 101.5 x 79, overall height
437 (each 9 x 40 x 31, overall height 171)
1/2

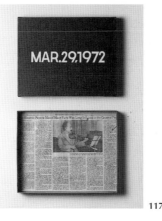

117

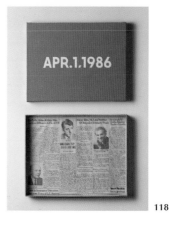

118

Provenance
Leo Castelli Gallery, New York
Mrs. Albert List, Greenwich, Connecticut
Sotheby's New York, Sale 5842, 2.5.1989,
Lot 50
Jay Chiat, New York
Christie's New York, 4.5.1993, Sale 7664,
Lot 20
acquired 1993

Exhibitions and Literature
Ottawa 1975, cat. no. 123, repr. p. 164
List Family Collection, Cambridge 1985
Affiliations, New York 1985

J. H. Cone, 'Judd at the Whitney', in: *Art Forum,*
May 1968, pp. 36 – 39
Sotheby's New York, auct. cat. Sale 5842, 1989,
Lot 50, repr.
Christie's New York, auct. cat. Sale 7664, 1993
Lot 20, repr.

cat. 115, ill. p. 253
Untitled
1978
Plywood
49.5 x 114.3 x 77.5 (19 1/2 x 45 x 30 1/2)
verso m. '78-29 Judd'

Provenance
...
Leo Castelli Gallery, New York
acquired 1988

Exhibitions and Literature
New York 1988, cat. no. 72, repr. p. 105

cat. 116, ill. pp. 156–7
Untitled
1989
Plywood
four parts, each 50 x 100 x 50
(each 19 5/8 x 39 3/8 x 19 5/8)

Provenance
Galerie Annemarie Verna, Zurich
acquired 1990

Exhibitions and Literature
Donald Judd, Annemarie Verna Galerie, Zurich,
April – May 1990 [no cat.]
Wiesbaden 1993 [not in cat.]
Donald Judd, Kunsthalle Brandts Klaedefabrik,
Odense, June – Sept. 1995 [no cat.]

Lars Morell, 'Talraekker hos Donald Judd', in:
Billedkunst, Oct. 1995, p. 10 ff., repr. p. 14

ON KAWARA
born 1933 in Aichi-ken, Japan
lives in New York

Bibliography
Stockholm 1980
*On Kawara. continuity / discontinuity 1963 –
1979,* exh. cat. Moderna Museet, Stockholm,
Oct. – Nov. 1980; Museum Folkwang, Essen,
Jan. – March 1981; et al.
Rotterdam 1991
On Kawara. Date Paintings in 89 cities,
exh. cat. Museum Boymans-van Beuningen,
Rotterdam, Dec. 1991 – Feb. 1992;
Deichtorhallen, Hamburg, March – May
1992; et al.
Über Malerei, Vienna 1992
Über Malerei, exh. cat. Akademie der
Bildenden Künste, Vienna 1992
Bordeaux 1993
On Kawara. 247 mois/247 jours, exh. cat.
CAPC Musée d'art contemporain, Bordeaux,
Dec. 1993 – April 1994

cat. 117
**MAR. 29, 1972 (For the first time in six years,
the Berlin wall was opened today to allow West
Berliners holiday visits in the East.)**
1972
Liquitex on canvas
25.5 x 33 (10 x 13)

Provenance
Sperone Westwater Gallery, New York
acquired 1988

Exhibitions and Literature
Stockholm 1980, repr. unpag.
Über Malerei, Vienna 1992, repr. p. 16

cat. 118
APR. 1, 1986
1986
Liquitex on canvas
25.5 x 33 (10 x 13)

Provenance
Sperone Westwater Gallery, New York
acquired 1988

Exhibitions and Literature
Über Malerei, Vienna 1992, repr. on book jacket
Bordeaux 1993, repr. unpag.

cat. 119, ill. p. 159
23. JAN. 1989
1989
Liquitex on canvas
25.5 x 33 (10 x 13)

Provenance
Galerie Max Hetzler, Cologne
acquired 1990

Exhibitions and Literature
On Kawara, Galerie Max Hetzler, Cologne 1990
[no cat.]
Über Malerei, Vienna 1992, repr. p. 18
Bordeaux 1993, repr. unpag.

cat. 120, ill. p. 160
24. JAN. 1989
1989
Liquitex on canvas
25.5 x 33 (10 x 13)

Provenance
Galerie Max Hetzler, Cologne
acquired 1990

Exhibitions and Literature
On Kawara, Galerie Max Hetzler, Cologne 1990
[no cat.]
Über Malerei, Vienna 1992, repr. p. 20

cat. 121, ill. p. 160
25. JAN. 1989 (Wednesday)
1989
Liquitex on canvas
25.5 x 33 (10 x 13)

Provenance
Galerie Max Hetzler, Cologne
acquired 1990

Exhibitions and Literature
On Kawara, Galerie Max Hetzler, Cologne 1990
[no cat.]
Rotterdam 1991, repr. p. 159
Über Malerei, Vienna 1992, repr. p. 22

cat. 122, ill. p. 161
26. JAN. 1989
1989
Liquitex on canvas
25.5 x 33 (10 x 13)

Provenance
Galerie Max Hetzler, Cologne
acquired 1990

Exhibitions and Literature
On Kawara, Galerie Max Hetzler, Cologne 1990
[no cat.]
Über Malerei, Vienna 1992, repr. p. 24

cat. 123, ill. p. 161
27. JAN. 1989
1989
Liquitex on canvas
25.5 x 33 (10 x 13)

Provenance
Galerie Max Hetzler, Cologne
acquired 1990

Exhibitions and Literature
On Kawara, Galerie Max Hetzler, Cologne 1990
[no cat.]
Über Malerei, Vienna 1992, repr. p. 57

126

ANSELM KIEFER
born 1945 in Donaueschingen
lives in Barjac, France

Bibliography
Venice 1980
 Klaus Gallwitz (ed.), *Anselm Kiefer.*
 Verbrennen, Verholzen, Versenken,
 Versanden, exh. cat. German Pavilion, XXXIX
 Biennale di Venezia, June – Sept. 1980
Stuttgart 1980
 Anselm Kiefer, exh. cat. Württembergischer
 Kunstverein, Stuttgart, Sept. – Oct. 1980
Groningen 1980
 Anselm Kiefer, exh. cat. Groninger Museum,
 Groningen, Nov. 1980 – Jan. 1981
Biennale, Venice 1980
 XXXIX Biennale di Venezia. L'arte negli anni
 settanta, exh. cat. Venice 1980; Milan 1980
Bordeaux 1984
 Anselm Kiefer. Peintures 1983 – 1984,
 exh. cat. Musée d'art contemporain,
 Bordeaux, May – Sept. 1984
Jahrhundert des Holzschnitts, Hamburg 1993
 Ein Jahrhundert des Holzschnitts, exh. cat.
 Hamburger Kunsthalle, 1993

cat. 124, ill. p. 80
Brünhilde – Grane
1978
Paint on woodcut mounted on paper
248 x 210 (97 1/2 x 82)
recto t. 'Brünhilde – Grane'

Provenance
Sonnabend Gallery, New York
acquired 1993

Exhibitions and Literature
Groningen 1980, repr. 4

Stuttgart 1980, repr. unpag. [not exh.]

cat. 125, ill. p. 79
Wege der Weltweisheit – die Hermannsschlacht
Ways of Worldly Wisdom – Arminius' Battle
1978
Acrylic and shellac on woodcut on paper mounted on canvas
360.5 x 339 (144 1/2 x 135 3/4)
recto b. 'Wege der Weltweisheit – die
Hermannsschlacht'

Provenance
Mary Boone Gallery, New York
Julian Schnabel, New York
Céline and Heiner Bastian, New York
Heiner Bastian Fine Art, Berlin
acquired 1994

Exhibitions and Literature
Venice 1980, repr. unpag.
Biennale, Venice 1980, p. 117

Jahrhundert des Holzschnitts, Hamburg 1993,
repr. p. 22 [not exh.]

On Loan to Staatsgalerie Stuttgart since April
1994

cat. 126
Teutoburger Wald
Teutoburg Forest
1978/80
Book of woodcuts on paper, 76 pages
62 x 50 x 12.5 (24 3/4 x 20 x 6)

Provenance
Marian Goodman Gallery, New York
acquired 1994

cat. 127, ill. p. 81
Der Rhein
The Rhine
1980–2
Woodcut on paper mounted on canvas
380 x 200 (149 5/8 x 78 3/4)
signed recto t. m. in black oil paint 'Der Rhein'

Provenance
Anthony d'Offay Gallery, London
Private collection, USA
Galerie Beyeler, Basel
acquired 1993

Exhibitions and Literature
Bordeaux 1984, repr. p. 28

cat. 128, ill. pp. 82–3
Dem unbekannten Maler
To the Unknown Painter
1982
Woodcut on paper
229 x 427 (90 1/8 x 168 1/8)
recto t. 'dem unbekannten Maler'

Provenance
Helen van der Meij Gallery, Amsterdam
Sonnabend Gallery, New York
acquired 1993

Exhibitions and Literature
Anselm Kiefer Woodcuts, Helen van der Meij
Gallery, Amsterdam 1982

IMI KNOEBEL
born 1940 in Dessau
lives in Düsseldorf

Bibliography
Winterthur 1983
 Imi Knoebel, exh. cat. Kunstmuseum
 Winterthur, March – May 1983; Städtisches
 Kunstmuseum Bonn, May – July 1983
Otterlo 1985
 Imi Knoebel, exh. cat. Rijkmuseum Kröller-
 Müller, Otterlo, April – June 1985
7000 Eichen, Tübingen 1985
 7000 Eichen, exh. cat. Kunsthalle Tübingen,
 1985; Kunsthalle Bielefeld, 1985; et al.
Baden-Baden 1986
 Imi Knoebel, exh. cat. Staatliche Kunsthalle
 Baden-Baden, April – June 1986
Schmidt-Wulffen, *Spielregeln,* 1987
 Stephan Schmidt-Wulffen, *Spielregeln.*
 Tendenzen der Gegenwartskunst, Cologne
 1987
Bilderstreit, Cologne 1989
 Siegfried Gohr and Johannes Gachnang (eds.),
 Bilderstreit. Widerspruch, Einheit und
 Fragment in der Kunst seit 1960, exh. cat.
 Museum Ludwig in den Rheinhallen der
 Kölner Messe, Cologne 1989
Neue Möbel, Esslingen 1994
 Neue Möbel für die Villa. New Furniture for
 the Villa, exh. cat. Villa Merkel, Galerie der
 Stadt Esslingen, Stuttgart 1994

cat. 129, ill. p. 86
Filipp
1975/84
Acrylic on plywood
six parts, installed overall: 233 x 395
(91 3/4 x 155 1/2)
each piece signed verso 'Q1' to 'Q6'; on Q1
verso b. m. 'Imi 75/84' and on Q3 verso b. m.
'Filipp'

Provenance
Marx Collection, Berlin
Heiner Bastian, Berlin
acquired 1989

Exhibitions and Literature
7000 Eichen, Tübingen 1985, cat. no. 18,
unpag.

cat. 130, ill. p. 87
Fester Bester, Bester Tester
1980/91
Varnish and acrylic on aluminum
six parts, overall 200 x 200 (78 3/4 x 78 3/4)
signed drawing by Knoebel with installation
instructions b. r. 'IMI 8/81'

Provenance
Dietmar Werle, Cologne
acquired 1986

Exhibitions and Literature
Winterthur 1983, p. 64

cat. 131, ill. p. 85
Schwarzes Quadrat auf Buffet
Black Square on Buffet
1984
Fibreboard and acrylic on fibreboard
and cardboard
four parts, overall 215 x 165 x 51.5
(84 5/8 x 65 x 20 1/4)
on cardboard 'M 84'

Provenance
Marx Collection, Berlin
acquired 1988

Exhibitions and Literature
Otterlo 1985, repr. unpag.
Baden-Baden 1986, repr. unpag.
Bilderstreit, Cologne 1989, cat. no. 364
Neue Möbel, Esslingen 1994 [not in cat.]

Schmidt-Wulffen, *Spielregeln*, 1987, repr. 30

BRUCE NAUMAN
born 1941 in Fort Worth, Indiana;
lives in Galisteo, New Mexico

Bibliography
New York 1968
Bruce Nauman, exh. cat. Leo Castelli Gallery,
New York, Jan. – Feb. 1968
Los Angeles 1972
Bruce Nauman. Works from 1965 to 1972,
exh. cat. Los Angeles County Museum of Art,
Los Angeles, Dec. 1972 – Feb. 1973; Whitney
Museum of American Art, New York, March –
May 1973; et al.; [German edition: Kunsthalle
Bern / Städtische Kunsthalle Düsseldorf,
1973]
Baltimore 1982
Brenda Richardson (ed.), *Bruce Nauman:
Neons,* exh. cat. The Baltimore Museum of
Art, Baltimore, Dec. 1982 – Feb. 1983
Basle 1986
Bruce Nauman. Zeichnungen 1965 – 1986,
exh. cat. Museum für Gegenwartskunst, Basle,
May – July 1986; Kunsthalle Tübingen, July –
Sept. 1986; et al.
Basle 1986 (Kunsthalle)
Bruce Nauman, exh. cat. Whitechapel Art
Gallery, London 1986; first: Kunsthalle Basel,
July – Sept. 1986 [with German supplement];
ARC, Musée d'art moderne de la ville de
Paris, Oct. – Dec. 1986; Whitechapel Art
Gallery, London, Jan. – Feb. 1987
Bruggen, *Nauman,* 1988
Coosje van Bruggen, *Bruce Nauman,* New
York 1988
Bilderstreit, Cologne 1989
Johannes Gachnang/Siegfried Gohr (eds.),
*Bilderstreit. Widerspruch, Einheit und
Fragment in der Kunst seit 1960,* exh. cat.
Museum Ludwig in den Rheinhallen der
Kölner Messe, Cologne 1989
Einleuchten, Hamburg 1989
Einleuchten. Will, Vorstel & Simul in HH,
exh. cat. Deichtorhallen, Hamburg 1989–90
Basle 1990
Bruce Nauman, exh. cat. Museum für
Gegenwartskunst, Basle, Sept. – Dec. 1990;
Städtische Galerie im Städelschen
Kunstinstitut, Frankfurt a.M., May – Aug.
1991; et al.; Cologne 1990
Amerikanische Zeichnungen, Vienna 1990
*Amerikanische Zeichnungen in den achtziger
Jahren,* exh. cat. Graphische Sammmlung
Albertina, Vienna 1990; Museum Morsbroich,
Leverkusen 1990
New Sculpture, New York 1990
Richard Armstrong / Richard Marshal (eds.),
*The New Sculpture 1965 – 75. Between
Geometry and Gesture,* exh. cat. Whitney
Museum of American Art, New York 1990;
Museum of Contemporary Art at the
Temporary Contemporary, Los Angeles 1991
The Readymade Boomerang, Sydney 1990
*The Readymade Boomerang. Certain
Relations in 20th Century Art,* exh. cat. The
Eighth Biennale of Sydney, 1990
Transform, Basle 1992
*Transform. Bild, Objekt, Skulptur im 20.
Jahrhundert,* exh. cat. Kunstmuseum und
Kunsthalle Basel, 1992
Madrid 1993
Bruce Nauman, exh. cat. Museo Nacional
Centro de Arte Reina Sofia, Madrid, Nov.
1993 – Feb. 1994 [Spanish edition of
Minneapolis 1994]
Amerikanische Kunst, Berlin 1993
*Amerikanische Kunst im 20. Jahrhundert.
Malerei und Skulptur 1913–1993,* exh. cat.
Martin -Gropius – Bau, Berlin; Royal
Academy of Arts and the Saatchi Gallery,
London, 1993 [english edition: *American Art
in the 20th Century. Painting and Sculpture
1913–1993,* London 1993]
Minneapolis 1994
Joan Simon (ed.), *Bruce Nauman,* exh. cat.
Walker Art Center, Minneapolis, April – June
1994; The Museum of Contemporary Art,
Los Angeles, July – Sept. 1994; et al. [English
edition of Madrid 1993]
Simon, *Nauman,* 1994
Joan Simon, *Bruce Nauman. Catalogue
Raisonné,* Minneapolis 1994
Lichträume, Dessau 1994
Lichträume, exh. cat. Bauhaus Dessau, 1994
Figur. Natur, Hanover 1994
Figur. Natur, exh. cat. Sprengel-Museum,
Hanover 1994–5
Attitudes/Sculptures, Bordeaux 1995
Attitudes / Sculptures, exh. cat. CAPC Musée
d'art contemporain de Bordeaux, March –
May 1995
Zurich 1995
Bruce Nauman, supplement Kunsthaus
Zürich, July – Oct. 1995 [German addendum
to exh. cat. Minnneapolis 1994]
Art of the Sixties, Tokyo 1995
*Revolution: Art of the Sixties. From Warhol to
Beuys,* exh. cat. Museum of Contemporary
Art, Tokyo, 1995
Biennale, Istanbul 1995
4. International Istanbul Biennale, Istanbul
1995
Pierrot, Munich 1995
Pierrot. Melancholie und Maske, exh. cat.
Haus der Kunst, Munich 1995
Human Form, London 1995
Of the Human Form, exh. cat. Waddington
Galleries, London 1995
New York 1995
Bruce Nauman, Museum of Modern Art, New
York, March – May 1995 [leaflet]

cat. 132, ill. p. 164
Untitled
1965
Fibreglass and polyester resin
170.8 x 16 x 8 (67 1/4 x 6 1/4 x 3 1/8)

Provenance
...
Sotheby's New York, 19.2.1988, Sale 5688,
Lot 67
Sperone Westwater Fischer Gallery, New York
acquired 1988

Exhibitions and Literature
Andre, Chamberlain, Flavin, Judd, Nauman,
Künstlerhaus Stuttgart, 1989 [no cat.]

Simon, *Nauman,* 1994, cat. no. 15, repr. p. 194
Sotheby's New York, auct. cat. Sale 5688, 1988,
cat. no. 67, repr.

cat. 133, ill. p. 163
**Shelf Sinking into the Wall with Copper-Painted
Plaster Casts of the Spaces Underneath**
1966
Wood, plaster and paint
177.8 x 213.4 x 15.2 (70 x 84 x 6)

Provenance
Nicholas Wilder Gallery, Los Angeles
Katherine Bishop Crum, New York
Sperone Westwater, New York
acquired 1993

Exhibitions and Literature
New York 1968, cat. no. 17, repr. unpag.
Los Angeles 1972, cat. no. 14, repr. p. 65
New Sculpture, New York 1990, cat. no. 25,
repr. p. 64
Madrid 1993, cat. no. 7, p. 84
Minneapolis 1994, cat. no. 8, repr. p. 115
Zurich 1995, cat. no. 8, p. 53
New York 1995, cat. no. 8, repr. p. 4

Willoughby Sharp, 'Nauman Interview', in:
Arts Magazine, vol. 44, no. 5, March 1970,
repr. p. 27
Bruggen, *Nauman,* 1988, p. 170
Simon, *Nauman,* 1994, cat. no. 55, repr. p. 205

cat. 134, ill. pp. 166–7
Eleven Color Photographs
1966–7/1970
Portfolio with eleven colour photographs
dimensions vary slightly, each app. 50.2 x 58.4
(each app. 19 3/4 x 23)
all signed and numbered verso:
Bound to Fail, 1966
Coffee Spilled Because the Cup Was Too Hot,
1966
Coffee Thrown Away Because It Was Too Cold,
1967
Drill Team, 1966
Eating My Words, 1966
Feet of Clay, 1966
Finger Touch No. 1, 1966
Finger Touch With Mirrors, 1966
Self-Portrait as Fountain, 1966
Untitled (Potholder), 1966
Waxing Hot, 1966
4/8 (*Finger Touch No. 1* is no. 3/8), published by
Leo Castelli Gallery, New York 1970

Provenance
Leo Castelli Gallery, New York
Pier Luigi Pero, Siena
Sperone Westwater Gallery, New York
acquired 1994

Exhibitions and Literature
Madrid 1993, cat. no. 9, repr. p. 86–7
Attitudes/Sculptures, Bordeaux 1995,
repr. p. 62–3

Simon, *Nauman,* 1994, cat. no. 175,
repr. p. 242

cat. 135
Shoulder with 3 Arms (Study for Shoulder Tree)
1967
Ink and wash on paper
40 x 62 (15 3/4 x 24 1/2)
recto b. r. 'BN 1967'

Provenance
Eugenia Butler Gallery, Los Angeles
Pace Gallery, New York
acquired 1994

cat. 136, ill. p. 165
Henry Moore, Bound to Fail
1967 (cast 1970)
Cast iron
64.8 x 61 x 6.4 (25 1/2 x 24 x 2 1/2)
4/9

Provenance
Helman Gallery, St. Louis
Leo Castelli Gallery, New York
acquired 1993

Exhibitions and Literature
Art of the Sixties, Tokyo 1995, cat. no. 114, repr.
unpag.

Bruggen, *Nauman,*1988, repr. p. 147
Barbara Catoir, 'Über den Subjektivismus bei
Bruce Nauman', in: *Das Kunstwerk,* no. 6,
Nov. 1973, pp. 3–12
Ludmilla Vachtova, 'Bruce Nauman: Der Körper
als Kunststück', in: *Kunstforum International,*
·spring 1992, pp. 138–142
Simon, *Nauman,* 1994, cat. no. 181,
[see repr. p. 246]

cat. 137, ill. p. 176
Templates for Right Half of My Body
c. 1967
Ink wash and pencil on paper
48 x 61 (19 x 24)

Provenance
Eugenia Butler Gallery, Los Angeles
Pace Gallery, New York
acquired 1994

cat. 138, ill. p. 177
RawWar
1968
Pencil, coloured pencil and watercolour on
paper
75.5 x 55.8 (30 x 22)
recto b. r. 'B. N. 1968'

Provenance
Galerie Bischofberger, Zurich
Ingvild Stöcker, Munich
acquired 1987

Exhibitions and Literature
Los Angeles 1972, cat. no. 95, repr. p. 139
Baltimore 1982, p. 62
Basle 1986, cat. no. 70, repr. 48

Bruggen, *Nauman,* 1988, repr. p. 156

cat. 139
Suite Substitute
1968
Neon tubing with clear-glass tubing suspension
frame
13.2 x 127 x 12.7 (5 1/4 x 30 x 3)
2/3

Provenance
Sperone Westwater Fischer Gallery, New York
Robert J. Dodds III, Pittsburgh
Sotheby's New York, Sale 6165, 1.5.1991,
Lot 86
Sperone Westwater Gallery, New York
acquired 1991

Exhibitions and Literature
Baltimore 1982, cat. no. 8, S. 56, repr. p. 57
Transform, Basle 1992 [not in cat.]

Bruggen, *Nauman,* 1988, repr. p. 154
Sotheby's New York, auct. cat. Sale 6165, 1991,
Lot 86, repr.
Simon, *Nauman,* 1994, cat. no. 129,
repr. p. 228

cat. 140, ill. p. 171
Run from Fear, Fun from Rear
1972
Neon tubing with clear-glass tubing suspension
frame
two parts: 19 x 116.6 x 2.8 and 10.8 x 113 x 2.8
(7 1/2 x 46 x 1 1/4 and 4 1/4 x 44 1/2 x 1 1/4)
6/6

Provenance
Galleria Enzo Sperone, Turin
Angelo Baldassarre, Bari
Sperone Westwater, New York
acquired 1986

Exhibitions and Literature
Baltimore 1982, cat. no. 13, p. 72, repr. p. 73
Basle 1986 (Kunsthalle), p. 16, repr. p. 16 and
repr. unpag.

Bruce Nauman, London 1987, repr. unpag.
Bruggen, *Nauman,* 1988, repr. p. 101
Simon, *Nauman,* 1994, cat. no. 222,
repr. p. 258

144

150

152

cat. 141, ill. p. 178
American Violence
1983
Pencil and tape on paper
76.2 x 99 (30 x 39)
recto b. r. 'B. Nauman 83'

Provenance
Donald Young Gallery, Chicago
acquired 1986

Exhibitions and Literature
Basle 1986, cat. no. 406, repr. 137
Amerikanische Zeichnungen, Vienna 1990,
repr. p. 77

Bruggen, *Nauman,* repr. p. 128

cat. 142, ill. p. 168
Musical Chair
1983
Steel I-beams, coiled rolled steel and wire
86.4 x 488 x 510 (34 x 192 1/8 x 200 3/4)

Provenance
Leo Castelli Gallery, New York
Sperone Westwater, New York
acquired 1986

Exhibitions and Literature
Nauman, Carol Taylor Art, Dallas, April 1983
[no cat.]
John Duff. Robert Mangold. Bruce Nauman,
BlumHelman Gallery, New York 1983 [no cat.]
Bilderstreit, Cologne 1989, cat. no. 503,
repr. p. 155

Bruggen, *Nauman,* 1988, repr. p. 84
Joan Simon, 'Breaking the Silence: An Interview
with Bruce Nauman', in: *Art in America,* no. 9,
Sept. 1988, pp. 140–149
Simon, *Nauman,* 1994, cat. no. 313,
repr. p. 287

cat. 143, ill. p. 173
Human Nature/Knows Doesn't Know
1983/86
Neon tubing with clear-glass tubing
suspension frame
230 x 230 x 35.5 (90 x 90 x 14)

Provenance
Leo Castelli Gallery, New York
Carpenter and Hochman, Dallas/Donald Young
Gallery, Chicago
acquired 1987

Exhibitions and Literature
Americanische Kunst, Berlin 1993,
cat. no. 215, repr.

Simon, *Nauman,* 1994, cat. no. 355,
repr. p. 300

cat. 144
Double Poke in the Eye II
1985
Pencil and watercolour on paper
57 x 76 (22 1/2 x 30)
verso b. r. 'B. Nauman 85'

Provenance
Leo Castelli, New York
Sperone Westwater, New York
acquired 1993

Exhibitions and Literature
Basle 1986, cat. no. 499, repr. unpag.

cat. 145, ill. p. 172
Double Slap in the Face
1985
Neon tubing with clear-glass tubing
suspension frame
76 x 127 x 13.5 (29 7/8 x 50 x 5 3/8)
5/5

Provenance
Galerie Konrad Fischer, Düsseldorf
Mr. and Mrs. Ernest Delville, Glabais
Catherine Duret, Genf
acquired 1992

Exhibitions and Literature
Bruce Nauman, Galerie Jean Bernier, Athens,
Feb. – March 1986 [no cat.]
Pierrot, Munich 1995, cat. no. 113, repr. p. 180
Figur, Natur, Hanover 1995, repr. p. 41

Simon, *Nauman,* 1994, cat. no. 334,
repr. p. 294
Annette Lettau, 'Das Rätsel seiner dauerhaften
Existenz. Pierrot – Melancholie und Maske. Eine
Ausstellung im Haus der Kunst in München', in:
Süddeutsche Zeitung, 19.9.1995, p. 13, repr.

cat. 146, ill. p. 174
Double No
1988
Two video tapes, two video monitors, two video
players
dimensions variable

Provenance
Donald Young Gallery, Chicago
Anthony d'Offay Gallery, London
Galerie Langer-Fain, Paris
acquired 1992

Exhibitions and Literature
Bruce Nauman. Videos 1965–1986, Museum
of Contemporary Art, Los Angeles, Feb. – April
1988

Simon, *Nauman,* 1994, cat. no. 381,
repr. p. 308

cat. 147, ill. p. 169
Untitled (Two Wolves, Two Deer)
1989
Foam, wax and cable
142.2 x 375.9 x 368.3 (56 x 148 x 145)

Provenance
Pentti Kouri Collection, Helsinki
acquired 1995

Exhibitions and Literature
Bruce Nauman. Heads and Bodies, Galerie
Konrad Fischer, Düsseldorf, Sept. – Oct. 1989
[no cat.]
Basle 1990, cat. no. 22, repr. 12
Minneapolis 1994, cat. no. 63, repr. p. 171

Simon, *Nauman,* 1994, cat. no. 437,
repr. p. 322

cat. 148, ill. p. 170
**Rinde Head/Andrew Head (Plug to Nose)
on Wax Base**
1989
Wax
83.8 x 119.4 x 73.7 (33 x 47 x 29)

Provenance
Galerie Konrad Fischer, Düsseldorf
acquired 1989

Exhibitions and Literature
Bruce Nauman. Heads and Bodies, Galerie
Konrad Fischer, Düsseldorf, Sept. – Oct. 1989
[no cat.]
Chamberlain, Flavin, Judd, Nauman, Künstler-
haus Stuttgart, 1989 [no cat.]
Basle 1990 [not in cat.]
Human Form, London 1995, cat. no. 20,
repr. p. 37

Raimund Stecker, 'Zerstückelt, geklont und auf-
gehängt. Bruce Nauman-Ausstellung "Heads and
Bodies" in Düsseldorf', in: *Frankfurter
Allgemeine Zeitung,* 25.9.1989, p. 35
Simon, *Nauman,* 1994, cat. no. 422,
repr. p. 319

cat. 149, ill. p. 179
Two Heads Double Size
1989
Pastel, pencil and tape on paper
framed 165 x 129.5 (framed 65 x 51 1/2)
recto b. r. 'B. Nauman 89'

Provenance
Donald Young Gallery, Chicago
acquired 1992

cat. 150
Untitled (Three Large Animals)
1989
Aluminum and wire
120 x 300 x 300 (47 1/4 x 118 1/8 x 118 1/8)

Provenance
Galerie Konrad Fischer, Düsseldorf
acquired 1989

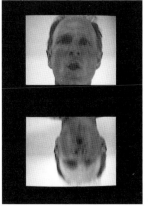

153

Exhibitions and Literature
Bruce Nauman. Heads and Bodies, Galerie
Konrad Fischer, Düsseldorf, Sept. – Oct. 1989
[no cat.]
The Readymade Boomerang, Sydney 1990,
cat. no. 315
Einleuchten, Hamburg 1989, cat. no. 85,
repr. p. 143
Basle 1990, cat. no. 22, repr. p. 109
[under the title 'Ohne Titel']

Simon, *Nauman,* 1994, cat. no. 435,
repr. p. 322

cat. 151, ill. p. 175
Raw Material with Continuous Shift – MMMM
1991
Video projector, two video monitors, two video-
disc players, two video clips
dimensions variable

Provenance
Galerie Konrad Fischer, Düsseldorf
acquired 1991

Exhibitions and Literature
*Bruce Nauman. "MMMM", video installation in
the Salzburger Kunstverein,* Künstlerhaus
Salzburg, 1992; Neuer Aachener Kunstverein,
Aula Carolina, Aachen 1993 [no cat.]

Simon, *Nauman,* 1994, cat. no. 472

cat. 152
Make Me Think Me
1994
Graphite and tape on paper
142 x 97.2 (55 7/8 x 38 1/4)
recto b. r. 'Nauman 93'

Provenance
Leo Castelli Gallery, New York
acquired 1994

Exhibitions and Literature
Bruce Nauman, Leo Castelli Gallery, New York,
Jan. – Feb. 1994 [no cat.]
Janine Antoni and Bruce Nauman, Museum of
Fine Arts, Boston Nov. 1994 [no cat.]

cat. 153
Work
1994
Two video discs, two video monitors, two video
players
dimensions variable

Provenance
Galerie Konrad Fischer, Düsseldorf
acquired 1994

Exhibitions and Literature
Lichträume, Dessau 1994 [not in cat.]
Biennale, Istanbul 1995, repr. p. 217

On loan to Sprengel-Museum, Hanover, since
February 1996

BLINKY PALERMO
born 1943 in Leipzig
died 1977 Kurumba, Maldives

Bibliography
Wuppertal 1968
Palermo. Bilder und Objekte, exh. cat. Von
der Heydt Museum, Wuppertal, Sept. 1968
Mönchengladbach 1973
Palermo. Objekte, exh. cat. Städtisches
Museum, Mönchengladbach, Jan. – Feb. 1973
Krefeld 1977
Palermo. Stoffbilder 1966 – 1972, exh. cat.
Museum Haus Lange, Krefeld, Nov. 1977 –
Jan. 1978
Art, Basle 1977
Kunstmesse Art 8'77, exh. cat. Sonderschau
der Bundesrepublik Deutschland, Basle 1977
Düsseldorf 1980
*Palermo. Wandzeichnungen und
Wandmalereien,* exh. cat. Galerie art in pro-
gress, Düsseldorf 1980
Bonn 1981
Palermo (Peter Heisterkamp), exh. cat.
Städtisches Kunstmuseum Bonn, Sept. – Nov.
1981
Art Allemagne Aujourd'hui, Paris 1981
*Art Allemagne Aujourd'hui: Différents Aspects
de l'Art Actuel en République Fédérale
d'Allemagne,* exh. cat. Musée d'art moderne
de la ville de Paris, 1981
Mönchengladbach 1983
Fred Jahn (ed.), *Palermo. Die gesamte Grafik
und alle Auflagenobjekte 1966 bis 1975.
Sammlung J. W. Froehlich,* exh. cat.
Städtisches Museum Abteiberg,
Mönchengladbach, March – April 1983;
Rijksmuseum Kröller-Müller, Otterlo, June –
Sept. 1983; et al.
Winterthur 1984
Palermo. Werke 1963–1977, exh. cat.
Kunstmuseum Winterthur, Sept. – Nov. 1984;
Kunsthalle Bielefeld, Jan. – March 1985; et al.
New York 1987
Blinky Palermo, exh. cat. Sperone Westwater
Gallery, New York, Sept. – Oct. 1987
Brussels 1988
Blinky Palermo, exh. cat. Galerie des Beaux-
Arts – Marie-Puck Broodthaers, Brussels,
Feb. 1988
Paris, Paris 1989
Paris, exh. cat. Galerie Karsten Greve, Paris
1989
Maas/Greenidge, *Palermo,* 1989
Erich Maas / Delano Greenidge (eds.), *Blinky
Palermo 1943 – 1977,* Gießen 1989
(English/German edition: New York 1989)
Leipzig 1993
Blinky Palermo, exh. cat. Museum der bilden-
den Künste, Leipzig, June – Aug. 1993;
Kunstraum München (selection), Sept. – Nov.
1993; Stuttgart 1993
Wide White Space, Brussels 1994
Wide White Space 1966 – 1976, exh. cat.
Palais des Beaux-Arts, Brussels 1994;
Kunstmuseum Bonn, 1995; Düsseldorf 1994
Bonn 1995
Thordis Moeller (ed.), *Palermo. Bilder und
Objekte, Zeichnungen,* catalogue in two vols.,
exh. cat. Kunstmuseum Bonn; Stuttgart 1995

cat. 154, ill. p. 93
Untitled
1964
Lithographic colour and watercolour on paper
29.5 x 21 (11 5/8 x 1/4)
recto b. r. 'P. H. 64 für Heide und Michael St.'

Provenance
Prof. Dr. Michael Stadler, Bremen
acquired 1993

Exhibitions and Literature
Bonn 1995, vol. 2, cat. no. 259, repr. [not exh.]

cat. 155, ill. p. 92
Untitled
1964
Lithographic colour, watercolour and white
paint on drawing paper
29.5 x 21 (11 5/8 x 8 1/4)
recto b. l. 'Palermo 64'

Provenance
Prof. Dr. Michael Stadler, Bremen
acquired 1993

Exhibitions and Literature
Bonn 1995, vol. 2, cat. no. 258, repr. [not exh.]

cat. 156, ill. p. 93
Untitled
1965
Lithographic colour and watercolour on paper
29.5 x 21 (11 5/8 x 8 1/4)
recto b. r. 'P. H. 65 für Heide und Michael St.'

Provenance
Prof. Dr. Michael Stadler, Bremen
acquired 1993

Exhibitions and Literature
Bonn 1995, vol. 2, cat. no. 284, repr. [not exh.]

cat. 157, ill. p. 92
Untitled
1965
Watercolour and white paint on light brown
cardboard
16.2 x 25.6 (6 3/8 x 10 1/8)
recto b. r. 'Palermo 65'

Provenance
Prof. Dr. Michael Stadler, Bremen
acquired 1993

Exhibitions and Literature
Bonn 1995, vol. 2., cat. no. 283, repr. [not exh.]

cat. 158, ill. p. 90
Untitled
1967
Blue muslin and lithographic colour on muslin
and wood
345 x 41 x 8 (135 7/8 x 16 1/8 x 3 1/8)
verso on the vertical bar 'PLAKABRAUN Nr. 55 /
diese Stange muß im Lot hängen / Palermo 67'
edition of 3

Provenance
Galerie Heiner Friedrich, Cologne
Ulbricht Collection, Düsseldorf
Galerie des Beaux-Arts, Brussels
Galerie Karsten Greve, Cologne
acquired 1994

Exhibitions and Literature
Wuppertal 1968, repr., unpag.
Mönchengladbach 1973, cat. no. 22,
repr. unpag.
Art, Basle 1977, repr. unpag.
Düsseldorf 1980
Bonn 1981, cat. no. 22, repr. p. 47
Art Allemagne Aujourd'hui, Paris 1981,
repr. p. 310
Brussels 1988, cat. no. 2, repr. unpag.
Paris, Paris 1989, repr. p. 157
Leipzig 1993, cat. no. 99, repr. p. 75
Wide White Space, Brussels 1994, p. 247
Bonn 1995, vol. 1, cat. no. 67, repr. [not exh.]

Wallraf-Richartz-Museum-Jahrbuch, vol. 34,
Cologne 1977, repr. p. 268
Rudi Fuchs, 'A Place for Art', in: *Architecture
and Urbanism*, 1984 (196), repr. p. 47
Maas/Greenidge, *Palermo*, 1989, repr. p. 85

Extended loan to Kunstmuseum Bonn since
Aug. 1995

cat. 159, ill. p. 89
Untitled
1967–9
Cotton backed with muslin
200 x 200 (78 3/4 x 78 3/4)

Provenance
Herbert Schulz, Amsterdam
Francesco Pellizzi, New York
Julian Schnabel, New York
Galerie Bruno Bischofberger, Zurich
acquired 1994

Exhibitions and Literature
Blinky Palermo. Bilder, Galerie Konrad Fischer,
Düsseldorf, Feb. – March 1968 [no cat.]
Krefeld 1977, cat. no. 6 [not exh.]
New York 1987, repr. cover page
Bonn 1995, vol. 1, cat. no. 96, repr. [not exh.]

cat. 160
The complete prints and multiples 1968–1975

Provenance
Fred Jahn, Munich
acquired 1982

Exhibitions and Literature
Mönchengladbach 1983
Leipzig 1993

cat. 160-a, ill. p. 91
Blaues Dreieck
Blue Triangle
1969
Lithographic colour on primed fibreboard
22.8 x 45.3 x 2 (9 x 17 7/8 x 3/4)
verso 'Palermo'
unnumbered/app. 7

Exhibitions and Literature
Mönchengladbach 1983, cat. no. 4, repr. p. 21
Winterthur 1984, cat. no. 55, repr. p. 70
Leipzig 1993, cat. no. 109, repr. p. 150

A. R. PENCK
born 1939 in Dresden
lives in London

Bibliography
Berlin 1988
a.r. penck, exh. cat. Nationalgalerie Berlin,
April – June 1988; Kunsthaus Zürich, June –
Aug. 1988; Berlin 1988
Honnef, *Kunst der Gegenwart*, 1994
Klaus Honnef, *Kunst der Gegenwart*, Cologne
1994

cat. 161, ill. p. 96
Komposition (Übertritt: Ost/West)
Composition (Passage: East/West)
1968
Acrylic on laminated cardboard
67.3 x 149 (26 1/2 x 58 5/8)
signed verso t. r. 'Für Eva 7.2... Ralph',
b. r. monogram 'r.'

Provenance
Eva Maria Hagen and Wolf Biermann, Berlin
Hauswedell & Nolte, Hamburg, Auction 272,
11.6.1988, Lot 1061
acquired 1988

Exhibitions and Literature
Hauswedell & Nolte, auct. cat. 272, Hamburg
1988, Lot 1061, p. 154, repr. 48

cat. 162, ill. p. 95
Standard
1972
Dispersion on unprimed canvas
110 x 110 (43 1/4 x 43 1/4)
signed recto b .l. monogram 'r.' and verso on the
stretcher t. 'a. r.penck 72'

Provenance
Dr. Gerhard Knull, Cologne
acquired 1990

cat. 163, ill. p. 97
N-Komplex
1976
Dispersion on canvas
285 x 285 (151 5/8 x 151 5/8)

Provenance
Galerie Michael Werner, Cologne/New York
The Saatchi Collection, London
Elisabeth Kübler Fine Arts, Zurich
acquired 1995

Exhibitions and Literature
Berlin 1988 [not exh.]
Honnef, *Kunst der Gegenwart*, 1994, repr. p. 67

165

SIGMAR POLKE
born 1941 in Oels, Silesia
lives in Cologne

Bibliography
Berlin 1966
Carl Vogel (ed.), *Sigmar Polke*, exh. cat.
Galerie René Block, Berlin 1966
Jetzt, Cologne 1970
Jetzt. Künste in Deutschland heute, exh. cat
Kunsthalle Köln, 1970
Grafik des Kapitalistischen Realismus, Berlin
1971
Grafik des Kapitalistischen Realismus, exh.
cat. Galerie René Block, Berlin 1971
São Paulo, 1975
Day by Day They Take Some Brain Away,
exh. cat. XIII. Biennale São Paolo, 1975
Tübingen 1976
*Sigmar Polke. Bilder, Tücher, Objekte,
Werkauswahl 1962 – 1971*, exh. cat.
Kunsthalle Tübingen, Feb. – March 1976;
Kunsthalle Düsseldorf, April – May; et al.
Bauch, Duchow, Stuttgart 1980
*Michael Bauch, Achim Duchow, Astrid
Heibach, Anna Konda, Klaus Mettig, Albert
Oehlen, Markus Oehlen, Angelika Öhms,
Sigmar Polke, Stephan Runge, Katharina
Sieverding, Memphis Schulze*, exh. cat.
Kunstausstellungen Gutenbergstraße 62a e.V.,
Stuttgart 1980
Westkunst, Cologne 1981
Westkunst – Zeitgenössische Kunst seit 1939,
exh. cat. Cologne 1981
Art Allemagne Aujoud'hui, Paris 1981
Art Allemagne Aujourd'hui, exh. cat Musée
d'art moderne de la ville de Paris, 1981
Faust, *Hunger nach Bildern*, 1982
Wolfgang Max Faust, *Hunger nach Bildern.
Deutsche Malerei der Gegenwart*, Cologne
1982
Sammlung Ulbricht, Bonn 1982
Sammlung Ulbricht, exh. cat. Städtisches
Kunstmuseum Bonn; Neue Galerie am
Landesmuseum Joanneum, 1982; et al.
German Drawings, New Haven 1982
German Drawings of the 60's, exh. cat. Yale
Gallery of Art, New Haven; Art Gallery of
Toronto, 1989
Rotterdam 1983
Sigmar Polke, exh. cat. Museum Boymans-van
Beuningen, Rotterdam 1983; Städtisches
Kunstmuseum, Bonn, 1983 – 4
Zurich 1984
Sigmar Polke, Kunsthaus Zurich, April – May
1984; Josef-Haubrich-Kunsthalle, Cologne,
Sept. – Oct. 1984
The Saatchi Collection, London 1984
Art of Our Time – The Saatchi Collection,
Vol. 3, coll. cat. London 1984
German Art, London 1985
*German Art in the 20th Century. Painting and
Sculpture 1905–1985*, exh. cat. Royal
Academy of the Arts, London 1985 [German
edition: *Deutsche Kunst im 20. Jahrhundert.
Malerei und Skulptur 1905–1985*, Staats-
galerie Stuttgart, Munich 1986]
Vom Zeichnen, Frankfurt 1985
Vom Zeichnen – Aspekte der Zeichnung, exh.
cat. Frankfurter Kunstverein/Steinernes Haus,
Frankfurt am Main 1985 – 6

Beuys. Palermo, London 1987
Beuys. Palermo. Polke. Richter exh. cat.
Goethe-Institut, London 1987
Der unverbrauchte Blick, Berlin 1987
*Der unverbrauchte Blick. Kunst unserer Zeit
in Berliner Sicht*, exh. cat. Martin-Gropius-
Bau, Berlin 1987
Brennpunkt Düsseldorf, Düsseldorf 1987
Brennpunkt Düsseldorf 1962–1987, exh. cat.
Kunstmuseum Düsseldorf, 1987
New York 1987
Sigmar Polke Drawings from the 1960's,
exh. cat. David Nolan Gallery, New York,
Oct. – Nov. 1987
Gachnang, *Polke*, 1987
Johannes Gachnang (ed.), *Sigmar Polke.
Zeichnungen 1963–1969*, Berne/Berlin 1987
Bonn 1988
*Sigmar Polke. Zeichnungen, Aquarelle,
Skizzenbücher, 1962 – 1988*, exh. cat.
Kunstmuseum Bonn, June – Aug. 1988
Paris 1988
Sigmar Polke, exh. cat. Musée d'art moderne
de la ville de Paris, Paris, Oct. – Dec. 1988
Refigured Painting, Toledo 1988
*Refigured Painting. The German Image
1960–1988*, exh. cat. Toledo Museum of Art,
Toledo, Ohio, 1988 – 9; The Solomon R.
Guggenheim Museum, New York 1989; et al.
Kölner Kunst, Copenhagen 1989
Kölner Kunst, exh. cat. Kunstforeningen,
Copenhagen 1989
Photo-Kunst, Stuttgart 1989
Photo-Kunst, exh. cat. Graphische Sammlung
der Staatsgalerie Stuttgart, 1989
Polke. Andre, Munich 1989
Polke. Andre. Eine Gegenüberstellung, exh.
cat. Kunstforum, Munich 1989
Bilderstreit, Cologne 1989
*Bilderstreit. Widerspruch, Einheit und
Fragment in der Kunst seit 1960*, Johannes
Gachnang/Siegfried Gohr (ed.), exh. cat.
Museum Ludwig in den Rheinhallen der
Kölner Messe, Cologne 1989
Kritisches Lexikon, Munich 1989
Sigmar Polke, in: Kritisches Lexikon der
Gegenwartskunst, Munich 1989
The Readymade Boomerang, Sydney 1990
*The Readymade Boomerang. Certain
Relations in 20th Century Art*, exh. cat. The
Eighth Biennale of Sydney, 1990
Artistes de Colónia, Barcelona 1990
Artistes de Colónia: alló bell, alló sinistre,
Centre d'Art Santa Mónica, Barcelona 1990
Baden-Baden 1990
Sigmar Polke. Fotografien, exh. cat. Staatliche
Kunsthalle Baden-Baden, Feb.–March 1990
Hentschel, *Polke*, 1991
Martin Hentschel, *Die Ordnung des
Heterogenen. Sigmar Polkes Werk bis 1986*,
diss. Ruhr-Universität Bochum, 1991
San Francisco 1991
Sigmar Polke, exh. cat. San Francisco
Museum of Modern Art, San Francisco, Nov.
1990 – Jan. 1991; Hirshhorn Museum and
Sculpture Garden, Smithsonian Institution,
Washington, D.C., Feb. – May 1991; et al.
Amsterdam 1992
Sigmar Polke, exh. cat. Stedelijk Museum
Amsterdam, Sept. – Nov. 1992

Sammlung Block, Copenhagen 1992
Sammlung Block, exh. cat. Statens Museum
for Kunst, Copenhagen, 1992; Museet für
Nutidskunst, Helsingfors 1992/93; et al.
Berlin1993
*Sigmar Polke, Gemeinschaftswerk
Aufschwung Ost*, exh. cat. Bruno Brunnet
Fine Arts, Berlin, May – June 1993
Aspekte deutscher Kunst, Salzburg 1994
Thaddaeus Ropac (ed.), *German Art. Aspekte
deutscher Kunst 1964*, exh. cat. Salzburger
Festspiele, Salzburg 1994; Heidelberg 1994
Stadt und Land, Augsburg 1994
Stadt und Land, exh. cat. Gesellschaft für
Gegenwartskunst e.V., Augsburg 1994
The Romantic Spirit, Edinburgh 1994
*The Romantic Spirit in German Art
1790–1990*, exh. cat. Royal Scottish Academy
and the Fruitmarket Gallery, Edinburgh 1994;
Hayward Gallery, South Bank Centre, London
1994–5; Stuttgart 1994 [German edition see:
Der Geist der Romantik, Munich 1995]
Kunst in Deutschland, Regensburg 1995
Kunst in Deutschland, exh. cat. Museum
Ostdeutsche Galerie, Regensburg 1995
Liverpool 1995
Sigmar Polke. Join the dots, exh. cat. Tate
Gallery Liverpool, Jan. – April 1995
Drawing the line, Southhampton 1995
Drawing the line, exh. cat. Southhampton
City Art Gallery; Manchester City Art Gallery,
1995; et al.
Los Angeles 1995
*Sigmar Polke Photoworks. When Pictures
Vanish*, exh. cat. The Museum of
Contemporary Art, Los Angeles, Dec. 1995 –
March 1996; Site Santa Fe, Santa Fe, New
Mexico, April – Aug. 1996; et al.
Der Geist der Romantik, Munich 1995
*Ernste Spiele. Der Geist der Romantik in der
deutschen Kunst 1790–1990*, exh. cat. Haus
der Kunst, Munich 1995; Stuttgart 1995
[original edition see: *The Romantic Spirit*,
Edinburgh 1994]
Art of the Sixties, Tokyo 1995
*Revolution. Art of the Sixties. From Warhol to
Beuys*, exh. cat. Museum of Contemporary
Art, Tokyo 1995
Biennale, Istanbul 1995
4. International Istanbul Biennale, Istanbul
1995

cat. 164, ill. p. 111
Für die Hausfrau
For the Housewife
1963
Ball-point pen on paper
30 x 25 (11 3/4 x 9 7/8)
recto b. r. 'Polke 63'

Provenance
Galerie Michael Werner, Cologne
Galerie Thomas Borgmann, Cologne
Dietmar Werle, Cologne
acquired 1987

Exhibitions and Literature
Bonn 1988, cat. no. 3.13
Drawing the line, Southhampton 1995, cat. no.
165, repr. p. 100

167

cat. 165, ill. p. 261
Fußwäsche (für Gundula)
Foot-wash (for Gundula)
1963
Ball-point pen on paper
29.5 x 21 (11 5/8 x 8 1/4)
recto b. r. 'für Gundula S. Polke 63'

Provenance
Salentin Collection, Cologne
Dietmar Werle, Cologne
acquired 1987

Exhibitions and Literature
Bonn 1988, cat. no. 3.7

cat. 166, ill. p. 110
Gestricke Alpen
Knitted Alps
1963
Ball-point pen and watercolour on paper
29.5 x 21 (11 5/8 x 8 1/4)
recto b. r. 'S. Polke 63'

Provenance
Nicole Hackert, Berlin
Bruno Brunnet Fine Arts, Berlin
acquired 1993

Exhibitions and Literature
Bonn 1988, cat. no. 3.23, repr. p. 19
Berlin 1993, cat. no. 6, repr.

Hentschel, *Polke,* 1991, cat. no. 81, repr. p.
121, pp. 119–121
Ernste Spiele, Munich 1995, cat. no. 368

cat. 167
Ohne Titel (Kaba)
Untitled (Kaba)
1963
Ball-point pen on paper
29.6 x 20.8 (11 5/8 x 8 1/4)
recto b. r. 'S. Polke 63'

169

Provenance
Galerie Bama, Paris
Adele Schlombs, Cologne
acquired 1995

Exhibitions and Literature
Bonn 1988, cat. no. 3.21
Kölner Kunst, Copenhagen 1989, repr. p. 68
Berlin 1993, cat. no. 8, repr.
Stadt und Land, Augsburg 1994, cat. no. 11,
repr.

cat. 168
Ohne Titel (3 Hemden)
Untitled (3 Shirts)
1963
Ball-point pen on paper
29.7 x 21 (11 3/4 8 1/4)
recto b. r. 'S. Polke 63'

Provenance
Galerie Michael Werner, Cologne
Adele Schlombs, Cologne
acquired 1995

Exhibitions and Literature
Bonn 1988, cat. no. 3.1

Gachnang, *Polke,* 1987, cat. no. 4, repr. unpag.

cat. 169
Untitled
1963
Ball-point pen on paper
29.5 x 21 (11 5/8 x 8 1/4)
recto b. r. 'Polke 63'

Provenance
Karlheinz Meyer, Karlsruhe
acquired 1987

Exhibitions and Literature
Bonn 1988, cat. no. 3.9
Drawing the line, Southhampton 1995,
cat. no. 166, repr. p. 26

Hentschel, *Polke,* 1991, cat. no. 318,
pp. 296–298

172

cat. 170, ill. p. 110
Ohne Titel (Punkte)
Untitled (Dots)
1963
Watercolour and gouache on paper
62.5 x 51.7 (24 5/8 x 20 3/8)
recto b. r. 'Polke 63'

Provenance
Galerie Michael Werner, Cologne
acquired 1984

Exhibitions and Literature
Bonn 1988, cat. no. 4.2, repr. p. 31
San Francisco 1991, cat. no. 84, repr. 87

Hentschel, *Polke,* 1991, cat. no. 110,
pp. 154–157

cat. 171
Reis
Rice
1963
Lacquer and felt-tip pen on canvas
60 x 60 (23 5/8 x 23 5/8)
verso on stretcher 'S. Polke 63'

Provenance
Katharina Sieverding, Düsseldorf
Dietmar Werle, Cologne
acquired 1985

Exhibitions and Literature
Bonn 1988, cat. no. 3.65, repr. p. 21

cat. 172
Weniger Arbeit, mehr Lohn
Less Work, More Pay
1963
Ball-point pen on paper
29.5 x 21 (11 5/8 x 8 1/4)
recto b. r. 'S. Polke 63'

Provenance
Galerie Pablo Stähli, Zurich
acquired 1986

171

168

171

173

 175

 177

 179

Exhibitions and Literature
Bonn 1988, cat. no. 3.24, repr. p. 22

cat. 173
Winterurlaub für Alle
Winter Vacation for Everyone
1963
Ball-point pen and gouache on paper
29.5 x 21 (11 5/8 x 8 1/4)
recto b. r. 'Polke 63'

Provenance
David Nolan Gallery, New York
acquired 1987

Exhibitions and Literature
Bonn 1988, cat. no. 4.3 [under the title
'Winterfreuden für Alle']
Ernste Spiele, Munich 1995, cat. no. 375

cat. 174, ill. p. 102
5 Punkte
5 Dots
1964
Dispersion on fabric
90 x 75 (35 1/2 x 29 1/2)
b. r. 'Polke 64' and verso b. r. 'Polke 64'

Provenance
Henning Christiansen, Copenhagen
acquired 1991

Exhibitions and Literature
Berlin 1966, repr. unpag.
Amsterdam 1992, cat. no. 1, repr. p. 37
[under the title '5 Punktebild']
Liverpool 1995, cat. no. 4, repr. p. 32
[under the title '5 Dots Painting']

cat. 175
Darf man Kinder auslachen
May one Laugh at Children
1964
Watercolour and paint on paper
29.5 x 21 (11 5/8 x 8 1/4)
recto b. r. 'S. Polke 64'

176

Provenance
Mary Boone Gallery, New York
acquired 1988

Exhibitions and Literature
Bonn 1988, cat. no. 4.4

Gachnang, *Polke,* 1987, cat. no. 1, repr. unpag.

cat. 176
Ohne Titel (Elefantenmann)
Untitled (Elephant Man)
1964
Lithographic colour and felt-tip pen on paper
75 x 75 (29 1/2 x 29 1/2)
recto b. r. 'Polke 64'

Provenance
Dietmar Werle, Cologne
acquired 1991

cat. 177
Ohne Titel (Überflieger)
Untitled (Head in the Clouds)
Lithographic colour and felt-tip pen on paper
74,7 x 48 (29 3/8 x 18 7/8)
recto b.r. 'Polke 64'

Provenance
Dietmar Werle, Cologne
acquired 1991

cat. 178
Ohne Titel (Yeti)
Untitled (Yeti)
1964
Lithographic colour and felt-tip pen on paper
74.7 x 50 (29 1/2 x 19 5/8)
recto b. r. 'Polke 64'

Provenance
Michael Buthe, Cologne
Dietmar Werle, Cologne
acquired 1991

cat. 179
Schwarzbrot, Graubrot, Weißbrot
Black Bread, Wholemeal Bread, White Bread
1964
Watercolour and ball-point pen on paper
29.5 x 21 (11 5/8 x 8 1/4)
recto b. r. 'S. Polke 64'

Provenance
Studio Oppenheim, Cologne
Salentin Collection, Cologne
Vahle Collection, Cologne
Dietmar Werle, Cologne
acquired 1986

cat. 180
Sekt für alle
Sparkling Wine for Everyone
1964
Watercolour and ball-point pen on paper
29.7 x 21 (11 3/4 x 8 1/4)
signed recto b. r. 'S. Polke 64'

Provenance
H. G. Prager, Cologne
Adele Schlombs, Cologne
acquired 1995

Exhibitions and Literature
Berlin 1993, cat. no. 9, repr.

Gachnang, *Polke,* 1987, cat. no. 17, repr.
unpag.
Hentschel, *Polke,* 1991, cat. no. 145

cat. 181, ill. p. 264
Steinleiden
Calculosis
1964
Watercolour and ball-point pen on paper
29.5 x 21 (11 5/8 x 8 1/4)
recto b. r. 'S. Polke 64'

Provenance
Studio Oppenheim, Cologne
Salentin Collection, Cologne
Vahle Collection, Cologne
Dietmar Werle, Cologne
acquired 1986

 176

 178

 180

181

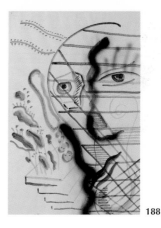

188

Exhibitions and Literature
Beuys. Palermo, London 1987, repr. p. 22
Bonn 1988, cat. no. 4.5

cat. 182, ill. p. 111
Warum nicht baden?
Why not bathe?
1964
Felt-tip pen on parcel paper
48 x 36.5 (18 7/8 x 14 3/8)
recto b. r. 'Polke 64'

Provenance
Studio Oppenheim, Cologne
Private collection, Cologne
Dietmar Werle, Cologne
acquired 1986

Exhibitions and Literature
Bonn 1988, cat. no. 4.7

cat. 183
Wir wollen frei sein wie die Väter waren
We Want to be Free like the Fathers Were
1964
Ball-point pen on paper
29.5 x 21 (11 5/8 x 8 1/4)
recto b. r. 'Polke 64'

Provenance
Galerie Pablo Stähli, Zurich
acquired 1986

Exhibitions and Literature
Bonn 1988, cat. no. 3.27, repr. p. 23

cat. 184, ill. p. 100
Würstchen
Sausages
1964
Lacquer on canvas
49 x 57.5 (19 1/4 x 22 5/8)
verso b. m. 'Polke 64'

Provenance
Gerhard Richter, Düsseldorf
Galerie Konrad Fischer, Düsseldorf
Private collection, Hamburg
Anthony d'Offay Gallery, London
acquired 1990

Exhibitions and Literature
Tübingen 1976, cat. no. 9, repr. p. 14
Liverpool 1995, cat. no. 3, repr. p. 28

The Independent, London, 7 February 1995,
repr. p. 20

cat. 185
Gelber Hut, schwebend
Yellow Hat, Floating
1965
Ball-point pen and gouache on blotting paper
29.5 x 21 (11 5/8 x 8 1/4)
recto b. r. 'p. Polke'

Provenance
Mary Boone Gallery, New York
acquired 1988

Exhibitions and Literature
Bonn 1988, cat. no. 3.48

cat. 186
Knöpfe
Buttons
1965
Dispersion on canvas
100 x 120 (39 3/8 x 47 1/4)
verso on canvas 'Polke 65'

Provenance
René Block, Berlin
acquired 1993

Exhibitions and Literature
Grafik des Kapitalistischen Realismus, Berlin
1971, repr. p. 46
Tübingen 1976, cat. no. 37, repr. p. 31
Zurich 1984, cat. no 26
The Readymade Boomerang, Sydney 1990,
cat. no. 356, repr. p. 303

Sammlung Block, Kopenhagen 1992,
cat. no. 368, repr. p. 260 [only exhibited in
Copenhagen]
Liverpool 1995, cat. no. 5, repr. p. 31

cat. 187, ill. p. 111
Mehl in der Wurst
Flour in the Sausage
1965
Ball-point pen, watercolour and paint on paper
29.5 x 21 (11 5/8 x 8 1/4)
recto b. r. 'S. Polke 65'

Provenance
Mary Boone Gallery, New York
acquired 1988

Exhibitions and Literature
Bonn 1988, cat. no. 3.49

Gachnang, *Polke,* 1987, cat. no. 52, repr.
unpag.

cat. 188
Ohne Titel (Großer Kartoffelkopf)
Untitled (Big Potato Head)
1965
Gouache on paper
95.9 x 63.9 (37 3/4 x 25 1/8)

Provenance
Dietmar Werle, Cologne
acquired 1984

Exhibitions and Literature
Vom Zeichnen, Frankfurt 1985–6, repr. p. 331

Hentschel, *Polke,* 1991, pp. 176–178

cat. 189
Ohne Titel (Bienennase)
Untitled (Bee Nose)
1965
Watercolour on paper
29.5 x 21 (11 5/8 x 8 1/4)
recto b. r. 'S. Polke 65'

183

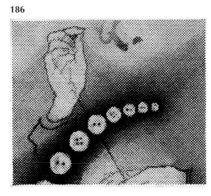

186

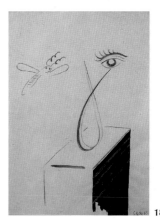

189

192

195

196

Provenance
Vahle Collection, Cologne
Dietmar Werle, Cologne
acquired 1986

Exhibitions and Literature
Bonn 1988, cat. no. 4.9, repr. p. 36
Beuys, Palermo, London 1987, repr. p. 23

cat. 190, ill. p. 110
Ohne Titel (Profil)
Untitled (Profile)
1965
Watercolour on printed paper
24 x 23 (9 3/8 x 9 1/8)
verso b. r. 'S. Polke'

Provenance
Nicole Hackert, Berlin
Bruno Brunnet Fine Arts, Berlin
acquired 1993

Exhibitions and Literature
Berlin 1993, cat. no. 14, repr.

cat. 191, ill. p. 103
Freundinnen
Girlfriends
1965/66
Oil on canvas
150 x 190 (59 x 74 3/4)
verso t. l. 'Sigmar Polke 1965/66 "Freundinnen"'

Provenance
Peter Florack, Düsseldorf
Galerie Thomas Borgmann, Cologne
acquired 1983

Exhibitions and Literature
Tübingen 1976, cat. no. 35, repr. p. 38
Refigured Painting, Toledo 1988, cat. no. 111, repr. p. 172
San Francisco 1991, cat. no. 7, repr. 8, unpag.
Liverpool 1995, cat. no. 10, repr. p. 13
Art of the Sixties, Tokyo 1995, cat. no. 129, repr. p. 238

Klaus Honnef, 'Malerei als Abenteuer oder Kunst und Leben', in: *Kunstforum International,* vol. 71/72, April/May 1984, repr. p. 164
Kritisches Lexikon, Munich 1989, repr. 2, p. 4
Hentschel, *Polke,* 1991, cat. no. 130, pp. 166–168

cat. 192
Akt mit Rauten
Nude with Squares
1966
Oil on canvas
80 x 60 (31 1/2 x 23 5/8)
verso on stretcher t. r. 'S. Polke'

Provenance
Galerie Michael Werner, Cologne
Galerie Fred Jahn, Munich
Dürckheim Collection, Entraching
Galerie Thomas Borgmann, Cologne
Manfred Lapper, Cologne

Wolfgang Wittrock Kunsthandel, Düsseldorf
acquired 1994

Exhibitions and Literature
Tübingen 1976, cat. no. 50, repr. p. 22
Zurich 1984, cat. no. 31
Amsterdam 1992, cat. no. 4, repr. p. 39 [under the title 'Akt in Rauten']
Liverpool 1995, cat. no. 13, repr. p. 37

Hentschel, *Polke,* 1991, cat. no. 177, p. 198

cat. 193, ill. p. 112
Geist
Ghost
1966
Gouache on paper
85 x 61 (33 1/2 x24)
recto b. r. 'S. Polke'

Provenance
David Nolan Gallery, New York
acquired 1992

Exhibitions and Literature
New York 1987, cat. no. 1, repr. p. 15
German Drawings, New Haven 1982, cat. no. 95, repr. p. 79

cat. 194, ill. p. 113
Ohne Titel (Kleiner Kartoffelkopf)
Untitled (Small Potato Head)
1966
Gouache on paper
61.5 x 86 (24 1/4 x 33 7/8)
recto b. r. 'S. Polke 66'

Provenance
Götz Adriani, Tübingen
acquired 1984

Exhibitions and Literature
Vom Zeichnen, Frankfurt 1985–6, repr. p. 332

Hentschel, *Polke,* 1991, pp. 176–178

cat. 195
Ohne Titel (Telephon)
Untitled (Telephone)
1966
Watercolour on paper
60 x 85.5 (23 5/8 x 33 5/8)
recto b. r. 'Polke 66'

Provenance
Galerie Pablo Stähli, Zurich
acquired 1992

cat. 196
Ohne Titel (Verneigung)
Untitled (Curtsy)
1966
Watercolour, pencil and silver lithographic paint on paper
29.5 x 21 (11 5/8 x 8 1/4)
recto b. r. 'Polke 66'

Provenance
G. Hoehme, Düsseldorf
M. Hoehme, Düsseldorf
Roman Zenner, Stuttgart
acquired 1992

cat. 197, ill. p. 114
Ohne Titel (Urlaub)
Untitled (Vacation)
1966
Watercolour and pencil on paper
29.5 x 21 (11 5/8 x 8 1/4)
recto b. r. 'Polke 66'

Provenance
Mary Boone Gallery, New York
acquired 1988

Exhibitions and Literature
Bonn 1988, cat. no. 4.11 [under the title 'Urlaub']

Gachnang, *Polke,* 1987, cat. no. 63, repr.

cat. 198, ill. p. 114
Ohne Titel (Libelle)
Untitled (Dragon-fly)
1966
Watercolour on paper
29.5 x 21 (11 5/8 x 8 1/4)
recto b. r. 'Polke 66'

Provenance
G. Hoehme, Düsseldorf
M. Hoehme, Düsseldorf
Roman Zenner, Stuttgart
acquired 1992

cat. 199
Ohne Titel (Haus und Mann)
Untitled (House and Man)
1966
Watercolour, ball-point pen and paint on paper
29.5 x 21 (11 5/8 x 8 1/4)
recto b. r. 'Polke 66'

199

201

204

206

Provenance
G. Hoehme, Düsseldorf
M. Hoehme, Düsseldorf
Roman Zenner, Stuttgart
acquired 1992

cat. 200, ill. p. 114
Ohne Titel (Sternenhimmel)
Untitled (Starry Sky)
1966
Watercolour and pencil on parcel paper
29.5 x 21 (11 5/8 x 8 1/4)
recto b. r. 'Polke 66'

Provenance
Dietmar Werle, Köln
acquired 1984

Exhibitions and Literature
Beuys. Palermo, London 1987, cat. p. 40
Bonn 1988, cat. no. 4.15
Der Geist der Romantik, Munich 1995 [not in cat.]

cat. 201
Urlaubsbild
Vacation Picture
1966
Oil on canvas
99 x 90 (39 x 35 3/8)
recto b. r. 'S. Polke l. 66'
[another composition on verso] verso on the
stretcher: 'Garten meiner Liebe' 1963; signature
illegible… 407 rheydt/rhl, gartenstr. 159

Provenance
Murken Collection, Aachen
Galerie Karsten Greve, Cologne
Ingrid von Oppenheim, Brussels
Dietmar Werle, Cologne
acquired 1984

Exhibitions and Literature
São Paulo 1975, repr. unpag.
Tübingen 1976, cat. no. 49, repr. p. 22
Refigured Painting, Toledo 1988, cat. no. 112,
repr. p. 173

Der Geist der Romantik, Munich 1995,
cat. no. 373, repr. 326, p. 367

Faust, *Hunger nach Bildern,* 1982, no. 41, p. 81

cat. 202
Ohne Titel (Akt mit Auge)
Untitled (Nude with Eye)
1967
Watercolour and pencil on parcel paper
29.5 x 21 (11 5/ x 8 14)
recto b. r. 'S. Polke'

Provenance
Dietmar Werle, Cologne
acquired 1986

Exhibitions and Literature
Bonn 1988, cat. no. 4.39, repr. p. 46

cat. 203, ill. p. 115
Ohne Titel (Die Andacht)
Untitled (The Prayer)
1967
Pencil, silver bronze paint and gouache on
paper
30.4 x 21.5 (12 x 8 1/2)
recto b. r. 'S. Polke 67'

Provenance
Dietmar Werle, Cologne
acquired 1986

Exhibitions and Literature
Beuys. Palermo, London 1987, repr. p. 25
Bonn 1988, cat. no. 4.34, repr. 48
Der Geist der Romantik, Munich 1995,
cat. no. 366

cat. 204
Ohne Titel (Hochzeitsgeschenk für Palermo)
Untitled (Wedding gift for Palermo)
1967
Watercolour, pencil and silver lithographic
colour
29.5 x 21 (11 5/8 x 8 1/4)
recto b. r. 'Polke 67'

Provenance
Galerie Fred Jahn, Munich
acquired 1986

Exhibitions and Literature
Bonn 1988, cat. no. 4.35, repr. p. 49
Der Geist der Romantik, Munich 1995
[not in cat.]

cat. 205
Ohne Titel (Kaffeetasse)
Untitled (Coffee Cup)
1967
Watercolour on paper
23 x 21.5 (9 x 8 1/4)
recto b. l. 'S. Polke'

Provenance
Vahle Collection, Cologne
Dietmar Werle, Cologne
acquired 1986

Exhibitions and Literature
Bonn 1988, cat. no. 4.24, repr. p. 33
Kunst in Deutschland, Regensburg 1995,
repr. p. 155

cat. 206
Ohne Titel (Palme)
Untitled (Palm Tree)
1967
Watercolour and gouache on paper
96 x 64 (37 3/4 x 25 1/4)
recto b. r. 'S. Polke 67'

Provenance
Galerie Fred Jahn, Munich
acquired 1993

cat. 207, ill. p. 115
Polkes Handlinien
Polke's Palm-lines
1967
Gouache and pencil on quadrille paper
21 x 14.7 (8 1/4 x 5 3/4)
recto b. l. 'Polkes Handlinien 67'

202

205

208

209

212

Provenance
David Nolan Gallery, New York
acquired 1987

Exhibitions and Literature
Bonn 1988, cat. no. 4.29

cat. 208
Schneeglöckchen
Snowdrops
1967
Dispersion and silver lithographic colour on plywood
77 x 72 (30 3/8 x 28 3/8)
verso b. r. 'S. Polke 67'

Provenance
Mariette Althaus, Zurich
Dietmar Werle, Cologne
acquired 1983–4

Exhibitions and Literature
Bonn 1988, cat. no. 5.44, repr. p. 66
San Francisco 1991, cat. no. 10, repr. unpag.
Liverpool 1995, cat. no. 11, repr. p. 34

cat. 209
Wenn die Brote anbrennen
When The Breads Burn
1967
Watercolour and ball-point pen on paper
29.5 x 21 (11 5/8 x 8 1/4)
recto b. r. 'S. Polke 67'

Provenance
Vahle Collection, Cologne
Dietmar Werle, Cologne
acquired 1986

Exhibitions and Literature
Bonn 1988, cat. no. 3.55

cat. 210, ill. p. 101
Moderne Kunst
Modern Art
1968
Acrylic and lacquer on canvas
150 x 125 (59 x 49 1/4)

Provenance
René Block, Berlin
since 1995 jointly owned by Froehlich
Collection, Stuttgart and René Block Collection, Møn

Exhibitions and Literature
Tübingen 1976, cat. no. 95, repr. p. 117 and book jacket
Jetzt., Cologne 1970
Westkunst, Cologne 1981, cat. no. 783, repr. p. 478
Art Allemagne Aujourd'hui, Paris 1981, repr. p. 179
German Art in the 20th Century, London 1985, cat. no. 251, repr. unpag.
Zurich 1984, cat. no. 48, repr. p. 59
Der unverbrauchte Blick, Berlin 1987, repr. unpag.

Brennpunkt Düsseldorf, Düsseldorf 1987, repr. p. 184
The Readymade Boomerang, Sydney 1990, cat. no. 361, repr. p. 73
Collection Block, Kopenhagen 1992, repr. p. 74
San Francisco 1991, cat. no. 17, repr. 22
Liverpool, 1995, cat. no. 18, repr. p. 39
Biennale, Istanbul 1995, cat. p. 314

'Museen in Köln', *Bulletin der Kölner Museen,* no. 2, Feb. 1970, repr. cover page
Klaus Honnef: 'Malerei als Abenteuer', in: *Kunstforum International,* repr. p. 160
Polke. Andre, Munich 1989, cat. no. 2, repr. unpag. [not exh.]
Munich 1989, cat. no. 4, repr. p. 5
Hentschel, *Polke,* 1991, cat. no. 365, repr. p. 329, pp. 328–332

On loan to Hamburger Kunsthalle since Dec. 1995

cat. 211
Ohne Titel (Konstruktivistisch)
Untitled (Constructivistic)
1968
Oil on canvas
40 x 50 (15 3/4 x 19 5/8)
verso b. r. on canvas 'S. Polke 68' and verso t. '909'

Provenance
Ulbricht Collection, Düsseldorf
Kunsthaus Lempertz, Cologne, 3/4 Dec. 1985, auction 611, Lot 909
acquired 1985

Exhibitions and Literature
Sammlung Ulbricht, Bonn 1982, cat. no. 156, repr. p. 65 [under the title 'Untitled']

Kunsthaus Lempertz, auct. cat. Cologne 1985, auction 611, cat. no. 909, repr.

cat. 212
Ohne Titel (Nierenform)
Untitled (Kidney Shape)
1968
Watercolour and silver bronze paint on paper
29.5 x 22.9 (11 5/8 x 9)
recto b. l. 'S. Polke 68'

Provenance
Nicole Hackert, Berlin
Galerie Bruno Brunnet Fine Arts, Berlin
acquired 1993

Exhibitions and Literature
Berlin 1993, cat. no. 44, repr.

cat. 213, ill. p. 115
Ohne Titel (Ufos)
Untitled (UFOs)
1968
Watercolour on paper
29 x 20 (11 3/8 x 7 7/8)
recto b. r. 'S. Polke 68'

Provenance
Oppenheim Collection, Cologne
Dietmar Werle, Cologne
acquired 1988

Exhibitions and Literature
Bonn 1988, cat. no. 4.49

cat. 214, ill. p. 104
Profil
Profile
1968
Dispersion on fabric
90 x 75.5 (35 3/8 x 29 3/4)
verso on stretcher 'S. Polke 68'

Provenance
Anna and Otto Block, Berlin
René Block, Berlin
acquired 1992

Exhibitions and Literature
Tübingen 1976, cat. no. 74, repr. p. 69
Rotterdam 1983, cat. no. 15
Zurich 1984, cat. no. 42, repr. p. 29 [under the title 'Profil-Bild']
The Readymade Boomerang, Sydney 1990, cat. no. 358, repr. p. 72
Sammlung Block, Copenhagen 1992, cat. no. 382, repr. p. 73
Amsterdam 1992, cat. no. 6, repr. p. 43
Liverpool 1995, cat. no. 22, repr. p. 14

Klaus Honnef, 'Malerei als Abenteuer oder Kunst und Leben', in: *Kunstforum International,* vol. 71/2, April/May 1984, repr. p. 157
Hentschel, *Polke,* 1991, cat. no. 239, p. 246

cat. 215
Raucher
Smoker
1968
Watercolour on paper
95.5 x 64 (37 5/8 x 25 1/4)
recto b. r. 'p. Polke'

215

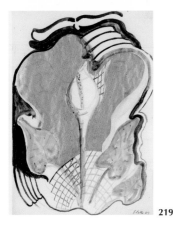

219

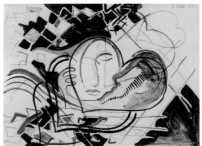

220

222

Provenance
David Nolan Gallery, New York
acquired 1987

Exhibitions and Literature
New York 1987, cat. no. 7, repr. p. 27
Bonn 1988, cat. no. 7.8

cat. 216, ill. p. 115
Der Sternhimmel am 24. 6. 24.00 Uhr zeigt als Sternbild den Namenszug S. Polke
The Starry Sky on 24 June 24.00 Hours Shows a Constellation in the Form of the Name S. Polke
1969
Ball-point pen and ink on paper
29.5 x 21 (11 5/8 x 8 1/4)
recto b. r. 'S. Polke V. 69'

Provenance
Mary Boone Gallery, New York
acquired 1988

Exhibitions and Literature
Bonn 1988, cat. no. 3.57, repr. p. 28
Der Geist der Romantik, Munich 1995
cat. no. 365

Gachnang, *Polke*, cat. no 95, repr. unpag.

cat. 217, ill. p. 99
**Höhere Wesen befahlen:
rechte obere Ecke schwarz malen!**
Higher Powers Command:
Paint the Right Hand Corner Black!
1969
Lacquer on canvas
150 x 125.5 (59 x 49 3/8)
verso on stretcher 'S. Polke 68'

Provenance
Oppenheim Collection, Cologne
Galerie Erhard Klein, Bonn
acquired 1986

Exhibitions and Literature
The Readymade Boomerang, Sydney 1990,
cat. no. 360, repr. p. 101
San Francisco 1991, cat. no. 19, repr. 19, unpag.
Liverpool 1995, cat. no. 23, repr. p. 43

Hentschel, *Polke,* 1991, cat. no. 333,
pp. 311–17

cat. 218, ill. p. 116
Untitled
1969
Dispersion on paper
63,5 x 53 (25 x 20 3/4)
signed

Provenance
Anthony d'Offay Gallery, London
Private collection, New York
Matthew Marks Gallery, New York
acquired 1995

cat. 219
Ohne Titel (Kalla)
Untitled (Kalla)
1969
Watercolour and silver lithographic colour
on paper
29.5 x 20.8 (11 5/8 x 8 1/4)
recto b. r. 'S. Polke 69'

Provenance
Nicole Hackert, Berlin
Bruno Brunnet Fine Arts, Berlin
acquired 1993

Exhibitions and Literature
Bonn 1988, cat. no. 4.37
Berlin 1993, cat. no. 59, repr.
Der Geist der Romantik, Munich 1995
cat. no. 371

cat. 220
Ohne Titel (Herzen)
Untitled (Hearts)
1969
Watercolour on paper
21.7 x 30.5 (8 1/2 x 12)
recto t. r. 'S. Polke 69'

Provenance
Nicole Hackert, Berlin
Bruno Brunnet Fine Arts, Berlin
acquired 1993

Exhibitions and Literature
Berlin 1993, cat. no. 60, repr.
Der Geist der Romantik, Munich 1995
cat. no. 370

cat. 221, ill. pp. 108–9
Bärenkampf
Bear Fight
1974
Fourteen black and white photographs
each 65 x 84 (each 25 1/2 x 33 1/8)
recto b. r. 'S. Polke 74'

Provenance
Speck Collection, Cologne
Galerie Bärbel Grässlin, Frankfurt
acquired 1985

Exhibitions and Literature
Bauch, Duchow, Stuttgart 1980, repr. unpag.
Zurich 1984, cat. no. 107
Bilderstreit, Cologne 1989, cat. no. 574
Photo-Kunst, Stuttgart 1989, cat. no. 138,
repr. pp. 330–334
Baden-Baden 1990, cat. no. 86–98,
repr. pp. 128–135
Los Angeles 1995, cat. no. 60, repr. cover

cat. 222
Quetta
1974/78
Painted photograph
63 x 95 (24 3/4 x 37 /8)
recto b. l. 'S. Polke 78 Quetta 74' and verso
b. r. 'S. Polke'

Provenance
David Nolan Gallery, New York
Christie's, New York, 19.11.1992, Sale 7570,
Lot 168
acquired 1992

Exhibitions and Literature
Los Angeles 1996, cat. no. 81, repr. pp. 162,
163

Christie's, New York, auct. cat. 1992, Sale 7570,
Lot 168, repr. [under the title 'Quetta 74']

cat. 223, ill. p. 105
Sicherheitsverwahrung
Safekeeping
1978
Dispersion, safety pins, razor blade, button and
sweet on fabric
110 x 130 (43 1/4 x 51 1/8)
recto b. r. 'S. P.' and verso 'S. Polke 78'

Provenance
Onnasch Collection, Berlin
Galerie Raffael Jablonka, Cologne
acquired 1987

Exhibitions and Literature
Aspekte deutscher Kunst, Salzburg 1994,
cat. no. 111, repr. p. 254

Dorothee Müller, 'Alte Herren am Katzentisch',
in: *Süddeutsche Zeitung,* 3.8.1994, repr. p. 11

cat. 224
Artaud: Zwei Zeichnungen
Artaud: Two Drawings
c. late 1970s
Painted photograph
127 x 235 (50 x 92 1/2)
recto b. r. 'Sigmar Polke'

Provenance
Galerie Hajo Müller, Cologne
acquired 1990

Exhibitions and Literature
Baden-Baden 1990, cat. no. 160, rep. p. 219
Los Angeles 1995, cat. no. 90, repr. pp. 168,
169

cat. 225, ill. p. 117
Ohne Titel (Porträtist)
Untitled (Portraitist)
1979
Pencil and gouache on paper
70 x 100 (27 1/2 x 39 3/8)
recto b. r. 'S. Polke 79'

Provenance
Galerie Hajo Müller, Cologne
acquired 1987

cat. 226, ill. p. 106
Hannibal mit seinen Panzerelefanten
Hannibal with his Armoured Elephants
1982
Lacquer on canvas
260 x 200 (102 3/8 x 78 3/4)
signed verso on the stretcher l. m. 'S. Polke 82'

Provenance
Galerie Erhard Klein, Bonn
Saatchi Collection, London
Gagosian Gallery, New York
acquired 1991

Exhibitions and Literature
Rotterdam 1983, cat. no. 48
Zurich 1984, cat. no. 133, repr. p. 113
Refigured Painting, Toledo 1988, cat. no. 250
San Francisco 1991, cat. no. 27, repr. 32, unpag.
Liverpool 1995, cat. no. 40, repr. p. 20

The Saatchi Collection, London 1984, vol. 3,
repr. 79

On loan to Tate Gallery since April 1995

cat. 227, ill. p. 107
Lingua Tertii Imperii
1983
Lacquer on canvas
260 x 200 (102 3/8 x 78 3/4)
recto t. 'LTI'

Provenance
Galerie Schmela, Düsseldorf
acquired 1984

Exhibitions and Literature
Zurich 1984, cat. no. 150, repr. p.
Refigured Painting, Toledo 1988, cat. no. 114,
repr. p. 175
Biennale, Istanbul, 1995, p. 314

Klaus Honnef, 'Malerei als Abenteuer oder Kunst
und Leben', in: *Kunstforum International,*
vol. 71/72, April/May 1984, repr. p. 195
Munich 1989, repr. 13, p. 12
Biennale, Istanbul 1995, cat. p. 314

cat. 228
Schwimmbad
Swimming Pool
1988
Lacquer on synthetic cotton
255 x 300 (100 3/8 x 118 1/8)

Provenance
Helen van der Meij, London
acquired 1989

Exhibitions and Literature
Paris 1988 [not in cat.]
Artistes de Colónia, Barcelona 1990, repr. p. 25
Liverpool 1995, cat. no. 50, repr. p. 79

On loan to Tate Gallery since April 1995

GERHARD RICHTER
born 1932 in Dresden
lives in Cologne

Bibliography
Hanover 1966
 Richter/Polke, exh. cat. Galerie h, Hanover
 1966
Ohff, *Pop und die Folgen,* 1968
 Heinz Ohff, *Pop und die Folgen,* Düsseldorf
 1968
Ströher Collection, Berlin 1969
 Karl Ströher Collection, exh. cat.
 Nationalgalerie Berlin, 1969; Städtische
 Kunsthalle, Düsseldorf 1969; et al.
Aachen 1969
 Gerhard Richter, exh. cat. Gegenverkehr/
 Zentrum für aktuelle Kunst e.V., Aachen 1969
Düsseldorf 1971
 Gerhard Richter. Arbeiten 1962 – 1971,
 exh. cat. Kunstverein für die Rheinlande und
 Westfalen, Düsseldorf, June – Aug. 1971
Venice 1972
 Gerhard Richter, exh. cat. 36. Biennale di
 Venezia, German Pavilion, Venice, June –
 Oct. 1972
Honnef, *Richter,* 1976
 Klaus Honnef, *Gerhard Richter,*
 Recklinghausen 1976 (Monographien zur
 rheinisch- westfälischen Kunst der
 Gegenwart, vol. 50)
Reinhard Onnasch Collection, Berlin 1978
 *Aspekte der 60er Jahre. Aus der Sammlung
 Reinhard Onnasch,* exh. cat. Nationalgalerie
 Berlin, Staatliche Museen Preußischer
 Kulturbesitz, Berlin 1978
Parnass, Wuppertal 1980
 Treffpunkt Parnass. Wuppertal 1949 – 1965,
 exh. cat. Von-der-Heydt-Museum, Wuppertal
 1980
Düsseldorf 1981
 Georg Baselitz – Gerhard Richter, exh. cat.
 Städtische Kunsthalle Düsseldorf, May – July
 1981
Westkunst, Cologne 1981
 Westkunst – Zeitgenössische Kunst seit 1939,
 exh. cat Cologne fair, 1989
Parnass, Paris 1982
 Treffpunkt Parnass. Wuppertal 1949 – 1965,
 exh. cat. Goethe-Institut, Paris 1982; Goethe-
 Institut, London, 1982; et al.
Parnass, London 1982
 Treffpunkt Parnass. Wuppertal 1949 – 1965,
 exh. cat. Goethe-Institut, London 1982
Loock/Zacharopoulos, *Richter,* 1985
 Ulrich Loock, Denys Zacharopoulos,
 Gerhard Richter, Munich 1985
Düsseldorf 1986
 Jürgen Harten (ed.), *Gerhard Richter. Bilder
 1962 – 1985,* exh. cat. Städtische Kunsthalle,
 Düsseldorf, Jan. – March 1986;
 Nationalgalerie Berlin, Stiftung Preußischer
 Kulturbesitz, Berlin, April – June 1986; et al.;
 Cologne 1986
Cologne 1987
 Gerhard Richter. 20 Bilder, exh. cat. Galerie
 Rudolf Zwirner, Cologne, Oct. – Nov. 1987

Toronto 1988
 Gerhard Richter. Paintings, exh. cat. Art Gallery of Ontario, Toronto, April – July 1988; Museum of Contemporary Art, Chicago, Sept. – Nov. 1988; et al.; London 1988
Bilderstreit, Cologne 1989
 Johannes Gachnang / Siegfried Gohr (eds.), *Bilderstreit. Widerspruch, Einheit und Fragment in der Kunst seit 1960,* exh. cat. Museum Ludwig in den Rheinhallen der Kölner Messe, Cologne 1989
Artistes de Colónia, Barcelona 1990
 Artistes de Colónia: alló bell, alló sinistre, exh. cat. Centre d'Art Santa Monica, Barcelona 1990
London 1991
 Gerhard Richter, exh. cat. Tate Gallery, London, Oct. 1991 – Jan. 1992
Pop Art, London 1991
 Marco Livingstone (ed.), *Pop Art,* exh. cat. Royal Academy of Arts, London 1991 [German edition see: *Pop Art,* Cologne 1992; Spanish edition see: *Pop Art,* Madrid 1992]
Pop Art, Cologne 1992
 Marco Livingstone (ed.), *Pop Art,* exh. cat. Museum Ludwig, Cologne 1992 [original edition: *Pop Art,* London 1991]
Pop Art, Madrid 1992
 Marco Livingstone (ed.), *Pop Art,* exh. cat. Museo Nacional Centro de Arte Reina Sofía, Madrid 1992 [original edition: *Pop Art,* London 1991]
Berlin 1993
 Gerhard Richter. Ausschnitt. 20 Bilder von 1965 – 1991, exh. cat. Neuer Berliner Kunstverein, Feb. – April 1993
Bonn 1993
 Gerhard Richter. Vol. III. Catalogue raisonné 1962 – 1993, exh. cat. Musée d'art moderne de la ville de Paris, Sept. – Nov. 1993; Kunst- und Ausstellungshalle der Bundesrepublik Deutschland, Bonn, Dec. 1993 – Feb. 1994; et al.; Stuttgart 1993
Die vertikale Gefahr, Kassel 1993
 Die vertikale Gefahr. Luftkrieg in der Kunst, exh. cat. documenta-Halle, Kassel 1993
abstrakt, Dresden 1993
 abstrakt: Der Deutsche Künstlerbund in Dresden 1993, exh. cat., Vol.: Albertinum der Staatlichen Kunstsammlungen, Dresden 1993
Madrid 1994
 Gerhard Richter, exh. cat. Museo Nacional Centro de Arte Reina Sofía, Madrid, June – Aug. 1994
The Romantic Spirit, Edinburgh 1994
 The Romantic Spirit in German Art 1790 – 1990, Royal Scottish Academy and The Fruitmarket Gallery, Edinburgh 1994; Hayward Gallery, South Bank Centre, London 1994 – 5; Stuttgart 1994 [German edition see: *Der Geist der Romantik,* Munich 1995]
Der Geist der Romantik, Munich 1995
 Ernste Spiele. Der Geist der Romantik in der deutschen Kunst 1790 – 1990, exh. cat. Haus der Kunst, Munich 1995; Stuttgart 1995 [original edition see: *The Romantic Spirit,* Edinburgh 1994]

Art of the Sixties, Tokyo 1995
 Revolution: Art of the Sixties. From Warhol to Beuys, exh. cat. Museum of Contemporary Art, Tokyo 1995

cat. 229, ill. p. 119
Faltbarer Trockner
Folding Dryer
1962
Oil on canvas
105 x 70 (41 3/8 x 27 1/2)
signed verso t. r. 'Richter 62' and m. 'Nr. 4' and m. 'Richter' [crossed out]

Provenance
Galerie Friedrich und Dahlem, Munich
Onnasch Collection, Berlin
acquired 1986

Exhibitions and Literature
Aachen 1969, repr. 4
Düsseldorf 1971, cat. no. 4, repr. unpag.
Venice 1972, cat. no. 4, repr. p. 46
Gerhard Richter. Vier Bilder von 1973, Galerie René Block, Berlin 1974 [no cat.]
Reinhard Onnasch Collection, Berlin 1978, repr. p. 134
Düsseldorf 1986, cat. no. 4, repr. p. 2
Bilderstreit, Cologne 1989, cat. no. 637, repr. p. 336
Pop Art, London 1991, cat. no. 197, repr. 191, p. 252
Bonn 1993, cat. no. 4, repr. unpag.

Klaus Honnef, 'Richter's New Reality', in: *Art and Artists,* no. 9, 1973, repr. p. 35
Honnef, *Richter,* 1976, repr. p. 20

Extended loan from the Onnasch Collection, Berlin, to the Kunsthalle Kiel from 1978 to 1986

cat. 230, ill. p. 120
Phantom Abfangjäger
Phantom Interceptors
1964
Oil on canvas
140 x 190 (55 1/8 x 74 3/4)
signed verso t. r. '140 x 190 Richter'

Provenance
Parnass Collection, Wuppertal
Jablonka Galerie, Cologne
acquired 1988

Exhibitions and Literature
Lueg, Polke, Richter, Galerie Parnass, Wuppertal 1964 [no cat.]
Ohff, *Pop und die Folgen,* 1968, repr. p. 24
Venice 1972, cat. no. 50
Parnass, Wuppertal 1980, repr. p.264
Parnass, Paris 1982, repr. p. 53
Parnass, London 1982, repr. p. 53
Düsseldorf 1986, cat. no. 50, repr. p. 24
Bonn 1993, cat. no. 50, repr. unpag.
Die vertikale Gefahr, Kassel 1993 [not in cat.]
Art of the Sixties, Tokyo 1995, cat. no. 130, repr. p. 245

cat. 231, ill. p. 121
Schwimmerinnen
Swimmers
1965
Oil on canvas
200 x 160 (78 3/4 x 63)
signed verso m. l. 'Richter 1965'

Provenance
Heiner Friedrich, Munich
Onnasch Collection, Berlin
acquired 1986

Exhibitions and Literature
Hanover 1966 [not in cat.]
Venice 1972, cat. no. 90, repr. p. 53
Reinhard Onnasch Collection, Berlin 1978, repr. p. 135
Düsseldorf 1986, cat. no. 90, repr. p. 41
Bilderstreit, Cologne 1989, cat. no. 638, repr. p. 337
Artistes de Colònia, Barcelona 1990, repr. p. 21
Pop Art, London 1991, cat. no. 199, repr. 192, p. 253
Pop Art, Cologne 1992, repr. 179;
Pop Art, Madrid 1992, repr. p. 263
Bonn 1993, cat. no. 90, repr. unpag.
Art of the Sixties, Tokyo 1995, cat. no. 131, repr. p. 246

Extended loan from the Onnasch Collection, Berlin, to the Staatsgalerie Moderner Kunst, Munich, from 1980 to 1986

cat. 232, ill. p. 122
Zwei Grau nebeneinander
Two Greys Juxtaposed
1966
Oil on canvas
200 x 150 (78 3/4 x 59)
signed verso b. r. 'Richter 1966' and verso t. r. '143–1'

Provenance
Heiner Friedrich, Munich
Onnasch Collection, Berlin
Hirschl & Adler Modern, New York
Cramo Fine Arts, Antwerp
acquired 1990

Exhibitions and Literature
Aachen 1969, repr. 66
Venice 1972, cat. no. 143/1, repr. p. 60
Reinhard Onnasch Collection, Berlin 1978, repr. p. 135
Düsseldorf 1986, cat. no. 143/1, repr. p. 60
Berlin 1993, repr. unpag.
Bonn 1993, cat. no. 143–1, repr. unpag.
abstrakt, Dresden 1993, repr. p. 71

Centre Georges Pompidou, *Les Cahiers du Musée National d'Art Moderne,* no. 49, Autumn 1994, repr. 10, p. 71

Extended loan from the Onnasch Collection, Berlin, to the Kunsthalle Kiel from 1978 to 1986

cat. 233, ill. p. 123
Stadtbild Paris
Townscape Paris
1968
Oil on Canvas
200 x 200 (78 3/4 x 78 3/4)
verso t. m. 'Stadtbild (P.)' and b. r. 'Richter 68'

Provenance
Collection Ströher, Darmstadt
Urs Rausmüller, Schaffhausen
acquired 1996

Exhibitions and Literature
Sammlung Ströher, Berlin 1969, repr. p. 150
Aachen 1969, cat. no. 92, repr. unpag.
Düsseldorfer Szene, Kunstmuseum Luzern, 1969
[no cat.]
Venice 1972, cat. no. 175, repr. p. 65, 76
Gerhard Richter, Kunstmuseum Luzern, 1972
[no cat.]
Gerhard Richter, Kunsthalle Bremen, 1975
[no cat.]
Gerhard Richter, Palais des Beaux Arts, Bruxelles
1976 [no cat.]
Westkunst, Cologne 1981, repr. p. 479
Düsseldorf 1986, cat. no. 175, repr. p. 73
Gerhard Richter, Hallen für Neue Kunst,
Schaffhausen 1990 [no cat.]
London 1991, cat. no. 11, repr. p. 50
Bonn 1993, repr. p. 45
Madrid 1994, cat. no. 14, repr. p. 63

Rolf Wedewer, *Zum Landschaftstypus Gerhard
Richters*, in: *Pantheon*, Nr. 1, 1975, S. 41 ff
Martin Hentschel and Ulrich Loock, 'Gerhard
Richter', in: *Artistes*, Dec. 1983, repr. p. 42
Peter M. Bode, 'Immer anders, immer er selbst',
in: *art. Das Kunstmagazin*, May 1983, repr. p. 59
Loock/Zacharopoulos, *Richter*, 1985, repr. p. 51
Coosje van Bruggen, 'Gerhard Richter. Painting
as a Moral Act', in: *Artforum International*,
May 1985, repr. p. 82

cat. 234, ill. p. 124
Seestück
Sea Piece
1975
Oil on canvas
200 x 300 (78 3/4 x 118)

Provenance
Galerie Konrad Fischer, Düsseldorf
Dr. Gerhard and Elisabeth Sohst, Hamburg
acquired 1994

Exhibitions and Literature
Galerie Konrad Fischer, Düsseldorf 1975
[no cat.]
Zwei Seestücke 1975, Kabinett für aktuelle
Kunst, Bremerhaven 1975 [no cat.]
Düsseldorf 1981, repr., unpag.
Düsseldorf 1986, cat. no. 377, repr. p. 189
Bonn 1993, cat. no. 377, repr. unpag.
Der Geist der Romantik, Munich 1995, cat. no.
390, repr. 120, p. 190 [not exh. in London]
Honnef, *Richter*, 1976, repr. p. 33

Extended loan from Dr. Gerhard and Elisabeth
Sohst, Hamburg, to the Kunsthalle Hamburg
from 1982 to 1994

cat. 235, ill. p. 125
Abstraktes Bild
Abstract Painting
1987
Oil on canvas
300 x 300 (118 x 118)
signed verso b. m. l. '620 Richter 1987'

Provenance
Galerie Rudolf Zwirner, Cologne
acquired 1987

Exhibitions and Literature
Cologne 1987, cat. no. 620, repr. unpag.
[under the title 'Ohne Titel']
Toronto 1988, cat. no. 620, repr. 76,
pp. 142, 143
Bonn 1993, cat. no. 620, repr. unpag.

FRANK STELLA
born 1936 in Malden, Mass.
lives in New York

Bibliography

Positionen, Berlin 1988
Positionen heutiger Kunst, exh. cat.
Nationalgalerie Berlin, 1988
Stuttgart 1988
*Frank Stella. Black Paintings 1958 – 1960.
Cones and Pillars 1984 – 1987*, exh. cat.
Staatsgalerie Stuttgart, Nov. 1988 – Feb.
1989
Munich 1996
Frank Stella, exh. cat. Haus der Kunst,
Munich, Feb. – April 1996

cat. 236, ill. p. 181
Lo Sciocco Senza Paura
1987
Mixed media and colour-etched magnesium on
aluminium
266.7 x 215.3 x 163.2
(105 x 84 3/4 x 64 1/4)

Provenance
Galerie Hans Strelow, Düsseldorf
aquired 1988

Exhibitions and Literature
Frank Stella, Galerie Hans Strelow, Düsseldorf,
May – June 1987 [no cat.]
Positionen, Berlin 1988, repr. p. 93
Stuttgart 1988, cat. no. 24, repr. p. 87
Munich 1996, repr. p. 212

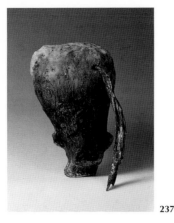

237

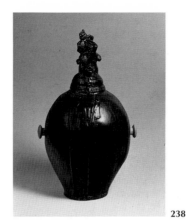

238

239

ROSEMARIE TROCKEL
born 1952 in Schwerte
lives in Cologne

Bibliography
Bonn/Cologne 1983
Rosemarie Trockel. Plastiken 1982 – 1983,
exh. cat. Galerie Philomene Magers, Bonn, and
Galerie Monika Sprüth, Cologne [no month]
1983
Hamburg 1984
Rosemarie Trockel. Skulpturen und Bilder, exh.
cat. Galerie Ascan Crone, Hamburg, Aug. –
Sept. 1984
Collection Joshua Gessel, Geneva 1984
*Une sélection de la collection particulière de
Joshua Gessel,* exh. cat. Halle Sud, Geneva 1984
Bonn 1985
*Rosemarie Trockel. Bilder – Skulpturen –
Zeichnungen,* exh. cat. Rheinisches
Landesmusem Bonn, Sept. – Oct. 1985
Basle 1988
Jean-Christophe Ammann (ed.), *Rosemarie
Trockel,* exh. cat. Kunsthalle Basel, June – Aug.
1988; Institute of Contemporary Arts, London,
Oct. – Nov. 1988
Camouflage, Glasgow 1988
Camouflage, exh. cat. The Third Eye Centre,
Glasgow 1988; Inverness Museum and Art
Gallery, 1988; et al.
Carnegie International, Pittsburgh 1988
Carnegie International 1988, Carnegie Museum
of Art, Pittsburgh 1988–9
Made in Cologne, Cologne 1988
Made in Cologne, exh. cat. DuMont Kunsthalle,
Cologne 1988
Oliva, *Super Art,* 1988
Achille Bonito Oliva, *Super Art,* Milan 1988
Das Verhältnis der Geschlechter, Bonn 1989
Das Verhältnis der Geschlechter, exh. cat.
Bonner Kunstverein, Bonn 1989
Prospect 89, Frankfurt 1989
Prospect 89, exh. cat. Frankfurter Kunstverein,
Frankfurt a.M. 1989
Bilderstreit, Cologne 1989
Johannes Gachnang / Siegfried Gohr (eds.),
*Bilderstreit. Widerspruch, Einheit und Fragment
in der Kunst seit 1960,* exh. cat. Museum
Ludwig in den Rheinhallen der Kölner Messe,
Cologne 1989
Einleuchten, Hamburg 1989
Harald Szeemann (ed.), *Einleuchten. Will,
Vorstel und Simul in HH,* exh. cat.
Deichtorhallen, Hamburg 1989–90
Zeitzeichen, Cologne 1989
*Zeitzeichen. Stationen bildender Kunst in
Nordrhein-Westfalen,* exh. cat. Ministerium für
Bundesangelegenheiten des Landes NRW,
Bonn; Museum der bildenden Künste / Galerie
der Hochschule für Grafik und Buchkunst,
Leipzig; et al; Cologne 1989
Life-Size, Jerusalem 1990
Suzanne Landau (ed.), *Life-Size. A Sense of the
Real in Recent Art,* exh. cat. The Israel
Museum, Jerusalem 1990
Artistes de Cólonia, Barcelona 1990
Artistes de Cólonia: alló bell, alló sinistre, exh.
cat. Centre d'Art Santa Monica, Barcelona 1990
Ausserhalb von Mittendrin, Berlin 1991
Ausserhalb von Mittendrin, exh. cat. NGBK –
Neue Gesellschaft für Bildende Kunst e.V.,
Berlin 1991

Boston 1991
Sidra Stich (ed.), *Rosemarie Trockel,* exh. cat.
The Institute of Contemporary Art, Boston,
April – May 1991; Berkeley University Art
Museum, June – Sept. 1991; et al.
Biennale, Istanbul 1995
4. International Istanbul Biennale,
Istanbul 1995

cat. 237
Wasserkopf I
Hydrocephalus
1982
Painted plaster and graphite
height: 46 (18)
signed

Provenance
Gessel Collection, Tel Aviv
acquired 1995

Exhibitions and Literature
Bonn/Cologne 1983, repr. unpag.
Collection Joshua Gessel, Geneva 1984, p. 58,
repr.
Boston 1991, cat. no. 1, p. 140, repr. p. 38

cat. 238
Lekyte I
1984
Painted plaster
height: 46 (18)
signed

Provenance
Gessel Collection, Tel Aviv
acquired 1995

Exhibitions and Literature
Bonn 1985, repr. 85, p. 51

cat. 239
Trophäe der Sehnsucht
Trophy of Desire
1984
Painted plaster
20 x 18 x 19 (7 7/8 x 7 x 7 3/8)
signed

Provenance
Gessel Collection, Tel Aviv
acquired 1995

Exhibitions and Literature
Hamburg 1984, repr. p. 7

Jutta Koether, 'The Resistant Art of Rosemarie
Trockel', in: *Artscribe,* no. 62, 1987, repr. p. 54

cat. 240, ill. p. 128
Balaklava Box
1986 – 90
Woolen balaklavas, mannequin heads and ple-
xiglass cabinet
34.5 x 154 x 32 (13 1/2 x 61 x 12 1/2)
signed

Provenance
Galerie Monika Sprüth, Cologne
Gessel Collection, Tel Aviv
acquired 1995

Exhibitions and Literature
Camouflage, Glasgow 1988, cat. no. 17, repr.
unpag. [under the title 'Ohne Titel (Balaclava)']

Deborah Drier, 'Spider Woman', in: *Art Forum,*
vol. 30, Sept. 1991, pp. 118 – 124, repr. p. 118

cat. 241, ill. p. 127
Ohne Titel (Schwarze Endlosstrümpfe)
Untitled (Black Endless Socks)
1987
Wool socks, glass and wood
240 x 56 x 3.5 (94 1/2 x 22 x 1 3/8)

Provenance
Gessel Collection, Tel Aviv
acquired 1995

Exhibitions and Literature
RAI 1987, Amsterdam 1987 [no cat.]
Einleuchten, Hamburg 1989, cat. no. 117, p. 51,
repr. p. 231
Boston 1991, cat. no. 14, p. 140, repr. p. 56

Monika Sprüth, *'Eau de Cologne',* in: *Artscribe,*
no. 68, 1988, p. 90, repr.
*'Endlich ahnen, nicht nur wissen, Rosemarie
Trockel im Gespräch mit Doris von Drateln',*
in: *Kunstforum,* vol. 93, Feb./March 1988,
repr. p. 211 [under the title 'Schwarzendlos
Strümpfe']
Donald Kuspit, 'The Modern Fetish', in: *Art
Forum,* Oct. 1988, repr. p. 138
Art. Das Kunstmagazin, Nov. 1989, repr. p. 182
David Galloway, 'Happening in Hamburg', in:
Art in America, May 1990, repr. p. 79

cat. 242, ill. p. 129
Cogito, ergo sum
1988
Wool
220 x 150 (87 x 59)
signed
1/3

Provenance
Gessel Collection, Tel Aviv
acquired 1995

Exhibitions and Literature
Basle 1988, cat. no. 9, repr. p. 27
Made in Cologne, Cologne 1988, repr. p. 123
Das Verhältnis der Geschlechter, Bonn 1989,
repr. p. 112
Prospect 89, Frankfurt 1989, repr. p. 196
Bilderstreit, Cologne 1989, cat. no. 732
Zeitzeichen, Cologne 1989, repr. p. 318
Boston 1991, cat. no. 32, p. 141, repr. p. 80
Biennale, Istanbul 1995, cat. no. 315

Carnegie International, Pittsburgh 1988, repr. p.
139 [not exh.]

243

245

Stephan Schmidt-Wulffen, 'Rosemarie Trockel
und die Philosophie', in: *Noema*, no. 22,
Jan. – March 1989, pp. 24 – 29, repr. p. 25
Veronique Bacchettam, 'Rosemarie Trockel.
Provokation und poetisches Rätsel', in: *Parkett*,
no. 33, Sept. 1992, pp. 32 – 39, repr. p. 35

cat. 243
Freude
Joy
1988
Wool
210 x 175 (82 1/2 x 68 3/4)
signed
1/3

Provenance
Gessel Collection, Tel Aviv
acquired 1995

Exhibitions and Literature
Carnegie International 1988, repr. p. 190
Das Verhältnis der Geschlechter, Bonn 1989,
repr. p. 111
Bilderstreit, Cologne 1989, cat. no. 734, p. 533,
repr. p. 91
Artistes de Colònia, Barcelona 1990, repr. p. 46
Boston 1991, cat. no. 33, p. 141, repr. p. 81

Jill Lloyd, 'German Sculpture since Beuys.
Disrupting Consumist Culture', in: *Art
International*, no. 6, spring 1989, repr. p. 15
Noema, no. 22, Jan. – March 1989, repr. title
page
N.N. in: *Capital*, Nov. 1989, repr. p. 394

cat. 244, ill. p. 130
Untitled
1988
Wax, iron, wood and glass
148 x 54 x 54 (58 1/2 x 21 1/2 x 21 1/2)

Provenance
Gessel Collection, Tel Aviv
acquired 1995

Exhibitions and Literature
RAI 1987, Amsterdam 1987 [no cat.]
Basle 1988, cat. no. 16, repr. unpag.

Oliva, *Super Art*, 1988, repr. p. 130
Daniela Salvioni, 'Trockel and Fritsch', in: *Flash
Art*, no. 142, Oct. 1988, repr. p. 110
Renate Puvogel, 'Katharina Fritsch, Rosemarie
Trockel, Anna Winteler', in: *Kunstforum*, vol. 97,
Nov./Dec. 1988, repr. p. 314 [under the caption
'Installation in der Kunsthalle Basel']

cat. 245
Untitled
1988
Glass, brass, wood and pig's bladder
130 x 50 x 50 (51 1/8 x 19 5/8 x 19 5/8)
signed

Provenance
Monika Sprüth Galerie, Cologne
acquired 1990

Exhibitions and Literature
Basle 1988, cat. no. 4, repr. unpag.
Artistes de Colònia, Barcelona 1990, repr. p. 44

cat. 246
Who will be in in '99 ?
1988
Wool
210 x 160 (82 1/2 x 63)
signed twice, dated and titled
1/3

Provenance
Gessel Collection, Tel Aviv
acquired 1995

Exhibitions and Literature
Carnegie International 1988, Pittsburgh 1988,
repr. p. 191
Life-Size, Jerusalem 1990, repr. p. 173

Jill Lloyd, 'German Sculpture since Beuys.
Disrupting Consumist Culture', in: *Art
International Magazine*, no. 6, spring 1989, pp.
14 – 15
N.N. in: *Capital*, Nov. 1989, p. 392

cat. 247, ill. p. 131
Ofen
Oven
1990
Lacquered metal and two hotplates
130 x 60 x 40 (51 x 23 5/8 x 15 3/4)
signed

Provenance
Gessel Collection, Tel Aviv
acquired 1995

Exhibitions and Literature
Ausserhalb von Mittendrin, Berlin 1991, cat. no.
27, repr. p. 132 [under the title 'Ofen (Unikat)']

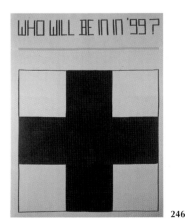

246

CY TWOMBLY
born 1928 in Lexington, Virginia
lives in Rome

Bibliography
Cologne 1975
 Cy Twombly, exh. cat. Galerie Karsten Greve,
 Cologne, March – April 1975
Hanover 1976
 Cy Twombly, exh. cat. Kestner-Gesellschaft
 Hannover, May – June 1976
Paris 1976
 Cy Twombly, Dessins 1954–1976, exh. cat.
 Musée d'art moderne de la ville de Paris,
 June – Sept. 1976
Lambert, *Twombly*, 1979
 Yvon Lambert, *Catalogue raisonné des
 œuvres sur papier de Cy Twombly. Vol. VI
 1973–1976*, Milan 1979
New York 1979
 *Cy Twombly: Paintings and Drawings
 1954–1977*, exh. cat. Whitney Museum of
 American Art, New York, April – June 1979
New York 1982
 Cy Twombly. XI Recent Works, exh. cat.
 Sperone Westwater Fischer, New York,
 April – May 1982
Sammlung Marx, Berlin 1982
 Heiner Bastian (ed.), *Joseph Beuys, Robert
 Rauschenberg, Cy Twombly, Andy Warhol.
 Sammlung Marx*, exh. cat. Nationalgalerie
 Berlin und Städtisches Museum Abteiberg,
 Mönchengladbach 1982
10 Painters, Boston 1984
 10 Painters & Sculptors Draw, exh. cat.
 Museum of Fine Arts, Boston 1984
Bordeaux 1984
 Cy Twombly, Œuvres de 1973–1983,
 exh. cat. CAPC, Musée d'art contemporain,
 Bordeaux, May – Sept. 1984
Baden-Baden 1984
 Cy Twombly, exh. cat. Staatliche Kunsthalle
 Baden-Baden, Sept. – Nov. 1984
Boston collects, Boston 1986
 *Boston collects: Contemporary Painting and
 Sculpture*, exh. cat. Museum of Fine Arts,
 Boston 1986–7
Kritisches Lexikon, Munich 1988
 'Cy Twombly', in: *Künstler. Kritisches Lexikon
 der Gegenwartskunst*, Munich 1988
Zurich 1987
 *Cy Twombly: Bilder, Arbeiten auf Papier,
 Skulpturen*, exh. cat. Kunsthaus Zürich,
 Feb. – March 1987; Palacio de Velázquez
 und Palacio Cristal, Madrid,
 April – July 1987; et al.
Bonn 1987
 Cy Twombly. Serien auf Papier 1957–1987,
 exh. cat. Städtisches Kunstmuseum Bonn,
 June – Aug. 1987
Barcelona 1987
 Cy Twombly, exh. cat. Centre Cultural de la
 Fundació Caixa de Pensions, Barcelona,
 Nov. 1987 – Jan. 1988
Lambert, *Twombly*, 1991
 Yvon Lambert, *Catalogue raisonné des oeuv-
 res sur papier de Cy Twombly: 1977–1982
 Vol. VII.*, Milan 1991
Bastian, *Twombly*, Munich 1992
 Heiner Bastian, *Cy Twombly. Catalogue
 Raisonné of the Paintings, Vol. I. 1948–1960*,
 Munich 1992

Die Sprache der Kunst, Vienna 1993
 Eleonora Louis and Toni Stoos (eds.), *Die Sprache der Kunst,* exh. cat. Kunsthalle Wien, 1993; Frankfurter Kunstverein, Frankfurt 1993–4
New York 1994
 Kirk Varnedoe (ed.), *Cy Twombly. A Retrospective,* exh. cat. Museum of Modern Art, New York, Sept. 1994 – Jan. 1995
Berlin 1995
 Kirk Varnedoe (ed.), *Cy Twombly. Eine Retrospective,* exh. cat. Neue Nationalgalerie Berlin, Sept. – Nov. 1995; Munich 1995

cat. 248, ill. p. 184
Untitled (Augusta, Georgia)
1954
Pencil on paper
48 x 64 (19 x 25)

Provenance
Heiner Bastian, Berlin
Anthony d'Offay Gallery, London
Hirschl and Adler Modern, New York
Private collection, London
Matthew Marks Gallery, New York
acquired 1994

Exhibitions and Literature
Cy Twombly, The Stable Gallery, New York, January 1955 [no cat.]

Bastian, *Twombly,* 1992, repr. p. 86 [t. r.]

cat. 249, ill. p. 183
Untitled (Grottaferrata, Italy)
1957
Oil, wax crayon and pencil on paper
50 x 70 (19 3/4 x 27 5/8)

Provenance
Betty di Robilant, Virginia
CRG Art, New York
acquired 1994

Exhibitions and Literature
Bastian, *Twombly,* 1992, cat. no. 72, repr. p. 129

cat. 250, ill. p. 185
See Naples and Die (Dawn Series #7)
1960
Pencil, chalk and ball-point pen on paper
49.9 x 70.2 (19 5/8 x 27 5/8)
recto t.m. 'See Naples and die'

Provenance
Leo Castelli Gallery, New York
Private collection, Florida
Duncan MacGuigan, New York
Acquavella Contemporary Art, New York
acquired 1994

cat. 251
Untitled
1964
Pencil, ink, wax crayon and crayon on paper
43.2 x 50 (17 x 19 3/4)
signed recto b. r. 'Cy Twombly 1964'

Provenance
Galleria La Tartaruga, Rome
Private collection, Rome
Pace Wildenstein, New York
acquired 1995

cat. 252, ill. p. 186
Untitled
1969
Pencil and collage on paper
88 x 45.7 (34 5/8 x 18)

Provenance
Robert Rauschenberg, New York
Leo Castelli Gallery, New York
acquired 1995

Exhibitions and Literature
New York 1994, cat. no. 71, repr. p. 128
Berlin 1995, cat. no. 71, repr. p. 138

cat. 253, ill. p. 187
Untitled
1969
Oil and pencil on paper
84 x 76 (33 1/4 x 30)

Provenance
Leo Castelli Gallery, New York
Sotheby's, London, 8.5.1978, Lot 62
Sotheby's New York, Sale 6554, 4.5.1994, Lot 24
acquired 1994

Exhibitions and Literature
Sotheby's London, auct. cat., 1978, Lot 62, repr.
Sotheby's New York, auct. cat. Sale 6564, 1994, Lot 24, repr.

cat. 254, ill. p. 188
Virgil I
1973
Oil, crayon and pencil on cardboard
70 x 100 (27 1/2 x 39 3/8)
signed verso 'Cy Twombly Virgil'

Provenance
Galerie Karsten Greve, Cologne
Marx Collection, Berlin
Thomas Ammann Fine Art, Zurich
acquired 1995

Exhibitions and Literature
Cologne 1975, repr. unpag.
Sammlung Marx, Berlin 1982, cat. no. 88, repr. p. 152 [under the title 'Virgil']
Bordeaux 1984, repr. p. 17 [under the title 'Virgil']
Baden-Baden 1984, cat. no. 31, repr. p. 154
Bonn 1987, cat. no. 6, repr. p. 91
Barcelona 1987–8, cat. no. V, repr. p. 85

Die Sprache der Kunst, Vienna 1993, cat. no. 25, repr. p. 36
Cy Twombly, Thomas Ammann Fine Art, Zurich, June – Sept. 1994 [no cat.]

Lambert, *Twombly,* 1979, cat. no. 56, repr. p. 80 [under the title 'Virgil']
Kritisches Lexikon, Munich 1988, cat. no. 10, repr. p. 9

cat. 255, ill. p. 188
Virgil II
1973
Oil, crayon and pencil on cardboard
70 x 100 (27 1/2 x 39 3/8)
verso t. 'Cy Twombly Virgil'

Provenance
Galerie Karsten Greve, Cologne
Marx Collection, Berlin
Thomas Ammann Fine Art, Zurich
acquired 1995

Exhibitions and Literature
Cologne 1975, repr. unpag.
Sammlung Marx, Berlin 1982, cat. no. 89, repr. p. 152 [under the title 'Virgil']
Bordeaux 1984, cat. no. p. 59 [under the title 'Virgil']
Baden-Baden 1984, cat. no. 32, repr. p. 155
Bonn 1987, cat. no. 6, repr. p. 92
Barcelona 1987–8, cat. no. V, repr. p. 86
Die Sprache der Kunst, Vienna 1993, cat. no. 25, repr. p. 36
Cy Twombly, Thomas Ammann Fine Art, Zurich, June – Sept. 1994 [no cat.]

Lambert, *Twombly,* 1979, cat. no. 55, repr. p. 80 [under the title 'Virgil']
Kritisches Lexikon, Munich 1988, cat. no 8, repr. p. 9

cat. 256, ill. p. 189
Virgil III
1973
Oil, crayon and pencil on cardboard
70 x 99.6 (27 1/2 x 39 1/4)
verso b. 'Cy Twombly Virgil'

Provenance
Marx Collection, Berlin
Thomas Ammann Fine Art, Zurich
acquired 1995

Exhibitions and Literature
Hanover 1976, cat. no. 10, repr. p. 61 [under the title 'Virgil']
Paris 1976, cat. no. 79 [under the title 'Virgil']
Sammlung Marx, Berlin 1982, cat. no. 90, repr. p. 153 [under the title 'Virgil']
Bordeaux 1984, repr. p. 16 [under the title 'Virgil']
Baden-Baden 1984, cat. no. 30, repr. p. 99 [under the title 'Virgil II']
Bonn 1987, cat. no. 6, repr. p. 93
Barcelona 1987–8, cat. no. V, repr. p. 87
Die Sprache der Kunst, Vienna 1993, cat. no. 25, repr. p. 36

261

262

Cy Twombly, Thomas Ammann, Zurich, June –
Sept. 1994 [no cat.]

Lambert, *Twombly*, 1979, cat. no. 51, repr. p.
77 [under the title 'Virgil']
Kritisches Lexikon, Munich 1988, cat. no. 7,
repr. p. 9

cat. 257, ill. p. 189
Virgil IV
1973
Oil, crayon and pencil on cardboard
70 x 100 (27 1/2 x 39 3/8)
verso b. 'Cy Twombly Virgil'

Provenance
Marx Collection, Berlin
Thomas Ammann Fine Art, Zurich
acquired 1995

Exhibitions and Literature
Hanover 1976, cat. no. 9, repr. p. 79 [under the
title 'Virgil']
Paris, 1976, cat. no. 80 [under the title 'Virgil']
Sammlung Marx, Berlin 1982, cat. no. 91,
repr. p. 153 [under the title 'Virgil']
Bordeaux 1984, repr. p. 15 [under the title
'Virgil']
Baden-Baden 1984, cat. no. 29, repr. p. 98
[under the title 'Virgil I']
Bonn 1987, cat. no. 6, repr. p. 94
Barcelona 1987–8, cat. no. V, repr. p. 88
Die Sprache der Kunst, Vienna 1993,
cat. no. 25, repr. p. 36
Cy Twombly, Thomas Ammann Fine Art, Zurich,
June – Sept. 1994 [no cat.]

Lambert, *Twombly*, 1979, cat. no. 52, repr. p.
78 [under the title 'Virgil']
Kritisches Lexikon, Munich 1988, cat. no. 9,
repr. p. 9

cat. 258
Untitled (Captiva Island, Florida)
1974
Mixed media and collge on paper
75 x 106 (29 1/2 x 41 3/4)
verso b. l. 'Cy Twombly Captiva Mar 74'

Provenance
Leo Castelli Gallery, New York
Warren Benedek Gallery, New York
David Whitney, New York
Robert McClain, Houston
acquired 1995

Exhibitions and Literature
*Works of Robert Rauschenberg and Cy
Twombly*, Leo Castelli Gallery, New York 1974
[no cat.]
New York 1979, cat. no. 81, repr. p. 100

Lambert, *Twombly*, 1979, cat. no. 115,
repr. p. 118

cat. 259
Sesotris II
1974
Oil, chalk and pencil on paper
70 x 100 (27 1/2 x 39 3/8)
recto t. 'Sesotris II' and verso 'Cy Twombly
Roma May 74 (Sesotris II)'

Provenance
Lucio Amelio, Naples
Bruno and Antonella Pisaturo, Naples
Galleria Lucio Amelio, Naples
acquired 1994

Exhibitions and Literature
Lambert, *Twombly*, 1979 cat. no. 98,
repr. p. 108

cat. 260, ill. pp. 190, 191
**Idilli (I am Thyrsis of Etna Blessed with a
Tuneful Voice)**
1976
Oil, watercolour, crayon, pencil and tape on
paper
two parts, left sheet: 134.3 x 150.3; right sheet:
69 x 53 (left sheet: 52 7/8 x 59 1/8.; right sheet:
27 1/8 x 20 7/8)
recto l. 'I am Thyrsis of Etna blessed with a
Tuneful Voice' and m. r. 'CT Aug 76'

Provenance
Galerie Karsten Greve, Cologne
acquired 1994

Exhibitions and Literature
Zurich 1987, cat. no. 33, repr. p. 87
Cy Twombly, Galleria Karsten Greve, Milan,
April – May 1994 [no cat.]

Lambert, *Twombly*, 1979, cat. no. 199,
repr. p. 182

cat. 261
Ramsés
1980
Crayon, pencil, charcoal and oil on paper
76 x 57 (30 x 22)
recto 'Ramsés' and verso 'Ramsés Cy Twombly
80'

Provenance
Yvon Lambert, Paris
Gagosian Gallery, New York
acquired 1994

Exhibitions and Literature
Lambert, *Twombly*, 1991, cat. no. 112,
repr. p. 115

cat. 262
Untitled (Bassano in Teverina)
1981
Oil and crayon on paper
100.4 x 69.8 (39 1/2 x 27 1/2)

Provenance
Sperone Westwater Fischer, New York
Mr. and Mrs. Ira Young, California
Heiner Bastian Fine Art, Berlin
acquired 1994

Exhibitions and Literature
New York 1982, cat. no. V, repr.

Lambert, *Twombly*, 1991, cat. no. 132,
repr. p. 126 [under the title 'Sans Titre (Bassano
été 1981)']

cat. 263, ill. pp. 192–3
Naxos
1982
Paint stick, acrylic, pastel and pencil on paper
three parts, overall 174.7 x 338.5
(overall 68 3/4 x 133 3/4)
recto t. l. on middle sheet 'CY Mar 82 Naxos'

Provenance
Sperone Westwater Fischer, New York
Mr. and Mrs. Graham Gund, New York
Anthony d'Offay Gallery, London
acquired 1993

Exhibitions and Literature
Chia, Cucchi, Lichtenstein, Twombly, Sperone
Westwater Fischer, New York 1982–3 (no cat.)
*Brave New Works: Recent American Painting
and Drawing*, Museum of Fine Arts, Boston,
1983–4
10 Painters, Boston 1984, cat. no. 54
Boston Collects, Boston 1986 – 7, cat. no. 86,
repr. p. 115
New York 1994, cat. no. 89, repr. p. 142
Berlin 1995, cat. no. 89, repr. p. 154

Lambert, *Twombly*, 1991, cat. no. 170,
repr. p. 161

ANDY WARHOL
born 1928 in Pittsburgh, Pennsylvania
died 1987 in New York

Bibliography
Turin 1965
 Warhol, exh. cat. Galleria Gian Enzo Sperone
 Arte Moderna, Turin, Feb. 1965 [leaflet]
Herzka, *Pop Art One*, 1965
 Dorothy Herzka, *Pop Art One*, New York
 1965
Stockholm 1968
 Andy Warhol, exh. cat. Moderna Museet,
 Stockholm, Feb. – March 1968
Ströher Collection, Munich 1968
 Karl Ströher Collection, exh. cat. Neue
 Pinakothek, Munich 1968
Ströher Collection, Berlin 1969
 Karl Ströher Collection, exh. cat. National-
 galerie Berlin, 1969; Städtische Kunsthalle,
 Düsseldorf 1969; et al.
Coplans, *Warhol*, 1970
 John Coplans, *Andy Warhol*, New York 1970
 [used as a catalogue for the touring exhibition
 for Pasadena, Chicago and New York, 1970,
 together with the corresponding index of
 exhibits]
Crone, *Warhol*, 1970
 Rainer Crone, *Andy Warhol*, Stuttgart 1970
 [English edition: London 1970]
Eindhoven 1970
 John Coplans (ed.), *Andy Warhol*, exh. cat.
 Stedelijk van Abbemuseum, Eindhoven, Oct.
 – Nov. 1970 [touring exhibition, start:
 Pasadena 1970]
London 1971
 Richard Morphet (ed.), *Warhol*, exh. cat. Tate
 Gallery, London, Feb. – March, 1971 [touring
 exhibition, start: Pasadena 1970]
Ströher Collection, Darmstadt 1970
 *Bildnerische Ausdrucksformen 1960 – 1970.
 Karl Ströher Collection*, exh. cat. Hessisches
 Landesmuseum, Darmstadt 1970
Basle 1972
 *Andy Warhol. Zehn Bildnisse von Mao Tse-
 Tung*, exh. cat. Kunstmuseum Basel, Oct. –
 Nov. 1972
Baltimore 1975
 Andy Warhol: Paintings 1962 – 1975,
 exh. cat. Baltimore Museum, July – Sept.
 1975 [leaflet]
Sperone, Rome 1975
 Jim Dine, Roy Lichtenstein, Morris Louis,
 Michelangelo Pistoletto, Robert
 Rauschenberg, Mario Schifano, Frank Stella,
 Cy Twombly, Andy Warhol, coll. cat. Galleria
 Gian Enzo Sperone, Rome/Turin 1975
Stuttgart 1976
 *Andy Warhol. Das zeichnerische Werk 1942
 – 1975*, exh. cat. Württembergischer
 Kunstverein, Stuttgart, Feb. – March 1976;
 Städtische Kunsthalle Düsseldorf, April – May
Seattle 1976
 Andy Warhol. Portraits, exh. cat. Seattle Art
 Museum, Nov. 1976 – Jan. 1977; Denver Art
 Museum, Feb. – April 1977

Crone, *Das bildnerische Werk*, 1976
 Hans Rainer Crone, *Das bildnerische Werk
 Andy Warhols*, Berlin 1976
Amerikanische Kunst, Berlin 1976
 Dieter Honisch and Jens Christian (eds.),
 Amerikanische Kunst von 1945 bis heute,
 Jensen, exh. cat. Nationalgalerie Berlin, 1976;
 Cologne 1976
America, America, Basle 1976
 America, America, exh. cat. Galerie Beyerle,
 Basle 1976
Zurich 1978
 Andy Warhol, exh. cat. Kunsthaus Zürich,
 May – July 1978
Humlebaek 1978
 Andy Warhol, exh. cat. Humlebaek Museum,
 Louisiana, Oct. – Nov. 1978
Hanover 1981
 Andy Warhol. Bilder 1961 bis 1981, exh. cat.
 Kestner-Gesellschaft, Hanover, Oct. – Dec.
 1981
Amerikanische Malerei, Munich 1981
 Amerikanische Malerei 1930 – 1980, exh.
 cat. Haus der Kunst, Munich 1981
Pohl et al., *Karl Ströher*, 1982
 Erika Pohl, Ursula Ströher and Gerhard Pohl
 (eds.), *Karl Ströher. Sammler und Sammlung*,
 Stuttgart 1982
Hamburg 1987
 Karl-Egon Vester (ed.), *Andy Warhol. 'Ich
 erkannte, daß alles, was ich tue, mit dem Tod
 zusammenhängt.'*, exh. cat. Kunstverein
 Hamburg, Oct. – Dec. 1987
Edelman Collection, Zurich 1987
 *Impressionist and 20th Century Masters.
 Ausgewählte Werke aus der Sammlung von
 Asher B. Edelman*, exh. cat. Thomas Ammann
 Fine Art, Zurich 1987
Houston 1988
 Andy Warhol. Death and Disasters, exh. cat.
 The Menil Collection, Houston, Oct. 1988 –
 Jan. 1989
Schellmann, *Warhol. Prints*, 1989
 Frayda and Jörg Schellmann (ed.),
 Andy Warhol. Prints. A Catalogue Raisonné,
 Munich/New York 1989
New York 1989
 Kynaston McShine (ed.), *Andy Warhol.
 A Retrospective*, exh. cat. Museum of Modern
 Art, New York, Feb. – May 1989; Hayward
 Gallery, London, Sept. – Nov. 1989; et al.
 (German edition: *Andy Warhol. Retrospek-
 tive*, exh. cat. Museum Ludwig, Cologne,
 Nov. 1989 – Feb. 1990; Danish edition: *Andy
 Warhol. A Retrospective*, exh. cat. Louisiana
 Museum, Humlebaek Sept. 1990)
Hackett, *Diaries*, 1989
 Pat Hackett (ed.), *The Andy Warhol Diaries*,
 London/Sydney/New York/Tokyo/Toronto
 1989 (German edition: Munich 1989)
Honnef, *Warhol*, 1989
 Klaus Honnef, *Andy Warhol 1928 – 1987.
 Kunst als Kommerz*, Cologne 1989
Osterwold, *Pop Art*, 1989
 Tilmann Osterwold, *Pop Art*, Cologne 1989
Tokio, 1990
 Andy Warhol, Tokio 1990
Inboden, *White Disaster I*, 1992
 Gudrun Inboden, *Andy Warhol – White
 Disaster I 1963*, Staatsgalerie Stuttgart,
 Werkstudien vol. 2, Stuttgart 1992

Zurich 1992
 Andy Warhol. Works of the Sixties, exh. cat.
 Galerie Bischofberger, Zurich, Nov. 1992 –
 April 1993
The Readymade Boomerang, Sydney 1990
 *The Readymade Boomerang. Certain
 Relations in 20th Century Art*, exh. cat.
 The Eighth Biennale of Sydney, 1990
Das goldene Zeitalter, Stuttgart 1991
 *Das goldene Zeitalter. Die Geschichte des
 Goldes vom Mittelalter zur Gegenwart*, exh.
 cat. Württembergischer Kunstverein, Stuttgart
 1991; parts of the exhibition: Goldzeit?, BAT
 KunstFoyer, Hamburg, April – Mai 1992
 [same catalogue]
Romain, *Warhol*, 1993
 Lothar Romain, *Andy Warhol*, Munich 1993
Hamburg 1993
 Andy Warhol. Retrospektiv, exh. cat.
 Deichtorhallen Hamburg, July – Sept. 1993;
 Württembergischer Kunstverein, Stuttgart,
 Nov. 1993 – Feb. 1994
Ratcliff, *Warhol*, 1993
 Carter Ratcliff, *Andy Warhol*, New York 1993
Amerikanische Kunst, Berlin 1993
 *Amerikanische Kunst im 20. Jahrhundert.
 Malerei und Plastik 1913 – 1993*, exh. cat.
 Martin-Gropius-Bau, Berlin 1993, Munich
 1993; Royal Academy of Arts and The Saatchi
 Gallery, London 1993; et al. [English edition:
 *American Art in the 20th Century. Painting
 and Sculpture 1913 – 1993*, London 1993]
Cézanne, Tübingen 1993
 Götz Adriani (ed.), *Cézanne. Gemälde*, exh.
 cat. Kunsthalle Tübingen, 1993; Cologne
 1993
Pittsburgh, 1994
 The Andy Warhol Museum, coll. cat. The
 Andy Warhol Museum, Pittsburgh 1994; New
 York/Stuttgart 1994
Lucerne 1995
 Andy Warhol. Paintings 1960 – 1986, exh.
 cat. Kunstmuseum Luzern, July – Sept. 1995;
 Stuttgart 1995
Art of the Sixties, Tokio 1995
 *Revolution: Art of the Sixties. From Warhol to
 Beuys*, exh. cat. Museum of Contemporary
 Art, Tokyo 1995
30 jahre (op) art, Esslingen 1995
 *30 jahre (op) art galerie esslingen. Galerie
 Hans Mayer Düsseldorf*, exh. cat. Villa
 Merkel, Galerie der Stadt Esslingen, 1995
London 1995
 *Andy Warhol. Vanitas: Skulls and Self-
 Portraits 1976 – 1986*, Anthony d'Offay
 Gallery, London, Nov. 1995 – Jan. 1996
 [leaflet]

cat. 264, ill. p. 218
Christine Jorgenson
1956
Gold leaf and ink on paper
32.9 x 40.7 (13 x 16)
b. l. 'Christine Jorgenson Andy Warhol'

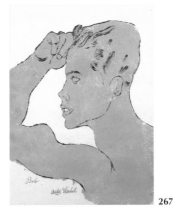

267

274

Provenance
Heiner Friedrich, Munich
E. A. Mosel Collection, Munich
Kunsthaus Lempertz, Cologne, Auktion Moderne
Kunst, 3.12.1993, Auction 699, Lot 1068
acquired 1993

Exhibitions and Literature
Stuttgart 1976, cat. no. 219, repr. p. 165

Kunsthaus Lempertz, auct. cat. 699, Cologne
1993, Lot 1068, repr. p. 135

cat. 265
Fidelma
1956
Gold leaf and ink on paper
21.6 x 28.6 (8 1/2 x 11 1/4)
recto b. r. 'Fidelma Andy Warhol'

Provenance
Matthew Marks Gallery, New York 1992
acquired 1992

cat. 266
Mrs. Richard R.
1956
Gold leaf and ink on paper
21.7 x 29 (8 1/2 x 11 1/4)
recto b. m. 'Mrs. Richard R. Andy Warhol'

Provenance
Matthew Marks Gallery, New York
acquired 1992

cat. 267
Bob
c. 1957
Gold leaf and ink on paper
50.8 x 38 (20 x 15)
b. l. 'Bob Andy Warhol'

Provenance
Matthew Marks Gallery, New York
acquired 1992

cat. 268, ill. p. 218
Golden Nude
1957
Gold leaf and ink on paper
44.4 x 29.2 (17 1/2 x 11 1/2)
b. m. 'Andy Warhol'

Provenance
Ferris Cordner, Minneapolis
Sotheby's New York, 2.5.1985, Sale 5316,
Lot 119
acquired 1985

Exhibitions and Literature
Stuttgart 1976, cat. no. 215, repr. p. 162
New York 1989, cat. no. 42, repr. p. 109
Das goldene Zeitalter, Stuttgart 1991, p. 75
Goldzeit?, BAT KunstFoyer, Hamburg 1992
[no cat.]

Sotheby's New York, auct. cat. Sale 5316, 1985,
Lot 119, repr.
Romain, *Warhol,* 1993, cat. no. 13, repr. p. 28

cat. 269, ill. p. 219
Helena Rubinstein
1957
Gold leaf and ink on paper
73 x 58 (28 3/4 x 22 7/8)
b. r. 'Andy Warhol'

Provenance
Galerie Holtmann, Cologne
acquired 1983

Exhibitions and Literature
Das goldene Zeitalter, Stuttgart 1991, p. 74
Goldzeit?, BAT KunstFoyer, Hamburg 1992
[no cat.]

cat. 270
Male
c. 1957
Gold leaf and ink on paper
50.8 x 40.6 (20 x 16)
recto b. r. 'Andy Warhol'

Provenance
The Estate of Andy Warhol, New York
Galerie Thaddaeus Ropac, Salzburg/Paris
acquired 1994

Exhibitions and Literature
New York 1989, cat. no. 60, repr. p. 113

cat. 271, ill. p. 219
Seated Male
c. 1957
Gold leaf and ink on paper
50.8 x 38.2 (20 x 15)
recto b. r. 'Andy Warhol'

Provenance
The Andy Warhol Foundation for the Visual Arts,
New York
acquired 1994

cat. 272
Unknown Male
c. 1957
Gold leaf and ink on paper
58.4 x 37.8 (23 x 14 7/8)

Provenance
The Andy Warhol Foundation for the Visual Arts,
New York
acquired 1994

cat. 273, ill. p. 219
Young Boy Dreaming
1957
Gold leaf and ink on paper
47.3 x 35.2 (18 5/8 x 13 7/8)
recto b. r. 'Andy Warhol'

Provenance
John Butler, New York
Rainer Crone, Munich
acquired 1994

Exhibitions and Literature
Stuttgart 1976, [not in cat.]
Das Goldene Zeitalter, Stuttgart 1991,
repr. p. 73

cat. 274
40 Two Dollar Bills
1962
Silkscreen and pencil on primed canvas
210.5 x 48.2; (83 x 19)
verso t. r. on canvas 'Andy Warhol 62'

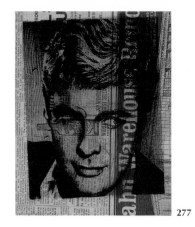 **277**

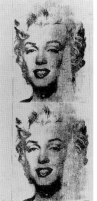 **278**

Provenance
Stable Gallery, New York
William A. M. Burden & Co., New York
John W. M.Good, New York
Sotheby's New York, 10.11.1988, Sale 5773,
Lot 63
Wendy Burden, New York
Leo Castelli Gallery, New York
acquired 1993

Exhibitions and Literature
Stockholm 1968, repr. unpag.
Art of the Sixties, Tokyo 1995, cat. no. 154,
repr. p. 272

Coplans, *Warhol,* 1970, repr. p. 37
Crone, *Warhol,* 1970, cat. 544, repr. p. 267
London 1971, repr. 12, p. 27 [not exh.]
Crone, *Das bildnerische Werk,* 1976, cat. no.
895, p. 386
Sotheby's New York, auct. cat. Sale 5773, 1988,
Lot 63, repr.

Extended loan to Staatsgalerie Stuttgart,
May 1993 – Aug. 1995

cat. 275, ill. p. 195
Campbell's Soup Can (Vegetable)
1962
Acrylic and pencil on primed canvas
50.8 x 40 (20 x 15 3/4)
verso 'Andy Warhol 62'

Provenance
Stable Gallery, New York
Gian Enzo Sperone, Rome
Heiner Bastian, Berlin
acquired 1985

Exhibitions and Literature
Sperone, Rome 1975, repr. unpag.
Baltimore 1975, cat. no. 3
Art of the Sixties, Tokyo 1995, cat. no. 152,
repr. p. 270

Crone, *Warhol,* 1970, cat. no. 462, p. 305
Crone, *Das bildnerische Werk,* 1976, cat. no.
811, p. 380

Extended loan to Staatsgalerie Stuttgart since
March 1992

cat. 276, ill. p. 196
Gold Marilyn
1962
Silkscreen and gold paint on primed canvas
two parts, diameter each 45.3 (diameter each
17 7/8)
each verso stamp of authenticity of the Estate of
Andy Warhol

Provenance
Fredrick W. Hughes, New York
Sotheby's New York, 3.5.1993, Sale 6454,
Lot 19
Matthew Marks Gallery, New York
acquired 1994

Exhibitions and Literature
Zurich 1978, cat. no. 37, repr. p. 79
[only Marilyn tondo]
Humlebaek 1978, cat. no. 6, repr. back of book
jacket
New York 1989, cat. no. 200, repr. p. 212
Das goldene Zeitalter, Stuttgart 1991,
repr. p. 544
Zurich 1992, cat. no. 15
Hamburg 1993, repr. 26
Lucerne 1995, cat. no. 9, p. 91

Sotheby's New York, auct. cat. Sale 6454, 1993,
Lot 19, repr.

cat. 277
Single Troy
1962
Unique silkscreen on newspaper mounted on
canvas
27 x 21.3 (10 5/8 x 8 3/4)
signed verso r. 'Andy Warhol'[in another hand]
and verso m. 'trial proof struck off on newsprint
of Andy Warhol Portrait of Troy Donahue
picked up from the fire house studio floor –
before "The Factory". Nathan Gluck' and verso
t. a glued-on newspaper cutting 'The Pittsburgh
Press, Wednesday, August 1, 1962'

Provenance
Nathan Gluck, New York
Christie's New York, 18.5.1979, Alexander,
Lot 67
Peter G. Buchholz, New York
Dietmar Werle, Cologne
acquired 1984

Exhibitions and Literature
Pittsburgh 1994 [not in cat.]

Crone, *Warhol,* 1970, cat. no. 602, repr. p. 272
Crone, *Das bildnerische Werk,* 1976, cat. no.
955, p. 393
Christie's New York, auct. cat. Alexander, 1979,
Lot 67, repr.
Sotheby's New York, auct. cat. Sale 4957, 1982,
Lot 66, repr.

Extended loan to the Andy Warhol Museum,
Pittsburgh, to June 1996

cat. 278
Two Marilyns
1962
Silkscreen and pencil on primed canvas
74.5 x 36.2 (29 1/4 x 14 1/8)
verso b. r. on Overlap 'Andy Warhol 2' [first
digit illegible]

Provenance
Marx Collection, Berlin
Heiner Bastian, Berlin
acquired 1985

Exhibitions and Literature
Lucerne 1995, cat. no. 8, p. 90

Inboden, *White Disaster I,* Stuttgart 1992,
repr. p. 22

Extended loan to Staatsgalerie Stuttgart, March
1992 – Aug. 1995

cat. 279, ill. p. 198
Double Silver Disaster
1963
Silkscreen, pencil and synthetic polymer on pri-
med canvas
104 x 133.7 (41 x 52 5/8)
verso t. on Overlap 'Andy Warhol 1964 Andy
Warhol' [signed later]

Provenance
Robert Graham Collection, California
Galerie Springer, Berlin
Sotheby's London, 3.4.1974, Sale without no.,
Lot 37
Galerie Zwirner, Cologne
acquired 1984

Exhibitions and Literature
Hamburg 1987, cat. no. 10, repr. p. 29
The Readymade Boomerang, Sydney 1990,
cat. no. 471,
repr. p. 21
Lucerne 1995, cat. no. 19, repr. p. 97

Sotheby's London, auct. cat., 1974, Lot 37,
repr. unpag.
Honnef, *Warhol,* 1989, repr. p. 61
Osterwold, *Pop Art,* 1989, repr. p. 177

Extended loan to Staatsgalerie Stuttgart, March
1992 – Aug. 1995

cat. 280, ill. p. 197
Five Deaths
1963
Silkscreen and acrylic on primed canvas
76.4 x 76.4 (30 x 30)
verso l. on overlap 'Andy Warhol with love to
Todd Brassner' and verso t. on overlap
'Andy Warhol Andy Warhol 62'

Provenance
Stable Gallery, New York
Galerie Ileana Sonnabend, Paris
Todd Brasner, New York
Gagosian Gallery, New York
Douglas Cramer, Los Angeles
Stellan Holm, New York
Sotheby's New York, 18.11.1992, Sale 6364,
Lot 145
acquired 1992

Exhibitions and Literature
Houston 1988, cat. no. 7, repr. p. 58
New York 1989, cat. no. 263, repr. p. 258
Art of the Sixties, Tokyo 1995, cat. no. 155,
repr. p. 273

Crone, *Warhol,* 1970, cat. no. 319, repr. p. 185
Crone, *Das bildnerische Werk,* 1976, cat. no.
757, p. 374
Sotheby's New York, auct. cat. Sale 6364, 1992,
Lot 145, repr.

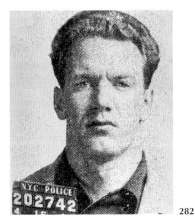
282

cat. 281, ill. p. 200
Liz
1963
Silkscreen, acrylic and synthetic polymer on primed canvas
101.5 x 101.5 (40 x 40)

Provenance
Leo Castelli, New York
Galleria Gian Enzo Sperone, Turin
Gian Maria Pellion di Persano Collection, Turin
Sotheby's New York, 30.4.1991, Sale 6164, Lot 18 A
Arnold Forde, Laguna Beach
Gagosian Gallery, New York
acquired 1994

Exhibitions and Literature
Andy Warhol, Pasadena Art Museum, May – June 1970, cat. no. [index of exhibits; Crone, *Warhol,* acts as catalogue for this exhibition];
Museum of Contemporary Art, Chicago, July – Sept. 1970 [Crone, *Warhol,* acts as catalogue for this exhibition]
Eindhoven 1970, cat. no 90, repr. p. 87
Musée d'art moderne de la ville de Paris, Paris 1970, cat. no. 18 [index of exhibits; Coplans, *Warhol,* 1970, acts as catalogue for this exhibition]
London 1971, cat. no. 25, repr. back of book jacket
Whitney Museum of American Art, New York 1971 [no cat.]
Galleria Gallatea, Turin, 1972, cat. no. 12
Lucerne, 1995, cat. no. 41, p. 119

Coplans, *Warhol,* 1970, repr. p. 87
Crone, *Warhol,* 1970, cat. no. 94, p. 290
Crone, *Das bildnerische Werk,* 1976, cat. no. 103, p. 334
Sotheby's New York, auct. cat. Sale 6164, 1991, Lot 18 A, repr.

cat. 282
Most Wanted Men No. 6, Thomas Francis C. (Front View)
1963
Silkscreen on primed canvas
120.3 x 100.3 (47 3/8 x 39 1/2)
verso t. r. on overlap 'Andy Warhol'

Provenance
Ileana Sonnabend, New York
Timothy Baum, New York
Galerie Zwirner, Cologne
Onnasch Collection, Berlin
Sotheby's London, 3.4.1974, Sale without no., Lot 79
Gian Enzo Sperone, Rome
Sperone Westwater Gallery, New York
acquired 1987

Exhibitions and Literature
Hanover 1981, repr. 13, p. 9
Lucerne 1995, cat. no. 30, p. 115

Crone, *Warhol,* 1970, cat. no. 398, p. 302
Crone, *Das bildnerische Werk,* 1976, cat. no. 715, p. 369
Sotheby's London, auct. cat. Sale without no., 1974, Lot 79, repr. unpag.

Extended loan to Staatsgalerie Stuttgart, March 1992– Aug. 1995

cat. 283, ill. p. 199
Red Jackie
1963
Silkscreen and acrylic on canvas
101.5 x 101.5 (40 x 40)

Provenance
Leon Kraushaar, Long Island
Ströher Collection, Darmstadt
Ursula Ströher, Darmstadt
Sotheby's New York, 2.5.1989, Sale 5844, Lot 8
Perry Rubenstein, New York
Sotheby's New York, 13.11.1991, Sale 6236, Lot 42
Thomas Ammann Fine Art, Zurich
acquired 1994

Exhibitions and Literature
Ströher Collection, Munich 1968, cat. no. 142, repr.
Ströher Collection, Berlin 1969, cat. no. 71, repr.
Ströher Collection, Darmstadt 1970, repr. p. 463
Amerikanische Kunst, Berlin 1976, p. 181
Hanover 1981, cat. no. 9, repr. p. 132
Amerikanische Malerei, Munich 1981, cat. no. 159, repr.
Lucerne 1995, cat. no. 22, p. 95

Herzka, *Pop Art One,* 1965, repr. 26
Crone, *Warhol,* 1970, cat. no. 102, repr. p. 126
Crone, *Das bildnerische Werk,* 1976, cat. 111, p. 335
Pohl et al., *Karl Ströher,* 1982, cat. no. 611, repr. p. 237
New York 1989, cat. no. 250, repr. p. 244 [not exh.]
Sotheby's New York, auct. cat. Sale 5844, 1989, Lot 8, repr.
Sotheby's New York, auct. cat. Sale 6236, 1991, Lot 42, repr.

cat. 284, ill. p. 201
Tunafish Disaster
1963
Silkscreen and synthetic polymer on primed canvas
114.9 x 200 (45 1/4 x 78 3/4)
verso b. m. on overlap 'Mrs. Brown + Mrs. McArthy' [sic]

Provenance
Stable Gallery, New York
Galerie Ileana Sonnabend, Paris
Galleria Gian Enzo Sperone, Turin
Galleria Apollinaire, Milan
Sotheby's London, 28.6.1995, Sale 5380, Lot 40
acquired 1995

Exhibitions and Literature
Turin 1965, repr. unpag.
Andy Warhol, Pasadena Art Museum, May – June 1970, cat. no. 41 [index of exhibits; Coplans, *Warhol,* 1970, acts as catalogue for this exhibition];

Museum of Contemporary Art, Chicago, July – Sept. 1970 [Crone, *Warhol,* acts as catalogue for this exhibition]
Eindhoven 1970, repr. p. 107
Musée d'art moderne de la ville de Paris, Paris 1970, cat. no. 80 [index of exhibits, no cat.]
London 1971, cat. no. 101, repr. p. 77
Whitney Museum of American Art, New York 1971 [Coplans, *Warhol,* 1970, acts as catalogue for this exhibition]
Biennale di Venezia, 1978, cat. 172
Art of the Sixties, Tokyo 1995, cat. no. 156, repr. p. 273

Coplans, *Warhol,* 1970, repr. p. 107
Crone, *Warhol,* 1970, cat. no. 430, repr. p. 234
Sotheby's London, auct. cat. Sale 5380, 1995, Lot 40, repr. p. 83

cat. 285, ill. p. 217
Cagney
1964
Silkscreen on paper mounted on canvas
76 x 101.5 (30 x 40)
verso b. l. 'Andy Warhol' b. '2' [in a circle]
2/5

Provenance
Private collection, New York
Sotheby's New York, 18.11.1989, Sale 5935, Lot 1308
Susan Sheehan Gallery, New York
acquired 1995

Exhibitions and Literature
Crone, *Warhol,* 1970, cat. no. 606

Sotheby's New York, auct. cat. Sale 5935, 1989, Lot 1308
Schellmann, *Warhol. Prints,* 1989, p. 132

cat. 286, ill. p. 202
Double Elvis
1964
Silkscreen and synthetic polymer on primed canvas
207 x 208.3 (84 1/2 x 82)

Provenance
Leo Castelli, New York
Tom Benenson, New York
OK Harris Gallery, New York
Galerie De Gestlo, Hamburg
Rolf Meyer Werner, Caracas
Galerie Rudolf Zwirner, Cologne
Asher Edelman, New York
Gagosian Gallery, New York
Private collection, New York
Gagosian Gallery, New York
acquired 1994

Exhibitions and Literature
Edelman Collection, Zurich 1987, cat. no. 9, repr.
28th Annual SCA Exhibition, Art Institute of Chicago, [no cat.]

Crone, *Warhol,* 1970, cat. no. 146, repr. p. 141 [in the English edition under the title 'Elvis III']
Crone, *Das bildnerische Werk,* 1976, cat. no. 163, p. 342

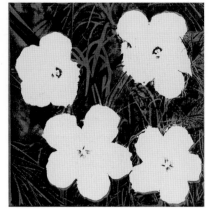

cat. 287, ill. p. 203
Early Self
1964
Silkscreen, synthetic polymer and acrylic on primed canvas
50.8 x 41 (20 x 16 1/8)
verso t. l. on overlap ' Andy Warhol 6'
[second digit illegible]

Provenance
Fred Hughes, New York
Renée Lachowsky, Brussels
Wolf Weitzdörfer, Cologne
Van den Bosch, Antwerp
Sotheby's London, 30.11.1994, Sale 4712, Lot 4
acquired 1994

Exhibitions and Literature
Lucerne 1995, cat. no. 28, p. 111

Crone, *Warhol,* 1970, cat. no. 171, p. 294 [in the English edition under the title 'Self Portrait']
Crone, *Das bildnerische Werk,* 1976, cat. no. 331, p. 348
Sotheby's London, auct. cat. Sale 4712, 1994, Lot 4, repr. p. 17 [under the title 'Self Portrait']

cat. 288, ill. p. 204
Flowers
1964
Silkscreen and acrylic on primed canvas
121.9 x 121.9 (48 x 48)
verso on overlap 'Andy Warhol 64'

Provenance
Ileana Sonnabend, Paris
Mr. E.J. Power, London
Mrs. Janet McIntyrne, London
Waddington Galleries, London
acquired 1994

cat. 289
Flowers
1964
Silkscreen, pencil and acrylic on primed canvas
121.9 x 121.9 (48 x 48)
verso t. r. on overlap 'Andy Warhol 64'

Provenance
Leo Castelli, New York
Warren Woodward Foundation
Galerie Bischofberger, Zurich
Galerie Rudolf Zwirner, Cologne
acquired 1985

Exhibitions and Literature
Hamburg 1987, cat. no. 12, repr. p. 28

Crone, *Warhol,* 1970, cat. no. 561, p. 308
Crone, *Das bildnerische Werk,* 1976, cat. no. 912, p. 389
Inboden, *White Disaster I,* 1992, repr. p. 18

cat. 290
Gold Jackie
1964
Silkscreen and gold paint on primed canvas
two parts, diameter each 45.1 (diameter each 17 3/4)

Provenance
Fredrick W. Hughes, New York
Matthew Marks Gallery, New York
acquired 1994

Exhibitions and Literature
Lucerne 1995, cat. no. 27, p. 116

cat. 291, ill. p. 206
Jackie
1964
Silkscreen on primed canvas
50.8 x 40.6 (20 x 16)

Provenance
Leo Castelli, New York
S. C. Burden, New York
Leo Castelli, New York
acquired 1994

Exhibitions and Literature
Baltimore 1975, cat. no. 15 or 16 [not clearly identifiable]
Birmingham, 1976 [no cat.]
Seattle 1976
Andy Warhol. Genesis of an Installation, Baghoomian Gallery, New York, April 1988 [no cat.]
Art of the Sixties, Tokyo 1995, cat. no. 158, repr. p. 274

Zurich 1978, repr. p. 97 [not exh.]

cat. 292, ill. p. 205
Little Race Riot
1964
Silkscreen and synthetic polymer on primed canvas
75.9 x 83.8 (29 7/8 x 33)
signed on overlap

Provenance
I. Pousette, Stockholm
Christie's London, 2.7.1992, Sale 4798, Lot 56
Ronald S. Lauder, New York
Gagosian Gallery, New York
Douglas S. Cramer, Los Angeles
Gagosian Gallery, New York
acquired 1995

Exhibitions and Literature
Humlebaek 1990, cat. no. 30, repr. p. 21

Crone, *Warhol,* 1970, cat. no. 420
Christie's London, auct. cat. Sale 4798, 1992, Lot 56, repr. p. 87

cat. 293, ill. p. 207
Marlon
1966
Silkscreen on canvas
104.1 x 116.8 (41 x 46)
verso r. and l. stamp of authenticity of the Estate of Andy Warhol, A 982.101, and twice 'VF' [Vincent Fremont]

Provenance
Father Canty, New York
James Corcoran Gallery, Los Angeles
Gagosian Gallery, New York
acquired 1992

Exhibitions and Literature
Seattle 1976
Art of the Sixties, Tokyo 1995, cat. no. 160, repr. p. 275

Extended loan to Staatsgalerie Stuttgart since Jan. 1993

cat. 294, ill. p. 208
Big Electric Chair
1967
Silkscreen and acrylic on primed canvas
137.2 x·185.5 (54 x 73)

Provenance
Leo Castelli, New York
Thordis Moeller, New York
Heiner Friedrich, New York
acquired 1985

Exhibitions and Literature
Hamburg 1987, cat. no. 20, repr. p. 32
Amerikanische Kunst, Berlin 1993, cat. no. 187, repr. unpag.
Lucerne 1995, cat. no. 43, p. 120

Crone, *Warhol,* 1970, cat. no. 382, p. 301 [in the English edition under the title 'Big Electric Chair']
Crone, *Das bildnerische Werk,* 1976, cat. no. 699, p. 367

Extended loan to Staatsgalerie Stuttgart, March 1992 – April 1993 and since Jan. 1994

cat. 295, ill. p. 209
Self-Portrait
1967
Silkscreen and acrylic on primed canvas
182.8 x 183 (72 x 72 1/8)

Provenance
Leo Castelli, New York
Mitchell Hutchins Inc., New York
Alfred Taubman, New York
Sotheby's Reno, private sale
acquired 1994

Exhibitions and Literature
London 1971, cat. no. 66
America, America, Basle 1976, cat. no. 79
Andy Warhol, Pasadena Art Museum, May – June 1970, [index of exhibits; Coplans, *Warhol,* 1970, acts as catalogue for this exhibition];

300

303

Museum of Contemporary Art, Chicago, July –
Sept. 1970 [Coplans, *Warhol*, 1970, acts as cata-
logue for this exhibition]
Eindhoven 1970, cat. no. 137
Musée d'art moderne de la ville de Paris, Paris
1970, [index of exhibits; no cat.]
London 1971, cat. no. 65
Whitney Museum of American Art, New York
1971 [Crone, *Warhol*, acts as catalogue for this
exhibition]
Lucerne 1995, cat. no. 47, p. 123, repr. book
jacket

cat. 296
Dennis Hopper
1971
Silkscreen and acrylic on primed canvas
101.5 x 102 (40 x 40 1/8)
verso t. r. on canvas 'Andy Warhol 5/5 71'

Provenance
Richard Feigen Gallery, New York
James J. Meeker, Texas
The Hon. James Dugdale, London and Nigel
Greenwood Inc., London
Benjamin Rhodes Gallery, London
acquired 1993

Exhibitions and Literature
New York 1989, cat. no. 328, repr. p. 312
Lucerne 1995, cat. no. 50, p. 125

cat. 297, ill. p. 210
Mao
1972
Silkscreen, pencil and acrylic on primed canvas
207.7 x 141.7 (81 3/4 x 55 3/4)
verso on canvas b. r. 'Andy Warhol'

Provenance
Galerie Ileana Sonnabend, Paris
Gian Enzo Sperone, Turin
Heiner Bastian, Berlin
acquired 1985

Exhibitions and Literature
Basle 1972, cat. no. 2, repr. unpag.
New York 1989, cat. no. 352, repr. 335
Lucerne 1995, cat. no. 52, p. 126

Crone, *Das bildnerische Werk*, 1976, cat. no.
183, p. 346

cat. 298, ill. p. 211
Hammer and Sickle
1976
Silkscreen and acrylic on primed canvas
183 x 219 (72 x 86)
verso t. l. 'Andy Warhol'

Provenance
Jonny Reinhold, New York
Joshua Mack, New York
acquired 1991

cat. 299, ill. p. 212
Skull
1976
Silkscreen and acrylic on primed canvas
183.5 x 203.8 (72 1/4 x 80 1/4)
verso t. r. on overlap 'Andy Warhol'

Provenance
Julian Schnabel, New York
Bruno Bischofberger, Zurich
acquired 1992

Exhibitions and Literature
Lucerne 1995, cat. no. 57, p. 137
London 1995, unpag.

Cézanne, Tübingen 1993, repr. 2, p. 256

cat. 300
Oxidation Painting
1978
Urine and copper paint on canvas
193 x 132 (76 x 52)

Provenance
Gagosian Gallery, New York
acquired 1987

Exhibitions and Literature
Andy Warhol. Oxidation Paintings 1978,
Gagosian Gallery, New York, 1986 [no cat.]

cat. 301, ill. p. 213
Diamond Dust Shoes
1980
Silkscreen, diamond dust and acrylic on primed
canvas
178 x 228 (70 x 90)

Provenance
Leo Castelli, New York
acquired 1992

cat. 302, ill. on cover
Joseph Beuys
1980
Silkscreen and gold paint on primed canvas
50.8 x 40.6 (20 x 16)
verso t. r. on Overlap 'A D Andy Warhol 80'

Provenance
Private collection, London
Anthony d'Offay Gallery, London
acquired 1992

Exhibitions and Literature
30 jahre (op) art, Esslingen 1995 [not in cat.]

cat. 303
Gun
1981
Silkscreen and acrylic on primed canvas
177.8 x 228.6 (70 x 90)

Provenance
Leo Castelli, New York
Galerie Paul Maenz, Cologne
Galerie Thaddaeus Ropac, Paris
Andy Warhol Foundation, New York
Edward Thorp Gallery, New York
acquired 1995

Exhibitions and Literature
New Dimensions, Akron Art Museum, Ohio
1985 [no cat.]
*Andy Warhol. Paintings 1962–1985 and early
prints*, Galerie Paul Maenz, Cologne,
Dec. 1985 – Jan. 1986 [no cat.]
Warhol, Galerie Thaddaeus Ropac, Salzburg
1987 [no cat.]
Houston 1988, repr. p. 23

Honnef, *Warhol*, 1989, repr. p. 83
Ratcliff, *Warhol*, 1993, cat. 97, repr. p. 101

cat. 304, ill. p. 214
Goethe
1982
Silkscreen on canvas
200 x 210 (78 3/4 x 82 3/4)
verso b. l. 'Andy Warhol 82'

Provenance
Galerie Hans Meyer, Düsseldorf
acquired 1986

Exhibitions and Literature
30 jahre (op) art, Esslingen 1995 [not in cat.]

cat. 305, ill. p. 230
J.W. Froehlich
1986
Silkscreen and acrylic on primed canvas
three parts, each 101.6 x 101.6 (each 40 x 40)
1: verso t. l. 'Andy Warhol 86' and verso t. m.
'Andy Warhol 86'
2: verso t. m 'Andy Warhol'
3: verso t. l. 'I certify this painting to be an origi-
nal Andy Warhol completed in 1986
Frederick Hughes l'

Provenance
Parts 1 + 2 (blue and blue/grey): Anthony
d'Offay, London
acquired 1986
Part 3 (grey): Andy Warhol Foundation,
New York
acquired 1987

Exhibitions and Literature
30 jahre (op) art, Esslingen 1995, repr. p. 104

cat. 306, ill. p. 216
Six Self-Portraits
1986
Silkscreen and acrylic on primed canvas
each 56 x 56 (each 22 x 22)
each verso t. r. on overlap 'Andy Warhol 86'

307

Provenance
Anthony d'Offay Gallery, London
acquired 1986

Exhibitions and Literature
New York 1989, cat. no. 19, repr. 99
Pittsburgh, 1994, repr. pp. 60, 61

Hackett, *Diaries,* 1989, cat. no. 37,
repr. unpag.
Romain, *Warhol,* 1993, cat. no. 139, repr. 18

cat. 307
The Last Supper
1986
Silkscreen and acrylic on primed canvas
101.5 x 101.5 (40 x 40)
verso t. on stretcher [in another hand] 'I certify
that this is an original painting by Andy Warhol
completed by himself 1986'; t. r. 'Andy Warhol'

Provenance
Julian Schnabel, New York
Bruno Bischofberger, Zurich
acquired 1993

Exhibitions and Literature
Hamburg 1993, repr. p. 199

cat. 308, ill. p. 215
The Last Supper
1986
Silkscreen and acrylic on canvas
101.6 x 101.6 (40 x 40)
verso t. [in another hand] 'I certify that this is an
original painting by Andy Warhol completed by
him in 1986 Frederick Hughes' and signature
stamp

Provenance
Alexander Iolas Estate, Milan
Sotheby's New York, 5.5.1994, Sale 6555,
Lot 216
acquired 1994

Exhibitions and Literature
Sotheby's New York, auct. cat. Sale 6555, 1994,
Lot 216, repr.

ACKNOWLEDGEMENTS

Anita Balogh, Stuttgart

Kirsten Berkeley, London

Joseph Beuys Archive,
Schloß Moyland/Kleve:
Frau Strieder

Georg Frei, Andy Warhol Catalogue Raisonné,
Thomas Ammann Fine Art, Zurich / Andy
Warhol Foundation for the Visual Arts,
New York,

Federica Gussoni, Stuttgart

Brigitte Kölle, Frankfurt

Sean Rainbird, London

PHOTOCREDITS

Franziska Adriani, Stuttgart: p. 234
Bert Burgemeister, Pfullingen: cat. 78, 81, 82,
94, 113, 305
Ken Cohen: cat. 236
D. James Dee: cat. 295, p. 38
documenta-Archive, Kassel: p. 21
Eberth: p. 11
Peter Foe: cat. 106
Bill Jacobson Studio: cat. 28, 248
Walter Klein, Düsseldorf: p. 37
Kober * Punctum: cat. 160-a
LAC, Basle: cat. 271, 272
Jochen Littkemann, Berlin: cat. 40, 131, 228,
263
Karl-Hermann Möller, Kassel: cat. 89
Jürgen Müller-Schneck, Berlin: p. 17
Museum of Contemporary Art, Tokyo: cat. 136
Volker Naumann, Schönaich: p. 2, cat. 125,
280, 293, 294
Phillips/Schwab: cat. 159
Eric Pollitzer, New York: cat. 140
Thomas Powel jr.: cat. 126
H. Rekort: p. 16
Friedrich Rosenstiel, Cologne: cat. 224
Bernhard Schaub, Cologne: cat. 247
Philipp Schönborn, Munich: cat. 102, 103, 105
Studio Schumacher, Wiesbaden: cat. 68
Uwe Seyl, Stuttgart: cat. 2, 13, 16, 17, 19, 23,
29, 30, 31, 32, 34, 35, 36, 37, 38, 39, 41, 42,
43, 44, 45, 46, 47, 48, 49, 50, 51, 52, 53, 54,
55, 56, 57, 58, 59, 61, 63, 64, 66, 67, 69, 70,
71, 72, 73, 74, 75, 76, 77, 79, 83, 85, 86, 87,
88, 90, 91, 92, 93, 96, 97, 98, 99, 109, 114,
130, 135, 137, 141, 149, 151, 153, 154, 155,
156, 157, 162, 164, 165, 166, 167, 168, 169,
170, 172, 173, 175, 176, 177, 178, 179, 180,
181, 182, 183, 185, 186, 187, 188, 189, 190,
193, 194, 195, 196, 197, 198, 199, 200, 202,
203, 204, 205, 206, 207, 208, 209, 212, 213,
214, 215, 216, 219, 220, 221, 225, 230, 232,
251, 252, 254, 255, 256, 257, 259, 261, 265,
266, 267, 270, 273, 285, 286, 298, 304, 307,
308
Staatsgalerie Stuttgart: cat. 274, 275, 278, 279,
282
Klaus Staeck, Heidelberg: p. 26
Tate Gallery, London: cat. 226
Caroline Tisdall: p. 27
Elke Walford, Kunsthalle Hamburg: cat. 1, 234
R. Wessendorf, SH: cat. 233
Dorothy Zeidman, New York: cat. 12
Uli Zeller, Stuttgart: cat. 223, 229
Zindman/Fremont: cat. 249

The other photographs are from the archives of
the Froehlich Foundation and Collection.

COLOPHON

This book is published by order of the Trustees
of the Tate Gallery 1996 to accompany the
following exhibitions:

Tate Gallery, London
20 May to 8 September 1996

Kunsthalle Tübingen
Staatsgalerie Stuttgart
Württembergischer Kunstverein Stuttgart
28 September to 24 November 1996

Deichtorhallen Hamburg
Kunsthalle Hamburg
23 January to 13 April 1997

Bank Austria Kunstforum, Vienna
20 May to 17 August 1997

Publisher
Froehlich Foundation, Stuttgart, in association
with Tate Gallery Publishing Ltd.,
Millbank, London SW1P 4RG

German edition published in Germany
by the Froehlich Foundation, Stuttgart

Project Management and Catalogue Design
Sylvia Fröhlich

**Catalogue of Froehlich Foundation
and Collection**
Angelika Thill, Brigitte Kölle

Concept and Data Processing
Gimlet & Partner, Cologne

Editors
Roland Nachtigäller, Nicola von Velsen,
Monique Beudert

Assistants
Anita Balogh, Matthia Löbke, Jasmin Nassimi,
Andrea Tarsia

**Translation from German of text
by Stefan Germer**
David Britt

Editors
Monique Beudert and Judith Severne

Reproductions
C+S Repro, Filderstadt-Plattenhardt

Printing
Dr. Cantz'sche Druckerei,
Ostfildern near Stuttgart

Typesetting
Fotosatz Weyhing, Stuttgart

Bookbinding
Kunst- und Verlagsbuchbinderei, Leipzig

© 1996
Froehlich Foundation, Stuttgart

© 1996 for the reproduced works
VG Bild-Kunst, Bonn for Andre, Artschwager,
Beuys, Flavin, Judd, Lichtenstein, Nauman,
Palermo, Pollock, Stella, Warhol
and the artists or the estates of the artists

ISBN 1 85437 204 1
A catalogue record for this publication
is available from the British Library.

Printed in Germany